GENDERING LANDSCAPE ART

**ISSUES IN
ART HISTORY SERIES**

Tim Barringer, Nicola Bown
and Shearer West
SERIES EDITORS

Steven Adams and Anna Gruetzner Robins, eds.,
Gendering landscape art

James Aulich and John Lynch, eds.,
Critical Kitaj

David Peters Corbett and Lara Perry, eds.,
English art 1860–1914: Modern artists and identity

Rafael Cardoso Denis and Colin Trodd, eds.,
Art and the academy in the nineteenth century

Elizabeth Prettejohn, ed.,
After the Pre-Raphaelites

Brandon Taylor,
Art for the nation

Gendering landscape art

EDITED BY STEVEN ADAMS
AND ANNA GRUETZNER ROBINS

Rutgers University Press
New Brunswick, New Jersey

First published in the United States 2001
by Rutgers University Press, New Brunswick, New Jersey

First published in Great Britain 2000
by Manchester University Press,
Oxford Road, Manchester M13 9NR, UK

Library of Congress Cataloging-in-Publication Data and
British Library Cataloguing-in-Publication Data are available upon request.

ISBN 0–8135–2974–3 (cloth
ISBN 0–8135–2975–1 (paperback)

Printed in Great Britain

Contents

Illustrations

Contributors

Steven Adams is Principal Lecturer in Critical and Cultural Studies in the Faculty of Art and Design at the University of Hertfordshire. He specialises in French landscape painting and visual culture of the nineteenth century and is author of *The Barbizon School and the Origins of Impressionism.*

Jane Beckett is Senior Lecturer in the History of Art at the University of East Anglia. She has published extensively on modernism in Europe and Britain as well as contemporary art, most recently *Lubaina Himid: Plan B,* Tate Gallery, 2000. She is completing a cultural history of Amsterdam.

Síghle Bhreathnach-Lynch is Curator of Irish paintings at the National Gallery of Ireland. She has published widely on Irish art and is the co-author of *Discover Irish Art,* 1999.

Anthea Callen was formerly Research Professor in the History of Art at De Montfort University, Leicester. She is currently Chair of Visual Culture at Nottingham University. Her publications include *The Spectacular Body: Science, Method and Meaning in the Work of Degas,* 1995 and *The Art of Impressionism: Painting, Technique and the Making of Modernity* (2000). She is currently researching a book on art and anatomy in France *c.* 1750–1920.

David Peters Corbett is Senior Lecturer in History of Art at the University of York. He has written widely on English art of the nineteenth and twentieth centuries, including a co-edited book *English Art 1860–1914: Modern Artists and Identity* (2000).

Anne Helmreich is Assistant Professor of Art History at Texas Christian University, Fort Worth, Texas. She is currently working on a book on national identity and the English garden 1870–1914.

Jo Anna Isaak is a writer and curator living in New York City. She teaches art history at Hobart and William Smith Colleges, Geneva, New York. Her publications include *Nancy Spero,* 1995, with Jon Bird *et al., Feminism and Contemporary Art: The Revolutionary Power of Women's Laughter,* 1996, *Laughter Ten Years After,* 1996, and *Looking Forward, Looking Black,* 1999.

Caroline A. Jones is Associate Professor of Art History at Boston University. Her publications include *Picturing Science, Producing Art* which she co-edited with Peter Galison, 1998,

and *Machine in the Studio: Constructing the Postwar American Artist,* 1996. She is currently working on the impact of Greenberg's criticism on post-war American art.

Denise Blake Oleksijczuk was Assistant Curator of Contemporary Art at the Vancouver Art Gallery. She is currently completing a Ph.D. thesis on panoramas for the University of British Columbia.

Anna Gruetzner Robins is Lecturer in the History of Art at the University of Reading. Her publications include *Walter Sickert: Drawings. Theory and Practice: Word and Image,* 1996 and *Modern Art in Britain 1910–1914,* 1997.

Pat Simpson is Lecturer in History of Fine Art and the Visual Culture at the University of Hertfordshire. She publishes on representations of women in Soviet art.

Paul Smith is Reader in History of Art at the University of Bristol. His publications include *Interpreting Cézanne,* 1996 and *Seurat and the Avant-Garde,* 1997. He is currently working on a book for Yale University Press on Cézanne and the notion of the primitive.

Introduction

Steven Adams and Anna Gruetzner Robins

Hear, Nature hear; dear goddess, hear (*King Lear*)

The chapters in this book examine landscape art and gender. While issues of gender have had a conspicuous effect on our understanding of art over the last few decades and while landscape has recently been subject to various forms of analysis by cultural historians and exponents of *the new art history*, landscape art has yet to be subject to an analysis informed by an understanding of gender. The attempt to explore these connections and bring landscape art and gender together first emerged as a part of the Association of Art Historians Conference at the Courtauld Institute in 1997. The chapters by Denise Blake Oleksijczuk, Síghle Bhreathnach-Lynch, David Peters Corbett, Caroline Jones, Pat Simpson, Paul Smith and our own contributions to this book were first delivered as papers at the conference and we are delighted that Jane Beckett, Anthea Callen, Anne Helmreich and Jo Anna Isaak also agreed to contribute to this volume.

All of the contributions to this book are informed by a shared awareness of the rich potential of landscape both as a 'collecting' structure for the representation of inner experience and as an ideological tool shaping the way in which we envision and construct the natural world. As the psychoanalyst Christopher Bollas has observed, the choice by artists of a representational form 'is an important unconscious decision about the structuring of lived experience, and is part of the differential erotics of everyday life'.[1] Landscape art, furthermore, has also increasingly been seen as a site for the articulation of class relations, a means of forming national identity or a conduit for the exercise of colonial power. The key issues that emerge in such approaches to the landscape are wide ranging and variously question ways in which we perceive space and how those perceptions are shaped by various psychic, social and cultural determinants. They raise issues, for example, about the manner in which early infantile experience determines our understanding of space; ways in which visual representation of the land provoke questions about ownership and class; they question notions of how we give the environment visual form and the ideological and cultural issues that emerge when sites are variously presented as ideal, forbidden, despoiled, polluted, wasted or untouched.

Not least, all of the contributions to this book are informed by the notion that women and men are given different and unequal access to imaginary and real spaces that make up landscape art. As the chapters in this book illustrate so vividly, *gender* – the notion that sexual difference is psychically and socially constructed rather than naturally determined – has imprinted and continues to imprint itself on the landscape in myriad form. Gender has shaped ways in which we see the environment. It is commonplace in many cultures, for example, to envision Nature or the earth as a fecund mother, a connection made by stoic philosophers in Hellenistic Greece and some eco-feminists two thousand years later.[2] In fact, the binary coupling of women to Nature and men to culture emerges – albeit in a variety of formulations – in nearly all of the chapters that follow. Furthermore, gender has also shaped the way in which we understand the representation of geographic space in the material fabric of the world around us. Here, a direct engagement with the landscape, the odyssey or trek across virgin territory or the physical manipulation of the material fabric of Nature are often described in terms of subjugation or defilement of the feminine earth. Notions of gender, in turn, have not only affected the ways in which the environment is made and perceived but also determines the very tools and practices used to give the landscape psychical form. In the same way that academic teaching in Europe gave priority to line over colour, so these two component parts of landscape painting were often gendered, the former as rational and male, the latter sensual and female. And, not least, notions of gender have also been called upon to shape national identity. For example, the female peasant as an icon of enduring tradition set against colonial powers or against industrialisation has shaped visual representations of the national identity in both Ireland and Holland.

A summary explanation of the terms *gender* and *Nature* is useful in providing a point of entry into both the chapters in this book and the broad spectrum of cultural, psychoanalytical, geographic and gender studies that inform them. In short, we use the term gender to define masculinity and femininity as they are culturally determined, constructed according to various scientific, medical, artistic, social, economic and political modes of representation, as distinct from the notion of a male and female sex which is biologically defined. Recent writing on the subject which draws on Marxism, sociology, literary, psychoanalytical and cultural theory as tools of analysis has done much to enable us to understand the role of gender in the making and assessing of art. Indeed, the role of gender within art practice has been the subject of extensive debate for the last two decades. This debate, however, has focused almost entirely on the body – the most obvious site of sexual difference as the recent publication *Gender and Art*, edited by Gill Perry, so ably demonstrates.[3] For the most part, however, landscape art – the visual representation of the urban and rural spaces gendered bodies move within or are excluded from, the spaces that are represented, symbolised and imagined, the ways in which gender difference has been projected on Nature and the landscape, and the perceived image of the exclusively male landscape artist, have on the whole escaped a similar level of sustained art historical examination.

Until comparatively recently Nature, was – and in some circles still is – seen as a relatively unproblematic term, a 'rude', edenic state, unencumbered by the trappings of culture. Writing in his seminal book *Keywords* in 1976, Raymond Williams asserted that Nature is the most complex word in the language.[4] For the purposes of landscape art, it is Williams's third definition of Nature as 'the material world itself, taken as including or not including human beings' which is of interest.[5] Williams points out that very early within western culture, Nature was persistently personified as 'Nature the goddess', 'Nature herself' and 'Mother Nature', the 'all-powerful creative and shaping force'.[6] Set beside the monotheistic Christian God of the middle ages, Nature was described as His deputy or minister. To these associations could be added a seemingly endless list of variations whereby Nature was gendered as female, variations which extend far beyond the confines of western culture. It is, of course, no longer possible to assert the earth's femininity, its association with motherhood, the feminisation of Nature, the notion that gender difference is naturally determined, without a parallel examination of precisely how, when and why those connections were made. Such interventions have increasingly led other feminists to realise that the terms *earth, femininity, woman* and *Nature* are constructed within a patriarchal culture and have shifted in meaning across history and culture thereby making essentialism hard to sustain. For example, as Williams indicates, the phrases 'conquest of Nature', 'mastery of Nature' were dominant not only in bourgeois thought but also through socialist and Marxist writing in the second half of the nineteenth century.[7] And it hardly needs pointing out that the notion that Nature was there to be subjugated coincided with increasing expansionist policies and colonialism, with the growing commodification of Nature, and the corresponding upsurge in demand for landscape art.[8] For, as Williams asserts, mastering the earth and 'pushing other people around … form the whole eternal ethic of an expanding capitalism: to master Nature, to conquer it, to shift it around, to do what you want with it.'[9]

This mastery can easily be linked to the discourse of landscape art, created almost entirely by male artists up to the end of the nineteenth century who professed not only to be conquering Nature but who also invented complex systems of representation for making it intelligible. Just as cartography can be seen to be a masculinist project for making Nature legible, so the rules of perspective, the invention of new compositions for landscape, the growing stress on the importance of viewpoint for representing Nature, the feminisation of the countryside as something to be courted, to give suck or to be seduced have an equal masculinist basis.

Here, the idea of the male gaze as first defined by Laura Mulvey in her highly important essay 'Visual Pleasure and Narrative Cinema' has significant implications.[10] Writing on the representation of women in cinema, Mulvey analyses the exchange which takes place when images are constructed according to male-defined codes and where the codes themselves re-confirm the identity of the viewing subject. Mulvey defines the gaze as a male fantasy projected on to the female figure. 'In their traditional exhibitionist role', Mulvey writes, 'women

are simultaneously looked at and displayed, with their appearance coded for strong visual and erotic impact so they can be said to connote a *to-be-looked-at-ness*'.[11]

More recently, the feminist geographers Gillian Rose and Catherine Nash have adopted the theory of the male gaze, suggesting that the male geographers 'gaze' at the landscape with its assumed feminine qualities in a manner that is reminiscent of and gives the same kind of pleasurable experience as that felt by the male spectator of the female nude. Writing in *Feminism and Geography*, Rose argues that 'the same sense of visual power as well as pleasure is at work as the eye traverses both field and flesh: the masculine gaze of knowledge and desire'.[12] In response to this feminist critique of the landscape tradition within geography, Catherine Nash has postulated a 'reclamation of looking and landscape through a critical feminist approach'.[13] By examining women's images of the male body as landscape, she reconciles a feminist approach which retains the idea of landscape as the focus of discussion, asserting the 'validity of a feminine heroic approach to landscape through a distanced and elevated viewing position, [in which] the power and naturalness of the masculine heroic is subverted'.[14]

Crucial issues surrounding the gendering of Nature remain. In 1974 Sheri Ortner posed her now frequently quoted observation that 'female is to male as Nature is to culture' and sought to explain what she described as the 'universal fact' of the association of woman with Nature and man with culture.[15] She argued that the reasons 'that led every culture to place a lower value upon women' can be explained in terms of women's association with the one thing 'that every culture defines as being of lower existence than itself – "Nature"'.[16] Ortner argued that 'every culture is engaged in the process of generating and sustaining systems of meaningful forms (symbols, artifacts etc.) by means of which society transcends the givens of natural existence, bends them to its purpose, controls them in its interest in which culture asserts itself to be distinct from but superior to Nature ...'.[17] The work of Ludmilla Jordanova provides a vital addendum to Ortner's assertions by addressing the importance of historical specificity – the notion that the gendered binaries that attend descriptions of Nature and the landscape have been articulated in and across a wide variety of institutions and spaces and have shifted and been modified accordingly. Writing in *Sexual Visions*, Jordanova explains gender not only in terms of an over-arching, binary opposition between Nature and culture, but locates it within a framework in which many other formative societal, historical, cultural and economic factors are called into play. For example, unlike many eighteenth-century philosophers, she notes that Jean-Jacques Rousseau's disciple, Jacques-Bernardin-Henri-de Saint-Pierre, located woman not as culture's other but as the primary social foundation on which cultural development as a whole depends. During the Enlightenment, men, in turn, were seen both as 'the progressive light of masculine reason' *and* the cause of the 'corruption of civil society'.[18] A close examination of such historical moments indicates that the articulation of gender differences was highly contingent and continually shaped by other cultural, historical and societal

forces. In Berndarin's case, for example, it is possible to see that the essentialist formulae linking woman with Nature gets inverted and needs a contextual elaboration that singularly undermines essentialist formulae.

Elsewhere, Jordanova has also observed that 'languages of Nature are made and not pre-given, and they are made, furthermore, according to different rules, assumptions and aesthetic preferences, for distinct purposes by various constituencies according to their context'.[19] The implications for the study of landscape art are vast – the idea of the landscape artist, the critical writing about landscape art and the ways in which landscape is represented are all affected by commonly held assumptions about the gendering of Nature. Here, the work of the eco-feminist Caroline Merchant is an inspiration. She argues, for example, that the idea of Nature as female and agency as male i s encoded as symbols and myths into 'the recovery narrative' about the discovery of the American frontier. Writing in *Earthcare, Women and the Environment*, Merchant observes: 'The narrative of frontier expansion is a story of male energy subduing female Nature, taming the wild, plowing the land, recreating the garden lost by Eve.'[20]

Thus far, we have pointed to a number of areas of enquiry that inform the gendering of landscape art: the gendering of Nature as female, a transcultural tradition which dates back to Antiquity; ways in which the subjugation of Nature coincided with industrial and colonial expansion and the ways in which such processes of subjugation were refracted through discourses in geography. We have also pointed to the way in which art history's preoccupations with gender have centred around the body and the way in which some feminist geography has reworked ideas about the processes of looking. Conspicuously absent from this line-up are direct and sustained links between gender and *landscape* art. This volume redresses the marked imbalance between art historical writing on the body and writing on the real, symbolic and imagined spaces that women and men inhabit.

The process of redress – the notion that landscape art constitutes a psychic, social or material space which is historically shaped by men for the real or imaginary occupation of women and the notion that those spaces might in some sense be contested and re-gendered – owes a considerable debt to a substantial body of art historical scholarship which presents landscape painting not as an object of unproblematised aesthetic delight but as a site for the articulation of economic, social and political relations.

Kenneth Clark's *Landscape into Art* first published in 1949 (still in print half a century later, and still a whipping-post of *new* art history) provides a well-worn but arguably no less current initial point of reference for ways in which the genre has been subject to an alternative form of art historical analysis.[21] For Clark, the history of landscape follows an unproblematic and unproblematised course through western culture in which each 'age' subjects the genre to different kinds of 'symbolic', 'factual', 'ideal' or 'natural' interpretation. Here, landscape painting is seen as a history of the 'human spirit' and its attempt to 'create harmony with its environment'.[22] Alongside this art historical narrative we find a parallel story line,

an essentially modern teleology, in which landscape is seen to have risen from its humble origins in Antiquity when it was conceived only as a form of decoration to become 'the chief artistic creation of the nineteenth century, without which, no evaluation of contemporary painting is possible'.[23] The two accounts are, of course, intimately connected: landscape painting reaches its high point at the moment when it becomes most aesthetic. Here, landscape painting is no longer encumbered by the hierarchy of the genres or confused with decoration, under the stewardship of a succession of great artists, it creates its own aesthetic and becomes instead the vehicle of individual perception.

John Barrell, Ann Bermingham, Stephen Daniels, Marcia Pointon, Michael Rosenthal, Andrew Hemingway and David Solkin have published significant contributions which have had a radical effect on the way art historians think about landscape art.[24] Two more recent collections of essays, edited by Simon Pugh and W. J. T. Mitchell, have also provided new frameworks to understand landscape art.[25]

Writing in *The Dark Side of the Landscape* of 1980, John Barrell, for example, examines English landscape painting between 1730 and 1840 from the vantage point of the social history of the period, specifically the representation of the rural poor. Using the example of E. P. Thompson's research into the emergence of an English working class in the late eighteenth and early nineteenth centuries (and in sharp contrast to Clark), Barrell sees English landscape painting as an 'ideological expression', a reflection of 'the actuality of eighteenth century life'.[26] Landscape painting, moreover, provides an opportunity to chart social relations and the place of the poor in English society as a whole and the ways in which such relations determine the compositional organisation of the works themselves. Here, rural imagery no longer prompts aesthetic appreciation but emerges as an ideological tool suggesting that 'the poor of England were, or were capable of being, as happy as the swains of Arcadia'.[27] Landscape painters of the period, Barrell notes, also stressed the moral dimension of rural labour in their pictures, thereby neutralising, or at least containing, the image of workers as a collective political force.

The notion that landscape painting of the period emerges as an ideological form, an object both of social relations and of social prescription, is also discussed in Ann Bermingham's study of the English rustic tradition in landscape painting. Writing in *Landscape and Ideology* (1987), Bermingham argues that landscape paintings of the late eighteenth and early nineteenth centuries contain a 'class view of landscape' that prompt social and finally economic values which lend such paintings their meaning.[28] Unlike Barrell, however, who sees landscape painting as a 'reflection' of social conditions, Bermingham goes one significant step further. Following the example of the French philosophers Louis Althusser and Roland Barthes, she demonstrates ways in which landscapes provide an illusionary account of the real countryside and locates such artefacts and the ideas they embody within the 'larger semiotic field', the social, political and cultural structures that gave them meaning.[29]

Another strategy for the problematisation of *landscape* – and here the term is extruded to include cultural forms such as the garden, terrestrial and extra-terrestrial colonial adventures and the picture postcard alongside landscape art – can be found in the essays in Simon Pugh's *Reading Landscape: County–City–Capital* of 1990. In this instance, however, the landscape takes on a form that goes beyond the kinds of analysis cited above. Here, the genre is subject to a process of 'reading' in which real and imagined spaces are constituted through *texts*, visual and verbal modes of representation. In Marcia Pointon's reading of Turner's artistic practice and Ann Bermingham's 'reading' of Constable, for example, conventional modes of stylistic and iconographical analysis of landscape are set aside. As Pointon shows, Turner's landscape paintings can be reconstituted through textual examination of the 'verbal' element in his work, through the discursive fields that constituted artistic practice during the late eighteenth and early nineteenth centuries, the literary conventions in Turner's letters and through ways in which their analysis provides an understanding of his landscapes.

Writing in *Landscape and Power* published in 1994, W. J. T. Mitchell identifies two major shifts in the way in which the term landscape has been understood. The first shift, associated with modernism, sees landscape painting in terms of the 'progressive movement towards the purification of the visual field', a movement essentially similar to that posited by Clark in which the landscape becomes the record of the innocent eye of the artist.[30] The second shift, for Mitchell, is essentially 'interpretive'. In this instance, the landscape is subject to various forms of decoding, either through methodological tools offered by social history or textual analysis. Mitchell goes on to posit a third method for envisioning the landscape, one which questions not what landscape 'is' or 'means' but what it 'does', 'how it works as a cultural practice'.[31] Landscape, Mitchell suggests, is an instrument of cultural power which represents an essentially artificial world – the landscape as a set of contingent visual and verbal conventions – as if it was something natural and given.

This summary account of some of the theoretical and historical concerns that have informed *gender*, *landscape* and *art history* over the past few years points to a significant gap. For while art history has addressed issues of gender, and landscape art has been analysed from the vantage point of social history and cultural studies, and while the landscape has been problematised, in turn, by feminist geographers, these issues have yet to be re-aligned so that landscape *art* has been rethought through notions of gender. It is precisely this gap that the chapters in this book begin to fill. The volume, then, is structured around the following themes: the gendering of technique and practice, the gendering of the landscape and national identity, psychoanalysis, gender and landscape art, and geographic space and gender.

The gendering of technique and practice

In *Landscape into Art*, Clark unquestioningly accepts and does much to perpetuate some well-worn clichés about landscape painting in general and nineteenth-century

landscape in particular. There is the assumption, for example, that 'great' male land-
scape artists paint the landscape as a way of ordering female Nature. There is also the
assertion that the nineteenth-century 'Natural Vision' of which he speaks, although
'miserably poor', is a record of a 'clear objective natural appearance without loss of
freshness […] the perfect expression of democratic humanism'. These assertions
still often underpin many accounts of the work of the Impressionists.[32] Several of the
chapters in this book vigorously challenge such assumptions and examine the ways
in which the image of the male landscape artist is based on once well-established but
subsequently forgotten tropes that had their origins in the political, scientific and
cultural discourse of nineteenth-century France.

As Steven Adams shows, the image of the male artist addressing female Nature
through the conduit of his landscape painting was far more complex and intricate
than most art historical narratives on the period imply. The address to female
Nature depended upon notions of artistic virility on the one hand and a child-like
integrity on the other. In this instance, landscape paintings were of aesthetic worth,
it appears, because their authors had a moral and physical integrity, concerns
which were a component part of the attempt to aestheticise art practice and criti-
cism during the politically conservative years of the Second Empire. Here, the
purity and naturalness of artists who represented the French countryside – the
purity of the person and of his landscapes – placated anxieties about an enfeebled
French nation whose hope for salvation lay in its wholesomeness.

Significantly, as Anthea Callen shows in chapter 3, the critic Octave Mirbeau
drew on aspects of this established stereotype of the landscape artist when he pro-
moted Monet as a 'male and healthy' artist. Within an established artistic hierarchy,
Impressionist painting was regarded as 'feminised' because colour, traditionally
regarded as feminine, had greater importance than line, which traditionally was
regarded as masculine. To establish the masculine character of Monet's highly
coloured painting, important shifts in meaning took place. Endorsed by the
expanding scientific discourse concerning the properties of light and the physi-
ology of optics, the depiction of light in painting acquired a new masculine
authority, and sight became 'the locus of masculine power'. This was an attempt by
Monet's supporters to affirm 'the artist's masculine virility both pictorially and
personally' in response to the persistent fears of Impressionist effeminacy.

Painting out of doors was a suspect activity for female artists in the nineteenth
century.[33] Helen Allingham, for example, made her reputation as a painter of the
Sussex countryside, but as Anne Helmreich shows, her male critics and dealers
erased the radicalness of this successful artist's venture, by stressing her role as
mother and homemaker. They expanded the 'parameters of the domestic sphere'
arguing that, as a woman, Allingham was far better suited to represent scenes of
English cottage life and thus urged that she worked as a landscape painter while
remaining close to the home, that fortress in the Victorian imagination of all femi-
nine virtues. Such was Allingham's talent as a watercolourist, that these same sup-
porters argued that she was upholding the tradition of the English school. But they

still maintained that there was a detectable gender difference evident in her method and technique of water-colour painting.

The gendering of the landscape and national identity

The idea of landscape as a culturally and politically value-laden form, capable of being read in many ways, is discussed by several contributors to this book. Jane Beckett, Síghle Bhreathnach-Lynch and Pat Simpson examine the ways in which landscape has been closely tied to ideas of nationhood and femininity, while David Peters Corbett shows that the new industrial landscape of modern England served as a powerful image of strident masculinity for Wyndham Lewis and the Vorticists which collapsed in the aftermath of the Great War. Here, landscape painting is considered as an ideological tool used to articulate ideas of masculinity, femininity and nationhood, a means of maintaining political order during periods of change and as a means of constructing the identity of colonial others.

Far from having a fixed, stable meaning, femininity and landscape has had conflicting and contradictory meanings that are closely tied to particular geographies, and social and political events. This point is clearly illustrated in Jane Beckett's discussion of Dutch landscape painting. She shows that the figures, both male and female, of labouring agricultural workers had a powerful hold between 1880 and 1920 in Dutch visual culture, and that artists adapted and reformed the image of these labourers to satisfy the changing political and social climate. During a period of modernisation when the production of food became factory-based, images of the Dutch maid as mother and homemaker shown in picturesque traditional costume and representing the productivity and fecundity of the landscape increased. These images appeared, however, at a moment when the rural economy based on dairy produce collapsed and was replaced by potato farming. The harvesting of potatoes was largely women's work, but these images of women soiled by agricultural labour were not easily accepted by the Dutch middle class, who imagined the countryside as a pure and wholesome place. Jane Beckett argues that the paintings of washing and bleaching by Mondrian were the antithesis of images of potato harvesters, and served to cleanse and purify the Dutch rural landscape, making it safe for urban eyes.

The image of the Irish female peasant as mother and homemaker was a powerful, commonly used trope, in the construction of the identity of the new, post-colonial, Irish identity. The landscape of the West of Ireland was appropriated as 'the real' Ireland, and the Irish peasant female, seen as passive, pure and nurturing, was co-opted as a personification of that authentic landscape. After the creation of the Irish Free State, legislation was passed to keep women in the home. Síghle Bhreathnach-Lynch argues that this reactionary move can be linked with the growing cult of mariology. The increasing proliferation of grottoes and shrines devoted to the Madonna that dotted the countryside were regarded, she argues, as the 'natural' landscape of Ireland, a powerful reminder of the link between Irish females and a feminised, pure landscape.

In contrast, a new type of idealised female who participated in sport and physical culture was depicted in Alexandr Deineka's painting *Razdol'e*, where the athletic sports-women who ran through the Soviet landscape represented the emancipated New Soviet Person. But as Pat Simpson argues, these images were framed within a patriarchal discourse that embodied ideas of Holy Mother Russia, the eternal feminine and the feminisation of Nature.

The English modernists, Wyndham Lewis and the Vorticists drew on an aggressive model of masculinity, which borrowed heavily from a late nineteenth-century French model of the bohemian, male artist. The Vorticists used new technological and mechanical forms to represent the industrial city, and the English countryside, believing that England's 'industrial genes' were the defining characteristic of the landscape. David Peters Corbett shows how, in the aftermath of the Great War, this model of masculinity collapsed, and was no longer tenable for a new generation of artists. He suggests that it was replaced by a new version of masculinity which he characterises as passive, powerless and victimised. As a result, 'modernity in the landscape', he argues, 'was constructed, squeezed into the intimate spaces that a privatised subjectivity allowed'.

Psychoanalysis, gender and landscape art

Ever since Freud in *The Ego and the Id* of 1923 first considered the relation of unconscious processes to various visual images, and the experiments of the surrealists, it has become accepted that 'landscapes … are always partly dreamscapes' and that artists may select landscape as a form of self-expression, not as an exercise in which art imitates Nature but to 'find metaphors of their own body and sensibility "in" the natural world'.[34] As Henry David Thoreau put it: 'It is in vain to dream of a wildness distant from ourselves. There is none such. It is the bog in our brains and bowels, the primitive vigour of Nature in us, that inspires that dream.'[35]

Paul Smith in chapter 9 and Caroline Jones in chapter 10 use psychoanalytic theory to assess the role of Mother Nature. Both authors, however, argue against a simplistic approach. Paul Smith draws on the work of the psychoanalyst Melanie Klein (1882–1960) which focuses on the tension between 'helpful' and persecutory interpersonal object relations in the first years of life – a psychic process through which the infant may overcome or submit to anxieties about harming the maternal body. For example, he argues that Cézanne had 'ambivalent and fluctuating fantasies about the maternal landscape', and suggests that it was through the process of painting that Cézanne, a 'pathological type' as defined by Klein, looked for an imaginative solution to his 'violent and fearful phantasies towards the maternal body in more loving reparative phantasies'. He poses an alternative to an interpretation which assumes that male artists represent the soft contours of a landscape as a passive, feminised mirror for the male gaze. Rather, Cézanne's professed attachment to his 'native soil' can be linked to deep-rooted patterns of phantasising over the mother's body, patterns which produced morphological and phenomenological

analogies in Cézanne's landscapes. In the late landscapes of Mont. St.-Victoire, 'Cézanne made whole the damaged object', Smith suggests; his 'aim appears to have been to capture the phenomenon in which objective, "feminine" and subjective "masculine" Nature are fused'.

Caroline Jones also argues that the idea of Mother Earth does not have a fixed meaning and that it can only be defined within the context of a particular artistic project. Writing about the Earthworks of Robert Smithson, she observes that the standard trope of Mother Earth and the heterosexual male viewer 'mutates into polymorphous new forms', and that these are best read within the framework of Queer Theory. She suggests that Smithson acted out a homoerotic fantasy of 'technological sex' and that in Smithson's view, the landscape itself displayed homosexual tendencies. This was Smithson's challenge to an 'Ecological Oedipal Complex' that had its roots in Freud's determined move to locate the myth of Oedipus within the confines of the heterosexual family. Smithson's challenging of Freud's explanation, Jones shows, coincided with the publication of an attack against Freud's Oedipus theory by the French philosopher Guy Hocquenghem which heralded other writings on homosexual desire. As Jones observes, unless we are aware of these complexities, simple categories such as *Mother Earth* can detract from the answers we hope to find when investigating issues of landscape and gender.

Geographic space and gender

At the beginning of the nineteenth century, global exploration and colonial expansion were largely a male preserve. At this time, many of the gendered distinctions about conquering the earth, plundering and controlling Mother Nature (still unhesitatingly accepted by many as a given norm) entered common language.

Women did travel during this period, but social restrictions prevented them from 'living' in the landscape in a manner similar to that of male adventurers. Visiting the Panorama – spectacularly large, three-hundred-and-sixty-degree landscapes located within a specially constructed, darkened rotunda – was a popular pastime for women. Denise Blake Oleksijczuk suggests that for women spectators such painted landscapes were a substitute for their unfulfilled fantasies about adventure and travel. Her contribution to this book raises questions about the perceived gender difference between male and female experiences of the landscape, experiences which were given a pseudo-scientific basis at the end of the eighteenth century. Blake Oleksijczuk's analysis of King George and Queen Charlotte's response to a painted seascape depicting the Grand Fleet of the Royal Navy, on their first visit to the Panorama, shows the importance of gender difference for these considerations. Social conventions not only decreed that women and men responded very differently to the sensation of landscape and space in the late eighteenth and nineteenth centuries but scientific enquiry was used to explain the rational and sensational operation of the human mind.

The idea of the male explorer, who enjoys tremendous adventures while travel-ling the globe, plundering and conquering Mother Nature, was once deeply embedded in modern consciousness. Until the impact of feminism and the envi-ronmental movement, the nether reaches and uncharted terrain of the globe con-tinued to be the exclusive territory of the male hero as personified in the endlessly mutating characters of adventure movies, comic strips and television series set against a jungle background.

Richard Long's image as an artist draws closely on the old model of the male adventurer and there has been an almost unquestioning acceptance of Long's pur-ported role. This worn out trope of masculinity and the equally familiar Romantic notion of Nature sit oddly, Anna Gruetzner Robins argues, with the radical nature of Long's art project. His arranged walks, the photographs and their accompanying texts, and his gallery installations undeniably have extended the boundaries of tra-ditional sculptural practice. Yet underlying this inventive creativity, there is a disre-gard for the perilous state of the Mother Nature that he claims to love, a disregard that has more in common with the first male explorers than modern day environ-mentalists and eco-warriors.

Jo Anna Isaak discusses seven 'Garbage Girls', who make landscape art in and around New York City using refuse and wasteland, including Mierle Laderman Ukeles, the 'pre-eminent garbage girl', who, as artist-in-residence with the New York Sanitation Department, has raised the profile of garbage (rubbish) collectors and waste management. These artists have adapted the task of cleaning up domestic spaces which have traditionally been assigned to women, and exercise this role within the broader urban landscape offering a compelling solution to a pressing environmental concern. By working with waste, the Garbage Girls show that the maintenance of the natural and urban landscape is not the opposite of cre-ativity, but a reinterpretation of it. Yet like Richard Long, all of them draw on the expanding field of recent art practice. But what a challenging and relevant image of the landscape artist they offer.

Mary Daly, Zoë Sofonlis, Joni Seager and Vandana Shiva have argued that cap-italism's use of the earth's resources is a perverse violation of the feminised earth's body and suggest that the reassertion of the binary coupling of woman and Nature can be used for political ends to undermine masculinist/multi-national capi-talism. This is one reason why the issue of gender and landscape art is of crucial concern. When we refer to the exploitation and domination of Mother Nature we are referring to the future of the entire planet. Like the eco-feminists who, in an effort to save this planet, ask us to reassess the traditional gendered categories of man and Nature, the Garbage Girls are fully engaged with social issues of our time.

Signs of recovery: landscape painting and masculinity in nineteenth-century France

Steven Adams

Introduction

Looking back on the recent history of French art from the late nineteenth century, critics and historians were able to locate a clear trend. History painting, once the highest of the genres, was widely considered a 'spent force'.[1] Closely associated with the prescriptive teaching of the École des Beaux-Arts and traditionally a vehicle for national 'gloire', history painting was thought inappropriate to the needs of a nation which had dis-established art and state and now asserted the importance of individual artistic freedom.[2] Genre painting also received a bad press. Reputedly the preserve of an ill-educated middle class who wanted pictures laced with anecdote made with conspicuous displays of manual dexterity, genre painting was said by the art critic and historian André Michel to be of 'ever diminishing importance in the history of French art'.[3] The fortunes of landscape painting, however, were different. Landscape was seen to have embodied the ideals of personal freedom rather than institutional constraint, creative intuition rather than academic dogma, mental and physical health rather than neurosis and disease. In fact, the robust physical and mental health of several generations of French landscape painters – their capacity to trust in personal intuition and endure the hostility of the conservative Académie and philistine public – accounted, according to some critics, for the landscape painting's 'final triumph' at the end of the nineteenth century.[4]

Several art historians have recently examined the 'delineation of artistic temperaments' and noted the manner in which Nature was feminised in nineteenth-century art criticism.[5] Little attention, however, has been given to the marked specificity of the narrative conventions surrounding the gendering of landscape painting, to the wide variety of material and discursive spaces in which this process of gendering took place, and to why this highly distinctive set of tropes should have had currency in so wide a spectrum of writing around art in the second half of the nineteenth century.[6] In the

first part of this chapter I examine some of the narrative conventions associated with
the image of the virile but child-like landscape painter and in the second look at three
very different discursive spaces in which the trope was produced, circulated and con-
sumed: the discipline of local history, illustrated luxury books and popular journalism
on the arts. The third part examines ways in which the trope of the landscape painter
as celibate but virile child and the discursive spaces in which he found form were
located within wider political and social debates on press censorship on the one hand
and the psychic, physical and social benefits of celibacy on the other. The Second
Empire and early Third Republic witnessed the imposition of draconian restrictions
on the publication of books and articles on 'politics, social matters and the economy'.
'The arts, science and letters' were generally exempt from such legislation and this
exemption extracted the arts from the field of politics and relocated them within a
rapidly expanding domain of writing about de-politicised leisure in which gendered
notions of the psychic and physical continence of the artist were important criteria for
personal and cultural validation. And in the same way that landscape painting was de-
politicised by its alignment with local rather than national history, personal rather
than social or institutional concerns, so landscape painting as an unproductive 'aes-
theticised' activity was re-validated through its close association with social and med-
ical pre-occupations about the virtue of celibacy on the one hand and the dangers of
unproductive, onanistic sex on the other. What emerges, I suggest, is a complex dis-
cursive formation around landscape painting in which male potency and child like
integrity provided the motive force for the development and the moral/aesthetic val-
idation of French painting during an era which increasingly sought to extract art from
the political sphere.

Writing about landscape: Bellier, Henriet and Taine

Writing about landscape painting changed in the early 1850s. During the first half of
the century landscape painters were often cast either as revolutionaries seeking to
undermine academic conventions or as itinerant hacks, habitués of working-class
drinking dens, turning out pictures of dubious quality for an overheated art market.[7]
During the Second Empire this formulation changed. Landscape painters were
fêted for their temperament and their works were read not as a topographical record
of a site but as a gendered demonstration of its author's personality. It is possible to
point to numerous cases where male psychic and physical resolve were seen as essen-
tial qualifications for authorial affirmation. One study, Emile Bellier de le
Chavignérie's *Récherches historiques, biographiques et litteraires sur le peintre Lantara*
of 1852, stands out as a useful point of entry into the literature on the subject because
it specifically sets out to challenge the depiction of the landscape painter as seditious
roué with a later nineteenth-century, physically and morally continent alternative.[8]
 The textual strategy used by Bellier, the way he re-worked his subject's identity
and the new method of 'disinterested' history he uses to substantiate the enquiry, is
worth exploring in some detail, not least because it featured so often in writing

about French landscape.[9] Written with the aid of a local archivist from Lantara's home town, the text, Bellier stated, 'was the result of seventeen months of patient research', the facts about the artist's life '... unearthed from layers of dust'. The enquiry, he went on, was the result of 'more labour than knowledge, a mass of historical detail which is interesting but above all authentic', an authenticity substantiated through ostentatiously detailed footnotes, a relatively new device in French historical studies.[10] Thus armed, Bellier was able to contest his subject's tarnished image with authority.

Bellier took issue with a number of historians and critics, each of whom had cast aspersions on Lantara's temperament, but fixed in particular on Jean-Baptise Picard's one-act play of 1808, *Lantara ou le peintre au cabaret*.[11] The dispute between the historian and the playwright centred on the notion that so gifted a landscape painter could have a 'brutish' temperament and Bellier went on to mobilise the tools of positivist history to dispose of each of the play's 'errors'. The image of Lantara that emerged is not Picard's 'un être abruiti' (brute-like creature) but an artist whose every action pointed to his 'loyauté', 'insouciance' and 'naiveté spirituelle'.[12] The delineation of Lantara's sexuality was an important component of this revised depiction. Unlike Picard, who casts Lantara as the father of one Célestine, Bellier was emphatic that his subject was 'célibataire', a state closely associated with creative 'geni' and 'esprit' in the second half of the nineteenth century.[13] Concluding an aside about the social standing of *cabarets* during the Empire, Bellier went on to state that Lantara's 'maitresse', one Jacqueline – in 1852 the designation clearly would have implied a sexual relationship[14] – would have protected her 'lover' from such an establishment. Bellier, however, went on to qualify the match by describing Lantara as 'ce caractère d'enfant qui a besoin d'un guide' (child-like character in need of guidance).[15] Qualifying the probity of the bond still further, he compared Lantara's relationship with Jacqueline to that of Jean-Jacques Rousseau and Madame de Warens, an ardent but chaste lover in a relationship that remained unconsummated.[16] For Bellier, something of the probity of the match imprinted itself directly on Lantara's work. In one part of the narrative the discussions about the woman and the picture become virtually indissoluble: Jacqueline was said to have taken form within the fabric of the landscape painting and Bellier records how, even during periods of extreme poverty, Lantara refused to part with pictures painted while he was in her company and notes how the artist claimed to be able to hear his mistress's voice within the picture.[17]

Bellier's feminisation of the picture is no rhetorical flourish. The idea that the production of a landscape could be explained in terms of a potent but celibate masculine address to a feminised landscape painting also featured in Frédéric Henriet's part-art history book part-travel guide, *Le paysagiste au champs* of 1866.[18] Here, Henriet describes (and illustrates) (Figure 1) an encounter between a peasant girl and a landscape painter in which notions of virility and celibacy again emerge as ciphers for the personal integrity of the artist and, by extension, the aesthetic integrity of his work. He writes:

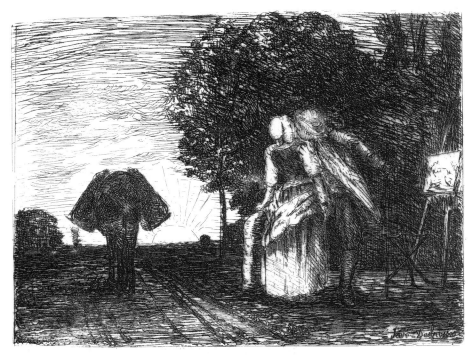

1 Léon L'Hermite, Illustration to Frédéric Henriet's *Le paysagiste au champs*, 1866.

Parfois les admirations du paysagiste, détournées par les énervantes langueurs du soir de leur direction habituelle, prennent momentanément pour objectif quelque brune faneuse, en chemisette et joupon court, qui revient des champs, le fauchet sur l'é-paule. Chemin faisant, on lie conversation; car on n'évite plus le 'dessineux' depuis qu'on le sait inoffensif.

Sans parler de son gout à voir lever l'aurore, qui établit déjà en sa faveur de fortes présomptions de vertu, le paysagiste mène aux champs une vie heureusement contrastée d'activité et de contemplations qui lui font un salutaire hygiène, garantie de moeurs pures. Il n'y a pas d'example, – parait-il – qu'on ait jamais eu à déplorer le moindre écart de la part d'un paysagiste engagé dans les liens de l'hymene .[19]

(Sometimes the attention of the landscape painter turns from the languors of the long evening to another direction, taking as his subject some tanned hay-maker in her blouse and short apron returning from the field with a basket on her shoulder. Making her way, she strikes up a conversation with the 'sketcher' since one knows him to be inoffensive.

Without speaking for his taste in sunsets, which already shows an indication of his virtue, the landscape painter in the countryside leads a life of activity and contemplation which makes for a wholesome, healthy existence and a guarantee of good manners. There is not one example, it seems, where one has ever had the slightest cause to deplore the behaviour of the landscape painter in the mood for courtship).[20]

Here, the artist's subject is, literally by turns, the 'setting sun' and 'the tanned hay-maker', a coupling which is underscored in an etching on the facing page showing the artist turning away from his landscape to embrace the peasant. The coupling of the embrace/picture, however, is far from the male subjugation of a feminised nature so common in later modernist landscape representation.[21] In this instance, the bracketing of virility and moral integrity – singularly absent from many examples of modernist discourse about creativity and masculinity – finds simultaneous proof in his 'sensitivity' to the landscape and in his decorum towards the tanned hay-maker.

The bracketing of virility, sexual abstinence and creative *esprit* also featured in Hippolyte Taine's description of the community of landscape painters who met at the Auberge Ganne, a country inn on the edge of the Fontainebleau forest, published in one of a series of articles in the journal *La Vie parisienne* in 1864.[22] Throughout the second half of the nineteenth century the *auberge* provided an important literary and critical setting for the articulation of the virile but celibate artistic personality, a setting evident not only in popular journalism but also art history and art criticism.[23] In Taine's article, for example, he refers in some detail to the boisterous, predatory behaviour of the landscape painters who came to stay at the *auberge*, specifically the 'egocentric discussions about literature and art', and how the young female serving staff had only 'Mère Ganne's fists and their little mystic books of devotion for protection'.[24] He also refers to how the ridiculous figure of père Ganne, drunk and crawling around the inn after his fifth *petit verre*, was regularly subject to 'ritual jibes' from the landscape painters.[25] However, such clear demonstrations of virility – the desire expressed for the serving staff and the quasi-Oedipal humiliation of the figure of père Ganne – were, once more, instantly qualified by Taine with a set of parallel assurances of the fundamental good and 'child-like' natures of the painters themselves. In a passage about a dinner held at another *auberge* at nearby Moret, Taine notes how, after six hours' work at the easel, landscape painters were said to take on the temperament and attitudes of children. Here, Taine writes: 'toutes les politesses, tout l'attirail compliqué des façons mondaines a disparu; on revient à la vie naturelle, exempte des précautions, d'affectations et de calcul …'. And goes on '… ici la plupart des natures son fines, cet épanchement n'a rien de brutal; le gout du beau surnage; on voit qu'il est sincère, qu'il fait le substance de l'homme'.[26] (all forms of politeness, all the complicated paraphernalia of worldly society have disappeared; one returns to the natural life, free from cares, affectations and calculation … here most personalities are good sorts, there is nothing brutal in these outbursts; good will prevails, one senses sincerity and that this is the substance of man.)

The *auberge* as a site for the assertion of the continent person of the painter (and especially for continent, aesthetically authentic landscape painting) is worth examining in detail. While the landscape *painting*, the male address to the feminised picture in a forest also gendered as female, constituted one way of enunciating masculinity, the *auberge* acted as its counterpart, a site for a more spontaneously felt expression of

creativity but this time lodged within the domain of the surrogate home. Here, the *auberge* was sustained not so much by a moral and sexual order – order suggests the possibility of disorder, a state hard to conceive within the literary and critical conventions that shaped the *auberge* as a *mise-en-scène* – but a marked sense of psychic repose in which male sexual desire was expressed only by innocents contained within the bounds of the surrogate family and even then through the conduit of good-natured 'brimades' (jibes) and 'plaisanteries' (jokes).[27] Contained within the orbit of the domestic interior, the libidinal energies of landscape painters were thus directed with full force into painting. In this instance, however, Taine calls attention to a special form of painting, the 'pochade' (sketch) – a mode of pictorial expression said to be 'vivifiées par un soufle de jeunesse' (animated with the breath of youth) and thereby more proximate to the landscape painter's psyche than conventional tableaux (Figure 2).[28] Clearly aligned to

2 Figure 'Pochades' from walls of the Auberge Ganne at Barbizon.

the 'brimades' and 'plaisanteries' that were part of the normal social round at the *auberge*, Taine describes these 'pochardes' as:

> fort joilis, ma foi, et meilleures, à mon gré, que leurs tableaux d'exposition, tant elles sont naturelle, pleines de gaieté, d'invention, d'insocience, jettée à l'improviste et à la débandade, comme la conversation d'un homme d'esprit. Voilà les images intérieures, non elaborées et tourmentée mais faciles, brillante exagerée ou boufonnes, telles qu'elles ont traversé leur cevelle.[29]

> (extremely beautiful in my opinion and better than their exhibition pieces, so natural are they and so full of gaiety, invention and insouciance, cast off without a thought like the conversation of a man of spirit. Such are the images, not elaborate but easy, brilliantly exaggerated or comic such as they have entered the mind.)

The 'auberge', then, provided a second and complementary domain for the articulation of masculinity, a domain in which notions of celibacy and virility were played out against the backdrop not of the feminised forest but that of another clearly gendered space, the domestic interior of the *auberge*. In each case the moral and aesthetic worth of the painter and the landscapes he made were predicated as a dialectical tension between the landscape painter's libidinal energies on the one hand (the painter's desire for the feminised landscape) and his psychic and physical continence on the other (the painter's moral authority as insouciant child). This tension, in turn, was resolved within the landscape painting: the genre was of aesthetic worth because its author was of moral worth. The task that remains is to locate the narrative of the artist as virile child within the literary and critical structures of the period.

Three gendered literary spaces

The historical specificity of these discursive forms and the part they played in gendering landscape art as a kind of de-politicised urban leisure for the middle classes can be measured by examining the official records of books and pamphlets published in France listed in the annual *Journal de la littérature* and by looking at critical responses to changes in the fabric of history as an academic discipline in the mid-1850s. The mid-1850s saw a dramatic rise in the production of books about the cultural history of France and a marked shift in their subject matter. In 1847, for example, just over six thousand texts were produced in France.[30] By 1856, the number had increased dramatically to over twelve thousand titles, a level maintained until the outbreak of World War I.[31] The increase in the quantity of publications appears to have led directly to an increase in the range of subjects examined by authors. The *Bibliographie de la France* for 1847 listed works on major public museums, medieval and renaissance art and architecture, Dutch and Flemish painting and a handful of Salon reviews. For the most part, the kind of art history contained in these texts typically consisted of well-rehearsed information about artists and historical movements along with a generalised cultural evaluation of

each nation's art. Dutch artists paint mimetic pictures; the Italians, like the Greeks and Romans, idealised nature; the art of the present lived in the shadow of that of the past and so on. By the mid-1850s, however, the number of publications on the fine arts had not only increased five-fold but also included numerous texts on the cultural backwaters of France. The *Bibliographie de la France* for 1856 listed almost two hundred books under the category 'beaux arts', many of which were concerned with marginal or local forms of French cultural history, a trend which continued throughout the 1850s and 1860s. Early during the Second Empire, it appears that publishers were concerned not with the production of a few books on a few politically and cultural value-laden subjects – subjects which asserted general cultural and political truths about nationhood and cultural identity – but with the production of many books on many subjects, and with it the production of a cultural vision of France which was extruded, fragmented (and arguably politically enfeebled) by the very pace at which it was being unearthed.

A number of authors commented directly about this systemic shift in history's constituents. Writing in 1855, Paul Lacroix, editor of the *Revue universelle des beaux arts*, a publication devoted specifically to guiding a new and expanding community of readers and amateurs through an 'unprecedented and bewildering quantity' of writing about the arts, noted that 'society had never been more concerned with the subject than today'.[32] He observed that this concern was rife not among 'sovereigns and governments' nor even 'rich and generous amateurs' but among a much wider and diverse interest group a 'newly enlightened and intelligent public who loved the arts'.[33] Lacroix commented directly on the effect this ever-expanding body of art lovers had upon the subject matter of the history of art and the rate at which history was being produced, and noted not just an increase in the production of books and journals, but in the way in which 'all questions in the arts' were subject to examination. Nowadays, he observed, 'on fouille dans les bibliothéques et les archives pour y découvrir les materiaux inconnus et presque effacé de l'histoire des artistes d'autrefois … On conspire à tous part à populariser le goût de beaux arts'.[34] (One gathers in the crowded libraries and archives in the hope of finding unknown material, almost effaced from the history of artists past … we conspire at every turn to make popular a taste for the fine arts.)

Similar observations were made in the first edition of the *Gazette des beaux arts*. Writing in 1859, the editor Charles Blanc also noted this sudden rise in public interest in the arts. This change, he observed, was due to the way in which the arts were no longer concerned with the great events of politics and history but had since become 'a consolation and a refuge' for a newly rich middle class. Like Lacroix, Blanc went on to observe a marked change in the fabric of cultural history and spoke of the way in which this new interest in the fine arts had prompted critics and historians 'to exaggerate the importance of a mass of historical details' leading to a loss in the 'physiognomy of French art', specifically to the shift from an idealist to a positivist – what Blanc described as 'German' history – referred to above.[35] The arts, he argued, ran the risk of being swamped by 'une marée montante des

paperasses' (rising sea of papers) in which 'les actes de baptême, les petits billets retrouvés, les autographes intimes' (records of baptism, lost letters and intimate personal records) were used to recover not the artists who had 'honoured humanity' but provincial painters whose works were of little philosophical consequence.[36] The observation was perceptive. Blanc, from the vantage point of the conservative right, sensed something of the political significance of rooting French art within a cultural backwater.

The localisation of history and the way in which masculinity was used to shore up this enfeebled vision of French culture continued in the production of texts on landscape painters printed in limited editions. Books and pamphlets on local history offered an insight into the person of the landscape painter but his physical and temperamental substance was refracted through the printed text. The text and illustrations acted as a referrant to rather than an immanent material demonstration of male temperament. The hand-crafted limited edition, however, put the person and psyche of the male landscape painter in much closer proximity to the reader. In many cases the texts were written by authors who knew their subjects in person and published in limited editions, often with the personal signature of the publisher validating their authenticity. The first edition of Henriet's *Le paysagiste au champs*, for example, ran to just 125 copies, each signed and numbered by the publisher, Alphonse Lemerre. These books, moreover, were also illustrated with etchings, a medium revived in the early 1860s and considered uniquely capable of enshrining the physical person and psyche of the painter, a point Henriet went on to address at some length in his commentary of the etchings of Charles-François Daubigny of 1874.[37] Not least, the intra-textual exchange between the various signifying layers – the narrative, the illustrations, the signature beside the numbered edition etc. – was also in step with the ways in which the book was consumed. Many publications were read, as Henri-Jean and Odile Martin have observed, in small exclusively male 'circles', 'academies' or 'cénacles' where readers, authors and publishers would meet to discuss the publications about subjects they knew in person.[38] Alphonse Lemerre (author of a pamphlet about the mechanics and poetics of the short print run)[39] and publisher of texts on precisely the historical and cultural backwaters of France to which Lacroix referred, ran one such circle in the basement of his book shop on the rue Lafayette in Paris and another from a shop called 'Percepeid' in the Passage Choiseul.[40] Honoré Champion ran two similar establishments in Paris, one from the quai des Grands-Augustins, the other from the rue de Seine.[41] What emerges, then, is a clear alignment between a masculine community as subject matter – tales of the *auberge*, the good-natured artist etc. – and the male consumers of such literature at the *cénacle*, an alignment made all the more resonant because of the way in which the signifying capacity of the text was seen materially to embody rather than merely refer to the person of the landscape painter.

The degree to which the landscape painter as virile-child was embedded within the fabric of mid-nineteenth-century French culture is evident when we turn to

popular journalism on the arts. Again, it is possible to point to a number of publica-
tions that called upon the trope mapped out above.[42] Hippolyte Taine's article,
however, takes on special significance. Taine spoke from an exceptionally authori-
tative and well-informed position. He had written in detail about the arts both as a
journalist and historian, and several months before the publication of his article
'Les artistes' was appointed as Professor of Aesthetics at the École des Beaux-Arts.
The journal in which Taine's article appeared, furthermore, gives an additional
indication of the extent to which debates about landscape painting and celibacy had
currency, not just in the restricted circles of the local historian and bibliophile, but
also among the middle-class reading public of the 1860s. The article appeared in a
journal dedicated to providing an amusing account of contemporary manners.
Writing in the first edition of the *Journal*, the editor Emile-Marcelin-Isodore
Planat, stated that the publication aimed 'to paint a recognisable, amusing and top-
ical picture of all aspects of life and manners'.[43] The edition in which Taine's article
appeared contained various light-hearted articles and reviews on horse-racing, the-
atre, fashion, cooking, art, literature and society, an indication that the image of the
gros garçon was a component part of a familiar range of topical urban interests. 'Les
artistes', furthermore, later appeared as one of a series of articles on contemporary
life and manners entitled *Notes sur Paris*, published under separate cover as *La vie
et les opinions de Monsieur Frédéric Thomas Graindorge* by Hachette in 1867, a best
selling text which remained in print for the remainder of the nineteenth century.[44]
The articles in the *Journal* and in the *Notes* included a range of very well-estab-
lished social stereotypes and cultural forms: 'salons' and 'public dances', 'parisi-
ennes', 'young women' and 'young men', 'society', 'advice to a nephew', 'marriage'
and 'conversation', and contained a set of well-rehearsed urban anxieties about the
erosion of the traditional family, the fecklessness of youth, the precocity of young
women. Taken together, as Lucette Cyszba has recently argued, the articles pro-
vided a panoramic set of iconic representations of contemporary Parisian life.[45]
Deeply embedded within an urban bourgeois mentality, the trope of the landscape
painter as virile-child was evident, then, not only in *local* and *localised* history – his-
tories about the provinces and history consumed within the *cénacle* – but was also
part of the much wider discursive fabric of reading matter produced for the middle
classes at leisure.

 Thus far, then, we have pointed to three distinctive but closely related discursive
formations around writing about landscape painting. Each of these forms of
writing emerged at a very specific historical moment, the period immediately fol-
lowing Louis Napoléon's *coup-d'état* of 1851. Clearly, it is important to guard
against reducing writing about landscape painting to a simple reflection of social
and ideological conditions. It is hardly necessary to state that the processes of cul-
tural consumption bound up with the reading matter discussed above were them-
selves social and ideological forms. At the same time, however, it is important to
account for the marked historical specificity both of the trope of landscape painter
as virile-child and the literary forms through which he was refracted.

Emasculation/re-masculation

The gendered image of landscape painter set out above and the literary spaces in which he found form were shaped, in part, by the severe restrictions placed on the publication of books, pamphlets and journals after the fall of the Second Republic. The government decrees of 16 July 1850 and 17 February and 28 March 1852 made sharp distinctions between the censorship of publications about 'politics, economics and political economy' and those on the 'arts, agriculture, literature and the sciences'.[46] Newspapers, journals and books about the former could only be published by French citizens with the vote and were printed subject to both the approval of the government after payment of a licence of between twenty five and fifty thousand francs and on payment of the *Droit de timbre*, a deposit paid to the Ministry of the Interior guaranteeing that the law on censorship would be observed.[47] After 1852, furthermore, infractions were examined by the criminal rather than civil courts; convictions led to the loss of the *timbre*, the imposition of fines of up to five thousand francs, to the possibility of the imprisonment of authors, printers, booksellers and publishers, and the suspension of the offending publication.[48] Books and journals on the 'arts and letters', however (and 'non-political' subjects generally), were free from government restrictions while they avoided political and economic issues, although there were a number of cases brought against publishers who tried to circumvent legislation by addressing political matters in non-political journals.[49] In fact, the preface to the decree of 28 March 1852 specifically noted that this legislation was particularly sympathetic to subjects dedicated to the 'sciences and arts'.[50] As a result, there emerged, as Philippe Van Tieghem has noted (and which Blanc and Lacroix pointed out at the time), a marked increase in such non-political publications, and specifically an increase in texts in which art and history were subsumed within a politically emasculating literature concerned with what Van Tieghem has termed 'superficial fantasy' or 'real but trivial facts'.[51]

Thus, it seems, the construction of a masculinity which called upon virility on the one hand and celibacy on the other was used to revalidate or *re-masculate* landscape painting – landscape was of aesthetic merit because of its 'force' and 'génie' – but at the same time to constrain such force within the sexually and political neutered domain of asexual childhood. Located well away from the political mainstream and set deeply within historical and cultural backwaters (backwaters constituted by narratives about long-lost Milly, the *auberge*, the 'rising sea of papers', the literary setting in which these narratives took shape, the short print run and another form of constraint, the legislation of 1851), the construction of the person of the male artist was the one single component that lent landscape painting its signifying capacity. Critics of the period were keenly aware of the extent to which the personal identity of the landscape painter was foregrounded during this period. The art critic Jules Claretie, writing about the work of another landscape painter subject to the same de-politicising process of revision, Jules Dupré, noted that in landscape painting in general, and Dupré's work in particular, 'le sujet disparait et

... l'individu seul, le créateur subsiste' (the subject disappears and only the indi-
vidual creator remains).[52] Charles Blanc, writing about modern French landscape
in the catalogue to the Exposition Universelle of 1878, concluded that the genre
more than any other lent itself to personal expression, a point picked up by Gustave
Larroumet, minister of culture in Jules Ferry's liberal government of 1881. Unlike
politically tendentious history painting, Larroumet maintained that landscape
'reconciled' rather than 'divided opinions'. The subject matter in landscape was of
no consequence and served only to point to the personality of the painter, and it was
for this reason he observed that 'le choix d'état se portent de préférence sur des
paysages et laissent de coté des ouvres les plus expressive' (the state's choice has a
preference towards landscapes and leaves to one side more tendentious works). [53]

The strategy for the gendering of landscape, its political emasculation/re-mas-
culation, relates not only to press censorship but to another form of restriction,
injunctions on *onanisme*, masturbation. In the same way that the integrity of the
landscape painter and his painting was vouchsafed through assertions of authorial
celibacy, so the personal, physical and moral integrity of all young French men was
thought to be guaranteed either through sexual abstinence or by the careful regula-
tion of productive sexual activity within the confines of Christian marriage. It is
hard to over-emphasise the degree to which this issue preoccupied the medical and
political establishment of the period.[54] François Lallemand, Professor of Medicine
at the University of Montpellier and author of the widely read *Les pertes seminales*
of 1836, maintained that there was no more pressing issue in France than that of the
regulation of male sexuality. It was of cardinal importance, he maintained, to 'the
welfare of families and the happiness of society'.[55] Unregulated, unproductive
onanistic sex led, he argued, to male impotence and to the rejection of men by
women which, in turn, led to homosexuality, a decline in the birth rate, the gradual
erosion of the French economy and the decline of society in general. Variations of
this argument were repeated during the 1850s and 1860s following a steady decline
in the birth rate and the pathologisation not only of masturbation but also many
forms of birth control.[56]

The pathology of the masturbating male is worth examining precisely because
the psychic and physical health of the wholesome and productive landscape
painter operates as its antitype. The excessive loss of seminal fluid, so the argu-
ment ran, led not only to the dysfunction of society but also to the physical and
psychic decline of the person, specifically to sunken eyes, low blood pressure, ali-
mentary and bowel disorders, internal bleeding and inflammation of the joints, to
melancholia and, in some instances, to madness, and, in the most extreme cases, to
death. More important than the pathological profile of the onanistic male, of
course, was the fact that during the mid-nineteenth century so many disorders
from heart disease to arthritis were perceived as one ailment centred upon the
effects of unproductive sex. Lallemand did not specifically address artistic pro-
duction in the 113 case studies listed in *Les pertes seminales*. However, the regimen
he offers for recovery – sexual abstinence, physical exercise, a simple vegetarian

diet and, most importantly, the steady acquisition of physical strength and an improvement in temperament that were seen as clear signs of recovery – squares precisely with the delineation of artistic temperament in many of the texts cited above. A more direct link between *onanisme*, abstinence and art, however, was picked up in other commentaries of the period. Henri-Frédéric Amiel's *Journal intime* of 1856, for example, quotes an essay *De la santé des gens des lettres* of 1768 in which the author, Jules Tissot, recommends 'cheerfulness' and 'exercise' as a guard against the impulse to masturbate that was likely to distract the artist and writer during the inevitable 'periods of loneliness' associated with literary and artistic professions.[57] Drawing upon the research of one Docteur Moreau from Tours, the entry under 'celibataire' in the *Grande Larousse du dix-neuvième siécle* of 1865, again connects creativity with celibacy both on the grounds that 'génie' is both a physiological product of the healthy regulated body and that creativity is a special mode of production which does not square with the demands of family life.[58] And the entry of the subject goes on to list a succession of philosophers, writers and artists, each of whom was either *celibataire* or who produced their best works 'in isolation'.

The 'isolation', about which the author of the entry in the *Grande Larousse* spoke, provides a useful point of reference to gather together some of the tropes and discursive forms mapped out above. At one level, we can see this isolation simply in terms of its aestheticisation, the confinement of art away from the social and political sphere, arguably a defining characteristic of modern(ist) art over the past 150 years or so and one that for Larroumet, at least, was seen as a defining trait in French art during the last quarter of the nineteenth century.[59] The isolated, autonomous artist, alienated from society, sustained configurations of Bohemia from Balzac to Clement Greenberg, from Bourdieu, Galton and Simpson to Carol Duncan, Griselda Pollock and beyond. In this instance, however, we are dealing not with an art historical meta-narrative but with a very particular type of isolation, a process of aestheticisation which was lodged within the specific historical, cultural, political and medical discourses of Second Empire France, and one that calls into question some of the grander narratives of modernism, even in its revisionist forms. Alongside the isolation of the personality of the landscape painter we find a series of other isolating strategies: the spatial, sexual and creative isolation of the artist and his work within the forest/*auberge*; the isolation of the artist within local history, histories written and consumed by isolated communities, histories published for leisure journals in which art is again isolated as an apolitical form of middle-class entertainment. And underscoring this wide range of critical literature were what might be seen as the two political and medical fields in which such processes of isolation were specifically rooted: the emasculation of writing about art through political censorship of 1851 and after and, not least, the notion that unproductive sexual activity enfeebles the mind and body, a contention evident not only in landscape painting but in French society as a whole.

3

Technique and gender: landscape, ideology and the art of Monet in the 1890s

Anthea Callen

Drawing is the masculine sex in art, colour in it is the feminine sex.

(Charles Blanc, 1867)[1]

Where does this impotence of colour to express anything by itself come from?

(Felix Bracquemond, 1885)[2]

The study of landscape art is one terrain relatively untouched by the disruptions of a feminist art history. The majority of recent feminist interventions in the discipline have privileged the body – figurative images – notably in the gendered spaces of modernity. If landscape has been neglected this is surely because it is less obviously susceptible than the body to a radical analysis of gender; where does one go beyond the truism of woman-as-nature? Certainly not into any trite anthropomorphism of breasts-as-haystacks or priapic-poplars. At first glance it seems a problematic field for feminists precisely because it comes uncomfortably close to essentialism, to a biologistic celebration of the earth-mother and of an intrinsic femininity. However, as this chapter sets out to demonstrate, an analysis of gender which delves deeper than subject-matter *per se* – which examines the very structures and constituents of pictorial language, and locates them within the complex historio-cultural nexus which both produced and consumed that language – can reveal new substrata of meanings apparently hidden in a tranquil grainstack.

Focusing on Monet's first Series paintings in the early 1890s, this chapter explores ways of theorising painting technique to analyse the work in terms of a politics of gender. This argument, concentrating on 'techniques' of drawing, colour, light and sight, is linked to Monet's strategy for a revised definition of the 'artist' – a strategy upon which his success in the 1890s was premised. Since conventional art theory argued that only form (the masculine) carried significant

meaning, and Monet's approach privileged colour over drawn or tonally modelled form, it is clear that the boundaries of significant meaning were challenged in Monet's painting.

From 1816, with the introduction of a 'Historic landscape' genre in the École curriculum, landscape painting became fertile ground for dissent between conservatives and avant gardistes keen to disempower the Academy and serve the growing market for modern art. Relatively less circumscribed by the weight of tradition than figurative art, landscape painting afforded a space where independent painters could articulate their resistance to official norms. Its ascendance all but complete by the 1890s, landscape was the perfect medium for embodying the ideals of French nationhood. With their new monumentality and lack of contextual specificity, Monet's Series served this function – and just as Claude and Poussin embodied the greatness of France, so too would Monet.

The 'nature' of femininities

> Modern society is racked without end by a nervous irritability. We are sick and tired of progress, industry, and science.
>
> (Emile Zola, 1896)[3]

French nationalism has been identified as a key concern during the 1890s, and linked to Monet's Series paintings.[4] This decade marked a shift away from the progressive industrialism symbolised by the Eiffel Tower at the 1889 Exposition Universelle, the exhibition characterised by critic Octave Mirbeau as 'the last flash of a moribund society, the supreme cry of an agonised civilisation'.[5] Thus, alongside the celebratory rhetoric of *La Belle Epoque* lay the image of France in crisis. Historians have recognised in this French 'decade of decline' a pathology of degeneration,[6] whose principal constituents and metaphors were political unrest, race, prostitution, syphilis, alcoholism, rising criminality, and fears of a loss of national vigour and productivity focused on population decline. To combat these, during the 1890s the Third Republic sought to revive a sense of national unity, *La Patrie*, in a conservative 'ralliement', linked to an artistic revival of the eighteenth-century rococo style – a shift of cultural self-image in which the swing from a masculine politics of progress to a feminised retrenchment and reaction has been identified.[7] Vital to 'ralliement' strategy was the representation of *La France* as *La Terre*, a discourse generously manured with nostalgia and distanced from masculinist ideals of progress.

I shall consider this notion of *La Terre* – and its implications for Monet as a painter of French landscape – from the viewpoint of gender difference. Green posited an ideological reading of difference as a constituent of modern, urban class relations; because 'nature' played 'a significant role in ... securing ... bourgeois hegemony', he argued that '... tackling the power of the countryside means getting to grips with the cultural dimensions of class formation'.[8] However, he noted that cul-

ture was vital not only in class formation: it actively produced, and reproduced, bourgeois ideals of gender. A reflexive network of images through which sexual difference – normative hetero-sexual difference – was constituted, is apparent in analysing manuals on painting technique, reviews of Monet's work, and the paintings themselves. Gendered binaries of passivity and activity, weakness and power inscribed the very material processes of artistic production with cultural paradigms of difference.

In recent work on Monet's Series the question of gender is implicit, but not overtly addressed.[9] This is apparent in an unselfconscious adoption of French linguistic gendering – the feminine for France itself (she, her), and a generic 'Nature'. Equally, to argue a connection between the human and the natural, Maupassant's novel, *La Vie* (1884), was linked both to Monet's *Poplars* and to his treatment of the seasons in the *Grainstacks*. Significantly, however, *La Vie* is the story of a *woman*'s life (Jeanne), of feminine innocence betrayed by the 'unnatural' vices of those around her; hence this argument in fact conflates the *feminine* and the natural. The distinction is particularly important since the emergence at this period of women as a social force in the public, male sphere was actively disrupting gender boundaries. This chapter, then, aims to complicate the politics of *La Terre* and landscape painting in late nineteenth-century France by focusing on questions of masculinity and femininity.

The feminine, in its polarised, class-specific form – the 'virgin-whore'[10] – provided bourgeois ideology with images to represent both positive and negative ideas of *La France* in the 1890s. The virgin *qua* 'Nature' represented an ideal of feminine moral and spiritual purity, and as such constituted a positive image of *La Terre* to nourish French nationalism. In contrast, the whore represented the degenerate 'feminine' body: the prostitute as a trope of the sickness of *fin-de-siècle* urban France.[11] 'Deviant' femininity provided key images of cultural decline, figured as hysteria, sterility, irrationality, weakness, sensuality, uncontrollability, bloodthirsty violence, etc. The success of Monet's Series enterprise in the 1890s lay in the efficacy with which his techniques encoded this discourse of *La France*. In a review of 1899, critic Raymond Bouyer made this explicit, his adjectives an incantation of the binary virgin-whore: thus 'Monet's work above all expresses [La] France, at once subtle and ungainly, refined and rough, nuanced and flashy'; for Bouyer, this achievement made Monet 'the most significant painter of the century'.[12]

It is now a common-place that both class and gender difference were inscribed into the hierarchies of artistic subject matter and classification by medium – distinctions enshrined in market values as well as in art training and practice.[13] In the nineteenth century, the gendered structuring of artistic discourse developed a new complexity and urgency, underwriting women's exclusion from the profession to marginalise their involvement in cultural production. Gender difference was embodied in the very material experience of art practice itself. In terms of formal training, the cerebral arts, drawing, perspective and anatomy, were associated with the masculine intellect and taught at the École des Beaux-Arts, whereas painting (colour) was taught solely in the privacy of the Academicians' teaching ateliers.

The mechanical arts, the physical, dirty 'manual' side of the trade, thus continued to connote both artisanal status and the materiality associated with the 'feminine'. In the same decade that Charles Blanc's *Grammaire des arts du dessin*[14] was published, institutional reforms imposed by the state introduced painting practice at the École and entailed a democratisation of its traditional hierarchies; the emergence of an industrial technocracy heralded a new validation of functional education and of practical skills.[15] The feminine was co-opted and promoted. The liberalisation of institutional attitudes to class went hand in hand with an intensification of cultural demarcation through gender difference.

These changes coincided with a new interest in artistic process and appreciation of the oil-painted *étude*, with its greater expressive freedom and spontaneity of handling.[16] The display of *facture* in painting marked both a self-conscious cultivation of the artist's personal *écriture*, the mark of masculine individuality, and a celebration of the feminine 'spectacle' of virtuoso craftsmanship. Labour – craftsmanship – and the feminine were appropriated within the new artistic discourse of 'plurality' (the heterogeneity of styles)[17] which characterised the arts under the Third Republic.

Sexual analogy functioned in artistic discourse to demarcate social distinctions of gender;[18] Charles Blanc made this explicit in 1867, when he wrote:

> The union of drawing and colour is necessary to engender painting, just as is the union of man and woman to engender humanity; but drawing must conserve its preponderance over colour. If it is otherwise, painting will run to ruin; it will be lost through colour as humanity was lost through Eve.[19]

The fear of young painters abandoning the rigours of intellectual invention for the easy facility of colour was, in treatises for artists and art students, parallel to advice promoting celibacy as essential to creativity. Couched in contemporary Darwinist rhetoric, the triumph of colour over drawing would precipitate the degeneration and effeminisation of 'masculine' culture. Literally, through sexual intercourse, and metaphorically, through colour, the feminine was ascribed the power to render the male painter impotent.[20] The threat of seductive colour was contained by representing the feminine as subservient to, and given meaning by, the dominant norm of the masculine: just as colour was subordinate to form, so female creative power was subsumed within the masculine in the idea of 'male genius'.[21] Images of female procreativity served to substantiate the male creative act: the production of the work of art entailed not only conception, but 'gestation' and 'giving birth', in a discourse which appropriated disturbing ideas of female sexual potency in order to empower masculinity and, simultaneously, to define woman's creativity as reproductive, determined by her biology.

Colour and light

The artist Félix Bracquemond's *Du dessin et de la couleur* (1885) was the only book on artists' techniques in Monet's possession.[22] Again using sexual analogy,

Bracquemond described colour as transient, 'mobile' and 'changeable'; colour –
unlike drawing – could only be '*relative*'.[23] According to Bracquemond, colour
itself subdivided into a hierarchy which was implicitly gendered. Echoing the
Aristotelian body organised around the humours, Bracquemond considered hot
colours active, and thus masculine, whereas cool colours he defined as passive,
hence feminine.[24]

Like Blanc, Bracquemond was committed to the primacy of line over colour but,
writing almost twenty years later, he saw colour as secondary not only to drawing,
but also to light – which he considered the 'fundamental principle of art': thus the
'… precise order which light brings to the distribution of its coloured elements
forms the basis of the theory of light applicable to the arts'. Bracquemond pursued
the gendered metaphors: light was active, and shade passive; shadow he identified
not as the negative of light but as *reflected* light, bathing and enveloping every
object. Form, which gave art meaning, was dependent upon light, as was colour
which 'is one of the forms of drawing just as in nature it is one of the forms of
light'.[25] Bracquemond found colour on its own to be expressively 'impotent'
because its appearances were unpredictable and always dependent on light: colour
could 'switch instantly to its complementary, leaving no trace of its original
colour …'. In order to master this 'fugitive element, so singular in its *inconstancy*,
art isolates colour …'.[26] He argued that light's varying intensities, which were rela-
tively stable and mathematically calculable, gave the means to visualise colour.
Although both light and colour are subject to the same physical laws, light –
because of its long association with reason and the intellect, and hence masculinity
– was identified as rational in opposition to colour.[27]

Bracquemond argued that *light* should replace *drawing* (the more conventional
sign of masculine order) as a means to organise disorderly (feminine) colour and
regulate its pictorial meaning. Thus if light provided the means to free colour from
the bounds of drawing, colour could play a more prominent pictorial role.
Bracquemond's views on light and colour echo Monet's preoccupations, his
emphasis on recording light; his choice of colours based broadly on the spectrum;
his colouristic rather than tonal palette layout;[28] and his pictorial deployment of
colour contrasts to represent *plein air* light. Just as with colour, so too with the land-
scape itself: for Monet in 1891, 'a landscape hardly exists at all as a landscape,
because its appearance is constantly changing …'. Like Bracquemond's colour,
Monet's feminised landscape lived 'by virtue of its surroundings – the *air and
light*'; although these 'vary continually', Monet found them more susceptible to his
control.[29] Monet's rejection of conventional drawing in favour of light and colour
involved risking the public legibility of his paintings. Representing a feminised *La
Terre* entailed re-negotiating the familiar visual boundaries of gender difference; in
so doing, Monet's work touched upon sensitive issues of male sexual identity.
Third Republican celebration of the feminine required careful orchestration if it
were not to lapse into a degenerate emasculation. For Monet and his supporters, a
campaign was needed to counter persistent fears of Impressionist 'effeminacy'

articulated by critics hostile to the new forms of pictorial order,[30] and to affirm the artist's virility – both pictorial and personal (see 'The gendered artist', p. 42).

Sight and light

Monet was not dependent solely upon theories of light to order his colour: *sight* played a pivotal role. Examining discourses of sight in relation to light reveals the cultural imperatives underlying contemporary concerns over gender. Whereas for the conservative critic Camille Mauclair, Monet's drawing in the *Grainstacks* Series was 'almost mathematical', most writers identified composition or light as the ordering principle of Monet's colour; I extend these to include sight. Crucial to Monet's pictorial order in the Series paintings was what Roger-Marx described as the 'acuity of [Monet's] vision'.[31]

 Sight requires light. Bracquemond's description of old-master colourists confirms that, by the mid-1880s, the primacy of light in painting was equated with the power of sight; both were sexualised: light and sight were perceived in terms of truth, invasion, penetration. Bracquemond said it was due to the light in paintings by colourists that 'sight penetrates everywhere; everywhere it circulates and can verify each incident provoked by the light'.[32] Developing the work of Foucault, and of psychoanalytic theorists, feminist analysis posits sight as a locus of power.[33] The sexualisation of sight was not new; by 1864 in *argot* the French verb *voir* (to see) meant (hetero)sexual intercourse; looking served as 'a metaphor … for power …' dividing the world into 'passive and active, weak and strong'. It therefore served as 'a metaphor for male sexuality … sexual pleasure and looking were male domains'.[34] Sight and light were ideologically and physically interdependent, and signified a sexualised masculine authority. Ascribed a cleansing power, too, in discourses of prostitution and public hygiene, light was an agent of bourgeois control, penetrating and purifying urban disorder.[35]

 The masculine authority of light in painting was renewed through nineteenth-century research in the physics of light and optics,[36] peaking from *c.* 1870 in the publication of work by men like Helmholtz and Rood.[37] Detailing these developments *per se* is beyond the scope of this chapter, but I would stress the reflexive scientific and artistic assumptions which normalised the gendering of light, sight and colour – and the ideological function of this process.

The *Grainstack* paintings

In Monet's Series, then, a masculine ordering of feminine colour (and of 'Nature') is effected primarily by light and by sight. The importance in his work of the light *effets*, and acute vision – his 'shrewd sight'[38] as Félix Fénéon called it – is common knowledge. In landscape painting, sight – by which I mean the artist/spectator's 'view' – can be inscribed in a number of ways. Most obvious is linear perspective which, by fixing the artist/spectator's viewpoint, constitutes the pictured

landscape as a singular (monocular) view, subject to the artist/spectator's individual visual control.[39] With linear perspective the 'point de distance' is mathematically calculated/able, and builds into the picture an ideal viewpoint. In the five single-grainstack paintings from winter 1890–91[40] discussed here, the eye-position is only fixed on the vertical axis, where the eyeline is dictated by the horizon (Figures 3 and 4).[41] On the horizontal axis the eye-position is indeterminate: Monet chose a motif without lines of recession. Placed parallel to the picture plane, the composition eliminates orthogonals which might suggest linear perspective. No vanishing point is therefore possible or implied, and consequently no fixed spectator viewpoint or viewing-distance. Rejecting linear perspective, Monet dislocated the gaze, making the spectator conscious of the act of looking: he does not know where he stands. Neither new to his painting, nor exclusive to it, nevertheless in the Series paintings Monet gave the artist's view, and the spectator's self-consciousness in the act of viewing, a new significance.

Linear perspective was often used in conjunction with aerial perspective for landscape painting; by the 1860s it was widely recommended as a naturalistic alternative to the rigid artifice of linear perspective.[42] While not fixing the viewing distance, it suggests illusionistic space and may direct the eye to an area of interest in the background, implying a vanishing point. Aerial perspective represents pictorially the effects of the atmosphere on the perception of distance, in the form of a skyline suffused with desaturated colour: warm or cool pale greys. A pictorial device based on empirical observation, in contrast to the abstract geometry of linear perspective, aerial perspective offered a means to suggest spatial recession based on the individual's impression or sensation – and as such it carries those connotations. The illusion of depth through aerial perspective was commonly reinforced by a varied paint application: brushwork was bolder, loaded in the foreground imitating natural textures, diminishing to small background brushstrokes or scumbling and blending to efface the brushmarks.

Even aerial perspective is subverted in these *Grainstack* paintings. Monet divides the composition into three horizontal bands of colour running parallel to the picture plane. A luminous, colour-modulated foreground extends half-way up the canvas to the line of poplars in the middle-distance; there is no graduated desaturation of tone or colour. On the contrary, the effects are reversed: pale tints change abruptly to saturated hues for the middle-distance band of minimally differentiated trees, houses and hills, which closes the vista, blocking deep recession. In two paintings (W.1282 (Figure 4) and W.1284) the light effect is *contre-jour*; the sun has sunk behind the hills and light reflected from the sky floods the foreground field, throwing hills and grainstack into contrasting shade. In two others (W.1281 (Figure 3) and W.1283) overcast skies give a neutral (*gris-clair*)[43] ambient light, while in the fifth (W.1280) – the only one to show a directional light source – warm southerly sunlight projects a cool afternoon shadow towards us, and the bottom right corner of the canvas. Logically, the highest tonal values are reserved for the skies. Sky and foreground are close in value, as are the contrasting pairs of dark

3 Claude Monet, *Grainstack, Snow Effect, Overcast Day*, 1890–91.

4 Claude Monet, *Grainstack at Sunset, Winter*, 1890-91.

hues for the hills and grainstack: instead of tone, colour contrasts of hue and temperature and descriptive brushmarks are used to distinguish the grainstacks from the hills behind. *Grainstack in the Morning, Snow Effect* (W.1280) is an exception: the combination of reflected sunshine lightening the hills and direct sunlight catching the stack roof, left, plunges the grainstack into a contrasting, deeply saturated shade. Here, in the glancing sunlight on the grainstack Monet hints at, but does not exploit, the sculptural potential which side-lighting affords the painter; indeed, all five *Grainstack* paintings stress the flat picture surface – in design, colour and impasted *facture*.

Despite his rejection of perspectival conventions, Monet found other means to direct the gaze and privilege the artist/spectator's sight. I mentioned his placing of the horizon: in the five *Grainstack* paintings, the spectator's notional eyeline is about two-thirds up. There are other devices: Monet's strategy of empirical observation; the representation of 'focus' in the paintings; and I shall briefly discuss his composition, *mise-en-scène*, and framing of sight.

Examining these five *Grainstack* paintings and the *Poplars*, I show how Monet made the phenomenon of sight, of visual acuity itself, his subject matter. Viewing the *Grainstack* paintings together, as planned, is crucial to their meaning; in all five the stack is similarly positioned, but the last two (W.1283 and W.1284) are from vantage points distinctly to the right of the others. In *Grainstack, Thaw, Sunset* (W.1284) this shift exposes a line of distant poplars which appear to the right of the stack; in *Grainstack* (W.1283) the shift is greater, revealing more of the poplars – yet the buildings, right, appear more distant. In this latter painting, the difference in viewpoint is most perceptible. Here, too, the quality of light gives the motif the greatest clarity: in the other four canvases light effects dissolve more thoroughly any background detail. That Monet conceived of this painting as distinct from the others is also apparent from its not having been re-worked and the grainstack moved, with its apex raised to coincide with the skyline, as happened with the others (see below). Significantly, it was the three with identical viewpoints which Monet exhibited in May 1891.

It is immediately apparent looking at this group of paintings, the importance which Monet's serial approach gave to small changes in viewing position *vis-à-vis* his motif. All five are on identical, standard canvases, 'horizontal landscape' no. 30 (65 x 92 cm) and hence differences in *mise-en-scène*, light effect and coloration are accentuated. Looking from painting to painting, assessing and comparing subtle compositional differences resulting from changes in the artist's viewpoint (as in the effect of parallax) and later studio adjustments, the spectator is made acutely aware of a shifting visual orientation, his perception of changing light effects, of colour, of the very *act of looking*. Just as Monet worked to harmonise a whole group of paintings, setting them up around him in the Giverny studio,[44] so too the spectator gets caught up in a comparative study, almost a narrative or filmic sequence of hours or days, weather and light variations.[45] Most importantly, the spectator relives changes in the artist's *point of view*, whether in space or time. Seen together, it is

hard simply to lose oneself in the individual sensation of a single picture; indeed, the horizontal compositional banding leads the eye from picture to picture. It is not surprising, then, that the visual centrality of the viewer is most apparent in relation to the paintings *as a Series*: Monet constructs as the pivot of pictorial meaning a privileged spectator position, that of the acute, discerning eye/I. Yet it is an obviously binocular vision – not the monocular convention of linear perspective. In the Orangerie *Nymphéas* paintings (1916–26), suppression of the skyline combined with a mural scale and 'boundless', cyclical design, means the spectator is enveloped in sensation, with viewpoint and viewing distance now notionally centred in an encircling ellipse.[46] This experience involves the whole body. However, the Series, with their easel-painted scale and conception, their repeated but clearly individuated motifs each contained by a frame, come closer to the distinct, disjointed reading of separate 'stills', and spectating remains much more closely tied to the dynamics of a specific organ, the eye(s).

Depicted light serves three specific pictorial functions, aside from naturalistic description: it articulates form and compositional structure, and it directs the eye. Individual objects – notably the stack and the buildings – are modelled through subtle changes in hue and colour temperature, and in what Bracquemond termed *direct* and *reflected* lights. With regard to compositional structure, Monet's choice of light effect in relation to *mise-en-scène* imposes a taut geometrical order through the alternating horizontal bands of lights and darks. Strong contrasts in the tonal value and colour temperature of his hues between sky and land, stack and foreground, and between stack and background, draw the eye to the main compositional lines and pictorial foci. As with writing, the movement of the eye 'reading' a painting is from left to right in Western culture; the light and shade, too, in the Northern hemisphere, move from left to right following the westerly movement of the sun.[47] Monet's *Grainstack* paintings conform to both phenomena. His composition leads the eye from foreground left to background right, from the prominence of the stack to the half-hidden buildings (both evidence, like Monet's painting, of man's ordering of nature). Direct sunlight is depicted falling from left to right (W.1280) or glancing upward from below the skyline (W.1282 (Figure 4), W.1284). In *Grainstack, Thaw, Sunset* (W.1284) and in *Grainstack in Overcast Weather, Snow Effect* (W.1281 (Figure 3)) this movement is reinforced by Monet's directional brushwork for the sky. Right-handed artists, of course, make marks slanting directionally to the right; but, characteristic of Monet's handling, brushwork also follows, describes and thus emphasises form – as in the grainstacks themselves. These devices become more significant in a serial reading of the paintings. Where a 'photographic' finish in painting gives crisp definition throughout, Monet uses changes in brushmark to inscribe variations in focal definition. Specific elements in the *Grainstack* paintings (notably the stacks) are given clearer definition by tighter 'drawing' with brush and colour, hence greater 'focus'. Evoking the memory of observed effects of atmospheric haze, blurred brushwork simultaneously forces the eyes to work at resolving incoherence. The spectator, whose gaze is drawn to the

'focused' parts, is made conscious of the function of his own binocular vision. In itself a sign of modernity, this paradigm shift from Cartesian monocularity to serious scientific consideration of binocular 'disparity' is a phenomenon of nineteenth-century positivism.[48]

Monet signals the (masculine) artfulness of his work through his emphasis on the apparently 'artless' (feminine) materiality of the painted surfaces. For, paradoxically, it is this insistent materiality which discourages the spectator from losing himself in a fictive pictorial 'reality', from losing his consciousness of looking. Monet's visible brushwork and varied *matière* represent his 'sensations'; standing as equivalents for observed appearances they counter a seamless, 'window-on-the-world' pictorial illusion like the academic 'licked' surface.[49] The vigorous muscularity of his *facture* also serves to distance him from the effeminacy associated with the painterly touch of a Renoir or a Morisot.[50] The discerning spectator/artist finds a higher order both in the raw material of nature and in the studied 'disorder' of the painting. Monet invites the viewer to rehearse the artist's sensual engagement with motif and medium, and thus vicariously to savour – from a reasonable distance – Monet's sensation of erotic and authorial power over both.

The stacks are also made a focal attraction in these paintings by their prominence and proximity. These devices are reinforced by the greater density and boldness of handling Monet generally reserves for the foregrounds, particularly the stacks themselves. In these areas he uses a predominantly short, impasted touch, stiff and chalky in paint-texture, built up and dragged wet over dry. Monet reinforces the stack outline in some paintings with long, flamboyant brushstrokes loaded with colour designed to vibrate with the background colours – in close-toned, simultaneous contrasts of hue. Fewer, or thinner, layers, with more fluid paint, dragged or scumbled in a softer painterly touch – an enveloping, often vivid blueness – serve to evoke 'distance', yet the canvas in *Grainstack at Sunset, Winter* (W.1282 (Figure 4)) is almost uniformly loaded. In thus orchestrating his key compositional effects, Monet reminds the spectator that the paintings record the activity of *sight*.

In four of these five *Grainstack* paintings Monet made the same compositional adjustments to the position of the stack (the exception is W.1283). All four show evidence of extensive work; the surfaces are richly built up in layers interwoven with wet-on-dry in addition to wet-in-wet paint handling. The material evidence of labour-intensive procedures – the time for both drying and the contemplation entailed in making compositional changes – remains very physically apparent. The altered position of the stack is particularly evident in *Grainstack at Sunset, Winter* (W.1282 (Figure 4)), but is found as *pentimenti* in the other three as well (W.1280, W.1281 (Figure 3), W1284): in each, the grainstack was moved approximately 4 cm (1½ in.) to the left of its original position, and its apex raised close to the skyline. The increased figure-field spatial ambiguities resulting from this change, as well as the enhanced compositional asymmetry, strengthen the pictorial dynamics. And these re-workings bear witness to the artist's in(ter)vention, authenticated by the culminating flourish of Monet's signature: his mark corroborating the individual

calligraphy of his brushwork. In *Grainstack at Sunset, Winter* (W.1282 (Figure 4)) the reflexivity of these signs of authority is reinforced by a signature painted in the same orange-red as his final accents on the repositioned stack itself. Monet's artistic agency thus palpably extends beyond the selection and delimitation of his motif, to impose his personal vision on any 'found' order of nature before him. He determines the view of the spectator, and the visibility of his mark-making and *reprises* simultaneously permits the spectator a privileged insight into the workings of the artist's mind.

The *Poplars*

[Monet] understood the poplar, which summarises all the grace, all the spirit, all the youth of our land.[51]

The *Poplar* Series of 1891 engages the spectator in a different, but complementary, awareness of looking: these exhibit notable variations in the pictorial framing of sight and thus in the positioning of the artist/spectator. Monet's low viewpoint in the *Poplars* is recognised as important, but treated as uniform: '[in] almost every canvas, Monet's vantage point appears to be just slightly above the level of the water, which suggests that he painted the series from [his] boat.'[52] In the five *Grainstack* paintings, sky, hills and field form a backdrop against which subtle changes in the *mise-en-scène* of the stack, trees and buildings register: the eyeline (horizon level) remains relatively constant. In the *Poplars* the horizon shifts significantly if subtly on the vertical axis while the main element of visual constancy is provided by the vertical tree-trunks. With some exceptions, Wildenstein arranges the *Poplars* into three groups; that these are determined by canvas format suggests that Monet bought stocks of sizes he deemed suitable for this motif. The earliest group contains seven paintings in the elongated 'vertical marine' no. 40 (100 x 65 cm); the second large group, of nine, is on a squarer, portrait no. 30 format (92 x 73 cm; e.g. W.1307 (Figure 5)). The final group is squarest; that their lengths approximate to standard measurements (the long bars of no. 25 (81 cm) or no. 30 (92 cm), see Figure 6), suggests Monet was employing interchangeable bars from the new, Universal stretchers for these non-standard canvases.[53] Whereas Monet's tall composition for the first group includes much of the canopy of his foreground poplars, the second, squarer group crops the tree-tops in a grid-like composition, the most abstract of which, *Four Trees* (1891, W.1309), is on a square canvas (82 x 81.5 cm).

Arguably even more challenging is *Wind Effect, Sequence of Poplars* (W.1302 (Figure 7)). Wildenstein placed this canvas (a 'vertical landscape' no. 40 (100 x 73 cm)), between groups one and two: it is among the majority which emphasise the motif's verticality. However, in contrast to his previous compositions, in the foreground there are three instead of seven poplars, and they appear far closer to the picture plane. To accentuate this frontality, a neutral *gris-clair* light gives uniform colour saturation – which Monet reinforces by 'bleeding' bright viridian-green

touches interchangeably between foreground and background; his bold, directional brushwork for the effects of a strong south wind in the foliage further blurs the distinction between near and far. His confrontational effect is strengthened by eliminating the foreground water, giving a very short viewing distance close to the riverbank and hence to the picture plane itself. Indeed, eye-level is *below* the bottom edge of the canvas. Flouting all picturesque theory, the only *land*scape as such here

5 Claude Monet, *Three Poplar Trees in Autumn*, 1891.

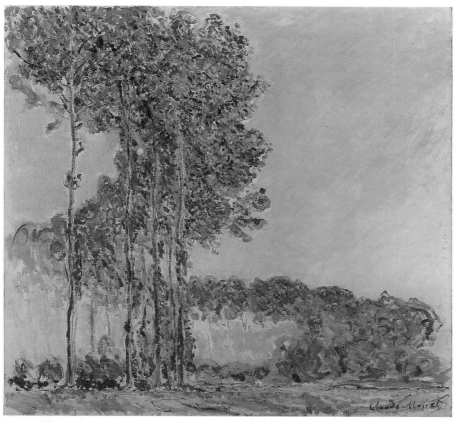

6 Claude Monet, *Poplars* (View from the Marsh), 1891.

is the immediate riverbank, behind which middle ground and distance descend out of sight in a recession signalled only by the sinuous line of tree-tops. The spectator is inscribed as gazing awkwardly upwards from below, at sky and soaring trees; the reassurance of cultivated order and the artist's compositional rhythms is disturbed by the dwarfing effect of this viewpoint, combined with the trees' physical proximity and height. This dizzying view stems not only from eliminating the landscape. A gap in the foreground trees, right, collapses the pictorial space: near and far are juxtaposed in an abrupt contrast of scale between spindly foreground giants and tiny distant poplars. Monet's intentionality here is explicit: he over-painted the fourth tree-trunk, retaining some foliage as a framing device, top right.[54] In a work already troubled by wind and bad weather, Monet's exaggerated dwarfing of the spectator goes beyond recording the motif's physical impact to complicate its political symbolism. For this Series has been directly identified with the poplar's longstanding national significance.[55]

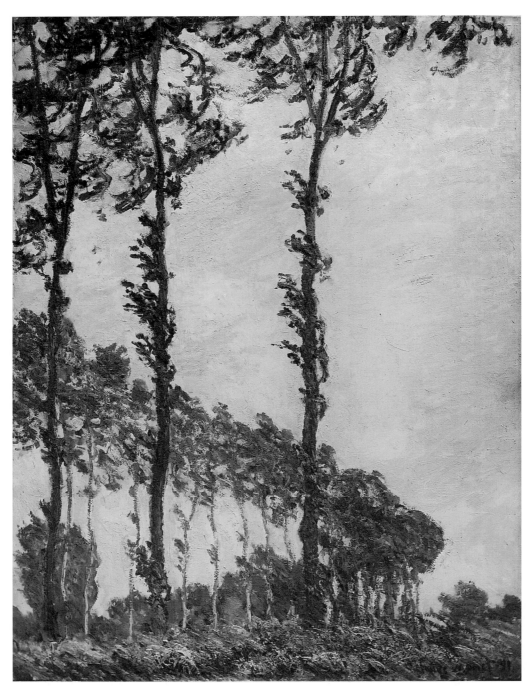

7 Claude Monet, *Wind Effect, Sequence of Poplars*, 1891.

Wind Effect, Sequence of Poplars (Figure 7) is, in these respects, arguably the most complex of the *Poplar* Series; it stands alone both compositionally and in its refusal to reassure the spectator. There are other overcast skies (e.g. W.1299), but none as brooding, nor with this disruptive wind or oblique viewpoint. Monet's other vertical studies all have a higher eye-line, and include the foreground river – which distances the spectator both physically and psychologically; a more extensive view of the landscape beyond the riverbank results, and with it a greater sense of control.

The eye-line inscribed in two late, barely horizontal, views – *Poplars on the River Epte, as seen from the Marsh* (W.1312, 88 x 93 cm), and *Poplars* (W.1313, 90 x 93 cm (Figure 6)) gives a higher vantage point but the river is absent. An expanse of meadow is now visible in the foreground as, again, is nearly the full height of the nearest poplars. These are proportionally reduced in scale due to the longer viewing distance; the main motif is thus pushed back in the pictorial space, into the middle ground. This change in orientation *vis-à-vis* the motif has the artist/spectator looking north (instead of east), positioned at seated level on land, rather than below, at water level. These two views from the marsh, as in most of the vertical *Poplars*, exploit the effects of warm sunlight and lively, contrasting shadows which evoke a sensation of benign optimism: a celebration of Nature and *La France* as burgeoning, vibrant and wholesome. For example, in *Poplars on the River Epte, as seen from the Marsh* a warm westerly sun dissolves the left side of the trees in a golden haze, while the *Poplars* (Figure 6) sparkle in a clear morning light from the right. By contrast, *Wind Effect, Sequence of Poplars* has sombre palette, its colours more broken and mainly cool. Confrontation in *Wind Effect* (Figure 7) gives way, in these two views from the marsh, to contemplation – of a more distanced, orderly nature: the artist has 'drawn back' from the motif. These are at once more expansive, panoramic in feel – a notionally extended frame, or 'long shot' – and more superficially decorative. Unlike Monet's forbidding *Wind Effect*, light effects and colouring in the marsh views, lyrical and seductive, return the spectator to a more comforting vision of a harmonious nature mastered; this was the dominant mood of the fifteen *Poplars* exhibited in 1892, and of Monet's modernisation of French rococo culture.[56]

The privilege accorded Monet's personal vision and, by extension, that of his spectators, was central to the pictorial and the aesthetic rhetoric of the 1890s. As such, it both produced, and reproduced, the bourgeois valorisation of *sight* (hence individuality) as a sign of its ideological power. Masculinity was empowered in the processes both of spectatorship and of pictorial organisation: selectively celebrated, the feminine was nevertheless still constituted as that requiring masculine order.[57] Feminine colour needed the artist to structure its chaos, just as feminine 'nature' – the countryside – required husbandry to fructify its bounty. Monet, the artist, transformed feminine nature into masculine culture – a 'victory' over nature (and his rivals), as his friend, the critic Gustave Geffroy described the *Grainstacks* exhibition.[58] The artist gave meaning to both culture and nature, their discursive

polarity at once signalled and married within the structured harmonies of his art. Enacted in the myths of a Monet embattled with the elemental, with nature's relentless cycle, with obsessive visual penetration of each motif, the repetitive artistic gesture on canvas after canvas aims to seize and render permanent the ephemeral sensation. His Series merchandise *en masse* the exclusive, unique performance of seductive femininity civilised by the male libido. Here was a femininity which could safely frame both 'disruptive' female sexuality and the fear of urban disorder. Thus, in these Series, *La Terre* and a benign, decorative femininity were secured to Third Republican 'ralliement' ideals. Somewhat jaundiced, Pissarro wrote, 'These canvases breathe contentment.'[59] But what of the ambivalent terms of masculinity and male desire?

The gendered artist

> What conquests from one year to the next! Not an instant of weakness, not a moment of hesitation or of regression in Claude Monet's upward, direct, unswerving, and swift course toward what lies beyond progress itself. It is something rare, deserving of the highest praise, this ceaseless outpouring of masterpieces.
>
> (Mirbeau, 1889)[60]

As a means to discredit the new art, writers opposed to Impressionist painting had, since the 1870s, couched their criticism in a rhetoric of effeminacy: in excess colour, lack of 'finish' and the absence of conventional drawing, form and composition.[61] In the 1880s, Monet consciously distanced himself from this unfavourable criticism, and the influential writer Octave Mirbeau was his main agent. To escape the cultural and economic marginality attached to (feminine) Impressionism and establish his discursive centrality, Monet's public image needed changing.

In order to qualify, in the 1890s, as a 'great French master' in the tradition of Poussin and Claude, Monet cultivated the image of the artist as masculine reason and vigour; the 'feminine' spontaneity and intuition of Monet's earlier Impressionism needed subordinating to a masterful mind. He himself later emphasised that series painting was an 'idea' which, over a number of years, had slowly 'germinated in my mind'.[62] It first came to fruition with the stark Creuse landscapes which, 'of Monet's entire œuvre' revealed to Octave Maus 'the most extraordinary mastery'.[63] Co-opting a metaphoric female pro-creativity, Monet's creative prowess was enhanced; the feminine sensuality identified with his subject matter and means (colour and *matière*) was subsumed into his new pictorial and serial order. The publication in *L'Art dans les deux Mondes* in March 1891 of Monet's *Grainstack* drawings in Mirbeau's article on him was no coincidence: an emphasis on Monet's draughtsmanship was vital to this new marketing strategy. Equally crucial was Mirbeau's insistence, in an important article of 1889, on Monet's premeditation, his discrimination and his discerning, scientific eye.[64]

Conscious of a need to dissociate Monet from effete contemporaries and from 'worry – the contemporary sickness so fatal to productivity', Mirbeau declared him 'male and healthy'.[65] Returning full circle to Maupassant's *La Vie*, the novel, set in a chateau called 'The Poplars', opens with a modern image of ineffectual creative power embodied in Jeanne's father – the Baron. He was 'without method and without toughness, which as it were *sapped the muscles of his will* and almost amounted to a vice'.[66] Mirbeau and Maupassant both make clear references to the male 'disease of the will' (abulia), which was associated with sexuality and artistic creativity. The structuring of male desire at this period into untenable polarities of normality and perversity (hetero- and homo-sexuality), produced a shut-down of will: 'The abulic male in nineteenth-century discourses is literally the pathological exception that marks the rule of the history of male sexuality'.[67] Hence Mirbeau's eagerness to promote Monet's work as 'the product of … comparison, analysis and a willed consciousness'. Nothing ineffectual here: periods of slack productivity could be characterised not as times of degenerate lassitude or neurotic paralysis, but of 'thoughtful reflection'.[68]

Émile Zola, too, in his fictional representations of the artist (writer and painter) in *L'Oeuvre* (1886), had salutary lessons for Monet: the impotent genius of the painter Claude, unable to finish his one great masterpiece, contrasts with the methodical discipline of the writer Sandoz. Bowlby remarks that Sandoz/Zola's approach was 'fitted to the short-term, continual requirements of the modern market'[69] – a market characterised by seasonal 'nouveautés' and artificially induced consumer demand – and comparable to Monet's own astute marketing strategies.[70] Notably with his Series paintings, Monet stimulated another kind of sight, economic foresight, encouraging speculation among his collectors: buying a 'new' Monet, having one of each 'Series' as they appeared, and provoking rivalry between his dealers. A majority of the paintings in each Series show were thus sold before the opening, leaving a colleague to complain that 'people only want Monets'[71] and 'the collectors only want *Grainstacks*'. For Pissarro, this resulted in Monet repeating himself, 'such is the terrible consequence of success!'[72] Openly anarchist in his beliefs, Pissarro wished to avoid the 'terrible constraints of Messrs. capitalist collectors – speculators and dealers'.[73]

Other parallels can be found. Where Mirbeau stresses Monet's relentless search for truth, stating '[a]rt that does not concern itself … with natural phenomena, and that closes its eyes to what science has taught us … is not art', Zola has Sandoz opine: 'Our generation is too clogged in lyricism to leave works of sanity … Truth, nature, this is the only possible basis, the necessary police outside of which madness begins.'[74] Not only gendered as feminine, madness was considered paradigmatically a woman's 'condition' through the sensational publicity surrounding the spread of hysteria.[75] Although hysteria was only occasionally admitted in men prior to World War I, neurosis in men – through the abulia diagnosis – was considered effeminate. Hence a compulsive attachment to masculine order manifest in truth, science and nature – Sandoz's 'necessary police' – can be

seen as a flight from feminine unreason, from insanity, and from connotations of weakness. What Sandoz/Zola (and Monet?) seeks, is 'the demarcation of a work-able boundary between reason and madness' – between masculine and feminine – and 'the displacement of notions of timeless quality by serial progression and quantitive accretion ... not a scattering of poetic fragments, but an ordered sequence of measurable parts'.[76]

The marketing of Helen Allingham: the English cottage and national identity

Anne Helmreich

The career of the water-colourist Helen Allingham was circumscribed by, relied upon, and exceeded accepted norms of landscape painting in the nineteenth century.[1] She painted out-of-doors, for example, a common mode of practice none the less considered suspect for respectable women and further complicated by her role as a mother. While she used watercolour, a medium long associated with women, she operated as a professional and at a time when women's participation in the arts as such was sharply curbed. Nevertheless, she was represented by one of the most important commercial art galleries in London, which negotiated these issues by insisting upon her respectable femininity and situating her work within the discourses of national identity.

Helen Allingham, née Paterson, was born in Swadlincote, Derbyshire to a middle-class family and received her art training at the Birmingham School of Art, the Female School of Art (London), and the Royal Academy schools. During her time at the latter, she began to work for engraving firms and quickly gained commissions from popular literary magazines. In 1870 she took a post at the *Graphic*, producing illustrations largely for the fashion page.[2]

In 1874 Paterson married William Allingham (1824–89), an Irish poet who had recently been appointed editor of *Fraser's Magazine*. She resigned her position at the *Graphic*, perhaps because of the financial security which William's salary granted, or, as is more likely, because of societal prescriptions against the employment of married women. Within a year of her marriage, Helen also became a mother, further complicating the possibilities of a professional career given the prevailing ideology of domestic motherhood and the wife as the 'angel of the house'. Nevertheless, Allingham chose to pursue a professional career, turning to exhibiting rather than illustrating. Her husband supported her professional aspirations, writing to friends with great pride about his wife's accomplishments.[3]

As a painter, Allingham favoured rural subjects in watercolour, adopting the largely pre-Raphaelite technique of recording the varied details and textures of nature with stippled and feathery brushstrokes assisted by scraping out. Her choice

of watercolour was significant. Throughout the eighteenth and nineteenth cen-
turies, it had come to be associated with women due in large part to its promotion in
drawing manuals as an easily handled medium well suited to women, as Marcus
Huish, the Managing Director of the Fine Art Society where Allingham exhibited,
explained:

> The practice of water-colour art would appear to appeal especially to womankind, as
> not only are the constituents which go to its making of a more agreeable character
> than those of oil, but the whole machinery necessary for its successful production is
> more compact and capable of adaptation to the ordinary house. The very methods
> employed have a certain daintiness about them which coincides with a lady's delicacy.
> The work does not necessitate hours of standing, with evil-smelling paints, in a large
> top-lit studio, but can be effected seated, in any living room which contains a window
> of sufficient size. There is no need to leave all the materials about while the canvasses
> dry, and no preliminary setting of palettes and subsequent cleaning off.[4]

Nevertheless, the leading instructors and exhibitors – the professionals of the field
– were men such as John Varley and J. M. W. Turner, and they worked to ensure
that watercolour would be taken seriously by developing what was dubbed the
'exhibition watercolour' – a large, highly finished work, often displayed in a gold
frame, that could rival oil painting.[5] A distinction, albeit malleable, was therefore
maintained between the medium as a leisure activity for middle- and upper-class
women and the medium as the mode of expression for professional, male artists. A
few women in the second half of the nineteenth century, such as Allingham and
Clara Montalba, transcended this distinction, evidencing sufficient technical skill
to merit exhibiting with the professional watercolour societies.

Of the professional societies at the end of the nineteenth century, the watercolour
societies were the most open to women. Women had long been excluded from such
organisations, a major hindrance to their advancement as membership provided a
degree of status that was often otherwise elusive. Furthermore, as Deborah Cherry
has noted, 'without this badge of professional status, women artists did not partici-
pate widely in the decision-making processes which established professional stan-
dards and categorised exhibitable art'.[6] In 1861, women were admitted to the Old
Water-colour Society (later the Royal Water-colour Society) 'in a special category
that allowed them to exhibit but denied them the other privileges of membership'.[7]
In 1889, these rules were changed and in 1890 Allingham was elected the first full
female member of the O.W.S.,[8] an event long anticipated by critics who recognised
that Allingham's abilities equalled those of her male colleagues. *The Times*, writing in
1878, claimed that 'when we learn that women having this gift are, by the condition
of their sex, confined to the lower ranks of the Society, we feel strongly that here, at
least, is one "woman's wrong", which demands righting'.[9]

Such comments, however, were an anomaly. Generally, reviews of the period
segregated female painters by grouping them together under such labels as 'lady
artists', and by discussing their work 'as expressions of feminine refinement,

delicacy, and maternal sentiment'.[10] In response to their separate status, women established varying positions, ranging from acceptance to refutation. Most important for Allingham was the strategy of reversing the power relationships embedded in the discourse of difference by reclaiming the terms by which women artists were designated 'other' as a source of power and positive contrast.[11] In other words, women artists and their supporters repositioned the language applied to female artists – refinement, delicacy and sentiment – so that it could become the means through which acceptance and advancement could be secured.

Notions of the proper spheres of the sexes extended into subject matter. The intellectual, didactic content of historical subjects was believed to be masterable only by men, and women were instead encouraged to exhibit landscape, floral and portrait studies, images that required the artist to work from a pre-existing model and therefore supposedly did not require higher thought processes. Yet, these very notions had been challenged by successful male landscape painters, such as Turner, who charged the landscape subject with the meanings, issues and conflicts long associated with history painting and thus raised regard for the genre. Over the course of the late eighteenth and nineteenth centuries, landscape painting rose in popularity in response to the spread of industrialisation and urbanism and the concomitant feared disappearance of rural life, as well as increased desirability of the countryside as leisure commodity and the related desire for travel souvenirs. Artists such as Allingham were able to exploit this market by producing landscape watercolours representing common tropes of rural life appealing to urban art buyers.

From the outset of her career, and as she climbed through the ranks of the art world by exhibiting at increasingly prestigious venues, Allingham explored rural themes. She and her husband were clearly attracted to rural life in its most idyllic mode; it figures in William Allingham's poetry and the family moved to the rural county of Surrey, on the outskirts of London, in the summer of 1878, and took a year-round residence in February 1881. They lived in a cottage, as did many in the middle and upper classes seeking an escape from the chaos and dirt of the urban sphere in the supposedly clean serenity of rural village life. By the end of the nineteenth century, as Jan Marsh has explained, 'love of country became an article of faith, as essential to respectability as the belief in manners or morality' among the upper-middle classes who participated enthusiastically in the back-to-the-land movement sparked by the growing fear and revulsion of the urban sphere.[12] The country became a quaint, exotic 'other' to the increasingly dominating metropolitan presence.

Allingham's work was exceedingly compatible with this movement: an urbanite herself, her watercolours made the countryside accessible and desirable to city dwellers. She represented a moral, ordered and rejuvenating landscape, an aspect that drew the art critic John Ruskin to her work, which he praised for depicting 'the radiance and innocence of reinstated infant divinity showered again among the flowers of English meadows'.[13] Ruskin claimed that Allingham's 'true gift', what 'the

Lord made her for', was to paint 'the gesture, character, and humour of charming children in country landscapes'.[14] These comments reflect Ruskin's belief, articulated several years earlier in his widely published lecture, 'Lilies: Of Queen's Gardens', that women's innate capacity 'for sweet ordering, arrangement, and decision' should be extended from the house into the landscape so that the industrially blighted environment could become a suitable space for children. Ruskin thus expanded the parameters of the domestic sphere, re-conceiving the greater landscape as one large garden to be presided over by women.[15] Allingham's representations suited this conceit: tightly framed on the cottage and its surrounding garden walls, her images often picture women standing at the edge of this domestic landscape in doorways and gateways looking out with a supervisory gaze to the landscape beyond. In his 1884 lecture, Ruskin offered Allingham's work as model didactic art appropriate for children and an inspiration for improving the countryside.[16]

The concept that art could change public behaviour was again inextricably linked with Allingham in her first one-woman exhibition at the Fine Art Society (F.A.S.) in 1886. Founded in 1876 with the explicit purpose of producing engravings, the F.A.S. had expanded its purview by the 1880s to include organising exhibitions, publishing catalogues, producing prints and selling art. Situated on Bond Street, a fashionable commercial district in London, the F.A.S. both recognised and downplayed its commercialism. In 1881, for example, the architect E. W. Godwin was commissioned to redesign the facade of the gallery so that it would appear 'rather less of a shop front'; the new vestibule accommodated an expanded display area while the balcony above suggested domestic rather than commercial architecture.[17] The domestic theme carried over into the interior, arranged to resemble a well-appointed home with carpets, easy chairs and tastefully arranged decorative elements. Correspondingly, while the F.A.S. supported a wide range of art, it focused on works appealing largely to the upper middle classes, or what the art critic George Moore called the 'villa' classes. In an article for the *Magazine of Art*, Moore explained that the 'villa classes' did not want large subject pictures that physically overwhelmed their spaces and demanded the full attention of the viewer; rather, they preferred 'pleasant and agreeable art that will fit their rooms and match their furniture … an art which is at once an art and a handicraft, a hybrid between the picture and the *bibelot*'.[18] The F.A.S. cultivated Allingham and several other watercolour painters of gardens, targeting their work to 'the toilers in the great cities, who, if they live in the suburbs, only catch a glimpse now and again of their flowers, and if they inhabit the town; can seldom take their holidays except when the glories of the garden are on the wane'.[19] The sales records from Allingham's exhibitions bear out this prediction: her work appealed to a broad audience, from the old, titled aristocracy to members of the new wealthy upper classes, particularly affluent professionals. Geographically, most of her patrons were drawn from the upper-middle-class London neighbourhoods around Kensington Gardens and Hyde Park and the fashionable, upper-middle-class suburbs surrounding London and extending out into the neighbouring counties.

For Allingham's first exhibition, the gallery concentrated solely on cottage subjects thus establishing her, in commercial terms, as an identifiable brand – the cottage painter (Figure 8). This decision to identify Allingham with rural cottages proved to be crucial for, with the exception of one exhibition of scenes of Venice, all of her future exhibitions with the F.A.S. dealt with the theme of rural domesticity. These paintings not only resonated with middle-class notions of womanly roles, they also intersected with contemporary political and social issues. The catalogue accompanying the F.A.S. exhibition, probably written by William Allingham, explained that the artist intended to provide an historical record of the

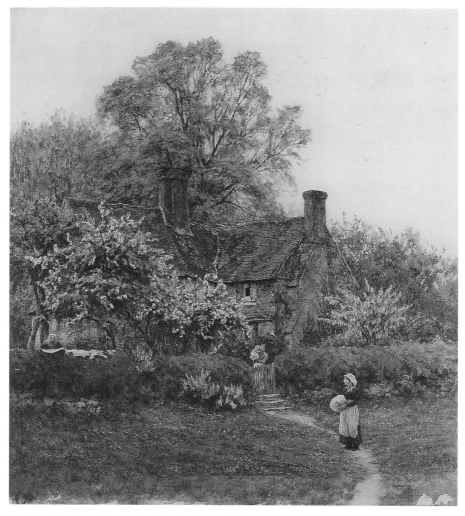

8 Helen Allingham, *Cottage at Chickingfold, Surrey*, 1903.

English cottage, because this form of domestic architecture was rapidly disappearing due to the economic decline of the countryside attendant upon the agricultural depression of the last quarter of the nineteenth century. Landlords unwilling or financially unable to repair increasingly decrepit structures were either destroying them or leasing them to wealthy urbanites who remodelled the structures beyond recognition. Allingham's watercolours compensated for the 'processes of deterioration going on [in the countryside]: trees cut down, roadsides enclosed, footpaths stopped up, obtrusive fences raised, pretentious mansions built, ancient cottages destroyed or spoilt' by erasing such signs of change.[20]

Although critics recognised that Allingham's view of the countryside was highly selective, they excused it by locating her work within the long-standing tradition of seeing and visually representing the countryside with a prejudiced eye that sees only the picturesque or the pastoral. The *Academy* explained, 'the beauty she finds she gives, and leaves the rest, following herein not only a pure and healthy taste, but a true artistic instinct'.[21] This myopia was so pronounced in eighteenth- and nineteenth-century art and literature that John Dixon Hunt has labelled it the 'cult of the cottage', denoting the practice of endowing the cottage with associations of pleasure, 'of visionary plenitude, of Golden Age fecundity' despite the fact that such structures were often poor hovels or even empty ruins – the detritus of the enclosure movement and the growing lure of urban centres.[22] The janus face of the cottage – idyll or pigsty – has been described as the 'cottage controversy' by George Ford, who argues that the cottage became a metaphor for 'felicitous spaces' because of its connection to a pre-industrial and pre-urban past that contrasted with the perceived corruption of the urban sphere.[23]

Allingham's 1886 exhibition garnered the attention of the leading art journals and newspapers and their positive notices secured a national profile for the artist. Her place in the Victorian art world is tellingly revealed in a *Punch* cartoon of 7 August 1886 (Figure 9). A satirical view of the Royal Academy membership's decision not to limit the number of works they could exhibit at the annual exhibition (despite the President's support of the measure), it depicts Royal Academy President Frederic Leighton leading a parade of notable 'outsiders' (so labelled by a placard held by a figure at right) that includes such artists as James McNeil Whistler (President of the Royal Society of British Artists). Prominent among the 'outsiders', although relegated to the periphery of the crowd, is Allingham. The success of the 1886 exhibition is demonstrated further by the gallery's decision to grant Allingham a succession of one-person exhibitions. Her work proved a popular commodity and throughout her career she little altered the formula established at the outset. Her reliance upon this formula perhaps stemmed from the fact that she became the sole supporter of her family in 1889 when her husband died. He left only £200, so ensuring that the earning of a significant steady yearly income fell to his wife.[24]

The F.A.S. also worked to shore up Allingham's reputation as the pre-eminent painter of blissful cottage life. In addition to the usual round of exhibitions with private press days and viewings, the Managing Director, Marcus B. Huish, a

AN AFFAIR OF ART.

HE Sage saluted each Member of the Procession as it passed before him. Several had come from Piccadilly, others from Pall Mall, quite a crowd from united Bond Street—New and Old.

"Any more, Sir FREDERICK?" asked the Sage of the leader of this strange gathering.

"Lots, my dear and valued friend," replied the polished P.R.A., "and, consequently, those who oppose my wish to limit the number of pictures hung by the same exhibitor at Burlington House, have the less excuse. As I have said to my respected colleagues HOLL, LESLIE, and COOPER WELLS, nowadays we have so many Galleries that——"

"The House of Burlington should be kept as a place for specimens. I share your opinion, Sir FREDERICK, and feel sure that Mr. HOLL, for instance, if he had excluded that picture of his of Sir JOHN MILLAIS, from this year's Academy, would not have damaged his reputation by the omission."

The P.R.A. smiled, bowed, and passed on gracefully.

"You appear pleased, Sir COUTTS?" suggested Mr. Punch.

"I should think so," exultingly replied the artistic Baronet, "I have got a large picture on the line."

"A large picture on the line! Where?"

"At the Grosvenor Gallery," was the ready response, and then the talented and titled LINDSAY added, "I don't know why it was so honoured."

"No more do I," returned Mr. Punch: "but I fancy I can guess. Well, Sir COUTTS, at any rate it is in good company."

An elderly Artist followed, "All hail, Sir JOHN, President of the Royal Society of Painters in Water-Colours. All hail!"

"Thanks; but I am thinking of retiring." explained the veteran, GILBERT. "You see, fond as I am of dispensing hospitality—of maintaining the reputation of the Painters in Water-Colours—I find that one grows older."

"To judge from your work, I should doubt it," replied the Sage, with a bow fully as graceful as that of the P.R.A., and turning to the next who approached him, offered him his hand. It was grasped with the utmost heartiness.

"Ah, Sir J. D. LINTON, I am glad to see you."

"On behalf of the Institute, I thank you," said the President. "Yes, Mr. Punch, I most respectfully thank you."

"Tired of Fancy Balls, eh? No more historical tableaux? No dance in Piccadilly this year, eh?"

"We have given up dancing, my dear Mr. Punch, since they tried—h'm!—well, something of the sort at the Grosvenor."

9 Anon., *An Affair of Art*, *Punch*, 7 August 1886.

Cambridge educated barrister, provided an extended overview of Allingham's work in the book *Happy England*, first published in 1903 and then again in 1909. This and other volumes, such as *Old English Country Cottages*, took her work beyond England's shores: for example, the Huntington Library's copy of the latter text is inscribed 'Betty Xmas 1906 Calcutta'.

Within this body of work, as well as magazine profiles of the artist and reviews of her exhibitions, several clear patterns of marketing and critical acceptance emerge. These tactics reveal what the sales record confirms – that Allingham's work was targeted to the mainstream art market, and her dealers and supportive critics thus found it necessary to take steps to ensure that her work would conform to the horizon of expectations held by this bourgeois audience. In these texts, one can observe the tricky negotiations of current ideological positions undertaken by her supporters in order to render Allingham, as a female artist, valuable in the eyes of the marketplace.

One key method by which the value of Allingham's work was secured was by positioning her within the male lineage of the English landscape and watercolour schools. The catalogue for Allingham's 1891 F.A.S. exhibition, written by M. Phipps Jackson, for example, situated Allingham within a peculiarly British interest in domestic landscapes, featuring humble rustic scenery, exemplified by the public favour accorded the work of Gainsborough and Constable, as opposed to disinterest in the 'semi-classicism' of Richard Wilson and de Loutherbourg.[25] Jackson's discussion reflects notions of a distinctly English school of painting (none the less sometimes semantically blurred with British) that developed in the nineteenth century. This school was associated most strongly with naturalism and, in particular, 'landscape and rural genre painting', claimed by critics to represent 'the image of the soul of the nation'.[26] Such art discourses were shaped by the political rhetoric of nation building and chauvinistic jingoism then circulating. The critic W. W. Fenn, for example, in an article on 'The Love of Landscape', argued that 'no nation excels us in an intuitive love of landscape', and claimed proudly that the English 'are the best landscape painters as a body with which the world has ever been blessed'.[27] Stewart Dick, in *The Cottage Homes of England*, 1909, explicitly situated Allingham within the *national* 'preference for homely subjects ... [and] rural life'. Echoing Jackson, Dick traced the lineage of this 'English school' of landscape from Gainsborough – 'the first English painter who struck the homely and natural note in his landscapes' – through George Morland, John Crome, John Sell Cotman and John Constable, to Allingham's mentors Birket Foster and Frederick Walker, and finally to Allingham herself.[28]

As a product of this family tree and national heritage, Allingham's imagery earned accolades. In this context, Allingham's gender was not an issue; instead, the paramount concern was her ability to perpetuate a tradition currently threatened by rising interest in modernism and its preference for overall effect rather than mimetic naturalism. As early as 1878 *The Times* had championed the artist because 'in these days of "impressionism", when the "blottesque" is apt to run riot, in reaction against the over-minuteness intolerantly insisted on in certain

schools, such work as Mrs. Allingham's is specially noticeable as showing how conscientiousness and thoroughness may be reconciled with artistic require-ments'.[29] Into the twentieth century, Allingham's œuvre was offered as testimony to the continued vitality of the English school. Stewart Dick, for example, claimed that Allingham 'belongs, alike in her sympathies and her methods, to the old school of water-colour painting, based on the traditions of masters of a hundred years ago', which he contrasted positively with the techniques of the 'modern impressionist', who would 'turn his flash-light on the cottage, and paint it as a blaze of red brick thatched with gold'.[30]

Allingham's connections to the earlier 'masters' also enabled her work to signify within the developing rhetoric of the watercolour as a uniquely English medium.[31] Despite the fact that many early nineteenth-century English watercolour painters, especially those in the circle around Richard Parkes Bonington, strove to produce an art that could not be associated with any one country, late nineteenth-century art critics ascribed the invention and elaboration of watercolour painting to English artists. Just as in landscape painting, these critics claimed that no other nationality was as capable as the English of bringing out the special characteristics of the medium.[32]

Of particular importance in securing Allingham's ties to the national tradition of landscape and watercolour painting was her connection to Frederick Walker (1840–75), upon whom many in the art establishment had pinned their hopes for rejuvenating the landscape tradition.[33] An illustrator, watercolour and oil painter, Walker was regarded as the leader of the 'Idyllist' school of rural figural scenes.[34] Allingham had briefly studied with Walker and critics frequently drew connections between their work, citing their shared motifs of classicised or otherwise refined peasant figures in rural landscapes and, more importantly, their blending of ideal-ism and realism. Allingham clearly benefited from being seen as the inheritor of Walker's mantle; *The Standard* noted in reference to an exhibition by Allingham that 'it is no humiliation to have to confess in your labour the influence of the labour that preceded you when, as in Frederick Walker's case, that labour is classic already'.[35] Nevertheless, critics also insisted carefully that Allingham's work was original and not purely imitative, thus staving off a frequent criticism of women artists as incapable of originality.[36]

The link to Walker, however, did not shield Allingham from the charge that her work was inherently different from that of her male counterparts. The latter reflected the contemporary belief, shored up by scientific and medical discourses, that an artist's gender marked the surface and subject of their work. The critic A. L. Baldry, for example, began his 1899 profile of the artist by informing readers that one could always detect the work of a female painter no matter how close her connections to her male colleagues:

> But there is always a delight in recognising in clever art work the characteristics of the woman's hand. However hard she may strive to bring her productions exactly into line with those for which the men of her time are responsible, and however great may be her success in mastering the intricacies and difficulties of the craft which they all

follow, she will always betray, or declare, the secret of her sex by unconscious little touches of manner and by significant revelations of her sympathies. Her nature affects both her choice of subject and her manner of working.[37]

The notion that an artist's gender could be read from their art work was particularly strong in nineteenth-century discourses of watercolour painting. Many late nineteenth-century critics perceived watercolour painting to be in a decline attributable, in part, to the influx of female painters. The influential critic D. S. MacColl, in reviewing the annual exhibition of the Royal Institute of Painters in Watercolour in 1895, for example, argued that the masculine qualities of breadth and control that marked British watercolour production were disappearing due to the rise in women painters who favoured sentimental subjects and overly crowded compositions:

> The practice of water-colour in Albion [England] is very grievously vexed by Feminine Delusions … That is not to say that all the deluded are women, though many of them are. It is to assert that hardly anywhere on these walls are to be found the more masculine virtues of largeness and strength, whether in the relating of forms or of colours or of emotions; the qualities of dignity and of tranquillity, of controlling, adjusting, excluding, summoning, marshalling thought, absent indeed.[38]

Embedded in this discourse was the art historical trope, traceable to the Renaissance, whereby *designo*, with its associations of intellectual creativity, was assigned as a male trait whereas *colore*, with its associations of unthinking imitation, was designated female.[39] Nineteenth-century critics reinforced such distinctions by applying terms derived from broader social discourses to art criticism, thereby naturalising the notion of gender difference as well as uneven power relations in the art world.[40] Thus critics' discussions of Allingham's work as 'purposely refined and intentionally delicate', charming (suggestive of seduction and surface beauty), dainty and tender were not merely reflective of her meticulous technique, but also served to insist upon her femininity.[41] By contrast, when discussing contemporaneous male watercolour painters of garden subjects, critics struck a balance between describing their paintings within the conventional language of the medium, with its feminine implications, and terminology suggestive of masculinity by carefully paired terms: the work of George Elgood, for example, was described as possessing 'delicate and firm draughtsmanship' and 'executive delicacy', and revealing 'exquisitely clever manipulation' and a 'masterly' handling of the 'quieter tones of delicate colour'.[42] When one examines the work of the two garden watercolorists side by side it is clear that the two artists possessed different working methods – Allingham used bodycolour, scraping and small touches of paint to create a textured, worked surface whereas Elgood used translucent washes and thus retained a smooth surface – but the notion that these differences could be attributed to gender is found nowhere in the works themselves but solely in the rhetorical strategies of art critics who were anxious to shore up the differences between female and male painters in accordance with broader social discourses.

The feminine associations of Allingham's work were reinforced by her frequent depiction of women and children in gardens and the near absence of male figures in her paintings. Gardens, as domestic spaces, were typically associated with the feminine sphere of influence, a connection reinforced by the frequent equivalence made between women and flowers throughout Victorian culture. Critics easily located Allingham within this framework, describing her art as, for example, 'domestic and ladylike'.[43] Indeed, her art reflected the subject matter – genre scenes of home life – that nineteenth-century women artists were encouraged to take up because of their associations with domesticity and respectable themes such as philanthropy, marriage and motherhood. By adopting domestic painting, women more easily won the approbation of critics and thus advanced their careers.[44] Allingham arguably made the choice to hinge her career upon a subject deemed suitable for women. Critics rewarded her decision to work within the perceived limits of her gender with praise: *The Athenaeum*, for example, opened its review of *Happy England* by pointing out that while professional women artists were rare and often regarded as 'eccentric' by the public, Allingham was prepared 'to meet them [the public] half-way' by 'restricting herself consistently to favourite subjects, to the things her sex instinctively likes – pretty children, pretty cottages, pretty flowers, and pretty blue skies'. In return the critic judged her work 'entirely successful within the limits she has assigned to her art'.[45]

Yet Allingham's cottage subjects also threatened these limits. Much of the praise critics heaped on her work derived from their perception that her work was truthful and based on direct observation of the scene in nature.[46] But such practices were regarded as unfeminine: as Jan Marsh has explained in reference to Pre-Raphaelite women artists, 'lone women sketching were liable to be harassed or openly insulted' for faulting the rules of propriety that held that women belonged at home and that women in the public sphere should be accompanied by a proper male escort.[47] Allingham's dealer, Marcus Huish, was aware of these potential problems and sought to avert them by explaining in *Happy England* that the artist never travelled far from home and that due to her maternal nature her work 'could not thrive away from her children even if absence was possible'.[48] In his later book on English watercolour painting, Huish again insisted that Allingham exemplified good motherhood, explaining how she balanced the needs of mothering and painting by using her children as models and only painting cottages near her home.[49] This balance, however, was not achieved without effort; Allingham relied heavily on nurses, governesses and housekeepers to help raise her children, like many other middle- and upper-class women, and in a letter to Baldry she expressed keen awareness that, given her workload, she was unable to fulfil the social roles assigned to women, such as paying visits and receiving callers:

> Dear Mr. Baldry: I have behaved very badly in not writing long ago to thank you for the article. I intended to do so at once – but was then, and have been always ever since, very busy with outdoors work & in the few quiet moments indoors found it difficult to collect my thoughts for more than absolutely necessary letters and the calls of my

family … may I add that in the winter, I am always at home on a Wednesday afternoon, in case you and Mrs. Baldry would care, or be able, to come to tea some day – but I am afraid that Hampstead is a long way from Kensington – and I am so busy myself that I find visiting almost impossible: so that it seems hardly fair to ask friends to see me. I remain, very truly yours. Helen Allingham.[50]

Any sense of intense work or sacrifice involved in Allingham's œuvre, however, was effaced by those writing about her art. Critics repeatedly insisted that her painting was an act of 'pleasure' (connotative of female leisure) rather than 'trouble or labour'.[51] Attaching notions of pleasure to Allingham's work rendered her work even more in keeping with the villa aesthetic identified by Moore. Dainty, small in scale and suggestive of delight, her watercolours concretised the concept of the *bibelot*. As such, Allingham's works performed much the same operation that Nicholas Green discussed in relationship to early nineteenth-century French landscapes: they functioned as visual commodities, circulating within the market place of the city and thus participating in both the visual spectacle of the urban sphere and the construction of the countryside as the binary opposite to the city. Within this context, 'being in the country and viewing images of nature in paint and print were equally set up as a *pictorial* treat, to be pleasurably consumed with the eyes'.[52] A treat made even more enjoyable in Allingham's case by the fact that it was served by a good and loving mother.

Huish's trump card in defending Allingham's choice of cottage subjects was the resonance of this subject with the public, in particular the ways in which the cottage signified Englishness. Huish himself helped to set in place the notion that Allingham's cottage subjects represented Englishness by entitling his published collection of her work 'Happy England'. The title signified on a number of different levels. Firstly, the title encouraged the reader to interpret Allingham's paintings as uniformly uplifting, but in point of fact her paintings often contained signs of the tremendous change overtaking the countryside as the agricultural depression undermined the infrastructure of the countryside, and the lack of work and the promise of jobs and wealth in the cities lured rural labourers to the city. Signs of economic dislocation can be detected in watercolours such as *The Six Bells*, which depicts a young couple begging at a country inn (Figure 10). This image is one of many realist works produced in this period, such as Hubert Herkomer's *Hard Times* (1885) that took as their subject the out-of-work agricultural labourer and his destitute family. Yet, unlike Herkomer, Allingham blunts her critique by depicting a fecund rather than dead and dormant landscape. In addition, Allingham's image hints at an act of charity, suggesting that her countryside is a tightly knit community that cares for its own. Indeed, in many of her watercolours, figures move through the landscape together, extending the familial atmosphere of the home into the landscape. Moreover, by exhibiting and publishing Allingham's works in collections, Huish directed readers to the cumulative effect of her images rather than focusing upon a single work and its possible indictment of rural conditions. The *Athenaeum* employed such a strategy in reviewing *Happy England* (in which

The Six Bells appeared), finding the book to be a 'one-sided and partial view of life and nature'. But the critic excused this limited perspective on two counts: it provided an escape from 'these unquiet days' and represented the viewpoint of an empathetic woman: 'If her work is not conceived quite in the spirit of our own time it is none the less is thoroughly sincere, womanly, and unpretentious as to deserve the popularity it has always enjoyed.'[53]

Secondly, the title 'Happy England' naturalised the relationship between Allingham's cottage subjects and Englishness so that her subjects, taken from a relatively limited geographical range, stood in for all of England. This was a common trope in this period: during the second half of the nineteenth century the southern metaphor of thatched cottages, village greens and hedgerows (as opposed to the northern metaphor of industry and urbanism) was transformed into the national metaphor in response to perceptions that the urban sphere had become a place of disease and chaos and was therefore no longer a viable symbol of the nation's strength and character.[54] In response, many turned to rural England, with its connotations of 'order, stability, and naturalness'.[55] The cottage was central to this conception of rural England and was recognised repeatedly as a form of national patrimony: William Allingham, in the catalogue for his wife's 1886 F.A.S. exhibition, called the cottage 'a piece of Old England, irrecoverable henceforth by all the genius in the world and money in the bank'.[56] The *Illustrated London News*'s reviewer found Allingham's cottages 'humble but characteristic expressions of

10 Helen Allingham, *The Six Bells*, 1892.

English national life'.[57] In *The Cottage Homes of England* (1909), illustrated by Allingham, Stewart Dick rhetorically asked 'what is the most typical thing in England?' and responded 'the old English cottage'. The cottage was not only an ever-present motif in the English landscape, it also constituted the image of home that Englanders always carried with them: 'A little cottage nestling amidst the green, and a bower of roses round the door … these are the pictures of old England that are carried away to other climes'.[58]

What sort of national identity did this portable icon of the cottage imply?[59] §According to the rhetoric of the period, the rural village community was 'ideally sheltered and separated from the public life of power-political, economic, educational, scientific'.[60] Untouched by public discourses of change, the rural village represented a stable hierarchical order in which everyone knew their place. While echoes of feudalism invisibly structured the country village, a more visible and tangible sense of order was maintained by domesticity. In Allingham's images, young mothers stand in their front gardens, presiding over their domains, establishing a familial network. None of the overcrowding, dirt or contagion reported by the social investigators hired by the agricultural commissions to study the effects of the depression taints her depiction of rural England. As a symbol of national identity, then, the cottage offered up a vision of the nation as domestic, moral, pure, ordered and respectful of tradition.

This sense of the nation existed in complex relationship to notions of Empire. While certain strands of thought, such as moral rectitude, moved across the discourses of national and imperial identity, the sense of national identity that the English cottage ideal offered was clearly constituted through the difference produced by comparing it with other parts of the Empire and perhaps even (chauvinistically) the world in general. The export of such books as *Old English Cottages* to expatriates and colonialists in places such as India provided a vehicle for a dialogue between home and 'other' – the new colonial landscape (which many attempted to transform into a simulacrum of Englishness). This dialogue brought renewed attention as to what specifically denoted home in the English landscape. The vision of the English cottage with an attached garden, for example, was in contradistinction to the Irish cottage, which was typified in visual representations as set in 'wild, uncultivated land' in contrast to the English cottage, whose garden signified 'cultivation and orderliness'.[61] The English cottage ideal was about turning one's attention inward, to the decoration of one's domestic sphere, and about respecting boundaries, both physical and metaphorical, in marked contrast to the outward turning, always expansive notion of Empire. Robert MacDonald has argued that British Imperialism was built on the notion of contrast between home and Empire and thus between the feminine sphere – that of home – and the masculine sphere – that of the outside world.

> As a world-view it [British Imperialism] was stoutly Eurocentric, or more properly Anglocentric, defining itself against, and asserting its own superiority to, all other systems. It was masculinist, and the politics of the home, in which women were

often subordinated, worked to create the expectation that domesticity was soft and feminising, while the 'proper' male sphere, the outside world, was active and invigorating.[62]

Activities such as war, hunting, sport, adventure stories and jingoistic music-hall ballads that championed a virile aggressiveness expressed and defined Imperial identity in marked contrast to the cosy feminine domesticity connoted by the cottage as the symbol of Englishness.

The ways in which the discourses of the cottage ideal and Imperialism were defined through and against each other should alert us to their necessary interdependence. The cottage ideal was the mirror image of Imperialism: one could only go forth and conquer new lands because of the powerful feelings of security generated by one's image of home. John Ruskin made such a connection when he argued in his 1870 *Inaugural Slade Lecture on Art* that in order to found and disseminate colonies (deemed necessary to maintain and to further England's prestige and strength) the homeland must provide potential colonists with 'thoughts of their home of which they can be proud … The England who is to be mistress of half the earth, cannot remain herself a heap of cinders … she must yet again become the England she was once, and in all beautiful ways … under the green avenues of her enchanted garden, a sacred Circe'.[63]

Allingham's watercolours provided this desired image of home: cosy, lushly cultivated and domesticated. The artist may have been positioned among the outsiders in the context of debates about the Royal Academy: but, in point of fact, her work embodied and became a lightning rod for contemporary discourses of national identity. In this context, in which the domesticity of her rural imagery was foregrounded, being female (if properly packaged) was construed as an asset rather than a liability. Only as a woman could Allingham provide the subjects in which, according to the *Art Journal* 'the people at large are interested … homeliness, domestic happiness, love, courtship, marriage, merry children, sweet girlhood; they love pictures of our country lanes, of nature in her happiest moods, something wholesome and human that goes straight home to the heart and the understanding'.[64] The appeal of her subjects was compounded by her choice of a painting technique and medium consecrated by national tradition.

An instructive comparison is offered by Elizabeth Armstrong Forbes, who also deliberately built a career around depictions of rural children enacting scenes of domesticity. Forbes, who worked 'en plein air' and participated in the Newlyn school, also found her desire to paint outdoors complicated by notions of respectable femininity and eventually elected to paint in spaces protected from the public gaze.[65] But these practices and accommodations did not mean that Forbes occupied the same place in the art world as did Allingham. Forbes was active in the circles surrounding the London Impressionists[66] and showed with the New English Art Club, an exhibiting society founded in 1886 as an alternative to the Royal Academy. (It is depicted in the *Punch* cartoon of 1886 as a schoolboy, at the end of the parade, who has lost his footing.) Many of the young artists that formed

the group had trained in France and privileged 'plein air' painting, manifested by contemporary outdoor subjects, attention to colour values and an active paint surface.[67] When it emerged, the New English Art Club found itself embroiled in debates over the merits of French painting, more particularly Impressionism, which members of the older generation, such as John Ruskin and W. P. Frith, argued would cause a decline in the national school if permitted to take hold in Britain. In this context, Allingham, rather than Forbes, appealed to those factions of the art world anxious to hold on to the status quo.

Much of the antagonism directed at the New English also resulted from the subjects taken up by its artists. Walter Sickert's view of the patrons and performer in a 'disreputable and popular' London music hall, Gatti Hungerford's *Palace I of Varieties: Second Turn of Miss Katie Lawrence*, exhibited with the New English in 1888, was attacked for its unrefined modern urban scene. It was, according to the *Builder*, 'the lowest degradation of which the art of painting is capable'.[68] Compare this response with that given by the journal on the occasion of Allingham's 1887 exhibition, 'In the Country': 'The subjects Mrs Allingham illustrates are such as for, perhaps, the purest and most unalloyed source of human pleasure – the beauty of flowers and trees and skies far out in the country, unspoiled by the neighbourhood of town'.[69] According to this reviewer, the world depicted by Allingham is implicitly clean and untainted, both morally and physically, and is defined in explicit contrast to the city, popularly figured as the locus of moral and physical degeneration. Her cottage watercolours captivated critics because they epitomised how many Englanders liked to imagine their homeland, even at a time when more citizens lived in town than in the countryside. Thus the *Builder*, to conclude its review, predicted 'what a great name Mrs Allingham will have when she becomes an old master (or old mistress) and how her little gems of work will be run after and "run up" at the "Christies" of future generations'.[70] Indeed, while her work is often overlooked today by cognoscenti, who dismiss it as too saccharine, it continues to be 'run after and "run up"' at Christies, as witnessed, for example, in the sale of the Marley Collection of Watercolours by Helen Allingham held in 1991. The passage of time, it appears, has only enhanced the yearning for the sense of Englishness attached to the cottage landscape rendered by the artist.

5

In the bleaching fields: gender, landscape and modernity in The Netherlands 1880–1920

Jane Beckett

Images of picturesque, tranquil landscapes punctuated by windmills, cattle and sheep were the staple of Dutch nineteenth-century landscape painting. From the 1880s images of the land, populated with agricultural workers, tending animals or potato harvesting, retained a powerful hold in Dutch visual culture at a critical moment when 'modern art' was negotiated and concepts of landscape and landscape painting redefined. In these redefinitions, three related themes can be identified: Dutch peasant imagery and its connections with an emergent nationalism, the gendering of landscape and landscape imagery and an emerging notion of 'modern art'.

Critics in the period connected contemporary Dutch landscape painting with recent French plein-air painting practices and with Dutch seventeenth-century landscape conventions. From 1875, when it became known as 'The Hague School', the critic J. van Santen Kolff claimed contemporary painting reproduced 'the landscape – healthily realistic, simple but true' and 'typically Dutch'.[1] George Marius's 1903 text established the parameters for discussion of Dutch landscape painting,[2] modified only after 1945 when frames of reference were refined, a chronology mapped, the main sites and themes located, the formation of a body of critical writing established, dealers and markets outlined and iconographic issues established.[3] Notions of power, the constitution of the land, the relationship of city and country, specularity and speculation, seasons or intense weather conditions, nationhood, and identity have all been implicit in the writing on Dutch landscape imagery. Much of this literature confirms W. J. T. Mitchell's assertion that 'the history of landscape is the history of landscape painting'. This is particularly the case, as Mitchell points out, with writing on modernism, where a progressive 'purification of the visual field' of landscape imagery has been taken as the sole force in Dutch art practice and aesthetic theory between 1915 and 1929.

This approach has excluded the gendered, contemporary and historical factors embedded within Dutch landscape painting. Semiotic and hermeneutic

approaches, and ideological and religious themes that touch on issues of gender, have opened up studies of Dutch painting. Recently David Matlass has suggested that landscape painting must be seen simultaneously as a site of economic, social, political and aesthetic value and that each of these aspects has equal importance.[4] Within this nexus, landscape painting is only one representation among many of 'something that is already a representation in its own right',[5] part of the multiple cultural significations of landscape in which gender is indelibly inscribed. But landscape is also a process through which social and gendered identities are formed. What then of the conjunction landscape and gender? The 'and' of this configuration poses difficulties. Gender, as Judith Butler so elegantly argued, is not a stable category, not rooted in nature or bodies, but actively in formation through institutional practices and discourses.[6] This chapter probes at some of these issues, building on arguments from recent studies to foreground gender in the problematics of 'landscape'.

The notion of a 'return' to landscape painting dominated post-1945 discussions of Dutch nineteenth-century painting. Many recent studies have looked at the re-appraisals of nature that took place during this period. Rieta Bergsma argued that, a Darwinian model and the cult of nature converged with an interest in French landscape painting to produce a purer, 'more realistic treatment (of nature)'.[7] Landscape painting came to be seen as a naturalistic genre which asserted the importance of a 'real' site. It is in this sense that some Dutch paintings of the period have been read and their probable sites located. But why certain sites were preferred to others, or if indeed they have any such specificity, remains largely unexplored. Some speculations on these questions follow.

In his 1875 account of The Hague School, van Santen Kolff directly associated the term *realism* with contemporary Dutch painting: 'If one understands by "realist", solely inspired by reality, recognising only the truth'. But whose or what truths are evident here? For van Santen Kolff, truths were embodied in the paint surface, in the invocation of mood and the recollection of experience. For the spectator, he suggested that truth lay in aesthetic value and in evocations of the feel, smell and touch of the countryside. These sensory pleasures were gender specific, rooted in and structured through different relationships to nature. But in his elaboration of the concept of realism, another reading emerges. 'Can anyone but a Dutchman', he asked, 'see nature so, conceive of it and render it so, embody such a wealth of poetry in the most unembellished, sober representation of the simplest reality?'[8] Here, the invocation of a poetics of nature is mediated through a 'seeing' masculinity and through the parallel assertions of a national identity predicated on sobriety and simplicity. J. H. Weissenbruch's painting *Landscape with a Windmill near Schiedam*, 1873 (Rotterdam, Boymans van Beuningen Museum), Anton Mauve's *Heath at Laren* (Amsterdam, Rijksmuseum) and Jozef Israëls's *The Frugal Meal* (Glasgow Art Gallery and Museum) conform to this model in which the landscape and its inhabitants are subsumed into an idyllic and timeless vision. A sunny day, grazing cattle, fleecy clouds, reflections on water, a lone shepherd driving sheep across heathlands in the evening light – this was the representational

vocabulary signifying the enduring beauty of the Dutch landscape. The daily meal of the rural poor was marked as the embodiment of the national virtues of thrift, morality and simplicity. But these claims were made at a historical moment when the land and landscape were undergoing severe disruption and change. Simultaneous changes within the political and religious spheres and in the industrialisation of the urban and rural economies led to the modernisation of the Dutch landscape and to the decline of long-standing agricultural practices. Further, in the emergent cultures of modernity so intimately linked to the economic processes of modernisation, the picturing of the landscape as well as modern gendered identities were repositioned.

The concept of land has particular meanings in The Netherlands, a country largely constructed from and on polderland. The modern Nether-lands, an inherited geographic and historical formation which, as Ann Jensen Adams pointed out, is a 'description not of a people, a location, another region or a political entity but of a physical quality of land',[9] is constituted, contained and held by a system of drainage conduits in which water levels must be maintained and controlled through sluices and pumping systems. It is land circumscribed by waterways in a country whose borders are always fragile, vulnerable internally and at the edges. During the nineteenth century, land reclamation, industrialisation, the introduction of road and rail networks and modernisation of agriculture redefined the land. If the maintenance and control of land and water, as Audrey Lambert argued, 'played a vital role in the shaping of Dutch society and the making of the landscape',[10] then it can also be read as central to the Dutch imagination. This history of land construction, control, inundation, loss and salvage – the making of land, and by implication the land itself – has highly gendered implications.[11] From the 1850s, moreover, private and state capital, power and gender played an instrumental role in defining the land and landscape, and its various forms of visual representation.

In contrast, the paintings, drawings and prints showing the Dutch landscape frequently depict a quiet, fertile, unchanging land, subject only to seasonal change. The vastness of the landscape with diminutive figures of men carrying out ritual agricultural tasks, cutting peat, herding sheep or cows or tending windmills is a common theme in pictures from the 1880s. The limpid water, sandy or moorland landscapes, cows in meadowlands beside canals and ditches and sheep on the heathlands, echo themes from seventeenth-century painting; little vignettes of men at work (another seventeenth-century visual convention) call attention to the endurance of rural values.[12] Industrialisation rarely figured in such scenes. Indeed, the very indeterminacy of rural images enabled them to imply ideals of national ownership, masking such political matters as land tenancy or rural labour. The journal *De Nieuwe Gids* (*The New Guide*), founded in 1885, circulated this ideal political stance while offering re-appraisals of seventeenth-century cultural forms as the reference point for a new aesthetics, becoming both arbiter of, and guide to, the Dutch landscape.[13]

The Dutch landscape during this period was also opened up to tourism. In his analysis of metropolitanism and the cultural production and consumption of the countryside in France, Nicholas Green argued that it was 'the material and cultural fabric of the metropolis which set the terms for the social production of the country-side'. His discussion makes links between the visuality of landscape, tourism, city spectacle, the new technologies of consumption and the network of dealers and artists to argue that 'being in the country and viewing images of nature in paint and print were ... a pictorial treat, to be pleasurably consumed with the eyes'.[14] This account usefully serves as a model for the study of The Netherlands. From the 1880s tourism played a significant role in the Dutch national economy. Guidebooks were published in which little distinction was made between directions for reading cities and their interesting sites, museums and galleries and ways of reading the country-side. The country was produced as another spectacle on offer from the city.[15] These activities were also markedly gendered.

In both official and unofficial strategies for tourism and for modernisation, a concept of 'Dutchness' emerged. The invention of traditions of 'Dutchness' at both official and social levels became a strategy for cohesion in the state. New insti-tutions were formed, such as small museums devoted to the display of farm imple-ments, regional costume and customs. Magazines and journals such as *Elseviers Geïllustreerd Maandschrijft*, *De Hollandsche Revue* and *Holland Express* carried illustrated articles on national costume, landscape and buildings. By 1911, *De Vereeniging tot Behoud van Natuurmonumenten* (The Society for the Preservation of Natural Monuments) with *De Bond Heemschut*, a union for the preservation of historic houses and countryside, had become powerful pressure groups for the preservation of the land. The term *Heemschut* carries inflections of 'homeland' and the *Bond*'s activities embraced notions of a homogeneous 'national' culture. The national state and the provinces were also highly active in forming a variety of tra-ditions understood as Dutch, around and in which the uneasy juxtapositions of the emergent democratic state could cohere. Local costumes and traditional dress, dif-ferent types of windmill and polder construction all played a critical role in estab-lishing 'national' traditions, specifically the idea of an organic and active relationship between past and present and the suggestion that this relationship was an integral, constitutive and permanent feature of Dutch culture. Dutch painters actively sought out sites in danger of destruction, such as the fishing village at Scheveningen depicted in Mesdag's huge circular panoramic painting of 1881.[16] Other paintings such as Mauve's depictions of the Laren heathlands were similarly read as the quintessence of an old, enduring Netherlands.

Writing on the Dutch landscape to the art critic A. C. Loffelt in May 1902, the painter Paul Gabriël touched upon two themes at the heart of the notion of '*Heemschut*'. At the beginning of the letter he described the return to his homeland from exile, when he was struck by 'the colour, lushness and richness of our country-side', and 'our beautifully coloured and well-proportioned cattle. Nowhere else', he continued, 'do you find meat, milk and butter like theirs, but then they are nourished

by our lush rich and beautiful countryside'.[17] Gabriël's notion of a shared 'Dutchness' was encoded in the recurrent imagery of canals, cattle, flat land and waterways, tulips and traditional dress and, significantly, to the appeal of Dutch agricultural produce – meat, milk and butter.

Michel Foucault has noted that 'a whole history remains to be written of spaces – which would at the same time be the history of power ... from the great strategies of geo-politics to the little tactics of habitat'.[18] The little tactics of habitat in the nineteenth-century Netherlands were imbricated in the geo-politics of food production. Dutch agriculture, partly hit by the agricultural depression from 1878, modernised and diversified and, by the late 1880s, had capitalised on land production in the division of the market for grain, potatoes, dairy products, market gardening, bulbs and flowers. In the diversification of agriculture under capitalism, furthermore, the use of fertilisers and pesticides on the soil replaced the systems of land fertilisation by cattle, while animal labour was replaced by mechanisation. Gradually, the production of food became factory-based.[19] In a sense, the Dutch landscape had always been perceived as malleable to engineering, construction and rationalisation. But, by the end of the nineteenth century, this perception was intensified by the industrial production of foodstuffs and by an increasing awareness of the economics of the world markets and their exploitation of the labour force.[20] In these processes, labour on the land gradually decreased and moved into factories. Yet, precisely at this historical conjuncture, picturesque 'traditional' costumes, tranquil rural scenes and the imagery of the rural mother and woman worker fashioned an image of 'homeland' centred on an unchanging natural environment and enduring gender relations. A cluster of concepts condensed in the image of the Dutch maid. Not only does she embody and gender the image of the nation, but in her striped skirt, apron, clogs and 'traditional' headdress, she is emblematic of the health and productivity of Dutch agriculture and of the moral duty and responsibility of country women as workers and mothers. Typically shown as dressed in regional costume, tending animals, harvesting and picking up potatoes, she is pictured not only as a fecund embodiment of the land but as a dutiful mother and wife.

The Dutch maid became a symbol of national identity at precisely the moment when small-scale farming was under threat. In the modernisation programmes of the 1880s, peasant smallholdings, based around cattle and dairy production, market gardening and vegetable production, were gradually eroded with the result that cheese, butter and milk became unavailable as staple foods and were replaced by potatoes. Potatoes, used for a variety of products from alcohol to flour, were a key part of the export industry. Although cultivated for factory production, potatoes were, an agricultural textbook suggested, 'in many cases with great convenience cultivated by the spade'.[21] In *Practical Agriculture*, a textbook produced for agricultural schools, David Low inferred that potato cropping was relatively easy (whereas, in fact, the manual processes of potato production – digging, planting, manuring, hoeing and lifting – are exceptionally heavy and labour intensive). Low

identified the domestic possibilities for the potato which, aside from boiling, could be used for bread, or fed raw to livestock and utilised in the production of 'ardent spirits by distillation'. Low, somewhat romantically, maintained that potato crops have lessened 'the hazards of famine, and added greatly to the comforts of the labouring people'.[22] But there are other implications to be drawn from the tactics of this habitat, laid out, as Fred Orton and Griselda Pollock have noted, in Vincent van Gogh's first major subject painting, *The Potato Eaters* of 1885.[23]

The painting depicts a peasant group seated around a table illuminated by an overhead oil lamp, eating their main meal of potatoes from a central dish. One of the two women pours coffee into cups. Writing of the image, van Gogh insisted that he had tried to emphasise that 'those people eating their potatoes in the lamplight, have dug the earth with those very hands they put into the dish and so it speaks of manual labour and how they have honestly earned their food'.[24] By placing his potatoes as a meal, rather than at the moment of their lifting, that is to say as an interior rather than an exterior subject, van Gogh integrated two themes: agricultural labour and the peasant interior, themes integral to the repertoire of seventeenth-century Dutch painting and The Hague School. But the women involved in domestic tasks in *The Potato Eaters* had, as van Gogh's writings and drawings suggest, also been active in the fields.

In *Scheveningen Women Gleaning Potatoes* (Amsterdam, Rijksmuseum) of 1874, the painter Philip Sadée restaged the agricultural worker, a central thematic of French Realist painting, in a Dutch context.[25] The three fisherwomen in Sadée's painting are placed by the sea, yet working on the land in the sandy soils behind the dunes. The standing, kneeling and digging figures suggest the seventeenth-century imagery of masculine labour. But in drawing on 'modern' French sources which depicted female agricultural labour, such as Millet's *The Gleaners* of 1852–53 or Jules Breton's *The Recall of the Gleaners* of 1854, Sadée re-gendered the inherited images of labour. By the end of the nineteenth century, harvesting potatoes was largely women's work, both for factory and domestic production. A government inquiry reported in 1906 on the conditions of agricultural labourers in The Netherlands and contrasted the economics of farming production on rich and poor soils, signalling yearly deficits on poor quality and thereby necessarily labour intensive land.[26] Small-scale potato farming was carried out in many of the poorer or clay soil areas and it was the labour on this small scale that was figured in representations of the subject. Paintings, such as Willem Witsen's *Woman Gathering Potatoes* (Amsterdam, Witsen House), for example, represent women grubbing in the soil, either kneeling or bending with potato baskets or spades in bleak and bare landscapes. The same visual tropes appear in photographs of women potato workers, taken for official reports, and clearly depict the thimbles worn to protect the hands. Contemporary accounts also show that women were active in dairy and vegetable production. These activities were depicted in paintings such as Witsen's and in Mauve's contemporary canvas *In the Vegetable Garden* (Rotterdam, Boymans van Beuningen Museum). The handling of paint to accent the play of light on the clods

of earth in Witsen's painting and the heavily pigmented texture of vegetables and foliage in Mauve's work, are usually interpreted as quintessentially modern painting. But, as Deborah Cherry has pointed out, 'this pictorialising vision focused on working-class women'.[27] Moreover, several studies have noted that the labouring female body was marked as different from metropolitan norms.[28] While tourism enabled a range of people to travel to and from the country and enjoy its pleasures, it also positioned bourgeois men and women as spectators, consumers and as artists. Public museums and private galleries in metropolitan centres became active sites for the consumption of the country.[29] Here, the image of agricultural labour was inscribed in difference to a metropolitan working class while religious and national interdictions were written on the gendered and classed rural body. What articulations of gender are inscribed in these discourses?

Depictions of rural labour in Dutch nineteenth-century landscape are rarely idyllic or bucolic. Class was constituted in The Netherlands mainly through religious affiliation. The suggestion that 'in an attempt to emphasize the intrinsic value of everyday life, realist painters often chose themes that were essentially secularized versions of popular religious subjects', while offering an important insight, does not explore why these were constructed around rurality and not urban subjects or why such forms of secularisation might be significant.[30] During the nineteenth century, agricultural workers were mainly represented within three broad categories: as political activists, as a docile, dutiful peasantry, or as a dangerous, impoverished and morally irresponsible underclass. The vigorous struggles of agricultural labourers for improvement to their working conditions and for political representation erupted in the 1880s. Their militant image persisted into the twentieth century and contrasted with popular and high cultural representations of urban workers in which distinctly modern forms of femininity and masculinity were represented.

In her discussion of ideas of pollution, Mary Douglas indicates some of the ways in which beliefs reinforce social pressures: 'the laws of nature', she argues, 'are dragged in to sanction moral codes'.[31] Pictorial representations drew on and mobilised these issues. Nineteenth-century images of rural women, either breast feeding or surrounded by children engaged in rural tasks, invoked concepts of the good mother also found in medical, national or religious discourses and served as injunctions to moral probity and social humility. As Douglas argues, 'ideas about separating, purifying, demurring and punishing transgressions have as their main function to impose system on an inherently untidy experience. It is only by exaggerating the differences between within and without, above and below, male and female, with and against, that a semblance of order is created.'[32] Indeed, the very form of the female agricultural body is established in and through discursive practices in which specific codes of representation and behaviours establish cultural coherence. In the establishment of rurality as a cultural category the bodies of agricultural labour play a key role, constituted as they are through the composition of boundaries, which instate limits and postures in their relationship to landscape.

Douglas's analysis can also advance discussion of landscape and gender. When rurality is acknowledged as a cultural category, then the bodies of women agricultural labourers that inhabit it must be given prime consideration, defined as they are through contours and boundaries which characterise the landscape. Here, landscape becomes not only 'without' and 'against' the metropolitan, but also a site in which the boundaries of gendered bodies are understood as material and their surfaces and contours signified as transgressive, at the limits of the social. In photographs, paintings and illustrations of the period, masculine bodies are often depicted as little more than a mark. These graphic ciphers note carting, herding animals, cutting peat or gathering faggots, the traditional themes of labour, underwritten as the embodiment of a Dutchness. In contrast, there is a notable difference in the depiction of women agricultural workers.

From the 1880s, numerous images portrayed women gathering potatoes, digging, collecting and placing them in baskets or in sack-aprons tied around their waists, shown as contained *within* and *by* the landscape and bound by their activity on the land.[33] The contours of the body of the woman in Witsen's *Woman Gathering Potatoes*, for example, are defined by the space of the upward sloping land. Kneeling on the ground, grubbing with her hands in the soil for potatoes, her body cramped, she is depicted in the earth which contains and binds her body, the spade at her back pinning her to her task. In Mauve's watercolour *Gathering Potatoes*, of the 1880s (Montreal, Musée des Beaux-Arts), a woman is similarly placed, her back and the horizon line becoming one. A digging man, by contrast, is positioned above the horizon. Both bodies are bound into the space and activity of their labour.

By the early twentieth century, the remote and picturesque islands of Zeeland had become a site visited by artists and the urban bourgeoisie.[34] Writing in 1910, Baedeker noted that the village of Veere was 'much frequented by artists'.[35] Artists and the photographic industries became both the recorders of the landscape and the guides to it. In the summers of 1904 and 1905, for example, Jan Toorop, working in and around Domburg and Veere, made a series of pencil and coloured chalk drawings, watercolours and paintings of the farming community. Toorop depicted men and women on small land plots engaged in vegetable cultivation, digging, cutting beans and sowing potatoes. On one level, these drawings pursue the representations of agricultural labour developed in the 1870s, such as Israëls watercolour *The Reapers* (Amsterdam, Rijksmuseum) or van Gogh's 1884–85 Nuenen drawings and paintings.[36] But there are significant differences. Like other artists of The Hague School, Israëls rarely portrays women engaged in manual labour, depicting them instead as tending cattle and sheep. Two canvases of the 1890s by Israëls depict a formulaic landscape – a pathway in the foreground marked off by fencing with fields in the middle ground, and buildings on the horizon line. But the way gender is depicted differs in the two landscapes. In *Bringing Home the Calf* (Edinburgh, National Gallery of Scotland), a woman's body is shown bent as she leads the animal along the pathway, her head conforming to the contours of the

distant townscape, while in *The Reapers* two men trudge along the path, scythes over their shoulders, breaking up the spatial boundaries.

In Toorop's Walcheren drawings of 1904–5, men and women depicted in profile and shown in close focus, gather beans and lift potatoes. Their straining bodies are carefully delineated. Behind them, strip fields continue to the horizon, encasing and enclosing the workers, binding them to the land. In Toorop's *Lifting Potatoes* (Rotterdam, Boymans van Beuningen Museum), a man and a woman are depicted with sacks of vegetables, while in his *Peasant Woman at Labour* (Venice, Galleria d'Arte Moderna) (Figure 11), a woman is shown leaning forward, digging a narrow strip field. The contours of the bodies in these pictures are bound into the land, their bodies becoming part of the materiality of the soil. Further, the traditional costumes of the women locate them in a timeless utopian past with a plentiful supply of food. These images circulated in the domain of high culture, were fuelled by and fed discourses of Dutch nationality. In the economies of modernity, in which tourism played a central role, rural images were structured as primitive and backward: newspapers, journals and guidebooks all noted the traditional costumes of Zeeland, and its 'primitive', 'ancient' and 'picturesque' aspects.

There are other elements in these drawings which further articulate landscape and gender. As Douglas suggested, ideas about separating and purifying 'have as their main function to impose system on an inherently untidy experience'.[37] The classification and ordering of nature, so often understood as disordered during the

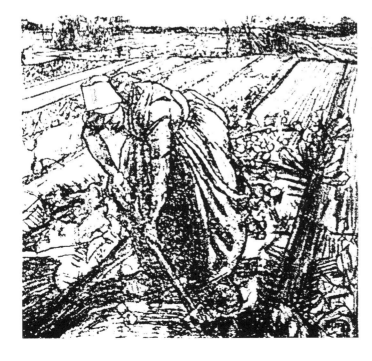

11 Jan Toorop,
*Peasant Woman at
Labour*, 1911.

nineteenth century, can be fruitfully elaborated in this context as imposing regula-
tory ordering systems on an unruly Dutch landscape through land construction and
mediated through new agricultural processes. In pinning the bodies of agricultural
workers into landscape formations, these bodies also assert the materiality of land,
which by the mid-nineteenth century was perceived as a site of dirt and pollution.

Dutch citizens were also anxious about the outbreak of *cholera asiatica* across
Europe. In the 1860s considerable panic was generated when the disease erupted in
the newly drained landmass of Haarlemmermeer, an area close to Amsterdam,
Haarlem and Leiden.[38] Although the cholera bacillus was not identified until 1883,
microbe bacteriology led canal and land water drainage to become the focus of
many official medical and governmental inquiries.[39] The investigation of water-
borne infections was seen to be critical to the public health of a country with large
areas of water. Official discourses were directed towards public awareness of the
necessity for cleanliness. The production of images of bacteria and microbes in
popular illustrated journals and educational textbooks provided many young
artists with an income. Piet Mondrian, for example, recalled: 'I did many kinds of
work – bacteriological drawings used for text books and in schoolrooms … and
then I began to sell landscapes.'[40] Mondrian's references to microbes and landscape
are evidence of a link, albeit unconscious, between the countryside as a simultane-
ously clean and healthy place and as a site of dirt, water and poverty. Under the
1865 Health Act, an inspectorate of physicians and civil servants was established in
each province. In an effort to combat the spread of disease, these inspectorates pro-
duced reports which focused on the disposal of refuse, on air, water and soil pollu-
tion. Measures were proposed against the spread of disease through animals and
through the widespread introduction of general health education. The introduc-
tion of the Burial Act of 1869, the Cattle Act of 1870 and the Epidemic Diseases Act
of 1872 marked efforts to control and limit pollution. Alongside social investigative
reports that sought to remedy urban and rural poverty, discussion on cleanliness
and personal hygiene can be found in numerous official statements on public
health. In 1907, for example, the respected daily *Nieuwe Rotterdamsche Courant*
commented that '… no one, who knows the Dutch people well, will consider clean-
liness to be its chief characteristic …' and although the writer mentioned the lack of
hygienic practices in the middle classes, the article indelibly tied dirt and, by impli-
cation, disease to the rural poor.[41] In attempts to improve public hygiene, earth
closets were also introduced in the country to maintain clean soil and the washing
of clothing and household linen was actively encouraged. The institution of steam
laundries in cities also slowly replaced the system of sending washing out to the
surrounding countryside.

Lines of washing were a recurrent theme in Piet Mondrian's landscape paint-
ings, a motif introduced in *Farmhouse with Washing* (The Hague, Gemeente
Museum) of 1895, painted in Winterswijk, the village in which his father was head-
master of the Protestant School. Washing and bleaching of cotton and linen was
common in this region, which from the seventeenth century had produced linens

and inexpensive unbleached cottons. In Mondrian's *Women Doing the Washing*, two women washing are set against the exterior farmyard. In a mutually defining juxta-position the cleaning of household linen serves as a contrast to the dirt of agricul-tural labour and women's domestic spaces are sharply contrasted with the masculine space of agricultural labour. Laundering was also the subject of a series of watercolours and oils Mondrian painted from 1900 of sites along the river Gein, a small tributary of the Amstel on the outskirts and thus the boundaries, of Amsterdam. In the watercolour *Farmhouse on the Gein* (New York, D. Morris Gallery, Inc.), the washing is tucked to one side in the composition, while in *Farmers' Wives with Laundry on the Border of a River* of 1902, women are shown stooped over the water or pinning out the washing on long lines between trees. These images can be read as a rural idyll. The laundry and trees mirrored in the river surface reference similar pictorial conventions found in the paintings of The Hague School implying a continuity between past and present, timeless tradition and tranquil settings.[42] Mondrian's *Farmers' Wives with Laundry* (Figure 12) has been read primarily in terms of its formal structure as prefiguring his later abstract work. However, it was exhibited in Amsterdam in the autumn of 1902 under the

12 Piet Mondrian, *Farmers' Wives with Laundry*, 1911.

title *Bleaching Fields on the Gein*.[43] Such an analysis would stress the purification of the formal dimension of the painting. But the act of washing and bleaching is tied into the gendered representation of the landscape. As Mary Douglas pointed out, concepts of the pathogenicity of dirt displaced old definitions of 'dirt as matter out of place …'. This idea of dirt, she argues, 'takes us straight into the field of symbolism and promises a link-up with more obviously symbolic systems of purity'.[44]

What then is the connective matrix of laundry/gender/landscape in Mondrian's watercolours? These images of bleaching and washing, rarely present in nineteenth-century landscape painting, imply a different reading from the images of men and women stooped over the soil or leading animals to and from fields and markets.[45] Mondrian depicted farming women washing, bleaching and hanging out laundry or simply laundry threaded on the line across the landscape. There is little sign in *Bleaching Fields on the Gein* of the intensely heavy manual work entailed in hanging out wet sheets, or the dangers from chemicals used for bleaching. But underpinning this idyllic image is the notion that the processes of bleaching purified and cleansed the dirt, the materiality of the country. The picturesque orchard setting by the river on a calm summer day in this watercolour frames the women's bodies and presents them as safe, clean and pleasing for urban eyes, the antithesis of the dirty potato picker or the invisible microbes borne by water or contained in the soiled landscape.

If 'un-cleanliness is matter out of place', as Douglas concludes, it must be approached through order. Her discussion of the religious invocations of defilement usefully serves to discuss one further aspect of Dutch landscape painting. In the period under discussion, political parties with strong religious affiliations were formed, which had clearly articulated policies for the arts and education. As part of the Dutch programme of imperial expansion, many of these policies were introduced into colonised territories, but in the cultural interchange that followed religious discussion was opened up to different readings of spirituality.[46] From the late nineteenth century, east and south-Asian religious philosophies and practices which stressed inner or other worldly forms of mysticism, precipitated debate on the nature of religion. These debates had a marked effect in the cultural domain, particularly through the Theosophic movement, which emphasised the cultivation of the soul through meditative contemplation of the natural world. The interest in Theosophy in avant-garde circles, reinforced by the lectures given in Holland by Rudolph Steiner, is noted in most critical studies.[47] For many artists, Theosophic texts offered a re-reading of nature distinct from orthodox theologies and provided a language in which concepts of both aesthetic and spiritual purity could be articulated.

In a series of notes and drawings made between 1912 and 1914, Mondrian laid out the underlying principles of the main Theosophic texts. The notes show that, for Mondrian, landscape and identity were gendered and eroticised concepts. Written at a moment of intense political pressure from the women's movement for inclusion as full state citizens, the notes can also be understood in a context of changing gender roles and identities. Through a structure of binary oppositions,

negative/female and positive/male, elements which he saw as hostile but attractive to each other, Mondrian connected nature/matter/gender. Women were 'matter' and 'real' and therefore static and linked to the horizontal, while men were 'spirit', 'unreal' and malleable, he argued. Woman, he wrote, 'with the horizontal line as characteristic element', recognises herself in the recumbent line of the sea and sees herself as complemented in the 'vertical lines of the forest (which represent the male element)'.[48] During this period, Mondrian painted and drew two main themes – the sea and trees. Any elision between texts and paintings should be treated with care. However, the montage of notes and drawings in the notebooks suggests that they may be read as interrelated.[49] One drawing particularly summarises and connects themes from the notes. In *Reclining Nude* woman, sea, and the upright forms of a sea-groin are dissolved through a cubist syntax. The woman's body and the seascape are interlinked, embodiments of matter, but purified through the aesthetic means of abstracted (masculine) form. But at the core of Theosophic doctrine lay concepts of sight, a vision turned inward and open to abstract values and committed, as Mondrian's notes indicate, to de-materiality, a concept which also repositioned gender.

By 1915, when Hague School painting attained its highest prices in the dealer markets, younger critics repudiated the sheer opportunism entailed in the endless provision of landscapes 'to hang in bourgeois interiors'. They rejected this work as 'cow' or 'ditch impressionism' and fiercely criticised the social irresponsibility of artists in the repetition of images of the rural poor.[50] Moreover, the category nature was interrogated and repositioned as part of the syntax of modern art. In a theoretical article on the principles of new forms of art, Theo van Doesburg argued that nature is not organised as a unitary category, but is discursively fragmented. Art, he maintained, had, at most, a contingent relationship to observation, while nature was varyingly framed in different and competing discourses. 'The cow', he argued, 'as source of food, as a product for sale, in a word, the natural animal, becomes for the formative artist a complex of formative (aesthetic) accents ...'[51] Animals and other staples of Dutch landscape and landscape painting were refigured in avant-garde practices, principally Fauvist and Cubist conventions, in a drive for the purification of painting. In Henri Le Fauconnier and Mondrian's work in Zeeland, and in the abstracted designs for stained glass and paintings made by van Doesburg and Vilmos Huszar between 1915 and 1921, gender and landscape were reconfigured, yet reconfigured on familiar territory, as van Doesburg's titles of small (*Kleine*) and grand (*Grote*) *pastorale* for two stained glass designs make clear.[52] In taking up the subject matter of 'traditional' and more recent Dutch landscape painting, younger painters could underscore and reposition disputed motifs, while simultaneously signifying a 'Dutchness' now placed in a Pan European avant-garde syntax.[53]

But these reappraisals also took place within the context of World War I, when 'Dutchness' was constantly asserted through visual invocations of land. Subject to severe wartime restrictions, agricultural produce was a key commodity in black market profiteering, sold to German and Allied troops alike and the constant focus

of cartoons in the press. Gender and landscape are imbricated in these representations. In the severe food shortages of 1917, the politics of agricultural and food distribution were the focus of extensive debate. Representations of food profiteering in cartoons depended on the contrasting imagery of fat capitalist male speculators eating in city restaurants, while thin, hungry poor women struggle to find food. In *De honger in Luilekkerland* (Hunger in the land of plenty), Joh. Braakensiek's cartoon published in the radical Amsterdam paper *De Amsterdammer*, a procession of women moves along a canal bearing banners proclaiming HONGER (Figure 13). On one side, men load the rich corn harvest on to a cart backed by a windmill and farm; on a strip of land in front of them, a man digs potatoes while a woman loads them into a basket. On the other side of the canal, cows graze in fertile fields, while the milk drawn from a cow is carried away in buckets. Here, the politics of profiteering in food are represented through longstanding pastoral devices. High cultural representations of the pastoral at this date took their place and their meanings not only within the constraints of the art market but also in the multiple emblematic references in such cartoons.

The pastoral recurs in the stained glass windows designed by Theo van Doesburg in 1921 for the Landbouwwinterschool in Drachten (one of many agricultural schools introduced by the government to train young men to be modern farmers (Figure 14)). Here van Doesburg's windows drew on themes of masculine agricultural labour – planting, digging, sowing and lifting potatoes. These 'traditional'

13 Joh. Braakensiek, *De Honger in Luilekkerland*, in *De Amsterdammer*, 1917.

images of seasonal labour are repeated across the sixteen windows but configured in a modern abstracted syntax. In each window the working body is controlled and contained within the square frame of the windows and, by implication, by the land and the task in hand, through strict regulation and ordering of bodily contour, and through shape and colour (red, yellow and blue). As Dutch landscape and landscape painting changed in the modern period, gender was constantly re-negotiated. At the time these windows were designed, images of working women disappeared from avante-garde painting. Furthermore, the visual emphasis on working men was situated at the threshold of the agricultural school articulating and gendering the spaces of knowledge.

14 Theo van Doesburg, *Grote Pastorale*. Stained glass window, Landbouwwinterschool, Drachen.

6

Landscape, space and gender: their role in the construction of female identity in newly independent Ireland

Síghle Bhreathnach–Lynch

This chapter explores how issues centring on landscape, space and gender intersected with the construction of a new Irish post-colonial identity. In the decades following political independence in 1922, the image of Ireland and the Irish projected by successive governments was that of a bleak but beautiful countryside, peopled exclusively by a sturdy Gaelic-speaking, Catholic people. This construct provided an instant recognisably different identity from its former ruler Britain, which was perceived as urban, English speaking and Protestant. The determination to be different in every way was further reinforced by projecting the Irish female as chaste, unsophisticated, even unworldly, whose sole role within the new state was that of mother and homemaker. Structures to support this stereotype were instigated both in legislation and in the formation of a new constitution. By fixing the position and role of women, as well as defining the very nature of womanhood, the new state could maintain a patriarchy already firmly in place during centuries of British rule.

In the visual arts, this image of Ireland and the Irish was sustained by numerous paintings of the west of Ireland, now promoted as the 'real' Ireland. Many of them included women, set against a backdrop of the landscape of the west, dressed in peasant costume. This kind of representation helped to anchor Irish women to a rural identity while at the same time reinforcing the supposed links between the female, nature and nurturing. Intersecting with that model was the Virgin Mary as signifier of moral purity and sexual innocence. Her presence, in the form of religious statuary, was evident not only in church interiors but increasingly in open-air grottoes dotted throughout the countryside. This chapter examines three important aspects of these ideological discourses surrounding Irish female identity. It begins by considering the gendering of the land as female and its relationship with male identity and then explores the concerted effort by more zealous nationalists to assert masculinity as the essential characteristic of the *Gael* (the new Irishman) and how

this impacted on the construct of the ideal Irish woman.[1] The investigations are completed by focusing on the locating of statues of the Virgin in open-air grottoes, arguing that they occupy a politically gendered as well as spiritually significant space.

Ireland, both geographically and politically, had long been allegorically identified with a woman. An analysis by Belinda Loftus traces how this image of Ireland changed in its representation, from that of a woman embodying political power and strength to a cowed and melancholy figure, often relying on an Irish male political leader for help.[2] In an examination of nineteenth-century popular and fine art imagery, Loftus relates the increasingly cowed poses of allegorical images of Ireland to unfolding historical events as well as to the style of political and economic life. This was the century of a disastrous famine, massive emigration, land agitation and an increasing call for Home Rule by those who objected to the union of Great Britain and Ireland. The Irish tradition of identifying both the physical reality and political identity of the land as female was one which gave credence to colonial strategies of representation. In Victorian England the image of Ireland as not-England was firmly rooted.[3] Victorian imperialists attributed to the Irish all those emotions and impulses which they, as an expanding world-wide power, had suppressed in themselves. If John Bull was steady, reliable and rational, then Paddy, who never seemed to be satisfied with the political solutions being offered him throughout the century, was thought to be irrational and unstable. These defects, perceived as not only childish but feminine, bolstered up the belief that the Irish were incapable of self-government. Artists like the Scottish painter Erskine Nicol helped to confirm this view of the Irish. His pictures show jolly peasants living out a life of simple pleasure in a picturesque, tranquil landscape.[4]

As already mentioned, with the coming into being of the Irish Free State in 1922, the idea of creating an Irish identity, separate and different from that of its erstwhile ruler, became an imperative.[5] So-called 'true' Irishness now became exclusively linked to the idea of an ancient and noble pre-conquest past, with a single Gaelic tradition, culture and language. At the same time there was a move towards a more masculine national identity. The conquered but now free needed to assert their strength and prowess; thus the Celt (characterised in the science of ethnography in the nineteenth century as a feminine people) metamorphosed into the manly Gael and the land chosen as worthy of the Gael was the western seaboard, a corner of Ireland perceived by writers, artists and nationalists as the cradle of Irish civilisation. What was so special about this part of the countryside and why did it exercise such a hold on people's political and cultural aspirations? Geographically it is a place of extraordinary wild beauty, a landscape of rugged mountains below which, stretching to the edge of the Atlantic, lie flat bog-land and coastal fields. Those who lived there in the nineteenth and early twentieth centuries spoke Irish, dressed in distinctive costume, and pursued a life-style which appeared to be untouched by wars, political upheavals or the less attractive aspects of urban industrialisation. These factors gave the location a sense of timelessness and uninterrupted continuity with the Celtic past.

In reality life here was a constant struggle against grinding poverty. Half the inhabitants lived on farms of less than fifteen acres and about 15 per cent had fewer than five acres. Those who did not flee the land at best eked out a living on it. Yet, in spite of bleak lives lived out in an even bleaker environment, this area of Ireland increasingly held an attraction for artists and writers from the end of the nineteenth century onward. It should be stressed that the seeking out of a 'pure' environment was not unique to Irish artists. The search ties in with a general European trend in which artists and writers fled from urban reality to recreate a more romantic and picturesque existence in word and image. But in Ireland's case it became closely identified with national identity aspirations. The west's distinctive language and culture were seen as vital components in the construction of a national identity (it was here that story-telling, native dance and music had survived).[6] This place was to become the locus of what the Irish painter Charles Lamb termed 'the national essence'[7] and among the many painters who came to this part of Ireland from 1910 onward seeking spirituality and authenticity were Paul Henry, Charles Lamb, James Humbert Craig and Sean Keating. Henry and Craig were especially interested in the landscape itself and carefully transcribed in paint the bleak beauty of its almost curvaceous outlines. It was their kind of landscape painting, in particular that of Henry, which was to become the archetypal Irish landscape. Sean Keating's paintings *The Race of the Gael* (Figure 15) and *The Gael* perfectly encapsulate that new breed of Irishmen 'worthy of the soil'. They are sturdy, pragmatic peasants whose very masculinity symbolically asserts the new Gaelic ideal. These men are seen to flourish in this sparse but invigorating place. More significantly, however, they embody the repossession of the land, historically perceived as an object to be possessed. The representation of that land as female therefore was to assert male domination at a political level. But it also articulated another kind of domination: the patriarchal belief in a symbiotic relationship between woman and nature in which woman is defined as the passive and voiceless embodiment of nature.

Both the political and the patriarchal come together in the design chosen for the new Irish Free State currency notes, in circulation from September 1928.[8] This image was based on a portrait of the wife of the artist Sir John Lavery. A friend of Michael Collins, one of those negotiating the Treaty for independence, Hazel Lavery had been involved in mediating between the Irish delegation and the British on a social and personal level. In the guise of *Cathleen ní Houlihan* she represents the nation as a pretty peasant woman, set in a landscape evoking the west of Ireland. On one level the notes serve as a constant reminder that this beautiful land of Ireland has finally been reoccupied by her own fellow country*men* (my italics). At the same time the representation visually articulates the new nationalist construct of Ireland. Her rural dress, the antithesis of contemporary fashions associated with England and elsewhere, proclaims the new state as an anti-urban entity. When the costume is considered in conjunction with the passive pose and gentle submissive expression of the figure, images of the Virgin Mary are recalled. Thus post-colonial Ireland is projected as a place of the spiritual rather than the temporal. The empty

landscape behind declares an anti-industrial location while at the same time sug-
gesting a place outside 'real' time, separate from the normal ongoing development
of a nation. But also embedded in this allegorical image of Ireland are notions of the
appropriate role of actual flesh-and-blood Irish women in the new state. The pas-
sivity and meekness of the figure on the currency notes portray the female role as a
subordinate one. So it was to prove.

Jean Baudrillard has defined hyper-reality as the simulation of the real which
ultimately becomes more real than the real itself.[9] In the case of newly indepen-
dent Ireland, self-conscious Gaelic masculinity assumed a hyper-masculinity. To
render it wholly authentic it, in turn, relied on the construction of a hyper-femi-
ninity, that hyper-femininity of necessity being deferential to its masculine equiv-
alent. While Irish men were encouraged to be strong, virile and active in the
affairs of the country, Irish women were encouraged to be, first and foremost,
mothers whose duty was to inculcate their children, especially their sons, with
love of country, of Gaelic traditions and of freedom. The central meaning of a
woman's existence was through her family, her space confined solely to the

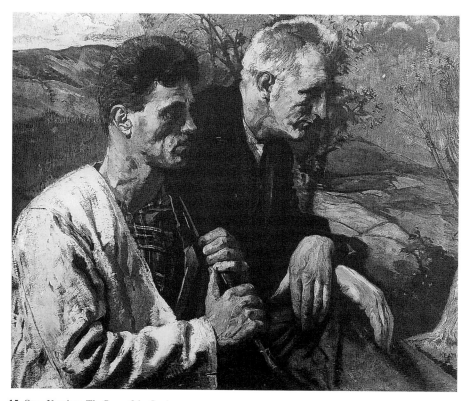

15 Sean Keating, *The Race of the Gael.*

domestic sphere. The homosocial bonding of nationalism required the exclusion of women from the body politic and structures were put in place to create a legal basis for this strategy. In 1925 a Civil Service amendment act, followed two years later by a juries bill, sought to curtail and restrict the role of women in Irish public life. Examinations for positions in the Civil Service were limited on the basis of sex which effectively prevented women from moving ahead in their careers. A decade later a ban was introduced to prevent married women from remaining in the Service. The Juries Bill virtually ensured that there would be no women jurors. A matrimonial act (1925) outlawed divorce and a censorship act (1929) denied women access to birth control information. From 1934 the sale and importation of contraceptives was prohibited and the new 1937 Constitution made it clear that a woman's place was in the home. Article forty-one, section two stated 'the State recognises that by her life within the home, woman gives to the State a support without which the common good cannot be achieved'.[10]

The image of the peasant woman in her rural habitat as painted by Keating, Lamb and others provided a suitable iconography for this domestically enshrined woman. What should be noted, however, is that the artists producing this kind of imagery, with one or two notable exceptions, were not specifically commissioned to do so. Rather, their view of Ireland and its people, with its roots in nineteenth-century romantic ideas about primitive places and people, usefully coincided with the new political order and helped to create a kind of corporate visual identity. One artist, Sean Keating, whose artistic vision was shaped and informed not only by earlier ideas but also his own passionate belief in a nationalist Gaelic Ireland, produced a large number of paintings of the western seaboard and its people. One such painting is *The Aran Fisherman with his Wife* (Figure 16).[11] With its emphasis on rural family life and fixed gender roles it perfectly encapsulates official ideology. Set in the landscape of the west, the male is presented as a simple fisherman, the provider of the family. The female dressed in a Macroom cloak, the cloak traditionally worn by married women in parts of rural Ireland, represents the homemaker and mother. The ideological message of the painting is unambiguous. Indeed, as such, it was utilised in one interesting way by a government department. A school reader, published in the early 1930s by the Educational Company of Ireland for the Department of Education, and aimed at second level students, included this image as its frontispiece.[12] Ironically, the very students it was intended for were from families who saw education as a means of escape from this rural Ireland. The ideal might project an idyll but the reality was economic stagnation and lack of opportunity. Although a good number of these paintings depicted young peasant women, increasingly there was a move towards the portrayal of older women. Catherine Nash in her exploration of issues of geography and gender argues that this shift reflects two things: firstly, the demographic structure of Irish rural society with its ever increasing depopulation of the young in search of work, and, secondly, the nature of the construct of femininity by Church and State that denied women's autonomous sexuality for an idealisation of what she terms 'asexual motherhood'.[13]

16 Sean Keating, *The Aran Fisherman with his Wife.*

Of all the visual artists who were painting in the early decades of independence, Paul Henry came increasingly to be regarded as the unofficial artist of the new state and reproductions of his paintings were used on posters to advertise Ireland abroad. Postcards and calendars also helped to project an image of Ireland which had retained 'an ancient pastoral distinctiveness'.[14] Although rooted in an essentially romantic vision of Ireland, Henry's imagery accorded neatly with the views of Michael Collins, a leading member of the first Free State government who believed that Irish civilisation was surviving in its purest form in the west. Collins declared:

> To-day it is only in those places that any native beauty and grace in Irish life survive … In the island of Achill, impoverished as the people are, hard as their lives are, difficult as the struggle for existence is, the outward aspect is a pageant. One may see processions of young women riding down on the island ponies to collect sand from the seashore, or gathering in the turf, dressed in their shawls and in their brilliantly-coloured skirts made of material spun, woven and dyed by themselves as it has been spun, woven and dyed, for a thousand years … It is only in such places that one gets a glimpse of what Ireland may become again.[15]

Collins's myopic vision failed to recognise that the vast majority of Irish women would not have known how to dye, spin or weave, let alone wish to do so. The fashion ideas of elsewhere, brought to them via popular publications and the cinema, were more in keeping with their tastes! Yet the reality of fact did not influence the standard representation of Irish women in art.

Although Henry began by painting the activities of the peasantry, gradually his images became 'pure' landscapes in which no human intrudes (Figure 17). The only references to the people who actually inhabited and worked the land are in the turf stacks (turf was dug in the bogs, dried out and then used to heat and cook) and in the depiction of traditional thatched cottages.[16] The cottage came to symbolise the idealisation of the rural family, as well as the chosen lifestyle of the new Ireland; one noted for its simplicity and frugality. It was in this environment that the Gael would be born and flourish, generation after generation. The role of women as begetters and preservers of the race was central to this vision. The cottage and its space signified both the role of women and their virtual imprisonment within the domestic sphere. Whether intentionally or unintentionally, the cottage takes the place of real women in Henry's paintings and becomes a metaphor for the banishment of women from the public arena and the site of power.

In spite of the wholesale promotion of a rural idyll, there was one interesting state commission which points to the tension between projecting the concept of a peasant society and the necessity to enter the age of technology. In the late 1920s, Sean Keating produced a series of paintings and drawings recording the construction of a dam on the River Shannon. The subject records a major milestone in the history of the Free State. In 1925 a contract was signed between the Irish government and the German engineering firm Siemens-Schuckert for the construction of the hydro-electric scheme. The building of a national electricity service was

nothing less than an act of faith in the future of a country trying to recover from civil war and hampered by an economic recession. Keating, inspired by a personal interest, began to do some drawings and paintings and he was subsequently commissioned by the Electricity Supply Board to record the work as it progressed.[17] The resulting images are entirely propagandist and consciously herald the new technological Ireland. For instance, in *The Key Men* the planners of the project are treated as heroic figures, recalling the Social Realist figures of Soviet Russia. The underlying message of the image is that the future of Ireland lies in the hands of these men. Ironically, many of the 'key' workers were foreign, men brought in by the Board due to the lack of Irish expertise! His painting *Night's Candles are Burnt*

17 Paul Henry, *A Connemara Landscape*.

Out tackles in an allegorical way the progress towards economic prosperity. The depiction of the dam, those who built it, and the young family pointing to it symbolise the new prosperity while a skeleton illuminated by an oil lamp is representative of a now redundant past. The representation of the family in the painting is noteworthy for its choice of costume. The father wears a bainin jacket while the mother is depicted wearing a red skirt; both garments recalling the peasant garb of the west. Keating, it seems, is at pains to remind the viewer that the transforming of Ireland from a purely agricultural role to a progressive economic one would be achieved by the peasant class.

Catholicism had been a cornerstone of Irish identity for centuries and in the decades following independence its role in the creation of a post-colonial identity was pivotal. Indeed the Catholic Church wielded enormous power with the new political order and in the drive to construct the ideal Irish woman, politicians received wholehearted support from the Church. The hierarchy, whose patriarchal views were identical to those of the men running the country, agreed that women should be denied access to the public arena. The Madonna provided the perfect exemplar. She had lived an entirely private life, devoting herself exclusively to the greater needs of her family. Above all, she had immaculately conceived and her virginity yet paradoxical motherhood was held up as the example to follow. What resulted were stereotypes of Irish women as either pure, chaste virgins, or mothers who had done their duty by their country in ensuring the continuation of the race. Her promotion in the new state as the embodiment of female perfection was not something new. From the mid-nineteenth century, as national fervour increased, a cult of mariology was encouraged by the Irish Church. Elizabeth Butler Cullingford has argued that this activity provided what she calls 'a deliberate identification of a conquered people with a cult which was anathema to their Protestant oppressors'.[18] But devotion to a Virgin/Madonna figure was also linked to the realities of Irish economic life in which a strict sexual code ensured the control of inheritance of the family smallholding. On another level it can also be seen to be a manifestation of a deep-rooted misogyny, a hatred of the female body as unclean and above all a denial of autonomous female desire.

In order to spread, as well as maintain a constant devotion to the Virgin, statues representing her were to be found in every church in the land. Smaller scale representations were in every Catholic home in the country. Many families prayed together each evening, expressing their devotion to her by reciting the Rosary. These statues stylistically looked back to the figurative tradition of great European religious art since the Renaissance but were worked in an utterly hackneyed format. The fact that they clearly lacked any real declaration of gender is of course a striking feature and at least partly relates to a long tradition in European art of concealing the Virgin's sexual identity. But to a sexually repressed society, such as was to be found in Ireland, this 'absence' helped further deny real Irish women's sexuality.

Significantly, such statuary was not confined to indoor public or private spaces. Throughout the country, particularly in rural areas, grottoes and shrines dotted the

landscape. These were sited either close to the local church or just outside villages or hamlets. A number of these grottoes and shrines were dedicated to Our Lady of Lourdes and so included statues of St Bernadette, whose visions of the Virgin had made Lourdes a centre for pilgrimage from the 1850s onward. Others glorified Mary's Immaculate Conception of the Christ Child, which was declared a dogma by the Roman Catholic Church in 1854. While devotion centred at these sites had been ongoing for more than a century, there was a distinct increase in the number of grottoes and shrines devoted to Our Lady in the 1950s, a decade coinciding with the institution of the Feast of the Immaculate Conception and the declaration of a Marian and Holy year. People were not only encouraged to stop and pray in front of these images but pilgrimages and processions to many of the sites took place at regular intervals throughout the year.

The proliferation of such statues out of doors was regarded by most people as part of the 'natural' landscape of Ireland and a further means of national identification. They verified in a truly concrete way the religious fervour of the nation and helped to reinforce the country's essential difference from secular nations, especially Great Britain. But they served another function. The Virgin was popularly regarded as Queen of Ireland. Her ubiquitous presence in the landscape fostered the notion of a visible ruler, ruling over her sanctified territory, that of the new Gaelic Ireland. But this perception was problematic. While the Virgin seemingly possessed unlimited power, it was a symbolic power because in reality Irish men dominated and ruled the land. More importantly, patriarchy, in the form of Church and State, promoted only those aspects which suited its purposes; her passive obedience, the meek acceptance of her fate as Virgin/mother.

One noteworthy example of this promotion of 'feminine' virtues in statuary is to be found in the grounds of a seminary college for priests in Dublin. It is a Madonna and Child limestone statue carved in 1922. The commission came from Father Tom O'Donnell, president of the seminary at All Hallows, Drumcondra. The statue commemorated two past members of the college and was located in the public grounds of the college, close to the chapel shared by local people as well as those living in the college itself. What is immediately striking about the statue is the apparel of the Madonna. She is depicted wearing the traditional Irish marriage cloak. The clear implication is that the Mother of God is somehow Irish! Meanwhile her maternal stance, cradling the Christ Child, stresses her role as mother while at the same time the pose and expression which suggest humility act as a reminder of the unquestioning role expected of Irish women. In his unveiling address, Father O'Donnell alluded to the importance of the Virgin as signifier of Irish women's devotion. 'As our mothers and sisters have always loved Mary', he declared, 'it was appropriate to represent her as a daughter of Erin, clad in the mantle of the country and bending over her child with Ireland's maternal affection'.[19]

The role of landscape, space and gender in the construction of female identity in newly independent Ireland is a pivotal one. The identification of the landscape as feminine but repossessed by the manly Gael symbolically allowed for the

continuity of patriarchy. The landscape of the west was used as a source of positive identification on the part of the Irish male but served to anchor the Irish female to a nurturing role through her supposed identification with nature. The imaging of women as peasants in this gendered landscape further reinforced a 'natural' affinity between women and nature. The role of the Virgin as exemplar, given concrete reality in statuary, spiritually validated the dis-empowerment of the Irish female, and her visible presence in the very landscape itself constituted an ideological significance. The importance of the images produced in these first decades of independence, is that, witting or unwitting, they were active agents in articulating and disseminating the attitudes and aspirations of a patriarchal society. In their proliferation they offered what seemed a stable, permanent and 'natural' construct for the Irish female. In reality, they masked the injustices towards women in depriving them of an active public role and in preventing them a voice in determining the future of their own country.

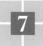

Soviet superwoman in the landscape of liberty: Aleksandr Deineka's *Razdol'e*, 1944

Pat Simpson

This chapter is concerned with representations of women in landscape used as an imaginative space for constructing and consuming gendered myths of Soviet national identity. It explores some of the possible complex and contradictory significations of the imagery – sportswomen running through the Soviet countryside – in Aleksandr Deineka's enormous Socialist Realist painting *Razdol'e* (1944) (Figure 18).

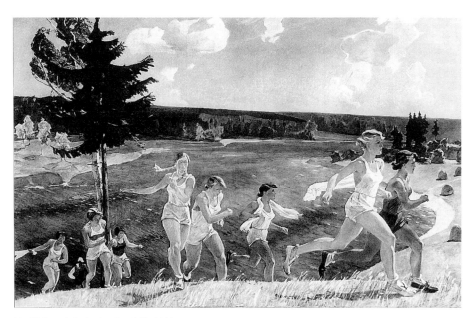

18 Aleksandr Deineka, *Razdol'e*, 1944.

The tenets of Socialist Realism, set up at the Writers Union Congress in 1934, demanded that all art and literature should have an educational and propagandistic function in relation to historically contingent ideological concerns of the Party and policies of the state. What was required in 1944 is typified by an editorial statement in the State Committee for Art Affairs newspaper, *Literatura i iskusstvo* of 19 February, defining the 'noble task of the artist' to 'be a singer of the strength and invincibility of our government, to express the aspirations and thoughts of the Soviet people, to seize the decisive victory over barbarism …'.[1] In effect, the requirement was for works which could be read as positive representations of Soviet identity in relation to wartime Party policy. Within this context, Deineka's painting signalled its claim to do so not only by its size, which marked it out as a monumental thematic *kartina* – a picture with a politically significant message – but also by its abstract title. The Russian word *razdol'e* conveys spatial expanse and freedom or liberty. The date of the work potentially situates some of the connotations of space/freedom in relation to the retreat of German troops from the Soviet territories they had occupied in 1941–42. What is being metaphorically celebrated here, perhaps, is the liberation of real Soviet space.

Using this assumption as a starting point, this chapter will investigate what the combined imagery of sport, women and landscape might signify in the contemporary context which would constitute sufficiently weighty material for a relevantly celebratory monumental *kartina*. With regard to the sporting aspect, this may be seen to connect, not just with Deineka's personal interest in sports themes but also with actual use of sporting events to celebrate the end of occupation, and with ideological concerns within the Party with *fizkultur* – physical culture – as a means to engineer the New Soviet Person. The naturalistic, sunlit landscape setting seems to function at this level as an encouragement to a literal reading of the optimistic 'realism' of the depicted event, or at least of the topicality of the fiction through which Deineka discharges his Socialist Realist duty to project images of New Soviet Person.

Regarding the images of women, it is suggested that in visual terms they relate to a generic Soviet female 'type' developed between the 1930s and 1940s, especially by Deineka and Vera Mukhina. Charting the significance of Deineka's choice of female images in *Razdol'e* is, however, a complicated task. Contemporary Soviet discourse on New Soviet Person was deeply patriarchal, largely devoid of direct theorisations of New Soviet Woman and tended to imbue approved images with qualities perceived as masculine – heroism, ideological purity and strength of body and will. For a recent Soviet writer, Genadii Revzin, the perceived presence of such qualities in Deineka's images of women rendered them into monstrous, de-eroticised, Nietzschean 'superwomen'. Arguing against this reading, it is suggested that *Razdol'e* rather maintains a tension between intimations of the erotic and the (ostensibly) masculinised heroic based on a non-Nietzschean concept of will, that may be related to a similar tension in Soviet cultural discourse on women, between emphatic promotion of the gender neutral construct of New Soviet Person and a subcurrent of concern for gratification of the male gaze.

Significantly, this tension can also be seen to be mediated in a contemporary sports newspaper, in a statement by Gorky which identifies an ambiguously sexy image of a young sportswoman as a signifier of Soviet victory, liberation and infinite opportunity for progress. This perhaps gives a clue to Deineka's choice of images of women to embody the central transcendent 'concept' of his deliberately monumental painting. Using Vera Mukhina's contemporary theorisation of monumental art, it is also suggested that the use of physiognomic stereotyping and so-called masculine physical attributes could signify the transmutation of the 'type' into an 'image' with a higher ideological meaning – relating to the courage of the Soviet people.

In relation to the notion of higher abstract meaning embodied in monumental art, it is argued that the panoramic landscape may be seen to have a number of signifying functions, the most important of which was to invoke a relatively new, feminised construct of Soviet identity – the Motherland – within which the war was projected as being fought to defend not just the native land but the 'purity' of Soviet women. Crucial to wartime propaganda, the idea of Motherland formed the basis of a re-theorisation of Socialist Realism to include landscape painting as a significant political genre. That Deineka consciously aligned himself with this in *Razdol'e* is implied by the unprecedented use of a detailed landscape background for a sporting picture. On this basis it is argued that on one level, the invocation of Motherland reinforces the relevance of choosing to use female imagery to celebrate liberation. On another level, however, it seems to carry contemporary implications regarding the consequence of liberation for Soviet women, which conflict somewhat with the notion of undifferentiated equality projected by the sporting images.

Documentary evidence suggests that the Party's notion of liberation was motherhood – combined with paid work – located in official terms as a high status and revered occupation. There is other evidence to suggest, however, that the lived-in reality of the 'liberated' Soviet woman was low status, domestic servitude which did not coincide with either the myth of Motherland/motherhood or that of undifferentiated equality.

The conclusions drawn from this exploration of *Razdol'e* are that a contemporary reading of the work as a relevantly celebratory monumental *kartina* depends on acquiescence with contingently intersecting patriarchal discourses: on the engineering of New Soviet Person through sport and physical culture; on the representation of women in Socialist Realist art; on women's gender role as defined by the state, and on landscape as signifier of Motherland, leading to a final suggestion that Deineka's apparent representation of Soviet superwomen in the landscape of liberty, by its contingent political correctness, can be argued also to constitute a heroic mystification of the patriarchal values underpinning Soviet social life.

The choice of subject matter in *Razdol'e* seems to some extent initially dependent on Deineka's personal and artistic interests. Deineka was himself avid about sport and his predominant artistic theme since the 1920s had been sport and *fizkultur*.[2] In the early 1940s such themes remained a prominent and highly

regarded aspect of his output in mosaics commissioned for the Moscow metro, in four sculptures exhibited in 1943 and in paintings such as *Razdol'e*.

The images of sportswomen in *Razdol'e* seem fairly consistent with those in his paintings and posters of the early 1930s, such as *Mother* (1932), *Playing Ball* (1932) and *Fizkulturnitsa* (1933) (Figure 19).[3] They have a similar physique, slender but muscular with jutting breasts and slightly large thighs, similar facial features, angular and spiky nosed, and are similarly predominantly blonde. Lacking strong indicators of class or of region, the images seem to represent an ideal type rather than particular individual women. The development of this type, although intimately connected with Deineka's personal preferences and fetishes regarding sport and the female form, can also be viewed as deriving from a deliberate, professional engagement with representing a cultural activity which was itself fetishised by Party and state as a means to engineer a new type of humanity – New Soviet Person.

The creation of an elevated genus, commensurate with a new type of society, was a major concern of early ideologues of Soviet culture such as Lunacharsky and Bogdanov both before and after the 1917 Revolution. Drawing on a variety of nineteenth-century sources as varied as the radical utopian socialism of Pisarev and Chernyshevsky, the quasi-Nietzschean mysticism of Vladimir Solovyev and Nikolai Berdyaev, and the eugenics-based writings of Mach and Herbert Spencer, they emphasised healthy robustness as a primary characteristic of the New Person.[4] In the 1920s, sport and *fizkultur* became established as important activities in the lifestyle of the new society, where, as evinced by the theoretical writing and designs of Varvara Stepanova, they were sometimes perceived to exclusively define leisure.[5] During this period, Soviet education and psychology tended towards biomechanical theorisations treating the human body as a perfectible machine dependent primarily on environment for correct development. These ideas seem to have had most impact on Meierkhold's theatrical construct of bio-mechanics and on the almost robotic representations of the figure by Deineka and other members of Ost and Oktober in the late 1920s.[6]

In the 1930s, while the theoretical goalposts were moved – outlawing such works and the bio-mechanical notions which may partially have motivated them – the cultural/social/political goal itself, of engineering a New Soviet Person, remained constant. In Soviet educational and psychological theory, the official replacement of bio-mechanical ideas with those which emphasised training and will, rather than environment, as the most significant factors in achieving the new human type, arguably gave greater emphasis to the educational benefits of *fizkultur*.[7] The Sunday nearest to 20 July was set aside as a public holiday – Fizkulturniks Day – taken up with parades, competitions and sporting events largely organised by the *KomSoMol* organisations of communist youth. The pressure to engage in *fizkultur* can be seen in Deineka's 1933 poster, *Fizkulturnitsa* – acclaimed in 1941 as presenting visions of 'positive heroes'.[8] The slogan reads: 'To work to build and not to whinge. We are directed towards a new life. You might not be able to be an athlete. But it is your duty to be a fizkulturnik.'

19 Aleksandr Deineka, *Fizkulturnitsa*, 1933.

As Toby Clark has pointed out, Soviet concern with *fizkultur* became perceived as some sort of guarantee of the fitness of workers for the project of 'building socialism' mythologised as a potentially transformatory activity.[9] The public duty to engage with *fizkultur* was not entirely utopian however, but also – like similar concerns in Nazi Germany and elsewhere in the West – extremely pragmatic and military, as indicated by Konstantin Nepomnyashchy, Chief of the Foreign Relations Department Physical Culture and Sports Committee in July 1944: '"Sport for sport's sake" is unknown in the Soviet Union. Physical culture is considered to have great state and social significance. This is expressed in the Ready for Labour and Defence badge.'[10] The badge involved tests in running, skiing, jumping and swimming and it may be that *Razdol'e*, with its hint of swimming – suggested by the towels in relation to the depicted river – represents a related activity rather than just a cross-country race.

Throughout 1944, as the Germans retreated, emphasis seemed to become keener on *fizkultur* and competitive sport not just as forms of military training but as expressions of 'strength and will to victory', and even as expressions of liberation. *Pravda*, having ignored the national festival in 1943, carried an editorial on 16 July 1944, celebrating physical culture as the 'most important part of the education of all workers and soldiers', approving mass participation in cross-country events and ending with the statement : 'One of the most important tasks is from day to day to prepare a reserve of physical strength and endurance capable of untiringly annihilating the enemy.'[11] Meanwhile *Krasnyi Sport* repeatedly emphasised a nationalistic impetus, deriving from decisions of the State Committee for Physical Culture and Sports Affairs and from speeches by Kalinin the Party Chairman, to draw more of the people into *fizkultur* and competitive sport. *Krasnyi Sport* also reported on two sports festivals held in Kiev during June and October to celebrate Ukrainian freedom from Fascist occupation.[12]

In relation to these points, Deineka's *Razdol'e* seems, by the combination of contingent context, sporting subject matter and sunlit scene, to offer a celebration of both the utopian and defensive connotations of *fizkultur*. Here are images of healthy, muscular young women, fit for anything, each exerting her individual will in striving onwards and upwards through the supposedly expansive, sunlit landscape space, yet in a collective activity with a shared goal, to build or to defend, their healthy youthfulness offering a symbolic hope for a bright socialist future – in Soviet terms, the ultimate in human liberation.

There is a sense in which the detailed naturalistic landscape setting may be argued to serve here to prompt a reading of contemporary relevance and realism, the illusionism conjuring up analogy with real outdoor spaces in which such events were being staged as expressions of liberation. Aspects of the imagery suggest, however, that while the subject matter was topical, *Razdol'e* was not to be read as a mere genre picture. The figures might be individuated in the sense of details of dress, gesture, movement of hair and of being delineated as occupying particular positions in the imaginary space, but the fact that they seem to belong

to one physical and physiognomic type seems to underscore the abstractness of the theme.

In *Razdol'e* Deineka was effectively addressing one set of discourses on the New Person – *fizkultur* – by means of another discursive formation which was also focused on this construct – Socialist Realism. At the Writers Union Congress of 1934 Socialist Realism, established there as the sole mode of future Soviet cultural production, was given the significant educational task of assisting in the realisation of the goal of a reconstructed socialist humanity, by projecting heroic, beautiful, moral and contingently politically correct images of the New Person – visions of perfected human and, of course, national identity to encourage and direct the aspirations of the Soviet citizen. Zhdanov's keynote definition of Socialist Realism as a representation of 'reality in its revolutionary development', emphasised that what was required were not pictures of life as it was, but typical visions of life as it ought to be.[13]

Typicality, a criterion for judging quality of content of Socialist Realism invoked on the authority of Engels by Soviet critics from the 1930s onwards, was a slippery concept.[14] Primarily it related to the imaging of ideal types of New Person. In principle there were as many potential types as there were possible art themes, but after 1934 three basic categories seem to emerge in Socialist Realist art practice; regional, class and lastly more generalised Soviet types – such as those represented in *Razdol'e* – in which specific class and non-Russian characteristics appear to be played down or absent.

Deineka's images can be argued to belong to a trajectory of imaging a generic Soviet woman-type developing throughout the 1930s and 1940s, mainly but not exclusively in representations of *fizkultur*. This type appears in paintings by Aleksandr Samokhvalov such as *The Sports Parade* (1937), and in Vera Mukhina's sculpture *Industrial Worker and Collective Farm Girl* (1935). Indeed in July 1943 Mukhina had apparently brought a topical edge of wartime patriotism to this type with her bust of a *Partisan Girl* (1942), critically acclaimed as a representation of 'human spirit, thought and will' when shown at *The Patriotic War* exhibition at the Tretiakovskii Gallery, Moscow in 1943–44.[15]

While such practices developed, there were few specific critical theorisations regarding the proper imaging of female as distinct from male types. The clearest parameters for representing New Soviet Woman that were available, articulated by Gorky in 1934, were that images should avoid any connotations of domestic slavery and celebrate women's achievements and new found equality with men, in order to inspire women to further achievement and to educate men away from traditional patriarchal behaviours.[16] Apart from this general guideline however, written discourse on the New Person in Socialist Realist art, like other trajectories of writing on the New Person, was distinctly patriarchal throughout the 1930s and 1940s using the masculine Russian word *chelovek* – denoting both man and person – as a neutral term to include both men and women. There was also a seeming preference for using masculine language forms to talk about images of women, exemplified in a

1944 *Krasnyi Sport* caption, 'young fizkulturniks' – masculine *fizkulturnik* used as neutral – under a photograph of parading Moscow sportswomen.[17]

Lynne Attwood has suggested that such refusal to engage overtly with gender difference was connected both to Bolshevik antipathy to the concerns of early revolutionary feminists such as Aleksandra Kollontai and Inessa Armand with issues of free love and separate women's organisations within the Party, and also to the rejection by Soviet psychological/educational theorists of Freudian concerns with biological difference.[18] It may also be that such tendencies derived from culturally embedded currents of misogyny fuelled partly by long standing social tradition, and partly by the antipathy to female sexuality – as a base and disgusting barrier to ideological elevation – expressed in the pre-revolutionary radical texts which may have contributed to the post-revolutionary construct of the New Person.[19] The endurance of the latter attitude is suggested by Shekhotov's approving critical response in 1933 to Deineka's painting *A Mother* (1932), as 'a powerful image of an energetic, independent, free woman' on the grounds that the image was one in which 'biology is mediated by elevated social consciousness'.[20]

Out of this context emerged a concept of the New Person that was ostensibly rooted in an assumption of an achievable equality between the sexes that cancelled difference. This notion, which became embedded in the new Soviet constitution document of 1936, seemed to be biased towards a transformation of women by the adoption of characteristics perceived within patriarchal discourses as being traditionally male – heroism, ideological purity, strength of body and of will.

Soviet critic Genadii Revzin, writing in 1990, appears to treat Deineka's approach to imaging women, particularly as represented in *Razdol'e*, as taking the patriarchal and voluntarist implications of the Stalinist notion of undifferentiated equality to extreme lengths to produce masculinised images of Nietzschean superwomen. The basis of this assertion lies in an apparent concern with the revolutionary hero as Nietzschean superman expressed in correspondence between Gorky and Lunacharsky in 1907, which Revzin speculatively links, via Gorky's post-revolutionary writing, to Socialist Realist constructs of the New Person.[21] The fact that Gorky's writings were given particular emphasis as containing patriotic models of potential use to visual artists in the early 1940s,[22] and the existence of certain resemblances between the constructs of *Ubermensch* and New Person – both in Gorky's work and elsewhere – lend Revzin's argument a superficial level of credibility. Both *Ubermensch* and the New Person are presented as transformed, transcendent types of humanity, creative re-shapers of the world whose prime characteristics are heroism, strength and will. In both cases, will appears to be perceived as related not to mere instincts and drives but to consciousness, directed towards selected goals and expressed through action.

At a deeper level however, these resemblances between the two constructs seem to break down. Nietzsche's construct of *Ubermensch* was imbued with scepticism regarding absolute values such as truth, good, beauty and rooted in contempt for both nationalism and egalitarian socialist ideals. It was a model of a rare, great, male

individual whose path to liberation lies in transcending the mass and dominating over them.[23] This contrasts strongly, in all but gender bias, with nationalistic post-1934 Soviet delineations of the New Person as an ostensibly egalitarian model for the transformation of the masses, invested with absolute moral, ethical and aesthetic values. The will exerted by this paragon seems to have been defined as a conscious pursuit of interests, particularly in aspects of self-training, based on needs deriving from 'concrete social, political, economic and educational conditions' and motivated by a sense of duty towards society – that is to say, towards the construct of society set out by the pronouncements and activities of the Party and state. The height of conscious freedom within this paradigm was the point of convergence of personal interests with those of society, rather than a distancing from them.[24]

However unconvincing Revzin's analogy between *Ubermensch* and the New Person seems at close quarters, it serves to set up the images of women in *Razdol'e* as monstrous and perverse. There is a thread of possible linkage here to a fashion in late and post-Soviet writings, exemplified by Boris Groys, to identify Stalin as a Nietzschean 'artist-tyrant', an embodiment of *Ubermensch*.[25] Read in this context, Revzin's reference to Nietzsche may implicitly convey the general sense that *Razdol'e's* images were elements of what Groys presented as Stalin's apparently single-handed manipulation of Soviet society. Revzin's critique of the great lies of official Stalinist culture however would seem to be not so much directed against the patriarchalism underpinning this culture as against the denial of it.

Revzin implies that the images are deliberately de-eroticised by the muscularity and inflections of physical powerfulness deriving from Deineka's avowed admiration of classical Greek representations of male athletes but, in Revzin's view – 'unnaturally' transposed on to representations of women. There is nothing generically unnatural about muscularity in women. It results from physical exercise and/or physical labour. In the Soviet wartime context it could be argued to be both natural and commonplace. Not only did official culture treat all sport and work as open to women, but women were of necessity the dominant labour force and also active in the armed services. Revzin's critique of muscularity as un-feminine/unnatural seems however less concerned with context than driven by two assumptions, firstly that images of women should be objects of erotic desire presented for consumption by the male gaze, and secondly that, by implication, the desirable image is one of softness and/or weakness.

Revzin's expression of these assumptions is primarily rooted in Russian anti-feminist discourse of the late 1980s and 1990s.[26] The assumptions themselves however may be argued to derive from a longer lived tradition of patriarchal attitudes within Soviet society, which created a tension in Soviet discourse on women between official promotion of the apparently gender neutral construct of New Soviet Person with its implications of undifferentiated equality of the sexes, and a sotto voce trajectory of interest in images of women as erotic objects for the male gaze.

Officially, the possibility that images of women might have erotic implications for the male viewer was a taboo topic. Bukharin's suggestion in 1934 that Socialist

Realism might address itself to a new type of eroticism was not incorporated into the repetitive doctrinal formulations.[27] Indeed, from 1934 the official moral climate became increasingly puritanical. Accusations of pornography could bring a five year jail sentence. Representations of the nude – both male and female – became rare in Soviet art and Deineka himself abandoned the nude representations of sporting women which had been prominent in his work of the early 1930s.[28]

Nevertheless glimpses of a subcurrent of erotic concern can be seen; for instance, in Aleksandr Gerasimov's series of Russian communal bath paintings of the late 1930s and 1940s representing generously proportioned nude women. Such concern perhaps also surfaced in Kalinin's 'Speech to the Art Workers' of January 1939 which suggested that representations of 'simple, not unattractive' girls would be more accessible to the people than elevated, untouchable images.[29] A stronger hint of an erotic ideal was offered in a poster by D. Antonov reproduced on the front page of *Literatura i iskusstvo* of 15 August 1942. It shows the dishevelled image of a young, fluffy-haired woman with no strong regional or class characteristics, small softly pointy features, softly rounded breasts, slightly downcast head, hands bound, dress partly ripped down from one shoulder, accompanied by the stirring slogan: 'Fighters of the Red Army! You will not give up your loved ones to infamy and dishonour by the Hitlerite soldiers.' This poster, which carried more overt connotations of sexuality than most wartime images of women, seems to offer a defiled version of a type defined in March 1944 as 'attractive' by Mikhail Tarasov, Chairman of the Central Committee, Soviet Railway Workers' Union Central Zone. Describing Zinaida Troitskya, the current Chief Master (sic) of Railways USSR as 'no blue-stocking' he asserted: 'On the contrary, she is quite a young and attractive person, with soft feminine features and ash blonde hair. She is always very well groomed and the uniform she wears is very becoming.'[30]

If 'becoming' is taken to signify an accentuation of the figure, then much the same might be said about the costume of Deineka's images, represented to reveal a maximum of illusionary rounded flesh and to outline explicitly the contours of breasts and nipples. The erotic potential for the contemporary male viewer was however perhaps held in check by the images' strong profiled and muscular departure from the types of erotic ideal suggested above. The tension here might be said to articulate visually the tension in Soviet cultural discourse on women.

It would seem that expression of this tension was legitimate in 1944 – at least in relation to images of sportswomen. On 18 July 1944, the edition of *Krasnyi Sport* devoted to coverage of Fizkulturnik's Day, carried as a front page slogan this quotation from Gorky:

> With every year our fizkultur parade seems ever more joyful, bright and rich. Ever more confident is the firm tread of the young woman, and more brightly in her eyes burns the joy to live in a country where the body is brought up [to be] so fast and beautiful, and so fiery and triumphant the heroic fighting spirit flowers in us, daily revealing itself in labour for the enrichment of the people, for the defence of the Motherland, almost daily flashing with daring victories for the welfare of our country.

Here, Gorky used an image of a sportswoman metaphorically as a sort of lens through which all the best characteristics and qualities of the state were focused, her own body – by implication educated to be fast and beautiful – subordinate to the larger heroic vision of national identity. It is possible that Deineka's images of women in *Razdol'e* attempt to represent something akin to this ambiguously sexy but transcendent and undifferentiatedly equal vision as the central 'concept' of his monumental picture, interpreted in relation to prominent aspects of contemporary discourse on monumental art.

Monumental art was perceived in 1941–44 as a distinct genre, focused on heroic, patriotic expression of the moral and physical strength and will of the Soviet people, frequently described simply in patriarchal terms as *muzhestvo* – courage, but literally manliness or virility – through big works with 'big forms' and a level of 'simplicity of means of expression'.[31] The sculptor Vera Mukhina had an authoritative voice here, articulating ideas which seem to relate closely to Deineka's practice as well as her own. In November 1944 Mukhina defined monumental art, with reference to the precedent of Greek sculpture, as an artistic expression of a 'concept' in which the representation of a certain class or occupational type – based on concrete individual appearances – became elevated into an 'image' of certain abstract qualities through a process of idealisation involving the omission of details and the 'exaggeration or intensification of the principal characteristic'. To Mukhina the process was 'realistic' if it was based on a 'real idea' which engaged with the ideological concerns of the Party and state.[32] In Mukhina's terms, Deineka's elevation of 'type' – sportswoman – into 'image' – national strength and freedom – depends on a level of stereotyping to focus the spectator's attention on the abstract concept being expressed through the clothing's revelation of the figure. The emphasis on muscularity might be read as an expression of a sort of *muzhestvo* analogous to that which Deineka claimed to perceive in Greek sculptures.[33]

In relation to *Razdol'e*'s claim to monumentality in contemporary terms, the panoramic representation of landscape would seem to have a number of functions. It serves for instance as a metaphor for the expanse of liberated territory. As a vista, it might also symbolise a re-affirmation of the Party's vision of the boundless opportunities and undifferentiated equality of Soviet society, so recently threatened by the German invasion. Most importantly, the landscape setting may be argued to operate as a signifier of a recent, feminised construct of Soviet identity also invoked by Gorky in *Krasnyi Sport* – the Motherland.

This construct seems to have been partly chauvinistically rooted in Russian mythologies of Holy Mother Russia, although having tenuous connections to Vladimir Solovyev's early twentieth-century idea of 'the eternal feminine' and to European feminisations of Nature.[34] It constituted another sort of mythologisation of the feminine aspect of Soviet identity which, however, implicitly contradicted the myth of undifferentiated equality. The literal Soviet title for the second world war was the Great Fatherland War, but in propaganda terms the war was waged in defence of a deeply patriarchal construct of the Motherland. While the

construct of Fatherland seemed tied to structures and institutions, primarily those of the state and the Party, the construct of Motherland was connected to everything organic, stable and traditional – on the one hand the family, especially mothers and children, and on the other hand the land and physical space of the USSR.

With the high profile given to the construct of Motherland in wartime propaganda, representations of the Soviet landscape took on a related, new and special ideological significance. Landscapes not only offered proof positive of the artist's patriotism but they also offered the spectator an emotional evocation of the beautiful Motherland that must be defended at all costs.[35] This gave a powerful impetus to a trajectory of critical theory, increasingly vociferous after 1938, attempting to recover landscape painting for Socialist Realism. During the 1930s landscape painting had been regarded as a painterly refuge from the main Party political thrust of Socialist Realism. After the German invasion of 29 June 1941, it was rapidly incorporated into the canon as a significant propagandist genre, signalled by the exhibition *The Landscape of Our Motherland* which opened in Moscow on 1 January 1942. Although a degree of Impressionist handling was allowable – judging from the high praise afforded by critics to Igor Grabar's landscapes – the main parameters for patriotic landscape painting supported by the Party and Committee for Art Affairs, were finish, legibility of resemblance, three dimensional illusionism and coherence of composition.[36] The recovery of Mikhail Baksheev (1862–1958) – a founder member of AKhRR in 1925 – for the Soviet canon, and emphasis on the ideological character of Issak Levitan's Itinerant canvases, set up canonical Russian Realist models of landscape painting for contemporary artists.[37]

In *Razdol'e*, Deineka may have been responding to this new situation. The use of a coherent, detailed and wide focused pure landscape setting was a new departure for Deineka's representations of *fizkultur*. His previous pictures tended to focus on the activity as foregrounded either by a compression of represented space – as in *Running* (1934), where there is no sense of perspectival recession between the figures and the background is a flat plane of neutral colour – or by a lack of defined space as in *Goalkeeper* (1934), where a sense of infinite deep space is suggested by a very low horizon and very simplified treatment of a distant clump of trees. Even the landscape in his small painting of a *Female Runner* (1936), while being less abstract than these works and having some compositional similarities with *Razdol'e* in the siting of the figure on a hillcrest with winding river behind, does not offer a vista. The landscape in *Razdol'e* reinvokes some of the characteristics of the countryside outside Moscow as represented in Deineka's small pre-war painting, *Moscow Countryside* (1938) (Figure 20). They share a similar blend of peaceful fields, green mixed woodland and a broad, winding river seen as if viewed from a hilltop above the river. In *Razdol'e* however the view is more panoramic, seen from a steeper elevation and the haystacks depicted in one field bear witness to productive, normal agricultural labour which in itself was integral to the construct of the Motherland.

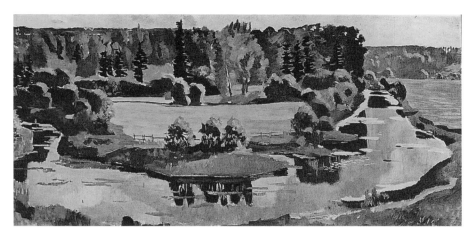

20 Aleksandr Deineka, *Moscow Countryside*, 1938.

Deineka's invocation of the Motherland, now seen as returned to normality, suggests a good, political reason for the choice of female imagery in *Razdol'e*. If, as in the 1941–3 propaganda campaign, 'Hitler is the most evil enemy of women', the war had been presented as being fought partly to defend the moral purity of Soviet women, then logically, images of women liberated from this threat should be a deeply powerful means to celebrate the end of the occupation.[38] The normalised image of the Motherland presented through the depicted landscape also implicitly conjures up associations with the commonly mediated, Party view of the consequence of liberation for women – motherhood, combined with paid employment – for which only the preliminary prerequisites, youth, health and strength, were directly signalled in Deineka's painting.

In the same year that women's equality to men in all aspects of life was declared in the new constitution, the state and Party also defined women's primary role as motherhood, partly through the de-legalisation of divorce and abortion and partly through a propaganda campaign heroising birth. Prior to the German invasion, the Party statement on International Women's Day, 8 March 1941, continued this theme, celebrating 'happy motherhood' and emphasising the upbringing of children as Soviet woman's primary task.[39]

Between June 1941 and mid-1944, official stress on the primacy of motherhood slackened, eclipsed by the more pressing need to encourage women to take up traditional men's jobs in industry and agriculture.[40] In terms of wartime propaganda however, while women workers and combatants were heroised, the main thrust tended to position women's gender role not only as defined by their relationship to men as wives, sisters, mothers, but also laid particular emphasis on the mother as incarnation of the Motherland. In paintings and posters the Motherland was often symbolised as a physically – and thus morally – strong peasant mother, as for instance in Ieraklii Toidze's famous recruiting poster *Motherland Mother Calls to*

You (1941) and Sergei Gerasimov's painting, *Mother of a Partisan* (1943) – which gained increasingly high status between 1943 and 1946 as a heroic expression of national identity.[41]

This context gave an extra patriotic significance to motherhood, used to advantage by the state in renewing its pressure on Soviet women during 1944 in the face of falling birthrates and wartime depopulation. The 'Motherland medal' – by its name directly linking the mythology with actuality – was just one of the new decorations and titles, all carrying financial benefits, announced on 8 July by Decree of the Presidium of Supreme Soviet USSR, to reward mothers for having large families.[42] In celebrating the Decree, the propagandists of *Soviet War News* declared to their English audience in July 1944 that motherhood was the ultimate fulfilment for all Soviet women.[43] At home, the Party was more circumspect, reserving a major emphasis on motherhood until after the war. In *Sovetskoe iskusstvo* (1946), the celebratory Party message for International Women's Day was reinforced by a reproduction of a poster by N. Vatolina depicting as its focal image a soft featured young woman gazing lovingly at the baby in her arms.[44]

In all this legislation and accompanying propaganda campaigns, there was no suggestion that men should share in domestic and childcare tasks. A revealing article on Soviet education in *Soviet Youth News* in October 1943 for instance underscored this in noting that in the newly instituted single-sex schooling system, only girls were taught domestic science 'for the girls will have to manage their homes'.[45] Revisions of family law instituted in 1944 reinstated differentiation between legitimate and illegitimate children, further reinforcing the sorts of traditional, patriarchal family structures and relationships which Engels in 1884 had identified as the source of female oppression. Liberated Soviet women were thus expected to shoulder a triple burden of employment, motherhood and domestic chores, which, despite the provision of nurseries, set limits to the real spaces they could occupy in Soviet social structure, even though by contemporary European standards they had unprecedented prominence in most areas of social and political life.

The lived-in reality of Soviet women was arguably as far removed from the mythology of undifferentiated equality projected through the representations of sportswomen in Deineka's *Razdol'e*, as it was from the conflicting mythology of Motherland/mother invoked by that painting's landscape, albeit for different reasons. The latter may have acknowledged the existence of gender difference but only to invert the social esteem afforded to mothers into something grand, heroic and sacred.

As a Socialist Realist painting of course, the function of *Razdol'e* was to project such heroic mythologies and not to portray everyday actualities. Nevertheless a contemporary audience's reading of the range of potential positive and celebratory significations of *Razdol'e*'s linguistic play on freedom/expanse may be argued to have depended primarily on acquiescence with the patriarchal basis of the discourses – on *fizkultur*, on representing the New Woman in Socialist Realism, on

landscape as a signifier of Motherland, and on women's gender role as mother defined by contemporary state legislation – which intersect in the work. Without this acquiescence, it is suggested that what Revzin inaccurately identified as *Razdol'e*'s Nietzschean image of Soviet Superwoman in the landscape of liberty becomes a piece of patriarchal mystification, both veiling and reinforcing the unenviable position of real Soviet women.

Landscape, masculinity and interior space between the wars

David Peters Corbett

In 1928, Wyndham Lewis, who fifteen years before had been a leading radical painter, published *The Childermass*, an experimental novel which sought to diagnose what Lewis saw as the overwhelmingly negative effect of World War I on English culture.[1] Set in the afterlife where the souls of those killed in the fighting congregate to await judgement, the novel opens on to a hallucinatory and highly visual landscape setting:

> The city lies in a plain, ornamented with mountains. These appear as a fringe of crystals to the heavenly north. One minute bronze cone has a black plume of smoke. Beyond the oasis-plain is the desert … The approach to the so-called Yang Gate is over a ridge of nummulitic limestone. From its red crest the city and its walls are seen as though in an isometric plan. Two miles across, a tract of mist and dust separates this ridge from the river. It is here that in a shimmering obscurity the emigrant mass is collected … like the tiny scratches of a needle upon this drum, having the horizon as its perimeter, cries are carried to the neighbourhood of the river.[2]

This landscape conforms very closely to the definition of the fantastic as a literary genre put forward by Rosemary Jackson in her book *Fantasy: The Literature of Subversion*. Jackson argues that the classical unities of space, time and character lose their authority in fantastic narratives. The integrity of the self and its 'situation … in relation to [the] dominant notion of "reality"', are put into question and, significantly, the topography of the Fantastic 'moves into, or opens up, a space without/outside cultural order'.[3] The landscapes in which the plots of fantastic texts are enacted eschew both the 'colourful fullness' of the romantic 'marvellous'[4] and the social mimesis of realism. Instead, they offer 'bleak, empty, indeterminate landscapes, which are less definable as places than as spaces, as white, grey, or shady blanknesses'.[5] In place of the sharply realised social worlds of Lewis's pre-war fiction, the fantastic as a genre creates 'an additional dimension'[6] to the social world, which in the texts 'is frequently narrowed down into a place, or *enclosure*, where the fantastic has become the norm'.[7] Lewis's grimly hermetic landscape setting for his

post-war novel gives a precise imaginative form to the constricted space in which he felt radical modernist art had to be made after World War I.

Lewis's negative diagnosis points to the appearance of an important tension within modernist practice in the years after the war, one which draws on two opposed responses to the modernist perception of the alienation of art from social meaning.[8] On the one hand there is a utopian conviction within modernism that the new art invented to describe the modern world must communicate with a broad audience, conceived as the wider polity to which the painter belongs and orients him or herself.[9] On the other hand there is a drive towards a hermetic and enclosed art practice which is cut off from an uncomprehending and indifferent audience and which, in response, devotes itself to a reflexive and self-conscious investigation of its own terms and conditions of meaning.[10]

The first of these positions dominated the self-understanding of much radical English art in the years before 1914. Lewis and the Vorticists conceived of their role as communicative and political in the broadest sense. They imagined an art practice that could engage with and transform their audience and operate effectively within the public sphere. It is not too much to say that, as a result, Lewis's aspirations in 1914 were geared to wholesale public success on a Victorian model. 'I might have been at the head of a social revolution', he later claimed, by which he meant able to wield the transformative capacities of modern painting to effect social enlightenment.[11] Despite the rhetoric of 'revolution', the Vorticists' art-politics were not intended to alter English culture fundamentally. Instead, the Vorticists insisted on their own status as the artists best suited to describe the character of contemporary experience to their fellow citizens. The artistic status that assertion carried with it was a gendered one.[12] Implicitly male, it can be unpacked into an interlinked system of signs in which power, masculinity and the ability to pronounce with authority on the nature of modernity were all connected, so that the radical artists of 1914 were exaggeratedly 'brutal' in their display of a culturally gendered masculinity. 'The artist of the modern movement is a savage', wrote Lewis, 'modern life serves him as Nature did more technically primitive man.'[13] The artist is violent, and in this sense 'primitive', possessed of a rugged vitality before which modernity, like the natural, has no chance but to yield. Although the apparent confidence of this position is to some extent deceptive, concealing anxieties and realities in which masculine power was less secure, the landscapes and cityscapes that dominate Vorticist art are nonetheless male spaces, observed through the grid of a masculine perspective.[14]

As society buckled and changed under the stress of the war and its aftermath, this ambition of the modernists of 1914 to express modernity came under severe pressure.[15] The dominant modes of experience in the decade after 1919 seemed to contemporaries to be ruled by a privatisation, an increasing interiority which put the terms of representation deployed in 1914 under question.[16] If the confident linkage of masculinity, artistic authority and the expression of modern experience within a public discourse became hard to sustain, representation of the public

spaces of the English landscape in painting shifted and changed accordingly. The male artistic inheritors of the modernist moment worked in the 1920s within a set of circumstances in which Lewis's constricted landscape, 'bleak, empty, indeterminate' where 'the fantastic has become the norm' seemed the appropriate response. It is no coincidence that the protagonists who inhabit this enclosed setting are described in *The Childermass* as sexually ambiguous and as ineffective in action and desire; as the ideological opposites, in short, of the image of the active, heterosexual, male artist which supported the ambitions of Vorticism in the years before the war.

In an important article, Lisa Tickner observes that many radical male artists before 1914 conjured a masculinity ostentatiously 'phallic in its flamboyance, its sexuality, and its studied neglect of ... the constraints of duty, decency, and social decorum' as a way of defining and confirming their status as artists.[17] Once magicked into social being, such a masculinity served as the sign of a serious modernist ambition, standing for the intensity, relevance and creativity of their art and of its capacity to be modern. Douglas Goldring, remembering Wyndham Lewis and Ezra Pound as prominent at the 'at homes' which Ford Madox Ford and Violet Hunt held for the *English Review* circle before the war, identified their public personae in terms which match those Tickner deploys:

> [They] made no secret of their calling, in clothes, hairdressing and manner. Ezra, with his mane of fair hair ... and his startling costume, part of which was a single turquoise ear-ring, contrived to look 'every inch a poet', while I have never seen anyone so obviously a 'genius' as Wyndham Lewis when he first appeared at Ford's parties.[18]

As Goldring's description implies, in Vorticism this aspect of ostentatious masculinity, what Tickner calls 'parade', is expanded far beyond the confines of the individual self, and constituted as a style at the level of the public sphere. The carefully bohemian appearance of these artists – 'a crowd of dirtyish, bearded, slouch-hatted individuals, like conspirators', as Ford himself put it – was intended as a medium through which their public ambitions could be given a stark, visual, form.[19] To this end, Lewis's personal deportment was extended to become a grand public text in the pages of *Blast*, the official voice of Vorticism.[20] *Blast*'s exuberant aggression and arrogance, its intensely self-conscious flouting of 'convention' and 'decorum', provided the public medium in which the image of the male artist as genius could be broadcast: 'we start from opposite statements of a chosen world. Set up violent structures of adolescent clearness between two extremes. We discharge ourselves on both sides.'[21] The voice that speaks in this style in *Blast*'s many manifestos and judgements is a male voice, hectoring, assertive, dogmatic, hortatory and aggressive, appropriate to artists who thought themselves 'Primitive Mercenaries in the modern world'.[22]

Vorticist works made this assertion of presence in the public world of modernity in part through the representation of landscape. The strand in Vorticist painting

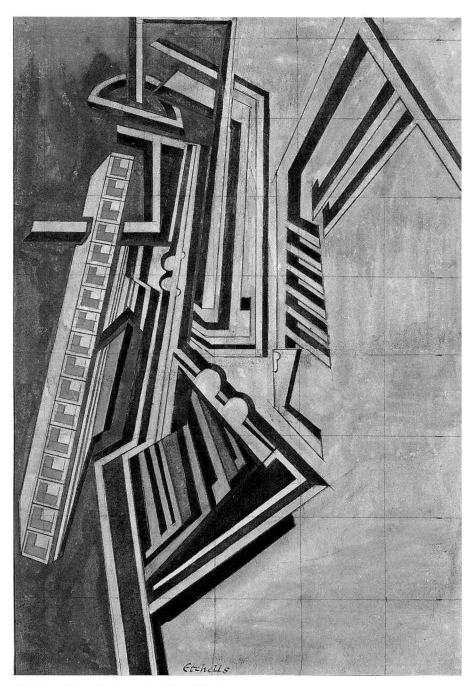

21 Frederick Etchells, *Composition Stilts*, 1914–15.

which runs through Lewis's city images – from *New York* (1914–15) to *The Crowd* (1914–15) – and through the manipulation of the map-like aerial views of city grids and streets in works like Frederick Etchells's *Composition Stilts* (Figure 21) and Wadsworth's *Vorticist Composition* (1914), is partnered by an interest in the way that saturation of the visual field by the technological city necessarily reconfigures the possible views of the landscape. Wadsworth's 1914 woodcut, *Landscape* (Figure 22), reworks the technological and mechanical forms used to describe the industrial city into a barely more organic version intended to serve for the countryside. The assertion here is that so pervasive are the systems and institutions of modernity that it is impossible any longer to see even the landscape – that sign of the pre- or anti-modern, the distillation of everything which lies at the farthest extreme from modern experience – except through eyes and languages which are formed by modernity. The landscape is no longer a Wordsworthian or a Birket Foster-like vision of the pastoral. The spectator now has to be shown and to acknowledge that his or her only pastoral is a mechanical one, and that this fact of their cultural experience has to be recognised and understood.[23]

Blast is intensely occupied with this reconstitution of nature and the nation as industrial. There is an emphasis on the English as an island and sea-faring race and on the docks as the sign of the modernisation of that relationship. *Blast* believes that 'an Art must be organic with its time'[24] but also its geographical location, 'the art for these climates … must be a northern flower'.[25] Since 'the Modern World is due almost entirely to Anglo-Saxon genius, its appearance and its spirit', so that 'machinery, trains, steam-ships, all that distinguishes externally our time, came far more from here than anywhere else',[26] the central definition of contemporary experience for its citizens is to be found in the British Isles, and any art which truly describes that experience must 'organically' base itself there:

> It is not a question of the characterless material climate around us. Were that so the complication of the Jungle, dramatic tropic growth, the vastness of American trees, would not be for us. But our industries, and the Will that determined, face to face with its needs, the direction of the modern world, has reared up steel trees where the green ones were lacking; has exploded in useful growths, and found wilder intricacies than those of Nature.[27]

The argument concludes by reinforcing this conflation of the natural with the mechanical and technological determinants of contemporary life:

> By mechanical inventiveness, too, just as Englishmen have spread themselves all over the Earth, they have brought all the hemispheres around them, in their original island. It cannot be said that the complication of the Jungle … is not for us. For, in the forms of machinery, Factories, new and vaster buildings, bridges and works, we have all that, naturally, around us.[28]

For the Vorticists, then, the city is a central presence in the countryside, conveying Britain's 'industrial genius' (a phrase Lewis later adapted to describe Wadsworth) as

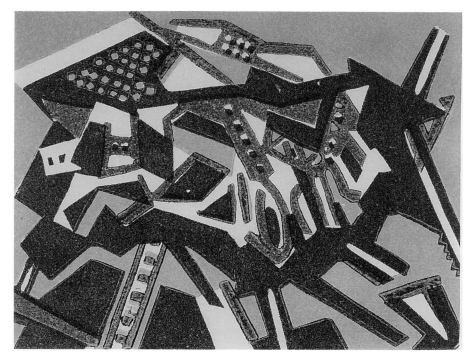

22 Edward Wadsworth, *Landscape*, 1914.

the defining characteristic of the landscape.[29] The British Isles are themselves masculinised, as a colossal 'Industrial Island machine, pyramidal workshop, its apex at Shetland, discharging itself on the sea', where the metaphor conflates the phallic power of the modern machine with that of the 'discharging' male.[30] In *Blast*, as in Vorticism more generally, the nation, its identity in landscapes and coastal formations, is reformulated under the sign of its technologisation which imposes modernity on it in ways conceptualised as gendered: the machine vital and masculine, the landscape passive and female.[31] The ability to identify and assess the nature and consequences of this fact lies with the masculine artist, whose authority and access to the public sphere allows the modernity of the landscape to become the vehicle for an analytic understanding of the realities of contemporary life. Masculinity, the public role of modernism and the qualities of the modern landscape are meshed together in this way as the signs of the ambitions of Vorticist modernism before World War I. The confidence of artists like Lewis before 1914 depended on that sequence of meanings and authority continuing to work. The ideological identity of the male as public actor was crucial to the health of these claims. Unfortunately for Lewis and his fellows the advent of the war destroyed the credibility of that identity and broke the sequence of meanings on which the ability of masculinity to relate to and understand the landscape had depended in the years before 1914.[32]

By 1919, masculinity as the Vorticists had defined it seemed irrevocably associ-ated with the violence of the war and its disruptions. The critic John Cournos announced 'the Death of Vorticism and all those "brother" arts, whose masculoma-niac spokesmen spoke glibly ... of the "glory of war"', and linked masculinity, modernism and warfare explicitly together:

> Marinetti talked openly of war. And one has but to look through the pages of the first number of *Blast* to ... see pictures entitled *Plan of War* and *Slow Attack* – curiously abstract representations of modern warfare, which now seem like wonderful prophe-cies ... The fact is, the artists, like the rest of the world hardly realised that the true exponents of modern art were the men on the German General Staff ... These people better knew what 'maximum energy' was. Their 'vortex' first sucked in mil-lions of German young men [and then] sent thousands of young men flying towards death like so many withered leaves.[33]

Vorticist modernity after the war was understood as an equivalent of the 'young men' muttering about revolution 'at street corners', 'the cave-man code' which in much writing of the immediately post-war period, contrasted with the longed-for 'normalcy' of the 'ways of civilian life'.[34] In these circumstances the sign of moder-nity, the declarative modernism of Vorticist style itself, became disallowed. Radical modernism was as tarnished for post-war culture as its aggressively masculine practitioners.

In *The Childermass*, Lewis describes the effect of the war on his protagonists by transforming them into the opposites of the strutting masculine artists whose 'parade' before 1914 was geared to asserting their status as active participants in the public meanings of their culture. The novel's two protagonists, Pullman and Satterthwaite, are ineffective, impressionable and passive. Pullman is introduced as a 'man-sparrow, who multiplies precise movements, an organism which in place of speech has evolved a peripatetic system of response to a dead environment ... a lost automaton rather than a lost soul'.[35] 'Satters', strongly masculine in form, 'big, thick-meated', is essentially and in his behaviour 'a wide-eyed suckling', whose 'wet cherry-mouth has burst open and displays its juicy fibres'.[36] Their deference and lack of authority before the world is figured in Lewis's novel as feminisation. Pullman – 'Miss Pulley' intermittently throughout the text – is described with 'a girlish hand ... the knee slightly flexed to allow the body to move gracefully from the slender hips'.[37] Satterthwaite is a vamp, 'swinging his body with an arch girlish oscillation'[38] or becomes a 'fat arch beauty coyly rising to her feet to be taken out to dance'.[39] They are the deceived and unknowing victims of others' manipulation, the 'hallucinated automata' of Lewis's cultural diagnosis in the 1920s, and that lack of force is imaged in their intense but unarticulated sexual relationship.[40] Their relationship 'has the sanctity of a pact that a kiss alone could properly seal'.[41]

This presentation of homosexuality as an ideological indication of cultural pow-erlessness is a trope Lewis repeats frequently during the inter-war period, and one can find it, with variations, widespread across writing and behaviours after 1920.[42] It

is as if the changed circumstances of the post-war are registered at the most intimate and vulnerable sites of masculine identity; as if, deprived of the ready access to public meaning the Vorticists believed they possessed, their version of masculinity itself collapsed into crisis. The protagonist of the 1929 novel *Death of a Hero* by Richard Aldington, a signatory of the *Blast* manifestos, is harassed by parents, wife, mistress and acquaintance.[43] His 'heroism', the putatively 'masculine' accomplishment of action, decisiveness and sexual authority, is revealed as empty, hiding a more fundamental passivity and powerlessness. Both his wife and lover, in contrast, have 'that rather hard efficiency of the war and post-war female, veiling the ancient predatory and possessive instincts of the sex under a skilful smoke-barrage of Freudian and Havelock Ellis theories.'[44] He dies in action, a 'wrecked man' and desperate suicide, rather than face his ordained post-war role, and is quickly forgotten.[45]

This compromising of the supposed qualities of masculinity threw the first post-war generation into a crisis of representation. Christopher Isherwood as a schoolboy and undergraduate in the early 1920s was 'like most of my generation ... obsessed by a complex of terms and longings connected with the idea "War"', which seemed to demand 'The Test', a fantasised proof of his masculinity. It is 'the Test of your courage, of your maturity, of your sexual prowess: "Are you really a Man?"' It is a test Isherwood longs for but constantly evades, convinced that if he were to attempt it 'I *should* fail' and that his masculinity could never be equal to the challenge of the war he was not old enough to fight.[46] Isherwood recounts his attempts to repress, delay and displace the test into a variety of different forms, some imaginative and some practical. Finally, he compresses the war and all it stands for into a motorbike, 'a visible metal contraption of wheels, valves, cogs, chains and tubes, smartly painted black', a bathetic distillation of Vorticist machinery, on which he notably fails to perform, wheeling 'the machine' and 'bending, every few yards, to peer and frown at the engine, so that passers-by should think it was out of order.'[47]

In a culture where this inwardness and privatisation of experience into a fantasy space was so widespread, the expansively Victorian ambitions for public statement held by the Vorticists in 1914 found no place. A number of issues which are central to Vorticism's attempt to describe modernity in the new languages of analysis before the war are involved here. There is a reconstitution of the meanings of the landscape, or rather a return to the view of the English landscape as encapsulating an indigenous spirit or genius of place which best expresses the anti-modernity and longing for established security of post-war fantasy.[48] And there is a renunciation of the public sphere as an area of activity in which radical languages and ambitions could feasibly find a place. The dominant discourses in post-war England are discourses of privatisation and interiority, an imagined and quietist continuity. In Alison Light's analysis, modernity after 1920 retreats into the 'most inward and private of places', and it does so because there is no longer a public language or a public forum in which the widespread experience of that modernity can be articulated.[49] The public languages are all of retreat and the negation of modernity

through contrast, so that the understanding of the culture's modernity which the landscape expressed in Vorticism was now recast to impute a conservative and regressive character to contemporary experience.

David Matless has recently argued against the automatic equation of landscape with nostalgia in this period, positing a more complex set of meanings and insisting on the interrelationship of modernity and the understanding of landscape.[50] The argument here is that it is exactly the implication of modernity within the landscape that is at issue. As the idea of representation and understanding of the landscape changes, so too does the understanding and positioning of contemporary modernity. In the 1920s, that understanding was concerned to evade the impact of the modern, and one of the ways in which this moment was registered was in the new privatisation of the landscape and the painter's account of it. The language that the Vorticists had spoken in 1914 was no longer a credible one, and this had powerful consequences for painters' relationships to both the landscape and masculinity in the 1920s. Modernity in the landscape was constricted, squeezed into the intimate spaces that a privatised subjectivity allowed. It was no longer the subject of public accounting or revelation.

This was so even for painters who came to maturity after 1919. The male painters who emerged and dealt with landscape in their art after the war were all faced with this necessary negotiation between representation and enclosure. Paul Nash, Stanley Spencer, Matthew Smith, Christopher Wood and Ben Nicholson all in their various ways felt themselves to be confronted with the difficulties of representing the modernity of the landscape which the new conditions posed. They all found the confident assertion of the pressure of modernity that the modernists had described to be beyond their scope. For post-war painters it was within the enclosed spaces of the private individual, defined through a reformulated masculinity, crisis-ridden and newly understood as passive, powerless and victimised, that the modernity of the landscape could be expressed. The remainder of this chapter looks at one of these painters, Ben Nicholson, as an example of the ways in which this situation exerted an important influence on the character of post-war practice.

Ben Nicholson is conventionally seen as the major proponent of a renewed linkage between English painting and continental modernism in the 1930s. Charles Harrison argues for Nicholson's takeover of the 7&5 Group in 1928 as countering 'the isolationism of English art during the twenties', and as marking the crucial moment at which 7&5 became 'the principal platform for the only significant group movement in English painting during the 1920s'.[51] Such a reading of Nicholson's work persists.[52] Interest here, however, is in Nicholson's career during the earlier 1920s when, as a member of the first post-war generation of English painters to come to maturity in the aftermath of war, he inherited both the account of landscape as modernity offered by Vorticism and conditions which made the Vorticist expression of that insight impossible to mobilise in good faith. Nicholson, like other artists of his generation, was obliged to work within this constraining situation, and the history of his art in the 1920s, which saw both his early essays in abstraction and a persistent fascination with primitive and naive idiom, is in significant part the history of the

negotiation of the Vorticist analysis of modernity in the landscape and of its gender implications as they were worked out in the first post-war decade.

Although Nicholson, born in 1894, had enrolled at the Slade as early as 1910, it seems unlikely that he developed any early interest in either Post-Impressionism or in the overt modernism of Futurism or the Vorticists.[53] His first intimate exposure to a dynamic modernist art appears to have been delayed until 1920, when he was introduced to Wyndham Lewis by the sculptor Frank Dobson. But Dobson was then exhibiting as part of Group X, Lewis's short-lived attempt to reinvigorate Vorticist modernism after 1919, and the swift collapse of that group, followed by clear evidence of Lewis's new marginality in the post-war formation, offered Nicholson and his generation only a negative example of the public relevance of advanced art.[54] It was only during periods on the continent, most notably between 1920 and 1922 when the Nicholsons spent part of each year at a house they owned at Castagnola in Switzerland as well as part in London, that he began to take an active interest in modern practice on the continent and in Britain.

Nicholson was exempted from military service during the war because of his asthma. His younger brother, Anthony, was killed in action in 1918. To that extent, he found himself in the situation of those who had not fought: any 'Test' of his masculinity as public channel for modern experience was accordingly open to probable failure, and in fact his lifestyle and practice after the war reflect the privatisation and constriction of access to the public sphere which Lewis and Isherwood diagnosed. In Nicholson's case, as with other members of his generation, this situation became the accepted condition of his life and work as a painter. Throughout the 1920s he and Winifred Nicholson sustained a contrived simplicity of life. 'Banks Head' in Cumberland where they lived from 1924 to 1931 served to focus this ideal of a non-metropolitan and non-modern existence, 'modest lives … coloured, or rather toned by Christian Science, vegetarianism and work'.[55] The landscape paintings Nicholson produced there throughout the 1920s are marked by a self-conscious naiveté and emotional directness.[56] *Landscape with Haystacks* (1928) (Figure 23) is typical in displaying a simplified, plain landscape on which sketchily naive haystacks, trees and horses are arrayed. They appear self-consciously child-like and romantic in their treatment of the world, precisely opposite in their implications to the Vorticist version of masculinity.

This deliberate cultivation of a naive vision for purposes of expressive force grows out of the processes of privatisation in the post-war period. These images are about the engagement with the motif of an observing self, self-consciously liberated from the contexts of tradition and public meaning. They are not so much naive as fantastic in Rosemary Jackson's sense, in their enclosure, separateness from the public languages of expression and the narrowing of meaning to the single point of the painting itself. They represent another version of the fantastic and unworldly landscape which Lewis proposed in the opening pages of *The Childermass*, enclosed and constricted in the possible range of meanings and the possible address to an audience which they imply.

23 Ben Nicholson, *Landscape with Haystacks*, 1928.

Like Pullman and Satterthwaite in *The Childermass*, or Christopher Isherwood's autobiographical self, Nicholson's artist in these works is a post-war creation, renouncing the capacity of modern art to enquire into the terms and meanings of contemporary experience. As a result, the landscape spaces which these paintings propose are gendered within the set of terms and the conceptual system inherited from pre-war Vorticism and its radical analogues. The specific, private and inward relationship with the landscape which they enact functions within this inherited system to feminise both the painted spaces and the artist who depicts them. Both the artist's self and its subject matter are, by the standards of the ideology of 1914, non-masculine, feminised and inward-looking.

This interiority and obsession with a private and particular relationship with the world which defined the new masculinity continued after 1924 when Nicholson began to produce abstracted works. Jeremy Lewison has analysed the character of the still-life paintings made between 1924 and 1932 in relevant terms:

> The point towards which Nicholson was deliberately moving was one where the idea depicted and the means of depiction would become synonymous and insepar-able, where objects were not represented but presented for the first time, where the object did not exist outside the reality of the painting but signified a self-sufficient

experience. The painting was no longer a window onto the world but was the world itself.[57]

First Abstract Painting, Chelsea (1924) (Figure 24) and *Painting – Trout* from the same year both contrive constricted and compressed spaces into which the abstracted forms of colour and shape are allowed to intrude. These are paintings in which the single point of observation and the hermetic possibilities of the cultivation of sophisticated and private languages amount to a different but homologous idiom to the privatisation and separateness of the naive landscapes made at the same time at Banks Head. In *Trout* the landscape dwindles into an ultimately privatised space, the scatter of coloured shapes across the surface of the image.

Nicholson's move into modernism during the 1920s, embracing its variety from the naive to the abstract, therefore marks out the central problematics of modernist production. Nicholson's modernity, whether in naive landscapes made at Banks Head or in his London still-lifes and abstractions, involves itself in explicit subject matter and paint processes which appear hermetic, élite and closed off from the

24 Ben Nicholson, *First Abstract Painting, Chelsea*, 1924.

comprehension or involvement of the wider audience. The painting becomes 'the world itself' in the abstract works, defining reality as comprehended and circumscribed by the framed space of the canvas and as implicitly turning its back on both the public sphere and the possibility of a significant communication with an audience. Under pressure of the sundering of the connection between aggressive masculinity and access to public discourse, the elaboration of artistic space as an alternative to the world, and the reduction of the world to what can be constrained within that space, defines a modernism which accepts the impossibility of communication with an alienated audience and contents itself with the imaginative recreation of reality within bounds which it can manipulate and define.

On the other hand, Nicholson's interest in defining a visual vocabulary which would unite the world and its depiction implies a direct relationship with both reality and the potential audience. This argues for an art of communication which opens out into the public world as an active principle of understanding and exchange. The art work is conceived of as able to structure, diagnose and convey the reality of experience to an audience which is understood to be receptive and capable of being educated and developed by that process of communication. *First Abstract Painting, Chelsea* or *Landscape with Haystacks* on this reading adopt their simplified vocabularies in the interests of an expressive force that will involve their spectators in the perceptions of the artists.

The fact is that modernist works like Nicholson's cannot resolve these alternatives. It is precisely the irresolution of the twin drives in modernism which the compromising of the masculinist, gendered route to public meaning brought with it for male artists after 1918.[58] The historical location of their production in the quietist and privatised period after the war, when modernity came to seem available only within Alison Light's 'most private and intimate of spaces', created a tension which meant that, ultimately, the position of these works within the spectrum of modernist ambitions and relations to the public sphere remained ambiguous and unresolved. Once the ideology of masculinity as presupposing a direct access to a universal public meaning was undermined, the capacity of male modernists to propose a univocal 'diagnosis' of modernity was undermined with it. When that occurred, the internal paradoxes of the project to describe modernity for an audience who were effectively alienated from representation became undeniable. The impossibility of the task of conveying the truth of modernity, only concealed by the fictional masculinity of 1914, blew apart in the arena of post-war representation.

Privatisation of the relations to modernity and the repudiation of the aggressive masculinity of the pre-war years thus go hand in hand. It is not that there is a direct causal relationship between them. They are both aspects of more general cultural transformations that occurred during and after the war in English culture. But the effect was nonetheless to question masculinity as an enabling principle which allowed the modernist art-work to occupy the central place in cultural representation and action. For the Vorticists, the ideological linkage between social action and masculinity defined a route along which the ambitions of modernist painting as

cultural agent could travel. If this principle was always an illusion, even in 1914, its possibility nonetheless continued to haunt the imaginations of certain modernist painters after the war. Nicholson's overt and advanced modernism takes up the attractive possibility of a communicative and revelatory modern art. Constrained by the cultural circumstances of the post-war, Nicholson's painting in the 1920s plays out the frustration of that possibility which was the universal experience of modernists in the first post-war decade. However 'radical' they appear to be in the terms proposed by a formalist modernism, Nicholson's works in the 1920s are marked by the collapse of access to the public sphere which followed the war and the disavowal of masculinism which it brought with it. That is why they reside in the 'bleak, empty, indeterminate landscapes, which are less definable as places than as spaces, as white, grey, or shady blanknesses' that Rosemary Jackson uses to define the fantastic. These are the enclosed and constricted spaces in which reality and the modern world are reduced to the compass of the flat and inflected surface of a canvas. Nicholson's landscapes and abstractions respond to interpretations that work to see them as either public or private. They do not resolve the twin impulses of modernism faced with the conditions which modernity enforces, and that fact defines the complexities of post-war modernist painting and the cultural changes which compromised the aggressive masculinity of modernist painters.

Cézanne's maternal landscape and its gender

Paul Smith

> Correspondence? … It's tosh; there again, it's not.
>
> (René, le comte de Mauvieuse)[1]

Cézanne's use of the phrase 'this old native soil' to describe his local Aixois land-scape, in a letter to Joachim Gasquet of 21 July 1896,[2] is one of many tokens of an attachment to the land of his birth that was both deep-seated and enduring.[3] His fondness for his indigenous landscape was not eccentric, however, as it corresponds to beliefs about the appropriate range of the landscape painter expressed by the landscape theorist, Frédéric Henriet, who in 1853 advised: 'La jeunesse, qui est l'âge des impressions vives et fraiches, est une qualité précieuse chez un paysagiste. … adoptons-nous de préférence le monde qui nous entoure, le pays qui nous a vu naître. Voilà la nature qui nous est familière: nous la comprendons, celle-là d'une façon plus intme, plus locale' (Youth, which is a time of vivid and fresh impres-sions, is a precious quality for the landscape painter. … by choice, let us adopt the world that surrounds us, the land that saw us born. There, nature is more familiar: we understand it in a more intimate, more local fashion.)[4] The very currency of the notion that the artist's native soil was his most suitable motif suggests it was under-pinned by more particular beliefs; and Cézanne saw at least two kinds of signifi-cance in his birthplace. First, he regarded the Provençal landscape as imbued with the Latin 'blood' in which he shared, and his pictures show this ideology at work.[5] Cézanne also believed his indigenous landscape was maternal – at least to judge from *L'Oeuvre* of 1886, in which Zola recalls how he and his friend enjoyed 'une absorbtion instinctive au sein de la bonne nature' (an instinctual absorption in the bosom of mother nature).[6]

This last interpretation of Cézanne's concept of landscape could indicate that his paintings reproduce the ideological values of a system of binary oppositions in which 'masculinity' and 'culture' are the hierarchically superior terms. It might also suggest that his works contain a 'masculine' mode of vision which functions simultaneously as a form of pleasure in, and control over, the 'feminine'. This

chapter will, however, be concerned to pursue the suggestions in the foregoing quotations that there might be a real basis for Cézanne's response to the landscape in infantile experience, since, taken together with their suggestion that the painter saw nature as somehow maternal, these would seem to indicate that his love of his 'native' soil was grounded in deeply rooted experiences of his mother's body.

This way of seeing Cézanne is clearly different from semiotic and allied approaches, especially those that view pictorial meanings as ideological fictions produced by the play of signs, inasmuch as it asserts that there is (at least among other things) a real, expressive, psychological content in his landscape paintings that he intends them to express. (Of course, this intention may be unconscious or un-verbalised, and may be recognised only after the work is completed.)[7] The account developed here nevertheless does not suggest that Cézanne's landscapes are expressive because they are anthropomorphic, or because the painter mistakenly saw his mother's body in the landscape. It will suggest, rather, that the way Cézanne saw the landscape involved a variety of projection grounded in a substrate of phantasy arising in the infant's experiences of the mother's body, and primordially, from the experience of the breast. This account thereby acknowledges a causal, and not merely casual, connection between the landscape and the maternal body; but in seeing such phantasies as a substrate to, and not the substance of, the artist's intention, it suggests that any female corporeality in the landscape is metaphorical, or is perceived and represented only 'as if' it were one of its properties.[8] The same account also allows that the artist, by dint of being continually aware of the depicting surface as the vehicle of his painting's depicted contents, would be aware that any connections in the work between the landscape and the maternal body are factitious, i.e. imaginative and not literal.[9] In other words, in what follows, seeing is not believing: it is at once much more complex and much more primitive. Furthermore, and counter to the idea that the artist's vision must entail a gendered form of power, the present argument will suggest that the operation of phantasy in (Cézanne's) landscape painting can mean that the gender of the landscape, and of the subject perceiving it, appear pictorially in ways that do not fit with the clear-cut, opposed categories of ideology.

The metaphorical landscape

A convenient way of fleshing out the argument that Cézanne's (like other painters') landscape paintings relate, but do not reduce, to phantasies and perceptions of the maternal body is to begin with an account of the way that they create morphological and phenomenological analogies between the motif and the female body. As other commentators have remarked, many of the Mont Sainte-Victoire paintings represent the mountain as if it were a breast;[10] some, such as *The Mont Sainte-Victoire with Large Pine* (of after 1885 or possibly 1888) (Figure 25), also lay out the whole landscape in a way that invites the spectator to imagine settling within it rather as an infant nestles in the mother's body.[11] This experience evidently had a special

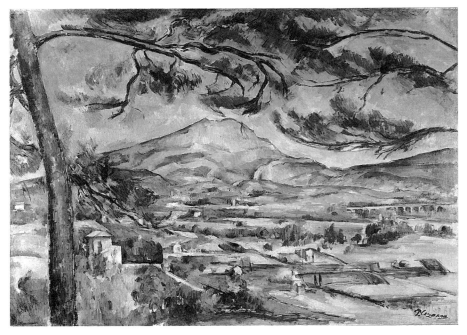

25 Paul Cézanne, *The Mont Sainte-Victoire with Large Pine*, 1885.

value for Cézanne since he actually represented his recently born son resting on Hortense Fiquet's naked bosom in his *Woman Nursing her Child* (of about 1872) (Figure 26).

This is not to say that Cézanne's landscapes suggest the mountain is a breast or a woman by making visual puns. Cézanne's mountains and landscapes are instead 'metaphorical objects': any corporeality in them is both an attenuated and a borrowed property.[12] In these respects, Cézanne's works play with a metaphorical interchange between the landscape and the female body that Baudelaire had exploited, and which very likely inflected the 'Baudelairean' painter's work.[13] Notably, in 'La Géante' from *Les Fleurs du Mal* (a book Cézanne owned and greatly admired), the poet *plays* with the idea of himself as child who nestles in the 'landscape' of the mother's body in order to express an amorous thought. Thus Baudelaire expresses a wish to 'Parcourir à loisir ses magnifiques formes; / Ramper sur le versant des ses genoux énormes, / Et parfois en été, quand les soleils malsains, / Lasse, la font s'étendre à travers la campagne, / Dormir nonchalament à l'ombre de ses seins, / Comme un hameau paisible au pied d'une montagne' (To explore her magnificent forms, to climb the slopes of her tremendous knees, and sometimes when the sickly mists of summer made her stretch out wearily across the fields, to slumber trustfully in the shadow of her breasts, like a quiet hamlet at some mountain's foot).[14] However, nothing in this suggests the poet *believes* his imagined

lover is either his mother or a landscape, any more than he believes he is a child or a hamlet. The same might be said of Degas, himself a reader of Baudelaire,[15] even though his *Steep Coast* of *c*. 1890–92 *seems* to court the belief that there *is* a giant female body in the landscape.[16] This work only asserts that this is the case, however, when it is seen, uncharitably, to be without irony or an element of play.

The corporeal metaphoricity of Cézanne's work is evidently much more attenuated than it is in Degas's, and arguably goes much deeper than superficial (or morphological) resemblances between characteristics of the landscape and features of the female body. One way of explaining what goes on in Cézanne is that the metaphorical connection between the two is perceived not through belief, but through feeling, which has less need to appeal to criteria of visual similarity. Psychoanalysis suggests further that this kind of metaphoricity rests on something more primitive even than feeling, and which can thus underpin a still more nebulous way of establishing the connection. This grounding is the substrate of

26 Paul Cézanne, *Woman Nursing her Child, c.* 1872.

phantasy associated with oral experiences of the mother's body (primordially suckling) which arises at a very early stage of development.[17] Cézanne certainly made remarks which equate his experience of the landscape with very early child-hood experience. For instance, he told Henri Gasquet in a letter of 3 June 1899 that 'je continue à chercher l'expression de ces sensations confuses que nous apportons en naissant' (I continue to seek the expression of the confused sensa-tions which we bring with us when we are born). And in a remark to Joachim Gasquet concerning his own and his friends' youthful ambitions, there is a suggestion that Cézanne's early object-relations had a markedly oral and manic character. The painter told him: 'Nous croyions manger le monde à cette époque!' (We expected to devour the world at that time!).[18]

Expressive perception of the landscape, or what Baudelaire calls 'correspon-dence', has other features too which suggest that it rests on a deep and formative sub-strate of phantasy: most importantly, it involves process of mind, such as kinds of identification and dis-identification, which are genetically linked to oral phantasies according to Freudian and Kleinian theory. Granting that this kind of process might explain Cézanne's work, this would involve the painter in an intentionality which is so early that the gender of the subject, and that of the object, are largely nebulous or free from ideology. The same body of theory also suggests that the identity of the per-ceiving subject in correspondence is confused or even chaotic because the experi-ence involves phantasies of expelling parts of the self into the landscape, and of taking parts of it in and of making these part of the self. Subject and object are thus relatively indistinct in this kind of intentionality, and so too are their genders.

Correspondence

Any historical exposition of this last argument should at least begin with some explanation of the theory of correspondence as it was known to Cézanne through his familiarity with Baudelaire's writings. Most famously, 'Correspondances' is a poem in *Les Fleurs du mal* in which the poet experiences nature, and its harmonious internal relations, as meaningfully related to himself.[19] This is also the central idea of section VII of the *Salon de 1859*, which elaborates the theory that a landscape is actually a perceptual array that has 'beauté' (beauty) only in relation to 'moi' (self). (This section, and its framing text, derives its literal sense from Swedenborg's and other writers' ideas, which argue that nature is a hieroglyphic 'dictionnaire' (dictionary) or collection of 'signes' (signs) which are meaningful, although only mysteriously so to the post-lapsarian subject. The overt foundation of this theory is that God, in creating the universe by uttering it, ordered it so that everything was established in a significant relation to everything else, including the perceiving sub-ject. After the fall, humankind lost the capacity to see these logocentric relations clearly, but people can none the less still perceive these, albeit obscurely, if they contemplate the landscape in the correct, imaginative and childlike spirit. In this case, the spectator can intuit correspondences on the earthly plane, where colours

suggest sounds, or smells; or for the spectator who perceives the world anagogi-
cally, colours will suggest moral attitudes, because the world reveals the Divine
mind that ordered it.)[20]

Baudelaire's ideas echo thoughts about the pantheistic basis of the meaningful-
ness of nature which had been enunciated a generation earlier in Lamartine – one
of the literary enthusiasms that Cézanne, Zola and Baille indulged during their
youthful excursions around the Aixois countryside. In later life, when speaking to
Gasquet of his attachment to the Aix of his youth, Cézanne would even quote lines
from Lamartine's poem, 'Milly, ou la terre natal' (an elegy upon exile from 'la
patrie' (the fatherland)), which attributes a rich subjective significance to the
objects of the poet's beloved landscape: 'Objets inanimés, avez-vous donc une âme
/ Qui s'attache à notre âme et la forcer d'aimer?' (Inanimate objects, do you thus
have a soul that joins with our own and causes it to love?) [21]

It is also reasonable to assume that Cézanne was exposed to thinking of this sort
when he first visited Paris in the early 1860s, when his interest in Baudelaire began.
For instance, Cézanne might have encountered the attack against Baudelairean
trends in landscape criticism that Fernand Desnoyers (the poet's sometime collab-
orator) launched in his *Salon des Réfusés: La Peinture en 1863*. Clearly appalled by
the increasing popularity of metaphysical criticism, the Realist Desnoyers
remarked scathingly:

> le Critique d'art … a fait des découverts d'esthétique, de Svédenborgisme, de
> philosophie et de spiritisme dans les paysages et dans les tableaux. … Le critique
> d'art est enfin venu, armé gros termes, et il a demontré aux peintres que les diverses
> écoles de philosophie allemande, n'étaient pas du tout étrangères à la peinture. Kant,
> Leibnitz, Spinosa, Hégel, Schelling, Fichte, Richter, Grimm, Locke, Condillac et
> Denis Diderot, Svédenborg et Saint Martin font bien dans le paysage et les critiques
> d'art, qui sont leur interprètes pour les peintres, les ont barbouillés de vermillon et
> de jaune de chrôme et ont puissamment prouvé la nécessité absolue de leur incarna-
> tion dans la peinture à l'huile. Avant la critique d'art, on ne savait que voir la pein-
> ture, on ne savait pas le lire. Actuellement, grâce aux critiques d'art, les peintres
> mieux renseignés, remplissent leurs paysages et leurs portraits d'esthétique et de
> Svédenborgisme. Heureux qui peut entendre un paysagiste approfondir les ques-
> tions *d'objectif et de subjectif*, de sensualisme, de matérialisme et de spiritisme.…

> (art criticism … has made discoveries of aesthetics, Swedenborgism, philosophy and
> spiritualism in landscapes and paintings. … Art criticism has finally arrived, armed
> with great terms, and it has demonstrated to painters that the several schools of
> German philosophy were not at all alien to painting. Kant, Leibnitz, Spinosa,
> Hegel, Schelling, Fichte, Richter, Grimm, Locke, Condillac and Denis Diderot,
> Swedenborg and Saint Martin have indeed to do with the landscape, and art critics,
> who interpret them for painters, have daubed them with vermilion and chrome
> yellow and have convincingly proven the absolute necessity of their embodiment in
> oil painting. Before art criticism, we could only see painting, we did not know how
> to read it. Nowadays, thanks to art critics, the best informed painters fill their

landscapes and their portraits with aesthetics and Swedenborgism. Happy is he who
can understand a painter going deeply into questions of the *objective and subjective*,
of sensationalism and of materialism and spiritualism....)[22]

As regards Cézanne's work, an equally significant, although neglected, aspect of
Baudelaire's theory of correspondence in the *Salon de 1859* is its suggestion that
landscape paintings achieve the expressive effects they do by metaphorising the
body. This idea is expressed somewhat elliptically, for instance, in Baudelaire's
analysis of Corot's 'profond sentiment de la construction' (deep feeling for con-
struction) in which he argues: 'Il est ... le seul, peut-être ... qui observe la valeur
proportionnelle de chaque détail dans l'emsemble, et, s'il est permis de comparer la
composition d'un paysage à la structure humaine, qui sache toujours où placer les
ossements et quelle dimension il leur faut donner' (He is ... the only one left, per-
haps ... who observes the proportional value of each detail within the whole, and, if
I may be allowed to compare the composition of a landscape to that of the human
frame, the only one who still knows where to place the bones, and what dimensions
to give them).[23]

While somewhat sketchy, and even mystical, Baudelaire's notion of correspon-
dence can none the less be re-stated in analytical terms. A model analysis of this
kind is Richard Wollheim's (part-Freudian) explanation of the idea, in which the
expressive perception of nature is seen to be a function of (complex) projection, a
psychic mechanism associated with the defence of splitting, in which the mind,
modelling its sense of its own functioning on bodily experiences, expels painful and
unwanted feelings as if they were internal fluids, and smears them on to the world
outside, which they colour accordingly.[24] In Wollheim's example, an unhappy
person projects his feeling on to the world which he then finds to be 'of a piece with
his sadness': meaning that the subject does not believe the world is (really) sad, but
feels it to have a kind of 'sadness' akin to the emotion he has projected. It may even
be that Baudelaire had some concept of the operation of a mechanism of this kind
inside correspondence since he describes a closely analogous process in the poem,
'De Profundis Clamavi'. In this, the lovelorn poet, his heart having fallen into the
'gouffre obscur' (dark gulf), finds that this 'univers morne à l'horizon plombé' (sad
universe with its leaden horizon) chimes in with his mood.[25]

According to Wollheim, in correspondence it sometimes happens that the mind
expels a bad feeling on to the landscape in order to preserve another, good feeling.[26]
So, for instance, a person who feels anxiety may split off the unwanted feeling and
stick it on to the landscape unconsciously, or without realising it. The phenome-
nology of this experience is that the landscape suddenly appears to have a mood
which strikes the spectator unbidden. A good example is van Gogh's experience
while observing the landscape of one of his last works, *Wheat Field under Clouded
Skies* of 1890. In a letter to his brother Theo, Vincent tells him:

> je me suis senti moi aussi encore bien attristé et avais continué à sentir peser sur moi
> aussi l'orage, qui vous menace. ... j'ai encore depuis peint trois grandes toiles. Ce sont
> d'immenses étendues de blés sous des ciels troublés et je ne me suis pas gêné pour

chercher à exprimer de la tristesse, de la solitude extrême. Vous verrez cela j'espère sous peu … puisque je croirais presque que ces toiles vous diront, ce que je ne sais dire en paroles, ce que je vois de sain et de fortifiant dans la campagne.

(I still felt very sad and continued to feel the storm which threatens you weighing on me too. … I have painted three more big canvases since. They are vast fields of wheat under troubled skies. I did not need to go out of my way to try to express sadness and extreme loneliness. I hope you will see them as soon as possible, since I almost think that these landscapes will tell you what I cannot say in words: the health and restorative forces that I see in the country).[27]

Evidently, what happened here is that van Gogh first of all found that the troubled sky corresponded to his own feeling of anxiety; he then expelled this feeling, making it of a piece with the world outside, with the result that he felt better (temporarily), and somewhat to his own surprise.

The explanation of correspondence Wollheim offers under this rubric is not the whole story, not least of all because Wollheim's other writings suggest it can be supplemented and deepened. These suggest, for one thing, that more can be said on how it is that spectators are able to see the same thing as the artist, and one another, when looking at a real or painted landscape. More can also be said about the complexity and richness of the experience. And the differences between the expressive perception of a natural landscape and a painted landscape can also be drawn more sharply.

On the first problem, that of the publicity of experiences of correspondence, Wollheim insists that the mood perceived in the landscape flows from the way it looks, even though he denies that what is experienced in correspondence is a property of nature. He does suggest, however, that projection is subject to stabilising and moulding factors (such as culture), implying that experiences of correspondence have a limited subjective universality. Wollheim also argues that a spectator can appreciate what a painter experiences when looking at a particular scene if she or he can share in the intentional character of its pictorial expression.[28] A (Wittgensteinian) way of putting the problem is that it does not quite show how experiences of correspondence have non-introspective criteria, as they must if they are to be real and public, and not just solipsistic.[29] Put more simply, there must be something visible in the landscape, whether real or painted, that grounds the possibility of different people knowing and agreeing about its particular expressive character. Drawing on Wollheim's own theory that parts of the world can appear expressive because they metaphorise the body, a possible candidate for the role of the criterion of the landscape's expressiveness is the particular bodily property that it metaphorises (especially since bodies in particular emotional states are relatively determinate expressively). However, corporeality is not inherent in the landscape, but is a projected property. It must therefore be the case that the real configuration of the landscape does establish its mood, but only inasmuch as it sets limits to the projections of corporeality that it can sustain.

Van Gogh's letter about the correspondence between his bodily disposition, or mood of anxiety, and the 'troubled' sky represented in his picture is one example of this phenomenon. Another comes in a poem by Desnoyers, entitled 'Ebauche de la Forêt', which was published in a well-known anthology, *Fontainebleau. Payages. Legendes. Souvenirs. Fantaisies,* of 1855. In this, the poet/narrator, remembering his erstwhile loves, has the (Wollheimesque) experience of looking at the landscape and suddenly finding it sad. While the dynamic of (complex) projection is undoubtedly responsible for this reaction, the landscape Desnoyers describes is specific enough to encourage projections of one kind of corporeality and feeling, while making other projections difficult. The poem reads:

> Là, comme on est heureux de respirer, de vivre, / De feuilleter son coeur dont le temps fait un livre / Où le bonheur passé se retrouve imprimé! / Comme on relit la page où l'on se crut aimé! ... J'entends toutes les voix du passé m'appeler / Dans les frissonnements des feuilles, et parler ... Je suis prêt à pleurer, et j'ignore pourquoi ... On renaît, on revit ses vingt ans, ses beaux jours! ... / On se voit à côté des anciennes amours ... Enlaçant de son bras une taille connue / Dont la chaleur palpite encore sous les doigts ... / On écoute en son coeur l'entretien d'autrefois ... On est seul à présent, et cependant on aime! ... // Puis, le chaos! – Des blocs et des entassments / De rochers désolés; d'énormes ossements, / Des têtes et des bras et des jambes de pierre; / Des granits prosternés qui semblent en prierre! ... // Comme ils souffrent, ces rocs, et hurelent de douleur, / Sans qu'on entend un cri, sans que paraisse un pleur!

> (There, how happy I am to breathe, to live, to leaf through my heart which time has made into a book where the happiness of the past is printed! How I reread the page concerning the time when I felt I was loved! ... I hear all the voices of the past call me in the quivering leaves, and speak ... I am on the verge of tears, and I do not know why ... I am reborn, I relive being twenty years old, those happy days! ... I see myself next to my old loves ... Encircling with my arm a familiar waist whose warmth still pulses beneath my fingers ... I hear the conversation of former times in my heart ... Alone now, but none the less I am in love! ... Then, chaos! – blocks and piles of desolate rocks; enormous bones, heads, arms and legs of stone, granites prostrate as if in prayer! ... How they suffer, these rocks, and cry out in pain, with no audible cry, with no visible tear!)[30]

The landscape described in this poem is not unlike the one in Corot's *In the Forest of Fontainebleau* of 1855–57, whose corporeal (or bony) rocks also produce a sad, expressive effect (and which also give credence to Baudelaire's remarks on the corporeality of Corot's paintings). Evidently, the particular qualities of the landscape have a role in determining its corporeality and its particular expressive effect. Nevertheless, it is important to note that the landscapes common to van Gogh's, Desnoyers's and Corot's work produce their expressive effects even though they are non-specific in gender (rather as, it will turn out, the 'maternal' landscape of Cézanne's work is expressive without being straightforwardly female).[31]

The same is also true of painted landscapes which metaphorically possess a kind of corporeality that derives from the vehicle in which they are depicted. (As Wollheim demonstrates, artists habitually project bodily feelings into paint, and especially colour, which can lend particular corporeal qualities to what is depicted.[32]) Paint was commonly made to support projections of corporeality in nineteenth-century colourist paintings, especially where colours in combination are made to advance or recede, swell or contract, clash, or harmonise, or to appear to interact rather like human bodies animated by feeling. Colourist paintings can therefore elicit bodily qualities and feelings from natural landscapes when these do not support such projections too well on their own (as perhaps happened with van Gogh's stormy sky). More specifically, this occurs through the agency of the artist who looks from the painting to the landscape and sees the latter in terms of the former, especially if, like Cézanne, she or he has done so after painting the landscape for forty years.[33] The ability of paintings to affect the look of the landscape by imposing an expressive corporeality upon it is also in evidence in Baudelaire's description of the physical and 'moral' interaction of colours in the landscape in the *Salon de 1846*. In this instance, the poet's emphasis on the harmony, contrast and reciprocal effects of colours in the landscape suggests that the world he describes is modelled on the paintings of his beloved Delacroix more closely than raw 'nature' (which the poet abhorred). In any event, Baudelaire evokes an expressive, 'moral' landscape which might easily have affected Cézanne (an admirer of Delacroix as well as Baudelaire, and himself preoccupied with the harmony of the real and the painted landscape), in which:

> A mésure que l'astre du jour se dérange, les tons changent de valeur, mais, respectant toujours leurs sympathies et leurs haines naturelles, continuent à vivre en harmonie par des concessions réciproques. Les ombres se déplacent lentement, et font fuir devant elles ou éteignent les tons à mésure que la lumière, déplacée elle-même, en veut faire résonner de nouveau. Ceux-ci se renvoient leurs reflets, et modifant leurs qualités en les *glaçant* de qualités transparantes et empruntées, multiplient à l'infini leurs marriages mélodieux et les rendent plus faciles.

> (In the same way that the daystar alters its position, colours change their values, but always respecting their natural sympathies and antipathies, they continue to live in harmony by making reciprocal concessions. Shadows slowly shift, and put colours to flight or extinguish them according as the light, moving itself, desires to make some of them resonate afresh. Some colours cast back their reflections upon one another, and by modifying their own qualities with a *glaze* of transparent, borrowed qualities, they combine and recombine in an infinite series of melodious marriages which are thus made more easy for them.)[34]

The second difficulty with Wollheim's theory of correspondence is that, while it emphasises how the spectator feels the mood of the landscape is 'of a piece' with her or his own mood, it is nevertheless a little reticent about this phenomenon. Again, other parts of Wollheim's work can remedy this problem, particularly those that

emphasise the important role of introjection in the psychic processes associated with art. According to Wollheim and his sources in Freud and Klein, introjection (like projection) is very primitive, being a form of 'psychic cannibalism' grounded in suckling, or a kind of mental functioning that arises on a substrate of phantasies of orally incorporating an object. In other words, through introjection, the subject takes in an external object and makes it part of herself or himself, rather as the infant takes in the mother's breast and makes it an 'inner object', or a component of her or his psychology.[35] Using this model, the depth or force of the feeling sensed by the spectator of nature who experiences correspondence might be attributed to introjection. Hence too, part of the reason why Desnoyers's and Corot's *Fontainebleaux* and van Gogh's and Cézanne's ('devoured') landscapes are expressive is that the poet/reader and artist/spectator introjects and identifies with the mood of the landscape. Since this is already a projection, and metaphorical, it subtly enriches the subject's feelings.

Acts of introjection and projection may also proceed from one another in rapid succession.[36] One reason for this is that projection is often imperfect and can involve expelling a good internal object, which necessitates re-introjection.[37] Conversely, introjection can entail assimilating a bad object that must be expelled.[38] Either way, the subject may often need to employ introjection and projection in close, reciprocal harmony and to exercise considerable discrimination (or 'taste') in the process. However, the very closeness or reciprocity between projection and introjection can mean that the process is not completed perfectly, with the consequence that the subject may be left with an ambivalent feeling as the end result. (This, it will turn out, is another important feature of Cézanne's expressive perception of landscape.)

A further reason for the richness of correspondence is that it may sometimes rest on a psychic mechanism known as 'projective identification'. To draw once more on the sources of Wollheim's theory of art and mind, this process can be identified with a substrate of phantasy in which the infant, as a defence against 'bad' internal objects (originally bodily fluids), splits these off and projects them into someone, or something, else.[39] Projective identification is thus associated with forms of psychosis that involve the subject splitting off parts of the self that cause pain to lodge them in others. But it also occurs in more everyday forms. For example, the phenomenon of the scapegoat illustrates the way that subjects split off those aspects of the self they find unbearable and lodge them in another being. In one extreme form, projective identification is associated with episodes of psychotic depersonalisation in which the subject feels her- or himself to be someone else.[40] But again this kind of identification has a common, milder manifestation in cases where a subject phantasises entering or taking over another personality. In this form, projective identification is described in Balzac's story 'Facino Cane' and in Baudelaire's prose poems, 'Les Tentations' and 'Les Foules' (in which it comes under the rubric of a taking 'un bain de multitude' (a crowd-bath)).[41] Splitting and identification working together in projective identification (and reinforced by

reading Baudelaire), might even explain Degas's frequent projections of an intensely proprioceptional female body into the landscape. It is almost as if the artist, unable to bear the thought of his 'feminine' part, splits this off and lodges it in the landscape as a derided object, with which he none the less 'secretly' identifies. It may even be that the artist, having gone through the obligatory routine of denial, can then allow himself to re-introject the expelled 'feminine' part of his self and thus re-integrate this within his (artistic) personality.

Again, while this idea may not be directly relevant to the psychological content of Cézanne's landscapes, it suggests that correspondence can involve a considerable degree, and complex kinds, of interaction between subject and object: such that self and other, good and bad, and crucially, male and female, are no longer phenomenologically clear-cut within the experience. To the extent that Cézanne's work involves correspondence, it might therefore be seen to involve the subject in perceptions which dissolve and re-make the ego, and which profoundly affect her or his gender in the process.[42]

Cézanne's maternal landscape

The fact that Cézanne's preoccupation with his 'native landscape', and with the Mont Sainte-Victoire in particular, lasted for forty years, undiminished by travel and encounters with other artists' work, may itself be an indication that his landscapes relate to a foundation of infantile phantasy connected with the mother's body.[43] There are also a number of specific and unusual features of Cézanne's landscapes which suggest that he envisaged the landscape and its mountain in sometimes highly ambivalent and complex ways which bear the stamp both of the infant's violent and fearful phantasies towards the maternal body, and of its more loving and reparative phantasies.

To appreciate this dimension of Cézanne's landscapes, it is necessary to consider Klein's account of the infant's developing attitudes towards its mother's body. Klein argues that while the breast is a good object in the infant's phantasy because it provides warmth and nourishment, the ever-needy infant also comes to regard it once it is withdrawn as a bad (part-)object that starves and tortures her or him, and accordingly, she or he punishes it in phantasy by biting it, and by scooping it out and robbing it of its contents.[44] In a normal or healthy development, the infant's fearful and violent phantasies will normally abate to an extent when she or he comes to learn that the nourishing breast will return. The infant is then able to accept the breast as a predominantly good object, and also to introject this good object and make it the core of its own ego.[45] This drift towards a healthy attitude towards the breast is normally aided at a slightly later stage in development, when the infant, having phantasised violence towards the breast, fears its revenge.[46] The revenging breast exists outside the infant, but is often incorporated in suckling along with the good breast, and hence the infant fears attack from within as well as without.[47] But this new consciousness makes a selection between good and bad

objects all the more urgent. As long as the infant is able to expel the bad and incorporate the good breast, it will actually accelerate the incorporation of a good object. And in normal development, the infant will eventually overcome her or his split attitude towards the breast precisely by accepting its ambivalence, and by recognising it as a component of a maternal body (or whole-object) which is real and independent, and which is both good and bad.[48] In addition, in the so-called 'depressive position', the excoriating phantasies of the earlier, 'paranoid-schizoid', position become checked by the reality principle and by guilt over the harm that they may have 'caused'. This guilt gives rise to a desire on the part of the infant to repair and make whole the 'damaged' object, which, once repaired, is subsequently incorporated as part of her or his own ego.[49]

However, there are other scenarios in which the infant's development is less salutary, and the outcome less decisive. For instance, the subject may suffer from a sense of the labile quality of the internal object, which threatens continually to deteriorate into persecutory part-objects.[50] Cézanne's psychological character seems to correspond closely to this pathological type, for he seems to have experienced strong persecutory phantasies into late life. Bernard, Larguier and Vollard all recall that Cézanne would sometimes remark: 'c'est effrayante, la vie!' (life is terrifying) or suchlike, often in relation to thoughts about women.[51] His fear of being touched was also extreme. Bernard recalls, for example, that Cézanne warned him (on an occasion he had tried to help the older man to his feet after a fall): 'Personne ne me touchera … ne me mettra le grappin dessus' (Nobody may touch me … or get his hooks into me).[52] Bernard also recalls that Cézanne had forbidden his housekeeper even to touch him with her skirt as she passed him by. The same traits seem to have affected Cézanne's artistic character as well: for instance, Gasquet recalls how the painter assaulted a painting of the Mont Sainte-Victoire that had previously been coming along well, which suggests that he suddenly saw the object in the painting as damaged and/or persecutory (as do similar accounts from other witnesses).[53]

Ambivalence towards the breast and associated persecutory phantasies can often persist into later life, especially when the subject is prevented by anxiety on behalf of the good object from performing potentially dangerous acts of projection and/or introjection satisfactorily.[54] The subject may also be blocked in her or his reparative endeavours through lack of confidence in her or his ability to maintain good object relations, or because of a fear of putting the damaged object back together wrongly, and thus of damaging it further instead of restoring it.[55] These kinds of problem seem sometimes to have made Cézanne both blocked and obsessional over his work. Vollard for one recalls that his progress with any painting was 'lent et pénible' (slow and painful) because he was afraid of spoiling the work he had already done by proceeding hastily, or by disharmoniously arranging his colours.[56] Notoriously, Cézanne also told the dealer that he was unable to fill in two blank patches in his portrait and so finish it lest 'je serais forcés de reprendre tout mon tableau en partant de cet endroit!' (I should be forced to start the whole painting again beginning at that point!).[57]

To stop at this point would, however, be misleading. Painting was emphatically not merely an activity in which Cézanne neurotically repeated the irresolvable scenarios of his phantasy; it was a means through which he was able to find an imaginative solution to them.[58] Arguably, even his early 'erotic' works, which evidence a kind of aggression towards women that can be related to Baudelaire's work (and particularly to his poem about the rotting carcass of a female body, 'La Charogne'),[59] allowed him to externalise and eventually overcome his phantasies. It could also be argued that in the more sedate landscapes of Cézanne's maturity, the artist found a way of converting his phantasies towards the breast into a kind of play concentrated on the metaphorical breast of the Mont Sainte-Victoire.[60] It is also possible that painting the landscape allowed Cézanne to recognise and accept the mother's body as an independent whole-object of considerable, if ambivalent, meaning for him. And by doing this, Cézanne might have been able to re-create his early objects in a more perfect form, rather as we re-create other lost objects in mourning them.[61]

A drift away from violence towards more loving and reparative attitudes is certainly a strong feature of the development of Cézanne's landscape. One early landscape, *The Railway Cutting with the Mont Sainte-Victoire* of *c*. 1870 (Figure 27), shows schematic evidence of violent fantasies and consequent paranoia inasmuch as it foregrounds a hillock (or *mamelon* in French) which is cut through as if it were the breast attacked in phantasy. An intact Mont Sainte-Victoire, in turn, subsists in

27 Paul Cézanne, *The Railway Cutting with the Mont Sainte-Victoire*, *c*. 1870.

the background as if potentially threatening revenge; but fully mature paintings, such as *The Mont Sainte-Victoire with Large Pine*, overwhelmingly treat the maternal landscape as a good object. In this work, for example, the tree in the foreground metaphorically rhymes with and 'caresses' the distant mountain (or metaphorical breast) and so brings it close to the artist/spectator, as if to express a desire to draw near and assimilate the loved object. Cézanne reputedly told Gasquet with reference to this landscape: 'je tiens mon motif' (I hold my motif).[62] Here, it is as if he used the tree (together with the painting's lower and right edges) to 'hold' the near and far elements of the landscape – just as his hands would have done if he used them to isolate and frame the motif following the practice of contemporary landscape theory.[63]

While a marked change in attitude towards the landscape is visible in Cézanne's mature work, the spatial peculiarities the Mont Sainte-Victoire paintings of the mid-to-late 1880s (in which there is a marked tendency to ambiguate the relationship between foreground and background)[64] suggest his attitude towards the landscape is not without the ambivalence that the subject experiences in relation to her or his objects as she or he comes to accept their reality. Later works, such as *The Mont Sainte-Victoire seen from Les Lauves* of 1904–6 (Figure 28),[65] have much the

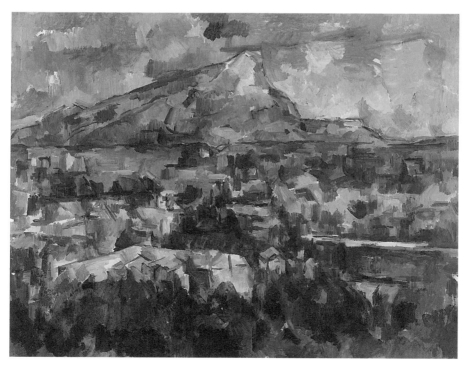

28 Paul Cézanne, *The Mont Sainte-Victoire seen from Les Lauves*, 1904–6.

same characteristics. They represent the motif from a viewpoint of considerable physical distance, yet they make the landscape *seem* near because the narrow angle of vision employed compresses the virtual space between the foreground and background.[66] Cézanne might have explained these effects in terms of his effort to follow the advice of J.-D. Régnier's *De la lumière et de la couleur chez les grands maîtres anciens* of 1865, which recommends that the painter employ an angle of vision of about eighteen degrees (and hence a distant viewpoint) to ensure that the image of the motif in his eye is small enough to be seen as sharp by the acute area of the central retina.[67] But the effect of Cézanne's procedure is to make the mountain appear at a safe distance, while it looms large just as the breast does for the infant suckling underneath it (an effect enhanced here by the mountain's 'ghosts' and its metaphorical nipple).[68] Such spatial ambiguities could be said to indicate that Cézanne accepts the ambivalent, or simultaneously good and bad whole-object – a conclusion which is consistent with the way the mountain appears simultaneously animated and threatening.

The same spatial ambiguities might also be explained by reference to the way that the infant, in any attempt to incorporate the whole-object, must simultaneously recognise its existence as a self-subsisting object independent of herself or himself, and of her or his phantasies. Cézanne's treatment of the landscape also seems to bear the imprint of other attitudes associated with the recognition of the whole-object. In particular, in works such as *Rocks near Grottoes above the Chateau Noir* of 1895–1900, Cézanne treats the incised and pitted quarry, seen frontally and vertically as if it were the mother's body, as a 'naturally' occurring excoriated surface which he can repair through his harmonious technique.[69] Cézanne also exhibits his painterly process as if to make sure it manifests his wish to make reparation through visibly 'enacting' repair. The interpretation is close to that of Adrian Stokes, who argued that the wish to make whole the damaged objects of phantasy underlies 'carving' (as opposed to 'modelling') in which all the parts of the depicting surface, and hence those of the objects depicted in it, are harmoniously integrated.[70] Cézanne's remarks to Gasquet about the way the Courtauld *Mont Sainte-Victoire* 'joint les mains' (joins hands) strongly suggest that 'carving' was in fact precisely what the artist intended.[71]

Conclusion

Broadly summarised, a Kleinian paradigm can suggest that the rock and the mountain in Cézanne's landscapes – and even the whole landscape – is grounded in phantasies connected with the mother's body conceived of, progressively, as a good object. It thus suggests that the gender of Cézanne's 'maternal' landscape is perceived in large part through an infantile conception of the mother's body that ontogenetically precedes a developed, or ideological, concept of gender difference. It also argues that in representing a metaphorical object of this kind, Cézanne's landscapes represent an object which he imaginatively incorporated into his ego,

especially while painting. It follows that what is represented in Cézanne's land-scapes is to some extent an 'undecidable' in terms of gender, being neither a gen-dered object in the usual sense of the term, nor even properly an object.[72] It may even be that Cézanne held something like this concept of his landscape as he is purported to have answered Bernard's question about whether painting 'la nature' (nature) meant painting 'notre nature' (our [human] nature) or 'la nature elle-même' (nature itself) by replying 'des deux' (both). Put another way, Cézanne's aim appears to have been to capture the phenomenon in which objective, 'femi-nine' and subjective, 'masculine' nature are conflated or fused.[73]

The same argument also suggests that when Cézanne painted the mountain or the rock, he figured the good object that he imaginatively introjected as the core of his ego. (The very hardness and massiveness of these objects perhaps indicates a desire for an enduring core or foundation to his ego.) Taken charitably therefore, Cézanne's preoccupation with his motifs is neither regression nor neurotic repeti-tion, but is the route by which he tried to reach back to the early foundations of his adult self in an effort to reorient himself away from phantasies associated with the paranoid-schizoid phase towards the more wholesome object-relations of the depressive position.[74] Taking this view, Cézanne's maternal landscape figures an ego incorporating a whole-object of the kind described in Baudelaire's, 'Tout Entière', in which the poet, when asked by the Demon for his favourite one among 'toutes les belles chose' (all the beautiful things) composing his beloved, replied: 'en Elle tout est dictame, / Rien ne peut être préféré (all Her being is my solace, nothing can be preferred).[75]

The Mont Sainte-Victoire seen from Bibémus of between 1895 and 1899 perhaps epitomises Cézanne's reparative and constructive way of seeing the landscape, since it fuses the ambivalent, but substantially good, mountain/breast and the damaged, but repaired, quarry/mother's body into a single, harmonious whole which, by virtue of identification, is also a part of the artist.[76] In doing this, the painter enacts exactly the kind of reparation of object and subject that Hanna Segal identifies when she describes how: 'in the unconscious of all artists … all creation is really a re-creation of a once loved and once whole, but now lost and ruined object, a ruined internal world and self. It is when the world within us is destroyed … that we must re-create our world anew, reassemble the pieces, infuse life into dead frag-ments, re-create life.'[77]

Taken altogether, it can look as though Cézanne's landscapes reach back to primitive phantasy to elaborate an alternative world, and potentially a form of life, in which subject and object enjoy a certain freedom from the normal consequences of ideologies of gender. Moreover, this world is not made for the artist alone; it is open to whoever is prepared to see it in the intentional structure of work.[78]

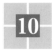

Robert Smithson's technological sublime: alterities and the 'female earth'

Caroline A. Jones

Introduction

It has never been earthshaking to assert that representations of land mobilise social categories of gender. The English phrases 'virgin land' and 'Mother Nature', religious goddess cults, and even Lovelock's contemporary Gaia hypothesis, all make metaphors of earth as if the planet's soggy biosphere possessed but a single sex, or at least a dominant one.[1] Of course, in such western thought patterns, the earth's sex is modelled on human reproduction; most metaphors do not draw on the more complex reproductive structures of plants (which are themselves mapped through human models separating supposedly 'male' from putatively 'female' parts).[2] But even beyond the European west, the earth is female. Monstrous or divine, the female earth seems deeply embedded in the strata of human metaphoric thinking. With the development of science as an autonomous disciplinary regime, there was merely a transition from reverence to domination in the employment of this operative metaphor.[3] Knowledge is less organised by professional and disciplinary regimes in art, yet many of the same discursive structures can be found. In the Earthworks produced by American artist Robert Smithson, however, the standard trope of the female earth mutates into polymorphous new forms. This chapter traces the origins and significance of that move.

The Earthworks movement (probably named by Smithson)[4] was both product and target of a new 'ecological age'. Since World War II, aerial photographs have fascinated the public; these views of the earth's surface and its natural and technological patterns were certainly stimulating to Smithson and his fellow Earthworks artists. Putting even these views in perspective, however, were the breathtaking 1968 NASA photographs of the earth in space – a fragile blue orb seen to be almost terrifyingly alone in the cosmos.[5] This image of 'Spaceship Earth' in its gossamer drapery of clouds soon came to permeate popular visual culture, from rock albums to covers of the *Whole Earth Catalogue*. The moment when Earthworks emerged in the late 1960s was characterised by the reign of plastics, 'better living through chemistry',

and a burgeoning military-industrial complex (demonstrated on the televised bat-
tlegrounds of Southeast Asia), yet these technological juggernauts were met by cor-
responding calls for going 'back to the earth'. Counter-cultural activists, feminists
and the incipient Environmental movement gave new momentum to the trope of the
earth's alterity – its femaleness, or in some variants, its Indianness.[6] Earthworks
artists, initially all male, emerged in this context. Yet for all their efforts to position
themselves as radically alternative to 'the absolute city system', they came them-
selves to be accused of doing violence to Mother Earth.[7] Smithson, emblematised by
his own *Spiral Jetty* (Figure 29), was the artist most identified with the Earthworks
movement in the United States. As Earthworks came under fire as examples of
human rapacity, he took it upon himself to respond.

Stung by a 1972 *New York Times* article in which a landscape painter had criti-
cised Earth artists for 'cut[ting] and goug[ing] the land like Army engineers ...',
Smithson published a rejoinder. He called the painter 'an etherealised representa-
tional artist [who] does mediocre Impressionist paintings' and contrasted this
effete, even irrelevant practice, to the Earth artists' more material engagement with
the soil. He complained about what he called an 'Ecological Oedipus Complex' in
which 'penetration of Mother Earth becomes a projection of the incest taboo onto
nature'. But rather than critique the gender assumptions behind his opponent's
attack, Smithson responded in equally loaded terms:

> An etherealised representational artist ... fails to recognise the possibility of a direct
> organic manipulation of the land devoid of violence and 'macho' aggression. ... The

29 Robert Smithson, *Spiral Jetty*, Great Salt Lake, Utah, completed 1970; as it looked in 1997.

farmer's, miner's, or artist's treatment of the land depends on how aware he is of *himself as nature*; after all, sex isn't all a series of rapes. ... If strip miners were less alienated from the nature in themselves and free of sexual aggression, cultivation would take place.[8]

What Smithson was trying to mobilise, then, was a sense of 'himself *as* nature' – albeit a dramatically technologised and dialectical form of the 'natural'. But what did he mean by this? Multiple interpretations are possible: he is a smaller element within the larger category 'nature' (as is a rock or a tree); *his* actions and natural actions can be placed on a continuum (as strip-mining is like an earthquake or avalanche), or, most ambiguously, he *is* nature (he occupies fully the discursive site 'nature' in all its forms). There is a fascinating tension here. The artist writes of the miner or artist as needing to be aware of 'the nature *in* himself' (human nature?) but he also demands an awareness of 'himself *as* nature', author of a 'direct organic manipulation' of the land, devoid of violence or aggression. This complicating of identity is extended further, for the process Smithson envisions also requires a removal or exteriorisation of nature to the position of Other (at least in this set of quotes). For to make Earthworks may not have been 'rape', but for Smithson, apparently, the activity still counted as 'sex'. Smithson seems to want not mere eroticism, but a sexual *relation* – one of physicality, pleasure, mutual response and even reproduction ('cultivation').

Pushing this quote still harder, we can view Smithson as building on the highly gendered discourse promulgated by his predecessors, the painters of American Abstract Expressionism. Here the art-making process itself was an encounter with sublime and elemental forces, usually gendered as 'oceanic' and female. Smithson, in attempting to bracket himself and his activities off from those he described as '*Representing* nature once removed in lyric poetry and landscape painting ...',[9] was only echoing the earlier claims of New York School abstractionists, who wanted their paintings to *produce the experience* of Sublimity, not depict it. Like Jackson Pollock, who had famously announced 'I *am* Nature' or Barnett Newman, who had analogised the experience of his enormous canvases to the sublimity of Indian burial mounds in the Great Plains, Smithson saw himself as an integral part of the natural-technological systems with(in) which he was working.[10] But in his complication of identity and difference, and in his problematisation of the discourse of Sublimity, Smithson achieved a much more radical destabilisation of the trope of the female earth. This chapter outlines the ways in which Smithson articulated nature as both 'within himself' and radically Other and argues that the terms which emerge in his discursive practices are those of a polymorphous sexuality, which can best be read within the framework that queer theory provides.

Fathering Earthworks

Smithson entered art history in 1965, with the simultaneous appearance of his first published essays and his first abstract geometric sculptures (generally made out of

pre-fabricated industrial materials and seen within the context of Minimalism).
Although he had been showing his art since 1959, Smithson later decided to begin
his official history with the date of 1964. It was only then, he claimed, that he
'began to function as a conscious artist …'. Smithson insisted that those earlier
'pre-conscious' years had been ones of purely private struggle, of getting things
'out of my system' and of getting 'rid of that problem [, overcoming that] lurking
pagan religious anthropomorphism'. But the view of Smithson's tumultuous past
tells a different story, one that makes his more famous Earthworks seem even more
powerful and complex.[11] In the past, the magisterial Earthworks projects were seen
as deconstructive, desublimating critiques. Through the prism of gender analysis,
however, a different set of questions is asked. Do Smithson's Earthworks operate
within the usual binaries of the sublime (e.g., Bounded male to Oceanic female,
Man to Nature, puny human to engulfing Mother Earth)? Or do they offer a col-
lapsed and conflicted model of difference? The conclusion to this chapter can only
begin to open the question, which extends far beyond the purview of this neces-
sarily brief excursus.

In the half-decade of professional art-making that Smithson attempted to
bracket off as 'pre-conscious', he worked out many of the ideas about sexuality and
the land that are later synthesised in the supposedly 'conscious' Earthworks.
Although most of these early assemblages on canvas were lost or destroyed, a few
survive as photographic images showing primitive, animal-like forms embedded in
bands of alternating textures, resembling stratigraphic diagrams made with an
Expressionist's brush. Writing about these works shortly after they were exhibited
in 1959, Smithson analogised them to 'Posters from Hell'.[12] This 'Hell' was not
merely an eschatological category, but for Smithson stood as a particular earth-
bound geological location. He described it in his poems at the time as a site of
unbearable compaction and compression, studded with keening souls trapped
within the cross-bedded rocks of sedimentary strata: 'Crushed under infernal /
Rocks … Shrieks pierce the bowels / Of the Damned'.[13] Far from considering such
images and narratives to be mere juvenalia, as he would later aver, it is argued that
these works express themes and concerns that extended throughout Smithson's
career.[14] Beyond visual and thematic signs of continuity, it is notable that Smithson
valued these early works at the time, and showed no signs of considering them pri-
vate or juvenile. He showed the 1959 'Hell' paintings in Manhattan galleries soon
after they were finished, sold them when there was interest, and chose them in 1961
for his first international exhibition at the Galleria George Lester in Rome.

It was around this time that Smithson completed several suites of pencil or pen
and ink drawings which indeed seem to have been more private (although even a
few of these were sold).[15] One such suite that appears to be complete is the extraor-
dinary *Hitler's Opera*, where Hitler is amalgamated with characters from homo-
erotic pornography and science fiction.[16] In one, a snake-like figure of Hitler
appears crucified on an airplane; in another, a jackbooted Hitler urinates on a tree
that sprouts snakes, horned beasts and swastikas in response. In these drawings, the

technological and the natural functioned for Smithson as oscillating alterities, but any pretence of a pure, natural 'ground' for an invasive technology is abandoned. Images of the technological in *Hitler's Opera* are demonic, but they are also erotic and generative (albeit of a monstrous spawn). Without a doubt, the erectile, technologically hardened figure of Hitler is partially a projection from within, as the repressed in Smithson's own identity, but it is also an Other. Nature, too, is both Hitler's victim and his progeny, both Other and offspring. Technology and nature are inextricably entwined in this oscillating alterity/identity formation.[17] Nature is Other to Hitler, but not Other to humanity; rather, humanity is seen *as* nature (as Smithson would later aver), but it is a human/nature made monstrous through its very links to Hitler, technology's avatar. Technology reconstructs the boundary between chaos and self that Hitler threatens to destroy; at the same time, natural boundaries are dissolved through Hitler's intervention. Smithson presents us with the 'mechan-organic' compound figured by the technological sublime, where body and ego boundaries alike are dissolved and then reconstituted through the mental experience of a technologised art (and the body experience of a hardened metallic form).[18]

This is not Sublimity's standard gender bifurcation between a female 'Mother Earth' and a heterosexual male viewer, who successfully resolves his Oedipal encounter through representation. In Smithson's sublimity, other narratives are in play. Trees, supposedly passive, vegetal components of the natural, respond to Hitler's 'watering' by bursting with nightmarish forms. The forms that emerge are uniformly male – the storm-trooper, the stag and masses of writhing, phallic roots. These demons display their faces, but in one dramatic instance, also their behinds. The homoerotic valence of the scene suggests that sodomy is in the air.

This reading may seem forced. But there is a loaded passage from one of Smithson's most celebrated later essays, *A Tour of the Monuments of Passaic*, that makes such a reading plausible. In this seriously funny essay, written in 1967 when Smithson's 'conscious' career was on the rise, the artist asks whether Passaic, a decaying industrial town in New Jersey, might have replaced Rome as the eternal city. As Smithson records his travels through Passaic, he analyses various monuments. We are introduced to the Fountain Monument, among others, in two different views that show a row of pipes spewing industrial effluent into the Passaic River. A great deal of space and attention is given by Smithson to these pipes, ready-made symbols of the ongoing industrial pollution of New Jersey's fragile riparian and wetland environments. Symbols that they are, it is significant that the artist sees them symbolically *not* in terms of heterosexual rape, but as participating in the definitional act of homosexual sex. He writes:

> The great pipe was in some enigmatic way connected with the infernal fountain. It was as though the pipe was secretly sodomising some hidden technological orifice, and causing a monstrous sexual organ (the fountain) to have an orgasm. A psychoanalyst might say that the landscape displayed 'homosexual tendencies,' but I will not draw such a crass anthropomorphic conclusion. I will merely say, 'it was there'.[19]

This passage is worth examining in some detail. It is not rape being described here, for the 'hidden technological orifice' achieves *jouissance*. And it is not heterosexual nor entirely polymorphous, for despite the photograph of multiple flows, the pipe is described as causing a *singular* 'monstrous' sexual organ to have an orgasm. (Lacan has established what the singular monstrous sexual organ must inevitably be.) The fantasised homosexual encounter here is carefully bracketed, doubtless part of that anthropomorphic past that the conscious Smithson has put behind him (so to speak). Smithson transfers this homoerotic reading to the speech of a psychoanalyst – but a psychoanalyst, it should be noted, is precisely that professional who is trained to access realms other than the conscious. Smithson can only insist on the quiddity of the event: 'it was there', but by scripting the psychoanalyst's speech he seeks to reveal the implicit meaning of the scene for his 'pre-conscious' self. In Smithson's carefully bracketed description, the technological sex takes place through the mediating body of the earth. The pipes are 'connected … in some enigmatic way …' and the earth is the organic medium for this orgasmic, technological coupling. The earth is not innocent, however. In Smithson's reading, *the landscape itself* can be said to 'display homosexual tendencies'. Clearly this is more complicated terrain than what is usually mapped by the trope of the female earth.

This challenges the very 'Ecological Oedipus Complex' that Smithson would complain about in his response to critics only a year later – an Oedipal formation thought to underlie the mechanisms of Sublimity itself. Is this male–male act a way of *fathering* Earthworks that leaves the trope of the female earth nothing more than a mute intermediary for a more socially transgressive act? Freud had left the classical roots of the myth behind when he located Oedipus in the bourgeois European family romance, yet a sexual female mother was still at the heart of the matter. There is no doubt about it: the father of psychoanalysis made the successful Oedipal passage into heterosexuality a *sine qua non* of civilised (male) adulthood. But at around the same time that Smithson was targeting the 'Ecological Oedipus Complex' for his scorn, French philosophers were beginning to aim their own devastating critiques against Freudian psychology's 'Oedipalising' of the unconscious. As Guy Hocquenghem wrote in his pioneering 1972 book on *Homosexual Desire*:

> … what the Oedipal construction manages to eliminate or channel is the sum of the challenges which are made by homosexual desire. Oedipal sexuality is based, as is the entire family universe, upon a game of imaginary oppositions which follow the rule of the double-bind. The double closure of false choices is obvious everywhere.[20]

In an intuitive (if more conflicted) way, Smithson was working towards a similar rejection of the Oedipal construct. In his writing on the 'monuments' of Passaic, whatever female elements remain in the landscape are elided with its 'homosexual tendencies', and the trope of the female earth is utterly undermined. Technological sex becomes homoerotically pleasurable, if a still-'guilty' echo of the monstrous homoerotic hybrids in the Hitler suite.

It should be clear that reference made to Freud here is not as a scientist *outside* of these cultural structures but as a member (and marker) of the same cultural continuum in which Smithson grew up (and, not surprisingly for one who considered himself an intellectual, Smithson had both *Totem and Taboo* and *Civilization and its Discontents* in his library). The discourse of 'sublimity' is itself inextricably marked by the ideas of subjectivity and narrative that would culminate in Freud's discovery of narrative therapy (the 'talking cure'). Just as the sublime operates through a narrative of its effects, so psychoanalysis relies upon literary structures of revelation and conclusion. Despite his incipient critique of the Oedipal, then, Smithson was marked by Freud, unwittingly echoing Freudian metaphors in his perception of Passaic's pipes as libidinous structures of desire that could only be de-coupled (so to speak) by a Freudian psychoanalyst. Freud, constructing his theory of the infantile fixations underlying an individual's homosexuality, had written: 'the various channels along which the libido passes are related to each other from the very first like inter-communicating pipes, and we must take the phenomenon of collateral flow into account.'[21] Smithson further signalled his Freudian attitudes in demonising such 'collateral flows', associating same-sex desire with Hitler and monstrosity. Smithson's pathologising Freudian accounts, like others that are still very much with us, were what Hocquenghem and other gay theorists were then attempting to destroy and it is clear that Smithson himself was struggling to construct a different reading. And indeed, it is argued that the discourse of Smithson's later Earthworks can be contained neither by Freud's medical schematics, nor by the standard narratives of the Sublime. By outlining the continuities between the early works and later Earth art, their deployments of sexual politics can be contrasted and the 'nature' of Smithson's production understood.

The blindness of the cartouche

Dating from the same time as the Hitler suite, and returning to the theme of Oedipus, is a sheet Smithson titled *Blind in the Valley of the Suicides*, from a group of drawings he executed in 1962.[22] As in the Hitler drawing from the year before, nature is wholly anthropomorphic. The sheet in question shows a single man who has become a tree, his upturned face blinded by two vertical branches that sprout from his eye-sockets and grow towards the light. The growth becomes a form of monstrous birth and potency, linked analogously to the monstrous and miraculous serpent progeny of the Hitler-fertilised roots of *Hitler's Opera*. The blind but growing branches are a figure for the potent phallus, a restorative inversion of the castration symbol implied by ocular impalement. One need think only of the classical models for violent blindness, some of which became Freud's own: Cyclops, his awesome power (phallic in its one-eyed, towering state) snuffed by a burning brand to the eye; Teresias, blinded by the gods for seeing Athena naked (and then turned into a female and given prophetic gifts); and most famously Oedipus, blinded by his own hand for crimes against patriarchal law and an unwitting desire for the

Mother.[23] Smithson's image of blindness-through-impalement (here originating in the 'nature' of organic growth) thus retains a highly sexualised subtext. And it is significant that this subtext is played out not in the simple body of a man, but in the polymorphous and hybrid form examined in this chapter, 'man-as-nature'.

By 1963, the Blake-like style of such drawings and their Bosch-inspired imagery began to shift towards more explicit eroticism, much of it copied or traced by Smithson from pulp pornography or science fiction magazines. The artist achieved emotional distance from such loaded images through a variety of means that I have termed the 'dialectics of the cartouche', seen in a collage dating from 1964 (Figure 30).[24] Nature *qua* nature disappears, but such cartouches set the template for the complexly gendered dialectics in Smithson's Earthworks to come.

It was Smithson who described such works as cartouches, thereby privileging the centred items over the more obviously 'authored' images at the edge. Even when shielding the works' actual content, Smithson recalled these drawings as crucially transitional: 'They were sort of proto-psychedelic in a certain kind of way. They were somewhat like cartouches. They freed me from the whole notion of anthropomorphism. I got that out of my system, you might say.'[25]

The notion of *anthropomorphism* was presumably exactly what had engendered the types of monstrous, humanoid trees we saw earlier; recall also that 'anthropomorphism' would be stigmatised as the psychiatrist's sin in the ruminations about the 'Monuments of Passaic'. The cartouche offered to bracket the kind of sexual and biological issues that were reflected in the anthropomorphic drawings of monstrous or castrating trees. The dialectic provided by the cartouche gave Smithson an important measure of discursive distance. Crucial for argument, however, is the fact that these works' seemingly perverse sexuality was bounded by the cartouche dialectic, but not destroyed. The centre of the cartouche becomes literally 'blind' to its surround (and vice versa), but it is a blindness which should be seen to preserve all of the psychosexual import and subconscious *knowing* of that state. In sum, the dialectic between centre and surround (or cartouche and field) became a model for Smithson in articulating a productive relationship between levels of content, a relationship particularly evident in his well-known site/nonsite phase preceding the later Earthworks.

Untitled (Hexagonal Center) (Figure 30) is much sparer in its imagery than some of the cartouches.[26] The drawing is dominated by 12 nesting hexagons separating erotic centre from pornographic surround. The nested forms alternate between colours of light and dark value to form a highly decorative pattern that conveys an illusion of deep spatial recession. The innermost hexagon, which reads as the 'hole' at the end of this recessive polygonal well – or the oculus at the centre of a camera's shutter – contains a fragment of the well-known School of Fontainebleau betrothal painting in which Gabrielle d'Estrées's nipple is pinched and displayed for the approval of her husband-to-be. The technological hardening that separates this charged erotic gesture from its flowing surround is not industrial machinery in this

instance, but geometry. The controlling geometry seems warped by the force of its eroticised margins and contents; destabilisation of the hexagons parallels our own as we brace ourselves from falling visually into the 'knowledge of corruption' that Smithson and d'Estrées seem to offer.

After moving into Minimalism and, finally, Earthworks, Smithson had positioned these dialectics of the cartouche as significant only as preparation for a dramatic rupture. The breakthrough, Smithson recalled in a 1972 interview: 'came once I was able to overcome this lurking pagan religious anthropomorphism. I was able to get into crystalline structures [that were] essentially abstract and devoid of any kind of mythological content. ... I had completely gotten rid of that problem.'[27]

30 Robert Smithson, *Untitled (Hexagonal Center)*, c. 1963–64.

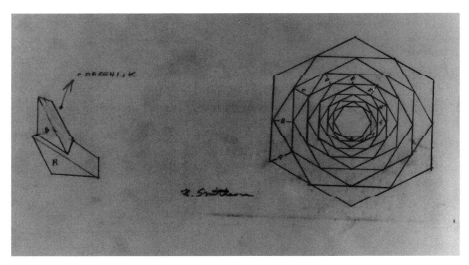

31 Robert Smithson, *Drawing for Gyrostasis*, 1968.

Smithson's rhetoric of purgation ('I got that out of my system', 'I had completely gotten rid of that problem') enforces a finality on his development that serves him psychologically. But in fact, the boundaries between humans and nature, the crystalline and the amorphous and the male and the female were more permeable, and continuities more compelling. As we have seen, the foundation for his dialectical system was already in place by 1963 with the cartouche drawings, and had been initiated even earlier with the Hitler suite in 1960. The linkage is demonstrated by the obvious connection between *Hexagonal Center* and the minimalist works that followed – particularly the sculpture *Gyrostasis*, for which a study survives (Figure 31). As the drawing indicates, Smithson took sections of a set of nested hexagons to generate the sculpture's form. The hexagons in this Minimalist drawing are clearly taken directly from the 1963 'pre-conscious' hexagonal cartouche – that destabilised, eroticised, ocular well.[28]

The important point to be made is that Smithson's later separation between 'conscious' and 'pre-conscious' phases will not hold. Traces of the flowing, bleeding, puddling, spiritual, erotic, hairy 'organic' negotiated with a metallic, faceted, spiky, hardened, scientistic, technological, 'crystalline' industrial aesthetic are in *all* of Smithson's works. The intertwining channels that link these terms in Smithson's art serve as a model of something *other* than heterosexual relations; they put the notion of a simple binary into question, and propose a gendering of Smithson's dialectic that appears quite different from the trope of the 'female' earth.

'*Gyrostasis* is relational', Smithson wrote in 1973, 'and should not be considered as an isolated object.' What he wanted to relate it to, of course, differed markedly from the links argued here: 'The title *Gyrostasis* refers to a branch of physics that

deals with rotating bodies, and their tendency to maintain their equilibrium. …
One could consider it as a crystallized fragment of a gyroscopic rotation, or as an
abstract three-dimensional map that points to the *Spiral Jetty*, 1970 in the Great
Salt Lake, Utah.'[29]

In place of an eroto-scopic section (the nested hexagons), *Gyrostasis* was
described as presenting a gyro-scopic rotation (the mapping of the earth); the one
has its origins in the 'pre-conscious' period, the other self-consciously reaches
towards Smithson's most famous and successful 'conscious' career, emblematised
by *Spiral Jetty* in all its discursive forms. The triangulated spiral found in
Gyrostasis is a hinge. It is a figure for the linkage between realms of consciousness in
identity, and a mark of sexuality's flexible boundaries (as opposed to gender's
inflexible, if performative, roles). The modest geometric form of the triangulated
spiral looms large in Smithson's thinking, positioned as central in an important
drawing from the year of the *Jetty's* construction, *A Surd View for an Afternoon*
(Figure 32).

Surd View charts Smithson's past, and plots his future trajectory. Its complex
surface is covered with overlaid sites, times, spaces and concepts. Drawn in pencil

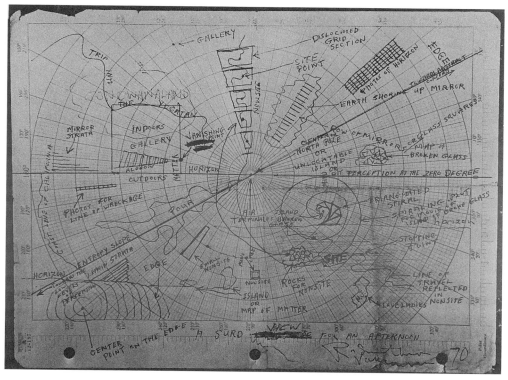

32 Robert Smithson, *A Surd View for an Afternoon*, 1970.

on a sheet pre-inscribed with 'polar coordinates' and gridded concentric circles, Smithson's nomadic conception takes as its cardinal points the arbitrary edges of the page, where the circles peter out into a peripheral void. He uses the absolute centre of the nested circles for an origin (ironically, empty of an image). This origin is marked as containing the 'air terminal site' where he first used the word 'earthworks' to describe his work. Using the same type of triangulated spiral as *Gyrostasis* (itself generated from *Hexagonal Center*), Smithson had proposed in this case to cast a flat composition of concrete embedded in the surface of the earth and meant to be viewed from an aerial perspective, available only from the vantage point of aircraft circling the air terminal site.

The triangulated spiral appears again, slightly off centre and to the right, but connected by a spiralling line to the map's origin point, the 'Center or North Pole or Unlocatable Island or Dot', as Smithson puts it. The originary triangulated spiral is explicitly connected to the curving spiral of the *Jetty* and the spiralling reels of film Smithson had made, or planned, of his various Earthworks. From the project that represented his first physical involvement with the supposedly 'female' earth, to the culminating discursive masterpiece of the *Spiral Jetty*, Smithson turned to the triangulated spiral, that loaded fragment from his cartouche, the mediating term (geometric, and quasi-industrial) separating realms of hybrid, anthropomorphic 'nature' in all its polymorphous eroticism and suspect homosexual tendencies.[30] The precarious equilibrium they represent is highly tenuous, held in place by the fragile construction of consciousness itself, a process at the heart of Smithson's evocation of the technological sublime.

Returning to the discourse of sublimity, this chapter concludes that Smithson's *Jetty does* work to problematise standard male narratives of the Sublime. The water that the jetty encloses is not only an oceanic expanse, it is a figure for the erotic beings (few of them exemplary heterosexuals) who floated beyond the boundaries of Smithson's cartouche. The *Jetty*'s crystalline path is not merely a rocky bulwark that keeps the organic at bay, but an unstable fragment of a constructed dialectic, slipping under water and tumbling inward in constant negotiation with the libidinous knowledge Smithson wants to retain.[31] The groaning bulldozers depicted constructing the jetty in Smithson's film and essay are not only metaphoric equivalents to the male body made rigid with technological power, they are also collaborative authors that trouble the traditionally male construct of the individual author. These troubles, and this instability, are productive. They are crucial to the polymorphous eroticism of Smithson's *Jetty*, in which the very structures of difference and ego are made the subject of a postmodern critique.

Theories of sublimity, from Edmund Burke to François Lyotard, have evolved into a psychoanalytic narrative of male subjectivity, in which the viewer of the Sublime encounters a great and terrifying vastness, an oceanic expanse or an awe-inspiring enormity reminiscent of the maternal body. This vastness dissolves the very ego of the subject, who is plunged into a terrifying yet exhilarating pre-Oedipal state, a state without language, and few visual conventions. Slowly coming

to terms with the experience through the representational process itself, the subject is reconstituted; ego boundaries are renewed, and the self is enriched through its very mastery of the dissolution threatened by the female Other.

Smithson complicates this trajectory. It is true that his earlier work was partially constrained by a Freudian model that viewed same-sex desire as a pathological development from the Oedipal phase of childhood sexuality.[32] As we saw, Smithson's orgasmic pipes conformed to the twin narratives of Freud's pathologised homosexuality (based on an arrested infantile sexuality that was itself represented via metaphors of connecting pipes) and a recuperative, sublimating Sublime. Moving through the earth (which became implicated in 'homosexual tendencies'), the secret sodomists engaged in explosive sex through an enigmatic and 'monstrous' realm of darkness. The ego was reconstituted through representation (both Sublime narrative and psychoanalytic 'talking cure').

But the sublime Oedipal trajectory does not play itself out in such a linear fashion in the extraordinary *Spiral Jetty*, nor in the cartouches which lie at its origin. The doubling and mirroring of the *Jetty* through films, photographs and essay works to complicate the fantasy of representational closure and recuperation of the individual author/reader that is crucial to the Sublime. Put simply, only part of the *Jetty*'s profound effect is a product of the masculinised discourse of technological sublimity. The *Jetty*'s stature as a prime object in the discourse of postmodernism is due to its simultaneous construction and deconstruction of Sublimity's standard binary terms. This chapter has attempted to reveal something of the extraordinary subterranean murmur that accompanies all of Smithson's work, a 'neither–nor' that can be heard critiquing the more simplistic 'either–or' of the trope of the female earth. These are the complexities needed when engaging the question of landscape and gender, where our very categories of analysis hobble the answers we hope to find.

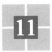

Gender in perspective:
the king and queen's visit
to the Panorama in 1793

Denise Blake Oleksijczuk

On 24 May, 1793, the Master of the Horse at Windsor Castle made the following note in his diary: 'The King went to see the Panorama in Leicester Square, in the Levée Coach.'[1] In fact, as reported in London newspapers, King George, Queen Charlotte, five of the princesses and Lord Harcourt as the Lord in Waiting, were the first visitors to what was to become one of London's most celebrated exhibitions.[2] The Panorama – a name derived from the Greek words for 'all' and 'view' – was an architectural apparatus built for the display of two enormous cylindrical paintings, one ninety feet, and the other thirty feet in diameter. Within each 'circle of observation', spectators emerged from a stairwell on to a platform suspended at the centre of a seemingly boundless view (Figure 33).

Robert Barker, holder of the patent for the invention and proprietor of the Panorama, was present for the Royal visit, as was his son, Henry Aston Barker, the painter of the massive canvas. Standing on the platform in the Panorama's interior, the king and queen, along with the other spectators, beheld a scene that had taken place two years earlier: the assembly of the Grand Fleet of the Royal Navy, the aggregate of the nation's naval power, moored off Spithead, near Portsmouth, in 1791.[3] While this picture is no longer extant, an idea of its appearance can be drawn from the surviving descriptive-sheet or key that was given to patrons (Figure 34). According to the key, the viewpoint of the picture was the frigate *Iphigenia*, situated in between the two parallel lines of anchored battleships. The viewing platform for the scene was made up to look like the deck of a ship.[4] Henry Aston Barker wrote about the Royal visit in his diary:

> The king asked many questions; and when answered, turned round to Lord Harcourt, to whom he gave the answer verbatim, always beginning with 'He says' so-and-so. His majesty had a large gold-headed cane, which he pointed with, and sometimes put into my hand, making me stoop down in a line with it, to be informed of an object so small that I could not otherwise understand him.[5]

33 Robert Mitchell, 'Section of the Rotunda, Leicester Square', from his *Plans and Views in Perspective of Buildings Erected in England and Scotland*, London, Wilson & Co., 1801.

34 Robert Barker, 'View of the Grand Fleet, Spithead', 1793.

In contrast, Barker continues, 'Queen Charlotte said that the sight of the picture made her feel sea-sick'.[6]

This account, particularly the comment on the queen's reaction to the view, has often been cited as testament to the high degree of realism achieved in the painted vista.[7] Barker's short narrative highlights the king's concern with identifying details in the picture and the queen's more visceral response. Because differences between modes of address to the visual field can only be examined with reference to specific instances of the viewing activity, Barker's anecdote is a useful commentary on the entry of two individuals into the unique visual environment constructed by the Panorama. As Peter de Bolla explains, the viewer's insertion into visuality 'includes the somatic locations of a particular body in determinable real space – as well as the imaginary sitings of the specific ideologies of the individual, be they inflected by class or gender, within the virtual space of visuality'.[8] He stresses that such insertions are interactive processes, as social status and gender attributes can be both reinforced or undermined in the sitedness of looking.[9]

Barker's description of the reactions of the first visitors to the novel visual apparatus indicates that the Panorama allowed for two different modes of visual address. According to several accounts, of which Barker's anecdote is the first, women's insertion into the visuality in this circular enclosure often conjured the sensation of seasickness. This chapter contends that far from simply reinforcing the classical pairing of women and nature, this unusual corporeal reaction to the new visual form suggests that the gendered discourse of sensibility became heightened in response to the two modes of vision allowed for by the Panorama.

In considering Barker's diary entry as a parable, that is, a textual representation that takes the form of a comparison, it is argued that Barker's account of the king and queen's reactions was rooted in two fundamentally different ways of viewing that depended upon a cleavage in the Panorama's structure of representation, a split that his text relates directly to gender. The gap between the physical spaces of the Panorama and the virtual space of the visual representation was productive of new meanings – especially with respect to the female spectator of refined sensibility – that had import for the definition of a modern visual model, and furthered the conceptualisation of a distinctively modern sense of the self.

The anecdote of the Royal visit to the Panorama will be used as a focal point of a local and precise study of the way that the discourses of gender, sensibility and visuality come together and were transformed at this site. In order to examine the cultural dimension of the king and queen's insertion within the visual field constructed by the Panorama at this historical moment, three overlapping issues will be explicitly addressed: gender and the spaces of illusion; sensibility and the performance of femininity; and the disjunction between the theory and the practice of perspective in relation to the static and the mobile spectator.

Seeing and feeling

Barker's description of the Royal visit has been repeated in nearly every historical account of the Panorama. Its suggestion that the queen was literally fooled by the artist's skill into mistaking an image for the real thing has never been questioned. In his manuscript Barker represented the king as a rational and analytical man engaged in translating what he saw into discourse, whereas he represented the queen as a woman with highly receptive senses given the visceral effect that she said that the image provoked in her. While the king's attention to the small and precise objects in the distance denoted conventional behaviour before a perspective view, it was the queen's physical response to the ensemble – the suggestion that she experienced a kinesthetic hallucination – that conveys the idea that the Panorama's verisimilitude was of an order never before witnessed.

Barker's report suggests that the queen confounded illusion with reality because she did not merely see the picture with her eyes but *felt* it with her entire body by appearing to be affected by the sway of an anchored ship. This was only the first of many such stories, all of which can be traced back, as Richard Altick suggests, to Pliny's account of the competition between Zeuxis and Parrhasios:

> Parrhasios and Zeuxis entered into a competition, Zeuxis exhibiting a picture of some grapes, so true to nature that birds flew up to the wall of the stage. Parrhasios then displayed a picture of a linen curtain realistic to such a degree that Zeuxis, elated by the verdict of the birds, cried out that now at last his rival must draw the curtain and show his picture. On discovering his mistake he surrendered the prize to Parrhasios, admitting candidly that he, Zeuxis, had deceived only the birds, while Parrhasios had deceived himself, a painter.[10]

Pliny's story provides one entry into a re-evaluation of the report of the king and queen's very different responses to the Panorama's illusionary devices; it allows us to consider Barker's diary entry as a modern parable, one that has similarly been repeated up to the present. A comparison of the Pliny and Barker parables reveals that they both imply two competitions rather than one. In the ancient story, the explicit competition between Zeuxis and Parrhasios is intimately connected to the implicit comparison between a bird's and an artist's ability to distinguish between nature and a painted likeness. In the modern parable, the explicit and implicit competitions are reversed, placing greater emphasis on the observers. Given the late eighteenth-century British propensity to measure modern improvements against antiquity's achievements, Henry Aston Barker's rival might be seen as the ancient painter Parrhasios. With regard to the competition set up between observers, in contrast to Pliny's description of an animal and a man responding in the same way to two different images, Barker makes a comparison between the differing responses of a man and a woman to the same image. Hence, in Barker's story, George III, whose eye is apparently not deceived, plays the role of the inquisitive, perceptive spectator, while Queen Charlotte occupies the place of

either the inferior painter who mistakes the painted curtain in Pliny's account for a real one, or the duped bird who is foolish enough to be caught trying to nibble at painted grapes.

When considered as a modern version of Pliny's tale, on one level, Barker's account affirms the wide consensus among late eighteenth-century writers that women's weakness, both of body and mind, was the basis of the female character, intellect and social situation.[11] Aristotle's complementary opposition of female memory and imagination to male discursive and speculative reason was at that historical moment being recast as an opposition between the female understanding of concrete details and the male command of abstract principles.[12] As Lorrain Daston explains, female intellectual traits were understood to differ significantly from those of the male in that the former were, 'corporeally grounded, largely determined by women's allegedly cold, moist bodily complexion. Sensory impression, stamped upon the brain as a seal upon wax, therefore adhered more easily, distinctly, and durably in the soft, humid female matter than in that of the hot, dry male.'[13] Within these terms, the mobility and sensitivity of women's organs presumably enabled Queen Charlotte to seize the painting with her entire body and not simply her eyes. The queen's 'feminine' sensitivity to the illusionistic power of the image would have been regarded as typical. Because the king and queen's reactions in Barker's anecdote accorded perfectly with the characteristics that many held were grounded in the authority of nature itself,[14] as a textual representation, it was not only a testament to the high degree of realism achieved in the painting, but more importantly, it served the function of forging and enforcing gender identities.

Yet the mimetic charge of the Panorama was achieved both by means of lifelikeness and by the construction of a space where the spectator was separated from the outside world. This too can be traced from the competition between Zeuxis and Parrhasios for, as Norman Bryson has emphasised, the enduring interest in the classical tale over the centuries depends less on a simple opposition between the real and the not real (real grapes here, painted grapes there) than on the kind of space in which the paintings were exhibited. For Bryson, it is critical that the painting competition occurred in a public theatre because the fictional reality that theatres construct depends on a series of thresholds that the viewer is required to pass through before he or she engages with the illusionistic decoration. The first threshold is traversed upon leaving the outside world for the built space of the theatre; next, there is the threshold of the auditorium where 'the conditions of the real world, the world of the auditorium, are suspended, and the space of reality yields to that of fiction'.[15] Lastly, there is the final threshold where the illusionistic space of the painting reconfigures the space of the stage, like a play within a play.[16]

While not a public theatre, the Panorama as a unique public space likewise set in place a series of interconnected spaces through which the viewer was made to pass before finding herself or himself surrounded on all sides by a spectacular, three-dimensional painting lit by natural light. In the Panorama, three thresholds

gradually separated the viewer from the conditions of the world outside. The first threshold was the boundary that marked the external space of the everyday life of the streets of London from the internal space of the architecture housing the illusionistic view. The second threshold was established by the boundary between the narrow, darkened corridor and stairwell and the surprising, vast and naturally lit space of the viewing platform or stage. The third degree of separation involved the almost invisible threshold that divided the area enclosed by the 10,000 square foot canvas that surrounded the viewer and the interior space of the picture. Since the image extended in all directions, the physical space of the round room was overlaid upon the virtual space of the perspective view to a much greater degree than on a conventional stage. Precisely because the Queen's somatic engagement with the image deviated from conventional practices of looking at framed pictures, what needs to be considered here is how the fictional reality created in the Panorama worked together with the social, cultural and discursive construction of gender and class to determine her particular position both within and in relation to the visual field.

Seeing the world

In view of the theatrical, unreal space established within the Panorama, we might also understand Queen Charlotte's response to the painting as a feigned, perhaps highly internalised, performance which conformed with socially accepted standards of the 'feminine'. The notion of sensibility was central to eighteenth-century psychological theory, and it referred to the perceptual and emotional sensitivity to impressions.[17] Physiologists argued that women were more sensitive than men were because they had finer and more delicate nerves. As the century progressed, however, a keen sensibility became a mark of distinction in polite society, a means of identifying women of the middle class or higher. The range of feelings and behaviours associated with the feminised disorders of 'the vapours', 'megrim' and 'crispations of the nerves' were all developed within the discourse of sensibility.[18] As women began to carry smelling salts in order to cope with their excitable bodies, they learned to use the discourse of sensibility because it at once communicated their high rank and captivated the male sex.[19]

As feminist scholars have long maintained, gender is not just socially but historically constructed. Because the subject is constructed in discourse and representations and is thus not a stable and unified category, 'femininity' or 'masculinity' are never established once and for all. Femaleness does not necessarily confer femininity, nor maleness masculinity, they are aspects of an individual's identity that need to be perpetually asserted, renegotiated and performed.[20] In the late eighteenth century, because she refused to display an exaggerated and pious sensibility, Mary Wollstonecraft was derided as an 'unsex'd female', that is, not a female at all.[21] On the other hand, intellectual males and dandies also took on the claims of sensibility to distinguish themselves from the manly virtues of commercial or navy men.[22]

Therefore excitement over the all-encompassing view was felt by certain types of men and women, and it is in a female poet's commentary that we find the delu- sionary effect mentioned: in 1794, Anna Seward described the View of the Grand Fleet as 'the watery delusion of the celebrated panorama'.[23] Moreover, it was fre- quently reported in the popular press that 'ladies with delicate nerves' and 'young dandies' felt a sense of dizziness or seasickness at the sight of the panorama's curved horizon line.[24] Since mental and physical strength and self-control were considered to be manly virtues, dandies, as men of leisure, devoted to fashion and frivolity, were considered to be effeminate, unmanly men.

According to Stephan Oettermann, spectators were attracted to the Panorama because during this period people 'sought … a tingle of excitement in situations that were easy to control. The experience of taking something to the limit was another reason for climbing the towers and mountain peaks and visiting their sur- rogate, the panorama.'[25] Oettermann identifies the discovery of the horizon as one of the key experiences of the late eighteenth century. He compares the Panorama to carousels which were popular at the same time, stating that they both provided a symbolic tour along the horizon. 'To the dismay of upholders of decency every- where', writes Oettermann, 'ladies in particular relished riding them to the point of nausea'.[26] While women and effeminate men were free to express their sensations of dizziness or nausea which were reported so frequently at this time, such a display of the human body's frailty suggests not only the limitations of human vision, but the limits of gendered identity. For while, as Oettermann contends, 'the notion that these limits should be challenged and overcome was prevalent',[27] that was only true of men eager to affirm their masculinity.

In the cross-section of the Panorama rotunda drafted by its architect Robert Mitchell (Figure 33), of all the fashionably dressed people depicted, two-thirds are women. While such a representation might erroneously create the impression that more women frequented the Panorama than men, it nevertheless conveys the idea that the Panorama was a respectable place for women to visit whether or not they were accompanied by someone. Free to walk around on a central platform, viewers would criss-cross one another's sight lines to look at any part of the painting's circumference. Just as the painting could be seen from all points on the compass, within the Panorama each spectator's body could also be looked at from all sides. Other spectators would inevitably come between each other's gaze and the view. When this occurred, the painting would function as a backdrop, trans- forming the audience into participants in the spectacle, into actors set off by astonishing scenery. For those who could afford the shilling entrance fee, spec- tating in the public Panorama involved watching others in the activity of looking, and in finding pleasure in the fact that one's own body was being observed and positioned in relation to specific social, economic and gendered categories of the individual.[28]

However, the access of women to new public spaces was not uncontested. As growing numbers of women began to enjoy the city's new entertainments, religious

reformers were at the forefront of the struggle to confine them to the home. In texts that extolled female chastity and modesty, an idealised domestic sphere was constructed and evoked based on a complete separation of the home and the world. As Elizabeth Bennett Kubek argues, 'the growth of new public places open to women as well as men in London posed a threat to a settled patriarchal order, which saw visual consumption as the most morally dangerous manifestation of desire for women, both as subjects and objects.'[29] Religious moralists warned that the security of the state depended on women's 'virtue'. There was a fear that if licentiousness and infidelity spread among women, society would be contaminated, and 'all would be corruption and disorder'.[30] By the end of the century, the increasing concern regarding passing on wealth and bloodlines to the next generation impelled several novelists, female as well as male, to encourage their virtuous heroines to reject the pleasures of the city.[31] They reasserted the domestic role of women in response to the perceived threat to society of women circulating in public spaces.

Hannah More, in her treatise *Strictures Concerning the Modern System of Female Education*, which saw several editions in the late eighteenth century, reviled the climate of the age in which women want to learn 'accomplishments' that have public display as their object. Using a derisive tone she fulminates: 'Seeing the world! Knowing the world! Standing well with the world! is spoken of as including the whole sum and substance of human advantages. They hear their education almost exclusively alluded to with reference to the *figure* it will enable them to make in the world.'[32] Men, on the other hand, More asserts, are more suited for the public exhibitions on what she calls 'the grand theatre of human life'. For, unlike women, their character does not suffer from being always employed in the constant commerce of the world.[33] Yet what More sees as a natural ability in men in fact was due to a gradual development that led commercial men to adopt personalities and behaviour best suited to the practice of mercantile capitalism.[34]

For women faced with the stark choice between the virtues of the home and the contamination of the world, the Panorama may have represented a compromise. A limited sphere implied restricted experience and restricted activity, and these two vital aspects of life were increasingly important to an individual's intellectual development at the end of the eighteenth century.[35] In short, by going to the Panorama, women could gain access via a simulated representation to geographical locations they would normally never see in real life.

Entering into the Panorama and positioned amid the waves on the British battleship, the *Iphigenia*, the presumed female characteristics of sensibility and impressionability could potentially respond to what one eighteenth-century commentator on women's traits referred to as the broad experience and strenuous activity of the 'always active man ... nourished on mountain peaks, at the edge of volcanoes, at sea, in battlefields, or in the midst of ruins'.[36] In view of the exclusion of women – even women as highly placed as Queen Charlotte – from important public spaces, the Panorama may have offered a place of inclusion. More than any other form of representation, the panorama depicting the masculine domain of Britain's Royal

Navy allowed the female beholder the vicarious pleasure of occupying a viewpoint reserved for a man of the world.

Because of this, women may well have sought out this kind of amusement as an escape from their routine and highly circumscribed lives. While Christian moralists may have reviled the ideas about travel and sightseeing that it put in women's minds, it was the pleasures of the self – of absorption and auto-voyeurism – that the Panorama offered them with which they were most concerned.

The Panorama as a new framework for visual perception

But the viewer's perception and judgement of *what* was seen in the panoramic apparatus was dependent on *how* it was seen. From yet another perspective, the conflicting responses of the king and queen registered in the anecdote above may derive from the extraordinary spatial effects of a heterotopia. Michel Foucault defines a heterotopia as an enclosed site composed of heterogeneous spaces that 'have the curious property of being in relation with all the other sites, but in such a way as to suspect, neutralise, or invert the set of relations that they happen to designate, mirror or reflect'.[37] Describing the ship as the greatest reserve of the imagination, Foucault acknowledges it as a heterotopia par excellence: 'the boat is a floating piece of space, a place without a place, that exists by itself, that is closed in on itself and at the same time given over to the infinity of the sea'.[38] As a place that is simultaneously mythic and real, a heterotopia's meaning is arrived at through its peculiar attribute of referring to the space outside of its boundary in such a way as to define that space's particular lack. Thus the heterotopia stands as a 'counter-site' which allows for the recognition of a problem with the conventional spaces of lived experience. The notion of a heterotopia provides a way of approaching what I call here the dual nature of the Panorama, that is, its two-fold structure of representation, which depends on whether a viewer is static – taking in one perspective view, or mobile – confronted with a series of perspectival vistas. These oscillating experiences of viewing can be understood as typified on the one hand by the king's rational inquiries concerning the objects represented in the image and, on the other, by the effect the illusion was seen to produce on the queen's body.

The Royal couple, as the nation's exemplary husband and wife, assumed traditional gender roles, and these are registered in the anecdote's stress on the authority of the king and the implied transport of the queen. During the Royal Family's visit to the Panorama, the king's relation to the scene was as the Royal Navy's supreme commander who customarily performed reviews of the fleet.[39] Conversely, the queen's relation to the image was that of an onlooker. According to Barker's anecdote, both king and queen were engaged in different processes of looking, both of which can be linked to moments of fantasy and desire. A heterotopic 'doubling' of space occurs at the instant that two people look at the same thing but construe two different objects.[40] But gender and experience stand in a complex relation to the structure of representation encountered in the Panorama, at once determining

accounts like Barker's while also indicating that significantly conflicting forms of comprehending the scene could be experienced by different viewers. Here, an analysis of how perspective works in panoramic representations will suggest that the apparently gender-based distinction between the king and queen's response to the view was reinforced by the Panorama's two-fold structure of representation.

The Panorama's painted landscapes were composed from six to eight rectangular drawings, executed at the site with the aid of a gridded perspective frame known as 'Alberti's veil'. The series of sketches would have been joined together to form a polygon, and their edges blended together to form a complete circle within the rotunda.[41] According to Barker's account, the king pointed to the painted view of the Grand Fleet with his cane and put it in Henry Aston Barker's hand, who bent down to be in a line with it so that they both could assume the same viewpoint. By elevating his cane towards the horizon line, the king mimicked the converging orthogonal lines of the perspective view, and established a *fixed* position for himself as spectator outside the space of the representation.

Perspective theory involves the imposition of various distances between the viewer and the picture. 'The distance of the picture' is the mathematical distance that the spectator must stand in front of the picture plane so that the perspective image can be viewed correctly.[42] As Peter de Bolla has argued in *The Discourse of the Sublime*, the 'prescription of the various distances involved in a perspective representation is one of the most forceful forms of legislation executed by theory over the practice of viewing'.[43] From this distance, the spectator is presumed to occupy the same viewpoint as the artist when he created the image. Thus, perspectival representation not only makes an absence present, it constitutes the observer as the looking subject and it does so by attempting to restrict her or him to the artist's point of view.[44]

Indeed, Barker's description of the king's experience of the image is consistent with a model of subjectivity theorised by eighteenth-century perspective treatises that attempted to restrict the viewing subject to its proper place – understood as 'the true point of sight'.[45] Albertian perspective's true point of sight not only promises *trompe l'œil*, but also represents the subject to itself as a measurable, visible whole. By standing still at a specific distance from the focal point of a perspective view, the subject obtains an illusion of self-mastery. From the vantagepoint of 'the true point of sight', as de Bolla has explained, 'the viewing subject is no longer subjected to representation but becomes the master of it, master of subjection, master of itself'.[46] The static and disembodied work of looking, ascribed to the king as the supreme commander of all he surveys, is one side of the two-fold structure of representation inherent in the Panorama's form, and it depends on the subject's contemplation of the image from a fixed distance.

The king's stationary, centred viewpoint found its counterpart in the two ships that were clearly highlighted in the key to the view. Unlike an anonymous sketch of Britain's Royal Fleet at Spithead that does not distinguish any of the 'ships of the line' (Figure 35), the Panorama key divides the two lines of ships into two separate

views, identifying two specific focal points for the image. Thus, despite being situated well to the left of the centre of the key, the ships named *Monarch* and *Carnatic* are depicted as central in the representation because they bear the highest masts. We can imagine these two focal points as organising the view of the image in the Panorama.

That the key indicates the effect of the wind on the pennants conveys the pivotal positions that the *Monarch* and *Carnatic* assumed. A close reading of the key indicates that the flags of these two ships were flying in the same direction, and that they were invisible on the key because they were in fact in line with each other. The visual effect of the directional flags on the key served to join the lower and upper lines of the ships together to form a continuous circuit that would have encouraged the viewer to align the schematic diagram of the key with the painted image in the cylinder. In the Panorama, these two ships would have been depicted facing each other, with the viewer at the centre point of the axis between them. Judging by the key, the ships on either side of the *Monarch* and the *Carnatic* in the Panorama would have gradually decreased in size according to the rules of perspective. In fact, given that 'Carnatic' was the European name of the region in southern India coming under increasing British control,[47] the flags and the decreasing size of the

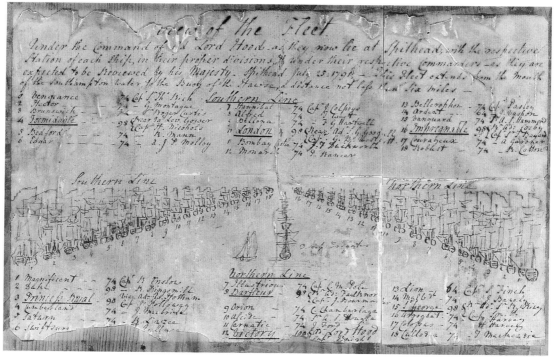

35 Anonymous, 'Key to the Spithead Review', 1791.

masts on the key suggests that it was not merely wind but power that emanated from the *Monarch* towards the *Carnatic*. Thus, despite their rank as third-rate ships, the *Monarch* and *Carnatic*'s strategic arrangement on the key can be taken to symbolise a top-down relation of power between the actual monarch of the British nation and this potential colony. Hence while the key established one focal point for each of the two 180° views, when joined together, they constructed an image in which the forces of nature colluded to legitimise Britain's authority over foreign territory.

Instead of having such focal points determine her position in space, the description of the queen's seasickness, as a motion sickness, suggests that she moved her body and eyes along the surface of the canvas. As noted previously, the panoramic image was composed by the juxtaposition of several images. Perspective views would have been adjusted to the cylindrical form of the Panorama, according the viewer a central, mobile position within its representation. Unlike flat perspective views that specify one position for the viewing subject, the Panorama placed the spectator at the centre of multiple vanishing points that he or she could not grasp all at once. However, as perspective theorist Joshua Kirby warned, looking at pictures from any other position than the true point of sight has a disorienting effect:

> But if the eye is not placed in the true point of sight, the projections of all objects, which are not parallel to the picture, will not seem to tend to their proper vanishing points; and for that reason, such representations will appear as starting out of their proper places, will lose their just proportions, and consequently will not convey absolute and perfect appearances to the eye of the spectator, viz. such as are strictly to be deemed mathematical projections. And to this we may add the bad effect it will have upon the horizontal line in particular, which is always determined by the place of the eye.[48]

Indeed, as Kirby pointed out, distortion of the image with respect to the horizon line is even more pronounced in pictures painted upon curved surfaces. Thus, when the viewer moves across multiple perspective views on a curved painting, he or she interferes with the visual rays that constitute the image and the appearance of the object changes. In an attempt to explain this phenomenon, de Bolla asserts that whenever the subject moves along an image comprising of multiple viewpoints, 'the possibility of its producing something in excess, an image that goes beyond the "real", poses a considerable threat to the horizons which determine the order of representation'.[49] The panorama's curvilinear representational form encouraged a physiologically based mode of perception – such as we can presume was practised by the queen – one that was neither tied to the strictures of perspective theory, nor to the constraints of discourse.

As this discussion of perspective construction suggests, while Barker's anecdote implies that the queen witnessed a Zeuxian-like mirage, the effect he says she experienced may have been caused by the failure of perspective to hide its own

mechanisms of display. By multiplying the views in a continuous circle in an effort to achieve an Archimedean point from which to grasp the entire horizon, the viewer was forced to move inside the painting, traversing the perspectival rays that constructed the image, a mode of looking which made the perspective illusion less effective. Instead of observing the image as an unmediated copy of reality, as Barker had hoped, the mobile subject witnessed the material signs of the representation's construction – including its distortions. Thus, while the queen's purported seasickness may have purposefully corresponded with the maritime scene, her response was more likely caused by the failure of *trompe l'œil* than its achievement.

In contrast to positioning oneself at 'the distance of the picture', the viewing location from which the representation constructs the subject as unitary, and all seeing, de Bolla describes the polyvalent point of view as a sublime and excessive practice of looking in which the subject moves between multiple points of sight. This mobile and temporal work of looking *vis à vis* representation involves a self-authenticating subject who brings her or his own point of view to the image, thereby renouncing both the artist's perception and the laws of perspective.[50] De Bolla's work deals with a deviant practice of viewing limited to large, horizontal, and planar landscapes, but it has particular resonance with regard to the spectator within the Panorama. His description of a mobile and temporal process of looking at a series of disconnected viewpoints accords fully with the other side of the Panorama's dual structure of representation, which was activated by a viewer moving across multiple points of sight along the curved surface of the image. Unlike the subject produced by and subjected to the perspective view, in this ambulatory mode of apprehension the self is not unique and produced all at once, but takes on a temporal dimension.[51] This kind of subjective, physiological viewing plays with limits, with the boundaries between the self and the object in such a way that they become mutually defining. In contrast to the sense of self-mastery and unity afforded the viewer by single point perspective, the mobile or polyvalent point of view encouraged if not demanded by the Panorama's size and circular form lead to a fracturing of the subject. While gender stereotypes predisposed the queen to display her higher sensibility before the spectacular scene, this performance does not obviate actual experiences that are outside the norm of masculinised discourse. Thus her performance, while operating as a constraint, also gave her greater freedom to engage in the mode of perception that produced a fragmented subject, a form of subjectivity that was at the centre of fierce debates concerning perception.[52]

The two-fold structure of representation that the Panorama set in place accommodated both the early modern and modern conceptions of vision. As Jonathan Crary has noted, the theoretical displacement of Cartesian perspectivalism in the late eighteenth century and early nineteenth century was linked to the shift from geometrical optics to a physiological account of vision. Crary describes a paradigmatic shift from the camera obscura as the model of an objective vision in which the

body stands outside of the visual operation, to a modern theory which holds that the body with its complex of nerves and retinal surfaces produces a subjective vision relatively indifferent to empirical accuracy.[53] Research into the holistic phenomena of vision and visuality developed out of the science of optics led to a new conception of vision as both mental image and somatic affect.[54] Within the Panorama's enclosed, dislocated space, perspectival illusionism had the potential to fuse with the body's sensual apprehensions. Furthermore, the multiple perspectival views of the panorama induced the viewer to move across the image, contributing to the production of a sensitive and sensitised observer. This mode of visual address fuelled research on a new concept of sight in which vision is directly tied to the dynamic movement of the body through space.

At the same time, philosophers, such as Pierre Maine de Biran, were reformulating and expanding Descartes's notion of the *cogito, ergo sum*, 'I think therefore I am' into 'I exist because I move and I think'.[55] The Panorama provided an arena for this new sense of self. It is through the sensate body that one has a sense of being a subject, and it is through the act of looking that the awareness of one's body in the Panorama was magnified and strengthened at once internally, by engaging with its second structure of representation, and externally, by being an object of sight for others in the circular architectural enclosure. Such developments in perceptual theory suggest a change in the social meaning of the discourse of sensibility. Instead of representing the gendering of nerves to serve the model of innate sexual difference, this structure of representation was put to a new purpose, one that was equally definitional of subjectivity.

Scanning a number of viewpoints on the horizon of the view in rapid succession would create a choppy, unnatural effect, as eighteenth-century perspective theory warned. Indeed, any such seasickness the queen may have felt in the Panorama was likely caused by the relatively small diameter of the rotunda as compared to the space represented in the picture: it was a consequence of the complexity involved in looking at a three-dimensional perspective projection of space within a three-dimensional, cylindrical canvas. As Oettermann describes, 'as observers adjusted their eyes to the illusion of distant vistas, and then they walked around on the platform, it seemed as if they were wearing seven-league boots and covering vast distances with each step. People became disoriented and likely to stumble.'[56] Certain viewers felt a mild motion sickness from the panorama for the same reason that people become seasick on a boat: the communication reaching the brain from the eyes is contradicted by the message arriving from the ears, which register balance.[57] In other words, the use of perspectival construction in a novel circular form created disjunctions in time and space that produced a corporeal reaction that was neither exclusive to Queen Charlotte, nor to women in general. Nevertheless, because such a reaction was perceived as a sign of weak and delicate nerves, the same response displayed by men was considered effeminate and unmanly.

The two-fold structure of representation within the Panorama had the potential to affect either women or men, and were not mutually exclusive in spite of the fact

that each structure depended on the failure of the other. Judging from the Panorama's popularity, the physical rush many experienced within this representational form was a highly sought-after sensation which worked to configure the discourse of sensibility in a new way. Far from the delusional feminised state of mind associated with this discourse, sensibility with regard to the spectator in the Panorama involved an awareness of the body's particular sensual response to the power of representation. This somatic effect may have lead to the exposure of the mechanisms it employed to trap the observer and direct his or her vision towards particular areas of the image. Paradoxically, the more spectators realised that they were being acted upon by the representation, that power lay in the view itself, the more likely they were to resist the intended meanings of the picture by inventing meanings of their own.

Nevertheless, different forms of lived spatiality have an effect on the ways women and men conceive of and use space, including the space of representation. Functioning in two opposing ways, a heterotopia can either offer an 'other' space of compensation for those who seek absolute order and control, or it can provide a space of illusion, an imaginary site outside of conventional social constraints.[58] Thus, the king as the commander of the British Fleet assumed a position of mastery and authority before the representation. Taking up a fixed position with regard to the picture – effectively experiencing it in the same way as he would a conventional, planar perspective view – involved the production of a space that was another 'real' space, that was as perfect and precise as the space outside was chaotic and confused. Relying on the order imposed by the perspectival construction to reinforce his own position in the social and global hierarchy, this mode of perception could assure the sovereign, and all spectators who looked at the image in this way, that everything had been carefully measured, and that everything was in its proper place.

Clearly, however, the temporal experience of seeing an illusion of three-dimensions in all directions produced unanticipated results. The physiological mode of vision, exemplified by the mobile act of looking practised by the queen, worked against the first, undermining its claim, based on Albertian perspective, to portray an objective visual truth. Despite the key's attempt to drive the viewer's eyes towards the two ships it placed at the centre of the picture, the 360° painting drew the spectator's attention to other parts of the image, including the artificial mechanisms that structured the view. This is what happened when the queen did not follow the rules of perspective.

In this chapter I have addressed gendered discourses about viewing and perception that happened to conform to two different material aspects of the Panorama: the use of perspective to depict the battleships on the immense sheets of canvas and the cylindrical space in which the viewers were encouraged to experience the space physiologically. The king's stationary viewpoint aimed at consensus and order, the perfect alignment of every spectator's vision with that of the artist's, while the queen's polyvalent point of view was connected to individual bodily experience.

These oppositional modes of spectatorship fed in to contemporary philosophical debates concerning objective shared perceptions and the subjective position of the individual. I have suggested that the Panorama's two-fold structure of representation had the power to affect both men and women equally. In the social space of the viewing platform, the act of looking destabilised what constituted male and female perception. But I have also suggested that in practice not only Queen Charlotte, but potentially every visitor to the space saw the 360° painting with not only her or his own eyes, but experienced it with her or his own body.

'Ain't Going Nowhere':
Richard Long: global explorer

Anna Gruetzner Robins

> Born in 1945, Richard Long is regarded internationally as one of Britain's most important living artists, a reputation consolidated in 1976 when he represented Britain at the Venice Biennale at the age of 31. His stature and acclaim have grown steadily since, and in 1989 he received the Turner Prize for his contribution to British Art.
>
> (Exhibition Guide, *Richard Long Walking in Circles*, Hayward Gallery, 1991)

This chapter is about the artistic project and practice of Richard Long and argues that Long outwardly follows the career trajectory of a latter-day British explorer with echoes of the colonial impulse. This is reflected in his encounters around the globe in India, Canada and South America, and in his identification with Bristol and the surrounding area of Somerset and Avon, his home county. It also examines the gender basis of Long's project within the tradition of the odyssey of the male explorer pursuing Virgin Nature and looks at aspects of his dropping and marking, the repetition – compulsion that drives Long's project. It looks also at the publication of critical texts approved by the artist, that reinforce antiquated gender biases and assumptions and a dated indifference to environmental concerns.

I first saw Richard Long's work at the Lisson Gallery early in January 1973, a few months after I arrived in England from Canada where I was born and where I grew up.[1] By then the components of his work – the photographs of outdoor sculpture with accompanying texts giving a time and place, the marked maps, the 'word works' and the indoor sculptures; these were in place.[2] (A more recent addition to Long's œuvre are the handprints, applied in mud in formal configurations, to gallery walls which Long first made in 1981.) At first what struck me were the photographs of outdoor sculptures made in places in England I knew of but had never visited, and especially the maps marked with walks Long had taken, which had a determined shape. They represented the England I had imagined as a child, while reading stories set in a country to whose Queen I pledged allegiance each morning

in school before classes began. This England of my imagination was green, pleasant and confinable.[3] I had assumed that the English walked or cycled everywhere, and that there were welcome stops for picnics and large teas during the excursions that English children enjoyed in the countryside.[4] *A Walk in Four Hours and Four Circles Dartmoor, England 1972, A Meandering Walk Around An Imaginary Circle England/A Four Day Walk in Wales 1990, Mountains to Mountains/a 138 Mile Walk/From the Comeragh Mountains to the Monavullagh Mountains, Waterford Tipperary Limerick Cork/Ireland 1980, Early Morning Senses Walk/Island Walk/Isles of Scilly 1982* – the titles of these works evoke extraordinary associations, and I willingly admit that at one time they seduced me.

I was soon aware, however, of another aspect of Long's work. Making work in countries outside Britain is an established aspect of Long's practice with origins in some of his earliest sculpture. For example, he visited Peru in 1972, Canada in 1974, and India and Australia in 1977. Alison Sleeman observed that when Richard Long and the sculptor Hamish Fulton, who frequently accompanied him on these journeys, 'first ventured to foreign places, they were following in the footsteps of other Britons. They voyaged to the "pink bits" on the map of the world, to places resonant in Britain with a colonial or imperial past.'[5] As someone who grew up in one of the 'pink bits' of the globe, I am uncomfortable with this colonial impulse, and in spite of the soothing seductive aspect of Long's work, it was my growing discomfort with its colonial impulse that made me think again about Long's project.

Richard Long takes a keen interest in all aspects of his work, arranging his exhibitions, selecting the material and directing the design and layout of his beautiful, increasingly sumptuous, exhibition catalogues, thus ensuring a high degree of visual pleasure. This has always been part of Long's practice. For example, in 1976, referring to the 'printed books, posters and exhibition cards, also, more loosely, prepared entries in magazines and catalogues', Michael Compton pointed out that Long 'controls as best he can the format of these'.[6] Take for example, *Walking in Circles*, the book published in 1991 to accompany the Hayward Gallery exhibition. Long chose the headings for the first nine sections of the book: 'Walking in Circles', 'Fragments of a Conversation 1-V1', 'Meandering Miles', 'Connemara Dreaming', 'Wind Stones', 'Following a Desire', 'Half-Tide', 'Canyon' and 'Walking Out of Stones', and arranged the sequence of images throughout. *Walking in Circles* is a fanciful guide-book. Its layout and bold typeset are reminiscent of the earlier, artist-designed *Shell Guides* of the 1930s which celebrated the new vogue for motoring amongst the British middle classes, guiding them to parts of England that were quite inaccessible without a car. The pages of Long's 'guide' are filled with photographs of outdoor sculpture sometimes arranged by kind but not in chronological or geographical sequence (one exception is the outdoor pieces made in the Sahara in 1988 which are published in sequence in *Walking in Circles*), interspersed with maps of arranged walks, 'word pieces' and photographs of the gallery installations. But *Walking in Circles* is a travel guide without directions to a global landscape bereft of its connecting geography.

Long made his first trip to South America, to the Andes in 1972 and continued to work abroad throughout the 1970s. Around 1980, when Long's career escalated, these global journeys became increasingly various. I cannot be entirely systematic in my listing of them because Long deters a chronological, art historical analysis in the catalogues and books published about him. The information that follows has been pieced together from the work published in exhibition catalogues and from Hamish Fulton's 'Muddy Waters', his 'straight facts' about Long, published in *Walking in Circles* which avoids a chronology when giving the details of Long's journeys.[7] This is my sampling of places Long has worked out of doors: the Andes 1972, the Canadian Prairie 1974, Nepal 1975, the Arctic 1977, Malawi 1978, Japan 1979, Mexico 1979, Morocco 1979, Bolivia 1981, Iceland 1982, California 1982, Japan 1983, Nepal 1983, Lapland 1983, India 1984, Barbados, Adirondak Mountains, New York 1985, Lapland 1985, Mexico 1987, the Sahara 1988, Mississippi 1988, Turkey 1989, Texas 1990. This list does not include the professional visits Long made to install exhibitions in other countries. Nor does it include journeys in England, Scotland and Ireland and to other parts of the European community. I am uncertain as to whether a recent trip to the Seychelles constituted a global journey or a Thompson Sun Holiday.

Long has said his work is about 'walking without travelling', or, it could be said, about 'walking in circles'.[8] Nevertheless walking is an integral aspect of his artistic practice. Walking and being out of doors draw on two well-established tropes of masculinity. Laura Mulvey has pointed out that being-out-of-doors is central to the concept of an outside, masculine space, a space where adventure, movement and cathartic action take place. The hardy explorer, the fearless adventurer, the intrepid desert traveller and the brave mountaineer; Long draws on all these guises and reworks them in a more recent form: the Hippie Backpacker, that iconic figure of youth culture in the 1960s, when getting in touch with Nature, utopian ideas of global travel, and reading about ancient myths and religions fired the imagination of the young generation.[9] There is a telling work, entitled *Hill Figure 600 and Climbing Mount Kilimanjaro, Africa, 1969*, which splices a photograph of Long standing with his backpack and a photograph of the Lymington Man, that supposedly ancient figure incised on a hill in Sussex.[10] In *Stones and Flies: Richard Long in the Sahara*, the film made in 1987, Long, as the Hippie Backpacker, takes centre stage.[11] Walking and living rough in the desert, all his worldly goods on his back, he cooks and sleeps in the open air, and acts out a shared fantasy of the counter-culture started by the Beats of the 1950s and Jack Kerouac's autobiographical novels *On the Road* and especially *Dharma Bums* (1958), where the artist and his Buddhist poet companion climb a mountain while discussing the quest for knowledge (dharma). But this is no simple model of the 'hip' male adventurer. Long's project as a global traveller abounds with traces of journeys taken in a different time and space, of storybook male heroes and real life male explorers. As Laura Mulvey argues, 'some legendary figures … persist through history, preserving their original identity and multiplying through other images and references … to form part of the psychic

vocabulary both of the individual and the collective culture ... giving private reverie a shortcut to a gallery of collective fantasy' where they 'function like collective mnemonic symbols' allowing ordinary people to resurrect 'long lost psychic structures'.[12]

In *Stones and Flies*, the film made about him making work in the Sahara, Long makes sculpture through hard physical labour. He paces back and forth, kicking away stones with his boot, until a line appears on the ground. Wearing gloves he lifts and gathers stones, arranging them into a familiar circle, often replacing them after taking a photograph. A spiral is dug in with the heel of his boot. *Stone on Innismore/Aran Islands/West Coast of Ireland 1975* consists in the turning upright in its bed of every large stone in that place, up to the limits of Long's physical strength.[13] Long's texts abound with details of the length and time of the walks made without travelling. Behind this mask of the male adventurer, there is of course a true modern-day professional who jumps on and off planes, who efficiently and quickly arranges exhibitions in the approved international network of galleries.[14] For example, 1994 was not an unusually busy year for Long. He had eight exhibitions in five countries that spanned three continents. But it is the hard physical labour, the arduous hot work that counts in Long's artistic persona which we might compare to the manly effort and the hardship that British, early male explorers endured for months and years as they battled with and empowered the vast new spaces they encountered. The following examples of these earlier heroes and their journeys come from *The Oxford Book of Explorers*: Ney Elias (1844–97) the British civil servant and explorer who crossed western Mongolia, 2,500 miles to the Russian frontier, then travelled another 2,300 miles to the then railhead at Nijni Novgorod; the British explorer Mungo Park (1771–1806) who was commissioned in 1775 by the African Association in London to trace the Niger and returned in 1805 after proving it flowed east; Henry Hudson (*c*.1550–*c*.1611) who discovered the Hudson River and Hudson Bay where he was cast adrift in a small boat when his men mutinied; or William Davies (fl. 1614) who visited the Amazon in 1608; or the British Polar explorer Wally Herbert (b. 1934) who travelled 23,000 miles by dog-sled in both the Arctic and the Antarctic.[15]

Long's links with these male heroes are reminiscent of earlier imperialist egos moving through the rough uncharted terrain of the colonial other.[16] Except of course, and this is important, Long's explorations are entirely bereft of their originating sense and context. Indeed this imperialism is probably not conscious; it would not need to be. Formulated in the travel writing of the first male explorers to Africa, North and South America and other parts of the British Empire, transposed into 'fictive' form in schoolboy's adventure stories, this imperialism exists as an imaginative subtext in English culture. But there can be no doubt that Long's critics have conspired in the telling of this tale about male adventure. For example, Anne Seymour observes: Long 'like the gods ... is capable of sustaining many roles ... including traveller, explorer, pilgrim, shaman, magician, peripatetic poet, hill-walker, and ordinary twentieth century person from Bristol'.[17] The defensive,

embattled, male self resorts to many masks, disguises and deceptions. I remember an occasion when Long was invited to speak about his work at the University where I teach. He played tapes of country music for an hour and said nothing. Apparently he did this on many other occasions when asked to speak to students.[18] The Western cowboy balladeer, a man of few words empowered by his machismo, his silence and his pain must be another role model for Long in his identification with the archetypal questing hero, the male adventurer who with strength, courage and physical mastery embarks on an odyssey braving the natural world.

Bristol, the River Avon and the surrounding southwest of England was the cata-lyst for the first landscape works made before Long went to St. Martin's School of Art. It remained his 'actual and psychical home', a touchstone for memories so strong that he often used the physical substance of the area for his 'home' works.[19] For example, he transported mud from the River Avon for gallery installations. 'I would really rather travel with my own mud because it is the best colour.'[20] Long's attachment to the very substance of the landscape had rich associations with child-hood, a psychically safe, confinable, interior space and a 'necessary contrast to the wide, open spaces of the unknown'.

It is hardly surprising that Bristol was the starting point for his global journeys and the place to which Long returned at the end of each odyssey. Furthermore, the landscape of the surrounding West Country, the Highlands and Dartmoor played a central role in his imagination whenever he was away from England. He willingly admitted that other landscapes evoked memories and associations with these English landscapes when he was travelling. This global re-semanticising had its roots in late eighteenth-century natural history which imposed a new global unity and order. Beginning in the eighteenth century, culture and history were subsumed into Nature as the need to see the likeness between things became the driving force of the new scientific discourse. The label 'granitic peaks', for example, could apply identically to Eastern Europe, the Andes and the American West. Long probably unwittingly used a mode of comparison to describe the land-scape that had its roots in this earlier discourse. Being in Alaska Long told us, was 'almost like being on Dartmoor but it is much bigger'. The 'boggy, windy, flattish kind of landscape like Lappland (sic) or Alaska' is familiar for the same reasons. 'A footpath is a footpath and it is probably the same in China as in Scotland.'[21] The universalising homogeneity of the world's landscape, with England as a constant touchstone, seemingly contradicts Long's impulse to traverse large areas of the globe. But this is not so. Long's sentimental attachment to the English landscape compares to descriptions in earlier travel writing, which related foreign land-scapes to the explorer's home culture, sprinkling it with references to little bits of England. When we remember that these little bits of England were only created in the nineteenth century by civil servants seeking a homeland in the southern coun-ties that they themselves largely concocted after long-serving colonial posts, then the analogies that Long makes between the English landscape and those of other countries are doubly ironic.[22]

Many of the links made in this chapter between Long and early explorers were formed after reading Mary Louise Pratt's highly important *Imperial Eyes. Travel Writing and Transculturation*, a historical study of early travel writing.[23] Pratt did not mention Long, nor is there any reason why she would have included him. Nevertheless, it is remarkable how closely Long's explanation of his post-colonial, post-imperial journeys adhere to earlier, established models of travel writing.

Pratt pointed out that the writings of early explorers never discussed the arduous and lengthy journeys they took by ship and land before they reached their point of discovery. Long saw himself as 'of the first generation where as an artist I could use the world as one arena, as it's possible to fly almost anywhere completely normally and cheaply'.[24] But in the writing about Long we are never told how Long travels to parts of the globe that are remote from England and yet like England. He 'sets out upon his journey, armed only with a length of string for making circles, pencil, notebook and camera for recording things perceived, map and compass for finding the way, gloves for lifting rocks, a water bottle for making water drawings, and a pair of well-worn boots'.[25] The air flights taking him many more miles than he could walk, the overnight stays in hotel airports and all the hidden extras that modern travellers expect are rarely mentioned. For example, referring to a trip made to Bolivia in 1972 in company with Hamish Fulton, Long described it as 'a very imaginative trip; we were light on our feet and our wits, travelling freely, by instinct and circumstance, making decisions as we went along'.[26] The viewer is asked to accept that these journeys are a primal quest divorced from time and space and all traces of modern travel are erased from the accounts of Long's journeys. For example, referring to the outdoor sculpture *A Circle in Alaska/Bering Strait Driftwood on the Arctic Circle*, Long told the critic Richard Cork: 'I just happened to find myself on the Arctic Circle, and it seemed just the perfect opportunity and place for me to make a circle.'[27] Similarly, Victorian male explorers rarely mentioned the unending discomfort of arduous travel in unknown terrain or indeed the role of native peoples in guiding them. As Pratt showed, their subsequent accounts simply described the moment when they reached the object of their discovery. For example, she suggested that the Victorian explorer's calling 'was to produce for the home audience the peak moments at which geographical "discoveries" were "won" for England.'[28] In Richard Burton's hugely popular *Lake Regions of Central Africa* (1860) his point of discovery Lake Tanganyika was described in a detailed verbal picture that avoided a boring repetitive narrative about 'making one's way to the region and asking the local inhabitants if they knew of any big lakes, etc. in the area, then hiring them to take you there, whereupon with their guidance and support, you proceeded to discover what they already knew'.[29] A narrative about the horror of international airports would ruin Long's verbal and visual pictures about these seemingly unknown landscapes imaged at a particular point. The fact that he made a sculpture there, in these named but strangely empty landscapes, is what matters. Of course, he did take the long walks that his texts described but the illusory function of these walks was to convince us that Long's journeys were the timeless

odyssey of the eternal male and that he alone had discovered and played with this Virgin landscape. 'The sticks and stones I find on the land,/I am the first to touch them.'[30]

Once again Long's tale of adventure was an accepted aspect of the growing literature on Long and gallery curators willingly tell these stories about his exploits. As Mario Codognato, the curator of the British Council sponsored exhibition, held in Rome in 1994, wrote: 'These lands, which are the least contaminated by human presence, have been visited by one man who, using his physical strength alone, without the aid of technological instruments, has left behind some simple universal signs.'[31]

But Long was not without his critics within the British art world. In 1988, the artist Rasheed Araeen, who arrived in Britain from Pakistan in 1964, made a series of works that deliberately pastiched some of Long's outdoor work, and challenged his supremacist, post-colonial attitude. Maintaining that Long's vision was one in which the world is stripped of human presence, Araeen made an installation, entitled *When the Innocent Begins to Walk the Earth* which re-framed Long's work in a critical context. *Arctic Circle*, made of empty bottles, referred to the corrupting influence of alcohol on the Innuit which previous European 'visitors' had introduced to the Arctic. *A White Line Through Africa*, an assemblage of a line of bleached animal bones, was a reminder of the suffering of war, starvation and disease.[32]

For earlier male explorers, it was the Imperial Ego on the move to collect and appropriate material conquests and subjections. Long's global exploration was his particular specific choice of artistic form, his chosen physical and psychic route. But as he travelled on through his experience the restrictions of perspective and practice remained (lines and circles) and all journeys into the interior (exploring subjective experience, emotional realities, self-exposure/examination/revelation even critical biography) were barred. For Long, the romantic mystery of self-discovery of the artist as hero, was replaced by the uncritical and apparently uncriticisable adoption of his own mystique. Unlike his Victorian counterparts who had one or two adventures in their lifetime, Long was the quintessential post-modern male adventurer, like Superman, effortlessly traversing the globe. A post-modern hero, he traversed time and space in a manner that would have been impossible without recent technological advancement. But he emphasised that his project, as I have pointed out, was about walking without travelling, a modern response to earlier narratives of the questing hero who constantly travels without purpose. Or, in the words of Bob Dylan which Long has quoted: 'Genghis Khan he could not keep/All his Kings supplied with sleep/We'll climb that hill/No matter how steep/But we still/Ain't going nowhere.'[33]

Long explained that 'a journey is a meandering line'. 'To walk straight makes a sculpture.'[34] The concept has been an integral aspect of his sculpture since *Line Made by Walking*, 1967. After cycling to a field on the outskirts of South London, Long walked up and down in a straight line until a mark appeared in the grass.[35] He then made two photographs, one standing on the line and one to the left of it. The

empty meadow in *Line Made by Walking* had the quintessential blandness of the southern English landscape. There are hints that an encroaching development of houses, shops and pavement was not far away. The repetitive marking and the idea of solitude in *Line Made by Walking* are key characteristics in subsequent works by Long. But in these all traces of the urban/suburban experience were eradicated. *Line Made by Walking* belonged to a long tradition, established in the nineteenth century, of artists who sought out green spaces at the suburban edges of London while longing for another more familiar locale. Constable's native Suffolk for example loomed large in his imagination when he lived at Hampstead in North London, and painted the rural activities that took place on the nearby heath.[36]

When working out of doors Long 'rearranges Nature'. A rocky landscape is erased to form the shape of a circle (for example, *Hoggar Circle, The Sahara*, 1988), stones and rocks are gathered from flatter ground to mark out a circle (for example, *Circle in the Andes*, 1972), driftwood cast at random at the water's edge is meticulously ordered into a converging circle (for example, *A Circle in Alaska. Bering Strait. Driftwood on the Arctic Circle*).[37] Here, Long found the shared shapes of these sculptures deeply satisfying. Long spoke about doing the 'same thing all my life' making 'sister circles and complementary lines all over the world' (*Stones and Flies*).[38] Black and white, and colour photographs, record the outdoor sculptures. Long explained: 'I am an artist who sometimes chooses to use photographs, although I am not a photographer.'[39] But these photographs were by no means tourist snapshots which captured these empty spaces at odd angles.

The outdoor work is what the critic David Sylvester has called 'the study and practice' aspect of Long's sculpture.[40] Following this line of thought and using nineteenth-century terminology, you could say that the difference between the outdoor work and the indoor work is the difference between a sketch and a finished picture. There is something touchingly romantic about the way Long talked about landscape. He spoke of the 'time of day', the 'light', 'my own feelings', the 'whole ambience (sic) of place' and making 'classicism out of order'.[41] These are the easily recognised tropes of the landscape painter, with a long established tradition.

The choice of site for the outdoor work, where 'the walk meets the place', usually identified by a line or circle motif, has close affinities with this landscape tradition. Two photographs made by Long of the sculpture *England 1967*, which had a vertical rectangle and a horizontal circle placed in the landscape showed that 'viewpoint crucially affects the constancy of the image'.[42] Michael Compton points out that in one 'the circle appears through the rectangle, almost on its central axis; the other is from a point of view further to the left so that parallax takes the circle outside the rectangle.'[43] The photographs of the outdoor sculpture show that viewpoint continues to be important. They were taken from carefully chosen vantage points, inspired by well-established landscape compositions. For example, the three horizontal bands of sky, water and shore in *A Circle in Alaska*, 1977, draw on seascape compositions by Courbet, Whistler and Monet. The composition of *Foot Path Waterline, Mexico*, 1987, with a footpath cutting into the middle distance framed by

clumps of trees, compares to compositions by Corot. The repoussoir of hanging branches above a circle of stones in the flowery woodland in *Brittany Circle, Domaine de Kerguehennec*, 1986, is reminiscent of pictures of the Barbizon forest by Théodore Rousseau. The original purpose of these compositions for landscape paintings was to create a sense of immediacy so that the viewers at exhibitions could imagine that they too had been in that landscape. Long had not made this connection with nineteenth-century landscape, preferring to describe himself as a classical artist. He saw the photographs of outdoor sculptures, the altered maps, and the texts when displayed within the gallery space, as serving to trigger the imagination taking us back to the natural world. As Long explained: 'My photographs and captions are facts which bring the appropriate accessibility to the spirit of these remote or otherwise unrecognisable works.'[44] But this is a modern experience of Nature. The word pieces tease the five senses, for example *Ten Mile Places*, 1986, refers to the smell of silage, the texture of flat mud patches, a singing skylark, space and time in a highly visual evocation of the landscape.[45] Long said: 'My work is not urban, nor is it romantic. / It is the laying down of modern ideas in the only practical places to take them.'[46] Importantly, Long repeated the lines and circles of the outdoor sculpture in sculptural and wall installations in a gallery space where they too resonate with associations and memories with Nature in its purest form.

The looking and consuming aspect of Long's outdoor work can be easily assessed within the growing discourse surrounding the theory of the gaze, and its application in the work of the feminist geographers Gillian Rose and Catherine Nash, who in turn have acknowledged their debt to the work on the gaze and the representation of the female body by feminist art historians.[47]

Rose emphasised that cultural geographers regard the landscape as being just like the female body, and thus collude with the conflation of Woman and Nature, which has a long history within scientific discourse. This encoding of feminine qualities in Nature is still an accepted aspect of the critical discourse of cultural geographers. Their writing is saturated with gendered and sexualised tropes about the desire to look, imagine, fantasise and visualise the landscape.

Traditionally going out to take a look at 'Mother Nature', as Long did, is something all landscape artists do when searching for a site or motif by which they take control of a landscape view. Furthermore, historically and socially determined gender difference has determined that the art of landscape, until recently, has largely been the preserve of male artists. It is hardly surprising that a sexualised way of thinking abounds in the writing on landscape art and that this in turn has influenced the writing on Long. For example, referring to *Turf Circle*, an early work by Richard Long, Rudi Fuchs writes: 'The turf was used and laid back, its tissue only momentarily severed.'[48]

Catherine Nash described male landscape artists 'overtly performing their gender, in neurotic relationship' to the landscape.[49] It is this repetitive, obsessive aspect of Long's work to which I will now turn. In 1969 Long enacted *Walking in a Straight 10 Mile Line Forward and Back Shooting Every Half Mile*, a film with a

soundtrack of walking and heavy breathing.[50] Since then obsessive repetition has
been integral to Long's practice. The later repetitious production of lines and cir-
cles compares to mass commodity production in the late twentieth century, which
artists such as Andy Warhol presented in a different way. In Long's case, the repet-
itive fondling, dropping and marking with stones and sticks satisfies, it would seem,
a deep psychic longing. Mucking about in mud, and playing with rocks and sticks
are part of childhood. And Long, who used the children's rhyme 'Five, six, pick up
sticks/Seven, eight, lay them straight' to entitle a 1980 publication, freely admits
this connection.[51] But these fantasies are not acted out in the domestic settled space
of childhood. They take place in a far away terrain, and they are hints, to my mind,
of veiled anger, envy and malice, as Long the male adventurer plays these childish
games. Once again, Long's project can be compared to the fieldwork undertaken by
male cultural geographers as observed by Gillian Rose who likens this activity to
repetitive boys' games. But in his quest for freedom, Long, like the great White
Explorer, will be held down by no woman. Messing with Nature is a fantasy of
empowerment over a threatening and desirable Mother Nature. And so continues
Long's obsessive quest; however, ultimately Mother Nature does not satisfy after
all. As the feminist geographer Joni Seager points out: 'It is disingenuous for a
spiritually hollow, urban, technical, male, ecobureaucracy ... to adopt the mother
imagery ... The earth is not our mother. There is no warm, nurturing, anthropo-
morphised earth that will take care of us if only we treat her nicely.'[52]

Yet Long saw himself as a tender lover, and claimed not to manipulate the phys-
ical environment. Others stress that he used only his hands and feet, and did not
enlist mechanical equipment as other artists such as Robert Smithson (see chapter
10). But in the light of pressing environmental concerns about the survivability of
the natural world, such statements about the inherent resilience of eternal
mother/feminised nature can only strike one as complacency bordering on indif-
ference. The alternative culture of the 1960s also produced the activist environ-
mental groups *Greenpeace* and *Friends of the Earth*. Long may have seen himself as
'Green' but there is little evidence of active environmental concern in his art.

Since the 1970s the combined effect of these radical environmental politics and
feminism (see chapter 13) has challenged the traditional discourse surrounding
representations of 'nature' and the physical world. Long's unreconstructedness is
evident by his lack of interest in constructions of the physical world other than one
that declares it is natural and mothered. And his work embarrassingly fails to con-
nect with environmental politics and ecological concerns, nor with the social con-
ditions of the countries where he walks without travelling. Time moves on. The
naive Hippie Backpacker of the 1960s, that supreme symbol of dumb youth travel
consumerism impervious to surrounding realities, has turned out to be the fore-
runner of today's modern global traveller. The Hippie Backpacker is the avant-
garde of the Holiday Inn tourist. The erstwhile Victorian explorer, cum Hippie
Backpacker, cum postmodern Superman, eerily refuses to change course, develop
or respond to changing times and perceptions. Of course, the pose of English global

explorer may be preferable to other worn out psychic routes of male artistic
endeavour in the modern era. Among the Abstract Expressionists, the mid–life
male crossroads pointed to alcoholism and suicide. Long, in Bob Dylan's words,
'just keeps on keeping on'.[53]

Trash: public art by the Garbage Girls

Jo Anna Isaak

The relationship between art and trash has always been a close one – there is a clear continuity in the line that runs from the Readymade, *objet trouvé*, *arte povera*, to the art of waste management, recycling, reclamation and redemption. Trash, junk, garbage, refuse, waste, offal, mess, dirt, rubbish, excrement – we produce it, we mass produce it in exponentially increasing amounts; we throw it out, pick it up, clean it out, bury it, truck it off, float it away, melt it down, compact it, pulverise it, recycle it, reassemble it, keep it moving … some place else, out of sight, but never it seems completely out of mind. It returns – sometimes even as art.

In the production of waste we are all active participants. According to Freud we instinctually value our waste, at least until we are trained to devalue it. The child is 'first obliged to exchange pleasure for social respectability. To begin with, his attitude to his excreta themselves is quite different. He feels no disgust at his faeces, values them as a portion of his own body with which he will not readily part, and makes use of them as his first "gift", to distinguish people whom he values especially highly. Even after education has succeeded in its aim of making these inclinations alien to him, he carries on his high valuation of faeces in his estimate of gifts and money.'[1]

Historically, artists have had a very important role in bringing us back to our initial assessment of our waste production; enabling us to 'own' them once again and thereby 'own up' to them, to take responsibility, even to take credit for our products. Marcel Duchamp, perhaps the foremost waste theoretician of the art world, asserted that 'Money is to art as shit is to shit', an assertion he made manifest in his Ready-mades in general and *Fountain* and *Elevage de Poussière* (Dust Breeding) in particular.

Numerous artists have been assiduously exploring this particular mother lode. Piero Manzoni, in *Merda d'artista* (1961), canned his own faeces and sold it by the gram for whatever the price of gold was on that day's market. Lynda Benglis produced an almost five-foot high pile of unmistakable composition, colour and viscosity entitled *For Carl Andre*. Karen Finley took up the sticky themes of coprophilia and abjection in her performance as she screamed, 'Smear chocolate all over your body until you are a human shit.' In the *Post-Partum Document*, Mary

Kelly analysed faecal stains for clues to her child's health, the mother's role within the patriarchy, and her own role as an artist. Mierle Laderman Ukeles recalls that the idea for the *Manifesto for Maintenance Art* came to her while she was changing her child's diaper. Margaret Morgan has been drawing upon plumbing designs and a vast photographic archive of bathrooms in public places to explore the complex site in which the individual and the mass butt up against each other and modern civilisation purges itself of its detritus. In *Portrait of a History of Modern Art as Sanitary System* (1997) she superimposes Alfred Barr's famous 'flow-chart' in which he set out the hegemonic history of modern art in an orderly system of influences and cultural advancements on to a plumbing diagram used to illustrate Adolf Loos's essay 'Plumbing'. In his paean to plumbing, Loos described the plumber as 'pioneer of cleanliness … quartermaster of civilization' as if civilisation itself was a war on waste. Subtitled *The House that Adolf and Alfred Built*, Morgan's architectural drawing (later realised in three dimensions as a wall-sculpture made of dysfunctional interconnected plumbing fixtures) suggests these early engineers of modernism's purity and lineage had a premonition of the wave of the future and the debasement to come (much like Clement Greenberg's worry about the encroachment of kitsch into High Art).

Today, their worst fears are being realised. Garbage is the new anti-aesthetic. Witness exhibitions like the one organised by Catherine Lord called *Trash* (1998), *Bathroom* (1998) at the Thomas Healy Gallery, *Dirt & Domesticity* (1992) and *Abject Art* (1993) held at the Whitney Museum of American Art, *Garbage! The History and Politics of Trash in New York* (1994) at the New York Public Library, *Garbage, Garbage, Garbage* at the Thread Waxing Space (1995), and the *Shit Show* (1996) at the Baron/Boisanté Gallery organised by Ingrid Schaffner shortly after she organised *Chocolate!* for the Swiss Institute.

In this chapter I examine the interconnections between the production of waste, the production of art, and the role of women in those productions. A disproportionate number of artists working with trash, waste management, pollution and the social factors associated with waste are women. I am interested in what draws so many women artists to this field and what role women in particular have to play in it. Many of these artists have created problem-solving works that address specific environmental situations, designed recuperative projects for degraded environments, and broadened public concern for what is becoming the most pressing ecological issue of our time – what to do with the trash.

Discussions about waste, its production and elimination, take on a peculiar privilege: that of mediating between psychoanalytic and non-psychoanalytic discourses. Julia Kristeva's *Powers of Horror: An Essay on Abjection* is the classic psychoanalytic text on the subject of waste. In it she argues that our waste production plays an important role in the formation of our identity, that our continuous attempt to extricate ourselves from our waste is part of our ongoing attempt to constitute ourselves as individuals. She elaborates upon Freud and Lacan's theory that the prohibitions on which social and symbolic order is based, from the incest taboo

to dietary regulations, simultaneously allow the subject to speak and produce categories such as cleanliness and filth, order and chaos. Learning to delimit and control the body is part of the process of developing a sense of borders, part of the perpetual construction of the self as separate from others. Our sense of a coherent ego requires that certain partial objects, originally thought of as part of the self (substances that issue from the body: blood, menses, faeces, urine, semen, vomit, saliva, breast milk, etc.), be cast out, ejected, abjected. For Kristeva, the horror in question is not the production but the return of the rejected and the fear that what must be expelled from the subject's corporeal functioning can never be fully got rid of. It hovers at the borders, threatening engulfment: 'what is abject, the jettisoned object ... draws me to the place where the demarcation between self and objects become ambiguous and meaning collapses'.[2]

Abjection reminds us of the frailty of our own borders and the instability of our own individuality. Abjection can be read as referring predominately to the social and symbolic ordering of the female body, primarily the maternal body, since the first delineation of the self as separate from the maternal body is the prototype for subsequent separations and since it is the mother who experiences one-ness with the baby and she is the one who has the greatest familiarity with the infant's bodily residues. Also, the female body during lactation and menses produces more of the substances designated as abject.

In her discussion of the abject, Kristeva draws upon the approach to pollution developed by the social anthropologist Mary Douglas in *Purity and Danger: An Analysis of Concepts of Pollution and Taboo*. Implicit in Kristeva's notion of the abject as the by-product or excessive residue left by the symbolic functioning is Douglas's notion that dirt is simply matter out of place. 'Where there is dirt there is system', Douglas writes. 'Dirt is the by-product of a systematic ordering and classification of matter, insofar as ordering involves rejecting inappropriate elements. This idea of dirt takes us straight into the field of symbolism and promises a link-up with more obviously symbolic systems of purity.'[3] Notions about what pollutes, what disgusts, what defiles depend upon the symbolic system in which they occur. Shoes are not dirty in themselves, she notes, but it is dirty to place them on the dining table. Although it is not the point of her investigation, gender relations come into play in these categorisations. The authority to make these distinctions depends upon who has authority in the culture in general. In a patriarchal society, the enterprises of men are more likely to be protected from female pollution than vice-versa. Also, she points out that as a greater and greater investment is made in the system of ordering, a conservative bias is built in. Yet, there are several ways of dealing with anomalies besides the obvious one of rejection. One way, she mentions, is to re-categorise the anomaly, the thing out of place, as art:

> But it is not always an unpleasant experience to confront ambiguity. Obviously it is more tolerable in some areas than in others. There is a whole gradient on which laughter, revulsion and shock belong at different points and intensities. The experience can be stimulating. The richness of poetry depends on the use of ambiguity, as

Empson has shown. The possibility of seeing a sculpture equally well as a landscape
or as a reclining nude enriches the work's interest. Ehrenzweig has even argued that
we enjoy works of art because they enable us to go behind the explicit structures of
our normal experience. Aesthetic pleasure arises from the perceiving of inarticulate
forms.[4]

Douglas ends with a chapter entitled 'The System Shattered and Renewed' in
which she draws upon William James to make a case for what she calls 'dirt-
affirming' rather than 'dirt-rejecting' philosophies; quoting his suggestion that
'ritual mixing up and composing of polluting things would provide the basis of
"more complete religion"'.[5]

There are certain parallels to be found between Douglas's theories of dirt and
Kristeva's notion of the abject, on the one hand, and Andreas Huyssen's insight
into the gender divide between modernism and mass culture. In 'Mass Culture as
Woman: Modernism's Other', Huyssen examines how cultural production and
consumption affected conceptions of the boundary between self and other and how
women were positioned in this great divide. He traces a notion that became com-
monplace during the nineteenth century – that devalued forms of popular or mass
culture have historically been associated with women while real, authentic culture
remains the privileged realm of male activity. He sees modernism as the historical
culmination of a kind of paranoid view of mass culture and the masses, both of
which are associated with women and with engulfment:

> In the late 19th century a specific traditional male image of woman served as a recep-
> tacle for all kinds of projections, displaced fears, and anxieties which were brought
> about by modernization and the new social conflicts. An examination of the maga-
> zines and the newspapers of the period will show that the proletarian and petit-bour-
> geois masses were persistently described in terms of the engulfing floods of revolt and
> revolution, of the swamp of big city life, of the spreading ooze of massification, the
> figure of the red whore at the barricades – all of these pervade the writings of the
> mainstream media. The fear of the masses in this age of declining liberalism is always
> also a fear of woman, a fear of nature out of control, a fear of the unconscious, of sexu-
> ality, of the loss of identity and stable ego boundaries in the mass.[6]

I would like to draw on one other theoretical work to make the connection between
women and waste. It comes from Michael Thompson's *Rubbish Theory: The
Creation and Destruction of Value*.[7] Thompson takes a synchronic approach to
garbage. He begins by identifying two general categories in which we place objects,
the transient and the durable. Objects placed in the transient class are thought of as
having finite life spans and as decreasing in value or turning into rubbish over time.
Objects viewed as durable retain their value or even increase in value over time.
Thompson's inquiry is into the ways in which objects can change categories.
Women themselves enter the transient category sooner, passing their 'sell by' date
more rapidly than men do. An example he gives, linking women to journalism and
transience (and, by implication, men to scholarship and durability) is provided in a

song sung by Mick Jagger: 'Who wants yesterday's [news]paper, Who wants yesterday's girl?' More significantly, Thompson reveals that women cannot affect the change of objects from the transient to the durable in the same way that men can. He traces the change in category of Stevengraphs – woven pennants or banners that were commonly sold at fairs during the Victorian era and up until just before World War II. These cheap souvenirs have become valuable collectors' items. The story of their metamorphosis is also the story of their shift in ownership from women to men. In the early days Stevengraph-collecting, like knitting, was largely a feminine occupation, 'the housewife's harmless little self-indulgence' as Thompson put it.[8] However, as the transition from transient to durable proceeds so Stevengraphs are transferred to male collectors. Men write authoritative books about the collections, and an exclusive auction house regulates their sales and prices. He concludes his analysis by noting: 'It seems probable that women were excluded from durability by a double mechanism. Items controlled by women were transferred to the durable category by transferring control to men and, when this transfer of control did not occur, nor did the transfer from rubbish to durable … Women have been excluded from durability just as they have been excluded from the Stock Exchange and from Great Art.'[9]

I have taken this brief excursion through these theories about waste and women in order both to establish women's credentials in the field of garbology and to suggest why women are strategically so well positioned to deal with the trash. Now I would like to look at the work of a number of the 'garbage girls' (to borrow Lucy Lippard's term for women artists working with waste).

Christy Rupp makes sculptures of endangered dolphins, fish and various species of marine life from the discarded objects that are destroying them. In *Red Tide* two giant turtles made of discarded red plastic Tide detergent bottles stuffed in steel armatures seem to be expiring on the gallery floor – one turtle lies belly up while the other looks on expectantly. Detergents are frequently given deceptively cheery names like New Era, Dawn, Cascade, Surf, Breeze, Sunlight as if to mask their effects upon the watershed. In *Fossil Fuels Forever*, made in response to Exxon's catastrophic oil spill in Prince William Sound, five tar-covered cormorants and two empty oil barrels form a kind of despondent *tableau vivant* – one bird is expiring while another tries to lift itself up from under the crushing weight of an oil barrel. In *Ooze Sorry Now*, oil seeps through the cracks in the shell of a snail made of steel taken from a deconstructed oil barrel. In *Deep Sea Dinner*, a dolphin form filled with cat food and tuna cans and covered with polyethylene netting – the same material used in fishnets that trap unwanted dolphins – becomes a monument to the thousands of dolphins killed each year by the commercial tuna industry. *Species Born-agradable* is a steel-framed frog made of so-called biodegradable garbage bags that do not, in fact, decompose in landfills. In *Synthethic Water* and *Wave of the Future* mussel and seashell forms are filled with transparent, blue, green and clear plastic water bottles. The double-edged elegance of the pearly nautilus is an ironic commentary on our growing reliance

on bottled water, another shortsighted solution which adds to the problem. With deft humour, Rupp's sculptures bring us right back to confront what we thought we had got rid of, giving new meaning to the notion of the eternal in art.

Nancy Rubins's sculptures portray the collective pathos of thousands of rejected consumer items. She turns scrap-yard junk (TVs, air conditioners, coffeemakers, hair dryers, toasters, plumbing appliances, etc.) into art of the abject. It is the scale of Rubins's work that commands our respect; respect for the millions of jettisoned Mr. Coffees, toasters, hair dryers, etc. that are accumulating yearly in our landfills. Once these unwanted consumer items return en masse, they are awe-inspiring. In 1982, she compiled *Worlds Apart*, a 42-foot high mushrooming cloud of trash that spiralled up and over Washington's Watergate Plaza. After it has had its apotheosis as art, the junk is dismantled again and returned to the dump. Rubins has moved on to ever more gargantuan junk. *Another Kind of Growth* (1988) (Figure 36) was made of discarded mobile homes climbing up and over live oak trees at Pittsburgh's Point State Park. Almost airborne, these mobile homes seem to have gained agency. As if sensing the urge for transcendence in all junk, Rubins went to the Mojave Desert to search for wrecked airplanes, junk that had once been able to fly, and refashioned them into works such as *Four Thousand Lbs. of Smashed and Filleted Airplanes* in 1986 and *Topanga Tree and Mr. Huffman's Airplane Parts* in 1990. One expects that the next step for Rubins will be space debris.

36 Nancy Rubins, *Another Kind of Growth*, 1988.

Betty Beaumont's *Ocean Landmark Project*, a sculptural reef for breeding fish, began when Beaumont, who is a scuba diver, realised that the only use made of the continental shelf off Long Island was as a dump site for everything including industrial sludge, atomic waste, unexploded bombs, discarded police guns, etc. and that this dumping, more than over-fishing, was the principal cause of the destruction of the marine life in the area. What is perhaps most intriguing about Beaumont's reef is that it is made of material that is causing another ecological problem on Long Island – waste coal fly-ash, the by-product of hydro-electric power plants. Working with a team of material scientists, Beaumont learned that although this ash is unstable above water and a potential pollutant, in water it can be stabilised and stored safely. She investigated a variety of reef-building methods used in Japanese aquaculture to determine the optimum shape and size of her sculpture. She had 500 tons of coal ash fabricated into 16-inch bricks at a concrete plant, trucked to the Jersey shore, and loaded on to a pocket barge. The blocks were then control dumped at the designated site to form a reef sculpture on the floor of the Atlantic. *Ocean Landmark Project*, completed in 1980, lies seventy feet below the surface of the water about 50 miles from New York City off the coast of Fire Island. It took over three years in the planning, but only a day to install. It is documented in photographs of every stage of the process, underwater film footage and sonograms as well as beautifully choreographed videotape showing the tugboat towing the barge out into the ocean and the controlled dumping of the bricks at the designated site. Subsequent visits to the underwater site in the first few months revealed the developing ocean plankton – the first link in the aquatic food chain – and then later fish began to inhabit the reef. It is now a flourishing aqua-system providing habitat and sustenance for a variety of marine life.

Ocean Landmark Project is a very pragmatic solution to several ecological problems and, at the same time, it is a fully resolved conceptual art work. As Beaumont says, 'Fundamental to the original concept of the work was the belief that its integrity resided in its invisibility – it could only be imagined.'[10] Conceptual artists attempted to address the problem of the surfeit of objects in the world, including art objects. Various 'dematerialised' forms were developed that aimed to make art part of the solution rather than part of the problem. As Daniel Buren described it: 'there was a group of people at that time, all of whom were working in a way which had almost nothing to do with aesthetics and which concerned itself with the question of how one can make something from nothing. There were people working from shadows – no cost; people working with words – no cost; people working with bits of wood found lying in the street or hedgerows – no cost; etc., etc. ... Of course', he goes on to say, 'a lot of this stuff became chic and expensive, stylish and academic'.[11] Overwhelmed by the power of the market-oriented art world and the failure to create a new context and new audience, the impetus faded: the dematerialisation concept was eventually re-embodied into commodities. But with the growth of more sophisticated art/political awareness during the eighties some of what conceptualism gestured at is being realised. In

large part, this is due to paradigm shifts taking place in art as a result of the convergence with broad-based movements like feminism and ecology.

A number of artists have dedicated themselves to cleaning up the waterways in performances that are as repetitive and ephemeral as housework. In 1987 Dominique Mazéaud organised trash brigades known as *The Great Cleaning of the Rio Grande River*, a performance she repeats each month. Since 1990, Suvan Geer has organised large groups of people to join her on Earth Day in cleaning up the Los Angeles River. These are extravagant gestures made in the face of a formidable task.

No less intrepid, Agnes Denes cleared a 2-acre landfill created from the debris from the construction of the World Trade Center in New York City. On land that is among the most valuable property in the world, she planted, tended and harvested 1,000 pounds of wheat. Throughout the summer of 1982, the sight of *Wheatfield Confrontation* (Figure 37), a golden field of wheat growing in the heart of the financial district, reminded an urban populace of its dependence on the land. Recently, Denes has completed *Tree Mountain – A Living Time Capsule*, a massive earthwork and land reclamation project located in an abandoned gravel pit in Finland. Ten thousand Finnish pine trees were planted in a spiral formation on a man-made mountain. This huge collective project involved numerous people and organisations such as the United Nations Environment Program, the Finnish Ministry of Environment, foresters, engineers and local citizens. *Tree Mountain – A Living Time Capsule* is a

37 Agnes Denes, *Wheatfield Confrontation, 2 acres of wheat planted and harvested by Agnes Denes (The Harvest)*, 1982.

realisation of the notion of 'stewardship' of the land, where one does not own the land, but looks after it for future generations.

Landfills seem to be the *œuvre* of choice for a number of women artists. Nancy Holt who is currently working on the New Jersey Landfill Project sees these vast landfills as distinctly American. 'The feeling of awe I frequently feel standing on top of the landfill is similar to the wonder I experienced on the huge American Indian mounds in Miamisburg, Ohio and in the Cahokia sites along the Mississippi River in Illinois. Both kinds of human-made mounds were built to meet vital social necessities, but here the similarity ends. Landfills result, of course, from the essential need to rid ourselves of the used-up, cast-off materials of our culture, while American Indian mounds derived from deep spiritual, social, and ritualistic needs.'[12] At times, Holt sounds a bit nostalgic for these old dumps:

> Trash piles have been with us for thousands of years, as far back as archeologists have traced. With a friend who is an archeologist, I once visited a cave home of the Anasazi, the earliest known human beings in the Southwest, in a high butte in northwestern Utah. There at the base of the butte, just below the cave I saw my first prehistoric trash – a large pile of broken pottery, fish and animal bone, shells and such ... Today's landfills, then, have a long heritage. Around the globe there are millions of these shunned earthen forms – forgotten trash heaps, relegated to the realms of the unconscious. By the end of the century, with more reliance on improved methods of recycling and incineration, laws will go into effect to prohibit the use of landfills for garbage disposal. These heaps of rubbish will be seen as the artifacts of our generation, our legacy to the future. So there is no escaping our responsibility for making these mounds of decaying matter safe by using the latest closure technology, and eventually reinterpreting and reclaiming them, giving them new social and aesthetic meanings and functions.[13]

Holt's response to this vast inelegance that lies deep within the personality of American technological consumer society led her to design *Sky Mound* for the New Jersey landfill in such a way as to enable it to form a link between America's past and future – referencing ancient Indian mounds as well as what looks like a landing site for future extra-terrestrial spacecraft. Her design uses the latest innovative technology of landfill closure: methane recovery wells, a methane flare, a surface drainage pond, mounds made of fill, a leachate collection system, a land drainage system, and a thirty-foot-deep slurry wall around the perimeter of the landfill. The area on top of the landfill was covered with a plastic liner made of recycled plastic soda bottles, then covered with topsoil and seeded. The mounds and steel posts in what she calls the 'lunar area' will mark the extreme orbital positions of the moon while from the 'solar area' the sun will be seen rising and setting on the solstices and equinoxes. When it is completed, this celestial calendar will be visible from the New Jersey Turnpike on one side and the *Amtrak* trains on the other and overhead by airplanes flying into the Newark Airport.

The preeminent 'garbage girl' is of course Mierle Laderman Ukeles. Since 1976 she has served as artist-in-residence with the New York City Department of

Sanitation. She has been commissioned by Cultural Affairs and the Department of Sanitation to be the artist in charge of designing the largest garbage dump on this planet – a three thousand acre municipal landfill on Staten Island. From the five boroughs of New York, this landfill receives 27 thousand tons of garbage a day which forms mountains of garbage – 300 to 500 feet high, what the architect Michael Sorkin termed 'the Alps of New York'. This *magnum opus* will occupy her for perhaps the rest of her life. When asked how she got on to this path which led to design the mother of all landfills she explained, she had a baby. As a mother, she became a maintenance worker. While she was doing the repetitive tasks involved in looking after the baby, she had a kind of Duchampian revelation – she realised that she was an artist and as such she could decide what was art, so she called what she was doing art. In her early performances involving repetitive activity such as changing diapers, picking up toys, dressing and undressing the child, she began an investigation of the greatest of all divides – the gulf that separates the unnoticed activity of housework from the highly valorised activity of art making. In focusing on this divide she has gone to the heart not just of an important gender issue but an important ecological issue – one that is deeply entrenched in our thinking, whether that thinking is conditioned by capitalist or Marxist ideology. Central to Marx's notion of human progress is freedom from manual labour, a freedom to be achieved through continuing technological developments. Marx tends to valorise cultural activity as the means to true individual fulfilment while grading as lowly many life-sustaining activities that could be potentially more fulfilling if approached and thought of differently. The result is that culture and self-expression are made to seem the complete antithesis of necessary material labour. Simone deBeauvoir has drawn attention to a similar kind of contrasting valuation between the self-limiting work of women and the self-transcending work of men. The work women are commonly engaged in such as housework, cleaning, growing and preparing food, caring for the young, infirm, or the elderly, etc., is treated as private, mundane, and concerned with the regeneration and repetition of life, while the work of men outside the home is regarded as public, important, concerned with shaping the future through technology and symbols.

In 1969 Ukeles wrote *Manifesto for Maintenance Art* which brought art and the work women commonly do into a provocative affiliation. It remains the central document that has influenced the content and direction of her work for thirty years. Her early performances included washing the floors of museums, scrubbing the sidewalk outside a gallery, and documenting the work of the maintenance staff of a branch of the Whitney Museum of American Art. The performances raised questions about enduring and ephemeral work, valued and undervalued labour, and the category of aesthetic value itself.

Making maintenance activity visible and involving all those who participate in it is the major impetus of her work. One of her projects was to shake the hand of every sanitation worker in New York City. *Handshake Ritual* (1978–79) remains one of her most memorable, arduous and controversial works. It involved a

complete immersion in the culture and routines of sanitation work. Mapping out the city according to a system of sweeps and shifts, she worked the day and night shifts to complete the performance. The attitude of the general public towards sanitation workers is one of indifference or even hostility; the public tends to associate the sanitation workers with the garbage and, in a way, blame them for it. They frequently receive insults and invective as they collect the garbage from the city streets. Ukeles first wrote to every sanitation worker explaining her intentions. She needed to gain their cooperation for this project – a number of workers did not want their friends and neighbours to know what they did for a living. Ukeles recounts stories of workers who would never dry their uniforms on outdoor laundry lines in order to hide the nature of their work from their neighbours. The intent of these thousands of handshakes was to honour and confirm the dignity of sanitation work. The performance attracted a lot of media attention and won her a place in the hearts of the sanitation workers. When the handshaking event was finished, Ukeles was appointed Honorary Deputy Commissioner of Sanitation and made an honorary member of the Teamster Union.

Handshake Ritual was part of an ongoing series of works designed to bring people closer to their garbage. *Transfer Station Trans Formation* undertaken in 1984 included performance and exhibitions at a waste transfer station at 59th Street in New York City. Here huge displays of sanitation tools and equipment and cages of recyclable material were arranged as monuments to the magnitude, energy and repetition of maintenance work. The show attracted thousands of visitors. In 1983, Ukeles installed a Plexiglas mirror on the sides of a garbage truck. As *The Social Mirror* (Figure 38), as it was called, made its rounds collecting garbage, people walking in the streets could see themselves reflected in the mirror, reminding them of their participation in this art work. In *Ballet Mechanique* (1983) she drew upon the Russian Constructivist tradition of choreographing machinery and scripted a ballet for six street sweepers and their drivers. The ballet was part of New York City's Art Parade. At the end of the performance, the drivers turned the huge machines to face the audience and took a bow by raising and lowering the sweepers' brooms while backing up. This was the first of several ballets she has orchestrated involving heavy equipment, including a barge ballet on the Hudson River. In this, as in all of her work, Ukeles likes to bring together opposites – the notion of dance coupled with work; lightness coupled with heavy equipment. In 1993, she choreographed a much larger piece involving twenty-seven city vehicles including garbage trucks, street sweepers, fire engines and barges for the city of Givors in France.

Ukeles's zeal for putting people in touch with their trash makes her sound like the inspiration for a character in Don Delillo's *Underworld*: 'Bring garbage into the open', he urges, 'Let people see it and respect it. Don't hide your waste facilities. Make an architecture of waste. Design gorgeous buildings to recycle waste and invite people to collect their own garbage and bring it with them to the press rams and conveyors. Get to know your garbage.'[14] Since 1983, at the same site as her first large-scale installation at 59th Street, Ukeles has been doing just that. Working

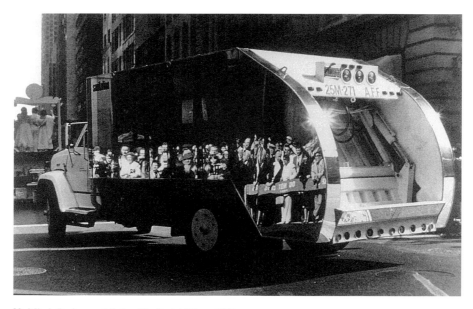

38 Mierle Laderman Ukeles, *The Social Mirror*, 1983.

with engineers, architects and ecologists she has been designing an ambitious public art and garbage access project called *Flow City*. Partly conceived of as a Museum of Human Labour, *Flow City* is intended to let people enter into an operational waste disposal system. It involves a series of sequential, participatory environments and observation points for the public. Ukeles is committed to bringing people into an immediate sensory experience with this giant influx of garbage because, as she says, it is theirs, it is an important social sculpture that they are producing every day. Like her work ballets, she sets up a series of philosophical contrasts in this site where mundane reality and the potential for transformation meet. The visitors enter through a long passageway whose walls and floors are made of recyclable material – glass, aluminium, newspaper, heavy metals, rubber, toxic materials. One wall of the passageway is clear glass, providing a view of the constant stream of incoming garbage trucks. From this passageway, the visitor comes on to the Glass Bridge, a proscenium framing the dramatic art of maintenance, what Ukeles describes as 'the violent theatre of dumping' – evidence of the tremendous energy and synchronisation involved in the transfer of garbage from truck to barge. On one side of the Glass Bridge, pictured through the glass windows, is a perfect postcard view of the Manhattan skyline, on the other side flows the Hudson River down which float the barges heaped high with garbage. The Glass Bridge ends in the Media Flow Wall, a wall of video monitors set in a sculpted wall of glass. The media wall will connect the building and its activities – via live transmission – to the landfill on Staten Island.

The juxtaposition of the rough, continuous mechanical frenzy of the disposal system with the sharply contrasting view of the pristine glass and steel towers of the Manhattan skyline, and the flowing water of the Hudson River, makes the installation a site of philosophical contemplation, bringing the viewer into a visceral relationship to this endless flow of material. As Ukeles says, 'we end, but the flow continues. Waste represents the ending of use, it's a metaphor for death, something most of us are afraid to deal with.'[15] Running throughout *Flow City* is the material and metaphorical realisations of transformation, reclamation and redemption.

The greatest danger today, suggests ecologist Joanna Macy, is the feeling that the crisis is too big to deal with. A major part of what needs to be done is what she calls 'despair work', envisioning ways to surmount what seem to be insurmountable problems. This may be one of the reasons why Ukeles, Holt, Denes, Beaumont, Rubins and so many others take on projects of such monumental scale. It may be the extravagance of the projects and the obsession that makes it work as art – as one reviewer wrote about the landfill project – 'One man's trash is another man's gold, but seven million people's trash, well that's art.' In the process they are radically redefining public art and expanding the realm of the aesthetic. As Ukeles says, 'the design of garbage should become the great public design of our age. I am talking about the whole picture: recycling facilities, transfer stations, trucks, landfills, receptacles, water treatment plants, and rivers. They will be giant clocks and thermometers of our age that tell the time and health of the air, the earth, and the water. They will be utterly ambitious – our public cathedrals. For if we are to survive, they will be symbols of survival.'[16]

In showing that maintenance is not the opposite of creativity, that it can be a reinterpretation of creativity, these artists are beginning to reverse the long process by which art became formalised and divorced from social and practical considerations. 'Artistic freedom' has been translated to mean the absence of any social consequences for art, but it long ago lost its emancipatory ring. The beliefs we have ascribed to art – that the problems of art are purely aesthetic and that art has no responsibility to anything other than itself – are beliefs that have diminished the capacity of artists for constructive thought and action, leading to cultural powerlessness. The premise that aesthetic creation is necessarily individualistic is a questionable romantic myth nourished by bourgeois liberalism's ideology of individualism, and one that belies art's essential communal and pragmatic dimension. This myth has been seriously undermined over the last two decades by the feminist intervention in art. The suggestion that art could become *useful* again, that it may in fact be in the process of being reintegrated into the praxis of life, may be what is the most disturbing aspect of all these women mucking about in the trash. As Sappho said, 'If you are squeamish, don't stir the beach rubble.'

Select bibliography

Attwood, L., *The New Soviet Man and Woman* (London, Macmillan, 1990).

Barell, John, *The Idea of the Landscape and the Sense of Place* (Cambridge, Cambridge University Press, 1972).
——*The Dark Side of the Landscape. The Rural Poor in English Painting 1730–1840* (Cambridge, Cambridge University Press, 1980).
Barker-Benfield, G. J., *The Culture of Sensibility: Sex and Society in Eighteenth-Century Britain* (Chicago and London, University of Chicago Press, 1992).
Bauer, R. A., *The New Man in Soviet Psychology* (Cambridge, Mass., Harvard University Press, 1952).
Bermingham, Anne, *Landscape and Ideology: The English Rustic Tradition 1740–1860* (Berkeley, University of California Press, 1986).
Bollas, Christopher, *Being a Character. Psychoanalysis and Self Experience* (London, Routledge, 1993).
Bryson, Norman, *Vision and Painting: The Logic of the Gaze* (New Haven, Yale University Press, 1989).

Cherry, Deborah, *Painting Women, Victorian Women Artists* (London and New York, Routledge, 1993).
Clark, Kenneth, *Landscape into Art* (London, Pelican Books, 1956).
Colomina, Beatriz (ed.), *Sexuality and Space* (New York, Princeton Architectural Press, 1992).
Compton, Michael, *Some Notes on the Work of Richard Long by Michael Compton* (London, British Council (published for the Venice Biennale), 1976).
Costlow, J. T., Sandler, S. and Vowles, J. (eds), *Sexuality and the Body in Russian Culture* (Stanford, Stanford University Press, 1993).
Crary, J., *Techniques of the Observer: On Vision and Modernity in the Nineteenth Century* (Cambridge, Mass., MIT Press, 1990).
Crawford Art Centre, 1997, A Road from the Past to the Future – Work by Richard Long from the Haldane Collection, Crawford, 1997.

Dalsimer, A. M. (ed.), *Visualizing Ireland: National Identity and the Pictorial Tradition* (Winchester, MA, Faber and Faber Inc., 1993).
Daniels, Stephen, *Fields of Vision. Landscape Imagery and National Identity in England and the United States* (Cambridge, Polity Press, 1993).
Daston, L., 'The Naturalized Female Intellect,' *Science in Context*, 5 (1992), pp. 209–35.

Douglas, Mary, *Purity and Danger: An Analysis of Concepts of Pollution and Taboo* (New York and London, Praeger Publishers, 1966).

Duncan, Carol, 'Virility and Domination in Early Twentieth Century Vanguard Painting', in N. Broude and M. Garrard (eds), *Feminism and Art History: Questioning the Litany* (New York, Harper Row, 1982).

Foster, Hal (ed.), *Vision and Visuality* (Seattle, Dia Art Foundation, 1988).

Fuchs, R. H., *Richard Long* (London, Thames and Hudson; New York, Solomon H. Guggenheim Foundation, 1986).

Green, Nicholas, *The Spectacle of Nature: Landscape and Bourgeois Culture in Nineteenth Century France* (Manchester, Manchester University Press, 1990).

Helsinger, Elizabeth, *Rural Scenes and National Representation, Britain, 1815–1850* (Princeton, Princeton University Press, 1993).

Hemingway, Andrew, *Landscape Imagery and Urban Culture, in early Nineteenth Century Britain* (Cambridge, Cambridge University Press, 1992).

Houston, Contemporary Arts Museum, *Circles, Cycles, Mud, Stones* (catalogue with an essay by Richard Brettell), 1996.

Hubbs, J., *Mother Russia. The Feminine Myth in Russian Culture* (Bloomington and Indianapolis, Indiana University Press, 1988).

Hunt, John Dixon, 'The Cult of the Cottage', in *The Lake District: A Sort of National Property* (Manchester, Countryside Commission and London, Victoria and Albert Museum, 1986).

Jordanova, Ludmilla, *Languages of Nature. Critical Essays on Science and Literature* (London, Free Association Books, 1986).

——*Nature Displayed. Gender, Science and Medicine 1760–1820* (London and New York, Longman, 1999).

Kristeva, Julia, *Powers of Horror: An Essay on Abjection*, trans. Léon Roudiez (New York, Columbia University Press, 1982).

Long, Richard, *Richard Long Walking in Circles*, London, The South Bank Centre, 1991; (book published on the occasion of an exhibition with contributions by Richard Cork, Hamish Fulton, Richard Long and Anne Seymour).

McDowell, Linda and Sharp, Joanne P., *Space, Gender Knowledge* (London, Routledge, 1997).

Mamonova, Tamara, *Russian Women's Studies: Essays on Sexism in Soviet Culture* (Oxford, Pergammon Press, 1989).

Marsh, Jan, *Back to the Land, The Pastoral Impulse in England from 1880–1914* (New York, Quartet Books, 1982).

Matilsky, Barbara C., *Fragile Ecologies: Contemporary Artists' Interpretations and Solutions* (New York, Rizzoli, 1992).

Merchant, Carolyn, *Earthcare, Women and the Environment* (London, Routledge, 1996).

Mitchell, J. T., *Landscape and Power* (Chicago and London, University of Chicago Press, 1994).

Mulvey, Laura, *Visual and Other Pleasures* (Basingstoke and London, Macmillan, 1989).
—— 'Reclaiming Vision: Looking at Landscape and the Body', *Gender, Place and Culture*, vol. 3, no. 2, 1996, pp. 149–69.

Nash, Catherine, 'Remapping and Renaming: New Cartographies of Identity, Gender and Landscape in Ireland', *Feminist Review*, 44, 1993, pp. 39–57.

Oakes, Baile, *Sculpting with the Environment – A Natural Dialogue* (New York and London, International Thomson Publishing, 1995).
Oettermann, Stephen, *The Panorama: History of a Mass Medium*, trans. D. Lucas Schneider (New York, Zone Books, 1997).

Perry, Gill, *Gender and Art* (New Haven and London, Yale University Press in association with the Open University, 1999).
Pollock, Griselda, *Vision and Difference* (London, Routledge, 1988).
—— *Differencing the Canon: Feminist Desire and the Writing of Art's Histories* (London, Routledge, 1999).
Pratt, Mary Louise, *Imperial Eyes. Travel Writing and Transculturation* (London and New York, Routledge, 1992).
Pugh, Simon (ed.), *Reading Landscape: Country–City–Capital* (Manchester and New York, Manchester University Press, 1990).

Rose, Gillian, *Feminism and Geography* (London, Routledge, 1993).

Segal, Hanna, 'A Psychoanalytic Approach to Aesthetics', in J. Phillips and L. Stonebridge (eds), *Reading Melanie Klein* (London and New York, Routledge, 1998).
Shiff, Richard, 'Cézanne's Physicality', in S. Kemal and I. Gaskell (eds), *The Language of Art History* (Cambridge, Cambridge University Press, 1991).
Smith, Paul, *Interpreting Cézanne* (London, Tate Publishing; New York, Stewart, Tabori & Chang, 1996)
Stokes, Adrian, *Inside Out; An Essay in the Psychology and Aesthetic Appeal of Space* (London, Faber and Faber, 1947).

Thompson, Michael, *Rubbish Theory: The Creation and Destruction of Value* (Oxford, Oxford University Press, 1979).
Thomson, R., *Framing France: Representation of Landscape in France, 1870–1914* (Manchester and New York, Manchester University Press, 1998).

Williams, Raymond, *Keywords, A Vocabulary of Culture and Society* (London, Croom Helm, 1976).
—— *Problems in Materialism and Culture* (London, Verso, 1980).
—— *Socialism and Ecology* (London, Socialist and Environment Resources Ltd, 1982).
Wollheim, Richard, *On Art and the Mind* (London, Allen Lane, 1973).
——*Painting as an Art* (Princeton, Princeton University Press; London, Thames & Hudson, 1987).

Notes

Notes to Chapter 1

1 C. Bollas, *Being a Character: Psychoanalysis and Self Experience* (London, Routledge, 1993), p. 41.

2 L. Jordanova, *Nature Displayed: Gender, Science and Medicine 1760–1820* (London and New York, Longman, 1999), p. 5.

3 G. Perry, *Gender and Art* (New Haven and London, Yale University Press in association with the Open University, 1999).

4 R. Williams, *Keywords: A Vocabulary of Culture and Society* (London, Fontana, 1976), p. 184.

5 *Ibid.*

6 *Ibid.*, p. 186.

7 R. Williams, *Problems in Materialism and Culture* (London, Verso, 1980), p. 7.

8 For a discussion of the commodification of Nature see N. Green, *The Spectacle of Nature: Landscape and Bourgeois Culture in Nineteenth Century France* (Manchester, Manchester University Press, 1990).

9 R. Williams, *Socialism and Ecology* (London, Socialist and Environment Resources Ltd, London, 1982).

10 See L. Mulvey, 'Visual Pleasure and Narrative Cinema', in *Visual and Other Pleasures* (Basingstoke and London, Macmillan, 1989), pp. 14–28.

11 *Ibid.*, p. 19.

12 G. Rose, *Feminism and Geography* (London, Routledge, 1993), pp. 98–9.

13 C. Nash, 'Reclaiming Vision: Looking at the Landscape and the Body', *Gender Place and Culture*, vol. 3, no. 2. London, 1996.

14 *Ibid.*, p. 157.

15 S. Ortner, 'Is Female to Male as Nature is to Culture?', in M. Z. Rosaldo and L. Lamphère (eds), *Woman, Culture and Society* (Palo Alto, University of California Press, 1974), pp. 67–8.

16 *Ibid.*

17 *Ibid.*

18 L. Jordanova, *Sexual Visions: Images of Gender in Science and Medicine between the Eighteenth and Twentieth Centuries* (New York and London, Harvester Wheatsheaf, 1989), p. 26.

19 Jordanova, *Nature Displayed*, p. 5.

20 C. Merchant, *Earthcare Women and the Environment* (London, Routledge, 1996), p. 43.

21 K. Clark, *Landscape into Art*, 1949 (London, Pelican Books, 1956). All quotations are from the London, Pelican Books, 1956 edition.

22 *Ibid.*, p. 17.

23 *Ibid.*, p. 15.

24 See J. Barrell, *The Dark Side of the Landscape: The Rural Poor in English Painting, 1730–1840* (Cambridge, Cambridge University Press, 1980); A. Bermingham, *Landscape and Ideology: The English Rustic Tradition, 1740–1860* (Berkley, Los Angeles and London, University of California Press, 1989); S. Daniels (ed.), *Exploring Human Geography: A Reader* (London, Arnold, 1996), *Fields of Vision: Landscape Imagery and National Identity in England and the United States* (Cambridge, Polity, 1993), *The Iconography of Landscape: Essays on the Symbolic Representation, Design and Use of Past Environments* (Cambridge, Cambridge University Press, 1988), co-edited with D. Cosgrove. See also M. Pointon, 'Geology and Landscape Painting in Nineteenth Century England', in L. Jordanova and R. Porter (eds), *Images of the Earth* (Chalfont St. Giles, British Society for the History of Science, 1979), pp. 84–116; M. Rosenthal, *British Landscape Painting* (Oxford, Phaidon, 1982), *Prospects for the Landscape: Recent Essays in British Landscape 1750–1880* (New Haven and London, Yale University Press, 1997); A. Hemingway, *Landscape Imagery and Urban Culture in Early Nineteenth Century Britain* (Cambridge and New York, Cambridge University Press, 1992); D. Solkin, *Richard Wilson and the Landscape of Reaction* (New Haven and London, Yale University Press, 1993); S. Pugh, *Reading Landscape: Country–City–Capital* (Manchester, Manchester University Press, 1990); W. J. T. Mitchell, *Landscape and Power* (Chicago and London, University of Chicago Press, 1994).

25 Pugh, *Reading Landscape* and Mitchell, *Landscape and Power*.

26 Barrell, *Dark Side of the Landscape*, p. 1.

27 *Ibid.*, p. 6.

28 Bermingham, *Landscape and Ideology*, p. 3.

29 *Ibid.*, pp. 3–4.

30 Mitchell, *Landscape and Power*, p. 1.

31 *Ibid.*

32 Clark, *Landscape into Art*, p. 100.

33 Griselda Pollock's seminal essay on Berthe Morisot published in *Vision and Difference: Femininity, Feminism and the Histories of Art* (London, Routledge, 1996), reveals how the social restrictions placed on an artist of her class and sex prevented Morisot from depicting the same subjects of modern urban life as her male Impressionist colleagues. The glimpses of landscape in Morisot's out-of-doors pictures, domestic and suburban scenes are tantalising. While Morisot did on occasion paint landscapes at tourist sites – the Isle of Wight, for example – it would have been inconceivable for her to travel through France, painting alone in front of Nature, as did Monet.

34 See Bollas, *Being a Character*, p. 40.

35 Henry David Thoreau, *Journal*, 30 August 1856, cited in S. Schama, *Landscape and Memory* (London, Harper Collins, 1995), p. 7.

Notes to Chapter 2

1 A summary of the standing of the genres on the eve of the Exposition Universelle of 1889 is given within H. Gautier, 'Causeries sur l'Expsoition Universelle', *Musée de familles*, vol. LXII (Paris, 1889), pp. 139–41.

2 For an account of the ways in which the state promoted artistic freedom during this period see L. Gonse and A. L. Lostalot, *L'Exposition Universelle de 1889* (Paris, 1890); E. Moliner, R. Marx and F. Marcous, *L'Exposition Universelle de 1900: l'Art Français des origines à la fin du XIX siècle* (Paris, 1900) and G. Larroumet, *L'Art et l'état en France* (Paris, 1895). These issues have also been more recently examined by M.-C. Genet-Delacroix, *Art et état sous la troisièmme république: la système des beaux arts 1870–1940* (Publications de la Sorbonne, Paris, 1992).

3 A. Michel, 'Les Arts à L'Expsoition Universelle de 1900', *Gazette des beaux-arts* (Paris, 1900), p. 294.

4 The assertion that landscape painting could be counted as the most progressive of the genres and the one most closely connected with the aspirations of the French is found in Henriet's monograph on Charles-Francois Daubigny, published in 1871. It is repeated in other monographs and biographical essays on *petits-maîtres* of the 1880s and 1890s, notably André Michel and Paul Mantz's biographical essays for the *Gazettes des beaux-arts*. The assertion is also taken up in official and quasi-official commentaries in the early 1880s, especially in the accounts of French art published to coincide with the Expositions Universelles of 1889 and 1900. See P. Mantz, 'Le peinture française', *Gazette des beaux-arts* (Paris, 1889) pp. 94ff. and L. Gonse and A. Lostalot, *Exposition Universelle de 1889; Les beaux-arts et les arts décoratifs* (Paris, 1889), pp. 23–44.

5 N. Green, *The Spectacle of Nature: Landscape and Bourgeois Culture in Nineteenth Century France* (Manchester, Manchester University Press, 1990), and Green's 'Dealing in Temperaments', *Art History*, vol. 10, no. 1, March, 1987, pp. 58–78.

6 I have used the term writing *about* and writing *around* landscape in preference to art criticism because the terms point to the several and often problematic relationships between writing on landscape painting and its object of study, a key concern in any attempt to map connections between the diverse forms of observations on landscape and gender in mid-nineteenth-century France. The matter is especially pressing because of the discursive breadth of the sources used in this chapter. For an account of .0the relationship between art and criticism during this period, see M. Orwicz, *Art Criticism and its Institutions in Nineteenth Century France* (Manchester, Manchester University Press, 1994), p. 1 and A. Rifkin, 'History, Time and the Morphology of Critical Language, or Publicola's Choice', also in *Art Criticism and its Institutions in Nineteenth Century France*, pp. 29–40.

7 This image of the landscape painter featured in a number of early nineteenth-century comic plays, including J. Théalon and A. Choquart, *M. Ducroquis ou le peintre en voyage* (Paris, 1822), and most conspicuously in Pierre-Yon Barré and Jules-Benoit Picard's *Lantara ou le peintre au cabaret* (Paris, 1812).

8 E. Bellier de la Chavignerie, *Recherches historiques, biographiques et litteraires sur le peintre Lantara* (Paris, 1852).

9 A significant quantity of writing published during the second half of the nineteenth century saw landscape painting as a highly respected genre but one that was largely ignored or marginalised due to the influence of conservative salon jurors and members

of the Académie des Beaux Arts. Landscape painters, especially those that eschewed
the neo-classical style of landscape that formed part of the academic curriculum,
worked, so the narrative runs, in lonely isolation in the countryside around the capital
and were thus forced to draw on their strong sense of personal conviction rather than
institutional recognition. Variants of this art historical narrative are evident, for
example, in Alfred Sensier's monographs on the landscape painters Georges Michel,
Jean-Francois Millet and, notably, in his study on Théodore Rousseau, known as 'le
grand refusé', following the painter's continued rejection from the Paris salons of the
1840s. See Sensier's *Souvenirs de Théodore Rousseau* (Paris, 1872); *Études sur Georges
Michel* (Paris, 1873) and *La vie et l'oeuvre de Jean-François Millet* (Paris, 1881).
According to the critical commentaries of the 1870s and after, the painters concerned
were given their rightful place in French art through the diligent efforts of historians
who recovered their reputations through patient archival research. By the early 1880s,
this textual strategy had become a commonplace and is evident in most historical
studies of the period. See, for example, Paul Marmottan's *L'École française de peinture*
(Paris, 1900), pp. 3–7.

10 Bellier, *Recherches historiques*, p. 22.

11 *Ibid.*, pp. 23–4.

12 *Ibid.*, p. 35.

13 See the definition under this heading in the *Grande Larouse du XIXe siècle* (Paris,
1867), vol. 3, pp. 679–81.

14 See the definition of the term contained with the *Grande Larouse du XIXe siècle* (Paris,
1873), vol. 10, p. 974.

15 Bellier, *Recherches historiques*, p. 40.

16 *Ibid.*, p. 40.

17 *Ibid.*, p. 34.

18 F. Henriet, *Le paysagiste au champs* (Paris, 1876), p. 6. (First published in limited edi-
tion by Lemerre in 1864. All endnotes refer to 1876 edition.)

19 Henriet, *Le paysagiste au champs*, pp. 66–7.

20 *Ibid.*, p. 45.

21 Issues of masculinity and modernism feature most conspicuously in Carol Duncan's
essay, 'Virility and Domination in Early Twentieth Century Vanguard Painting', in
N. Broude and M. Garrard, *Feminism and Art History: Questioning the Litany* (New
York, Harper Row, 1982), pp. 294–313, and, more recently, in G. Pollock,
Differencing the Canon, Feminist Desire and the Writing of Art's Histories (London,
Routledge, 1999), pp. 34–5 and 41–3. The subject of both Duncan and Pollock's
enquiry centres fundamentally around a modernist canon. It is worth questioning,
however, the place of that canon and the historical nature of canonicity itself within
the narrative construction of nineteenth-century French art. In many instances quite
different, albeit no less powerful, assertions of masculinity were articulated in which
gender difference was given a form quite distinct from the tropes of heterosexual
masculinity which Duncan and Pollock articulate so effectively. While masculinity
may have been played out in the works of Degas, Van Gogh and the Expressionists,
et al., highly specific variants of masculinity also took shape not only in the texts
cited in this essay but in numerous other books, articles, exhibition catalogues and
personal memoirs of the period, articulations that *modern* art history and its various
revisions have often left unexamined.

22 H. Taine, 'Notes sur Paris: Les Artistes', in *La Vie Parisienne* (Paris, May 1865). Quotations are taken from the 1867 Hachette edition of the *Notes sur Paris: Vie et opinions de M. M.F.T. Graindorge, recueillies et publiées par H. Taine* (Paris, 1867).

23 The *auberge* as a site for the articulation of masculine identity is found in René Ménard's cultural atlas *Le Monde vue par des artistes: géographie artistique* (Paris, 1881) and in the landscape painter Georges Gassies's memoires on the artists' colony at Barbizon, *Le Vieux Barbizon: souvenirs du jeunesse d'un paysagiste* (Paris, 1907); descriptions are found in a number of other examples of criticism and popular journalism. For a summary of critical responses see the exhibition catalogue *Barbizon au temps de J.F. Millet* (Barbizon, Salle des fêtes de Barbizon, 1975), pp. 33–46.

24 Taine, 'Notes sur Paris', pp. 285–6.

25 *Ibid.*, p. 284.

26 *Ibid.*, p. 296.

27 *Ibid.*, p. 283.

28 *Ibid.*, pp. 284–5.

29 *Ibid.*, p. 286.

30 *Bibliographie de la France: Journal générale de l'imprimerie et de la libraire* (Paris, 1847).

31 *Bibliographie de la France: Journal générale de l'imprimerie et de la libraire* (Paris, 1856).

32 P. Lacroix, *Revue universelle des beaux-arts* (Paris, 1855), vol. 1, p. 4.

33 *Ibid.*, p. 5.

34 *Ibid.*, p. 17.

35 See Charles Blanc's introduction to the first edition of the *Gazette des Beaux-Arts* (Paris, 1859), pp. 6–7.

36 *Ibid.*

37 Writing in the introduction to his monograph of Daubigny's etchings, Henriet noted that the artist was so animated that Léon L'Hermite, the artist commissioned to etch a portrait for the frontispiece to the book, found it hard to capture his image. Here, the impressionistic style of the portrait was seen as a record of the effect temperament had on the painter's body and the etching an authentic representation of that temperament. F. Henriet, *Daubigny et son oeuvre gravé: eaux-fortes et bois inédits par C. Daubigny* (Paris, 1875), p. 3.

38 *Histoire de l'édition française, Le temps des éditeurs: du romantisme à la belle époque* (Promodis, Paris, 1985), p. 206. See also Louis-Xavier de Ricard, *Petites memoirs d'un parnassien, 1898–1900* (Paris, 1967). Also Bibliothéque nationale, Archive Impr. Q (Lemerre).

39 Alphonse Lemerre, *Le livre du bibliophile* (Lemerre, Paris, 1874). See also the account of the work of book sellers and reading circles in Paris in Auguste Poulet-Malassis's *Bibliographie raisonné et anecdotique des livres achetés par Auguste Poulet-Malassis* (Paris, 1885) and Louis Carteret's *Le Trésor du bibliophile* (Paris, 1924–28), p. 9.

40 De Ricard, *Petites mémoire d'un parnassien*, pp. 49ff.

41 J. Monfrin, *Honoré Champion et sa librarie, 1874–1878* (Paris, 1978).

42 The image of the landscape painter as virile-child appears in numerous examples of art criticism and popular literature on the subject. It is evident, for example, in Georges Gassies's memoire *Le Vieux Barbizon*, p. 18.

43 'Journal de Paris', March 1862, p. 44.

44 The publication was reprinted in 1873, 1875, 1878, 1880, 1882, 1886, 1888, 1890 and 1892. The print runs for each volume, moreover, were comparatively high. See Archives nationale, F/17/233.

45 L. Cyszba, 'Taine-Graindorge et les Jotessor Paris', *Romantisme*, vol. 4, 1982, pp. 34–55.

46 See P. Lahaire, *Contrôle de la Presse, de la Librairie et du Colportage sous le Second Empire* (Paris, Archives nationale, 1993), pp. x–xii; P. Guiral, *Histoire générale de la presse française* (Paris, 1973), vol. 2, *La Presse de 1848 à 1871*.

47 The restrictions placed on the publication of books, photographs and prints were generally in line with those placed on journals. The Decree of 17 February and 28 July 1852 required the formal registration of publications with the Ministry of Police, the registration of the publisher with the local *préfecture* or mayor, functions which were overseen by a permanent government commission, and the payment of the *estampille*, a stamp licensing the public sale of books. See Décret du 28 mars 1852 Article 1e. and Décret du 17 février, 1852, Article 25.

48 E. Hatin, *Manuel de la liberté de la presse* (Paris, 1868), p. 395.

49 Décret du 28 mars 1852 Article 1e. reprinted in the Introduction to P. Lahaire, *Contrôle de la presse*, p. x.

50 These observations are reflected in the statistics given by Eugène Hatin in which he notes a decline in subscriptions for the political press and a rise in the readership of 'la presse non politique', namely leisure and cultural journals. E. Hatin, *Le Journal* (Paris, 1882), p. 76.

51 H. Taine, *Vie et opinions de Monsieur Frédéric-Thomas Graindorge* (Paris, Hachette, 1957), p. ix.

52 J. Claretie, *Peintres et sculpteurs contemporains* (Paris, 1874), p. 4.

53 G. Larroumet, *L'Art et l'état en France* (Paris, 1895), pp. 17–18.

54 A. Copley, *Sexual Moralities in France, 1780–1980, New Ideas on the Family, Divorce and Homosexuality* (London and New York, Routledge, 1980), pp. 79–107. See also J. Weeks, *Sex Politics and Society: The Regulation of Sexuality Since 1800* (London, 1981), and P. Gay, *The Bourgeois Experience from Victoria to Freud: The Education of the Senses* (New York, Fontana 1984), vol. 1. For a more general discussion of the pathologisation of masturbation in the nineteenth century, see M. Foucault, *History of Sexuality* (Harmondsworth, Penguin, 1990), vol. 1, pp. 30, 104 and 121.

55 C.-F. Lallemand, *Les pertes séminales involontaires* (Paris and Montpellier, 1836–42).

56 The issue of the mental effects of masturbation, typically an inclination towards depressive, melancholic behaviour, is charted in Charles-Adolphe Claude's *De la folie causée par les pertes séminales* (Paris, 1849).

57 H. F. Amiel, *Journal Intime* (Paris, 1856), p. 45.

58 *Grande Larousse du dix-neuvième siécle* (Paris, 1867), vol. 5, pp. 44–5.

59 Larroumet, *L'Art et l'État en France*, p. 92.

Notes to Chapter 3

1 Charles Blanc, *Grammaire des arts du dessin* (Paris, 1867), p. 22.

2 Félix Bracquemond, *Du dessin et de la couleur* (Paris, 1885), p. 46.

3 In D. Silverman, *Art Nouveau in Fin-de-siècle France: Politics, Psychology and Style* (Berkeley and London, California University Press, 1989), p. 7; hereafter referred to as Silverman.

4 See for example Silverman, *passim*. On the nationalism of Monet's Series, see P. Tucker, *Monet in the '90s, The Series Paintings* (New Haven and London, Museum of Fine Arts, Boston in Association with Yale University Press), 3rd edn (July 1990) esp. chs 1 and 5; hereafter referred to as Tucker; all references unless specified are to the Royal Academy edition.

5 Octave Mirbeau, 'La Grande Kermese', *Le Figaro,* 18 July 1890, quoted in Tucker, p. 132.

6 S. Barrows, *Distorting Mirrors: Visions of the Crowd in Late Nineteenth-Century France* (New Haven and London, Yale University Press, 1981); Robert Nye, *Crime, Madness and Politics in Modern France: The Medical Concept of National Decline* (Princeton, Princeton University Press, 1984).

7 Silverman, see especially Part Two, chs 2 and 3, and *passim*.

8 N. Green, *The Spectacle of Nature: Landscape and Bourgeois Culture in Nineteenth-century France* (Manchester, Manchester University Press, 1990), pp. 5–6.

9 See Tucker, p. 111.

10 See G. Pollock, 'Modernity and the Spaces of Femininity', in *Vision and Difference: Feminism, Femininity and the Histories of Art* (London, Routledge, 1988), p. 78.

11 See A. Corbin, 'Commercial Sexuality in Nineteenth-Century France: A System of Images and Regulations', in C. Gallagher and T. Laqueur (eds), *The Making of the Modern Body* (Berkeley, University of California Press, 1987); C. Bernheimer, *Figures of Ill-Repute: Representing Prostitution in Nineteenth-Century France* (Cambridge, Mass., and London, Harvard University Press, 1989), chs 6, 7 and 8; A. Callen, *The Spectacular Body: Science, Method and Meaning in the Work of Degas* (New Haven and London, Yale University Press, 1995), chs 2 and 5; Silverman (*passim*).

12 R. Bouyer, under the pseudonym of L'Angèle, 'Lettre d'Angèle', Chronique du mois: L' impressionnisme: Corot-Monet, etc.', *L'Ermitage*, vol. 10, May 1899, pp. 399–400, quoted in Tucker, p. 275.

13 R. Parker and G. Pollock, *The Old Mistresses: Women, Art and Ideology* (London and New York, Routledge and Kegan Paul, 1981); T. Garb, *Sisters of the Brush: Women's Artistic Culture in Late Nineteenth-Century Paris* (London and New Haven, Yale University Press, 1994); and Callen, *The Spectacular Body: Science, Method and Meaning in the Work of Degas*.

14 Blanc, *Grammaire des arts du dessin*.

15 N. Green, '*All the Flowers of the Field*: The State, Liberalism and Art in France under the Early Third Republic', *Oxford Art Journal*, vol. 10, pt. 1, 1987, pp. 71–84.

16 See A. Callen, *The Art of Impressionism: Painting Technique and the Making of Modernity* (New Haven and London, Yale University Press, 2000), ch. 1 and *passim*.

17 See Green, '*All the Flowers of the Field*: The State, Liberalism and Art in France under the Early Third Republic'.

18 On sexual analogy, see M. Ellman, *Thinking About Women* (London, Macmillan, 1968), pp. 15–18; and see Callen, *The Spectacular Body: Science, Method and Meaning in the Work of Degas*, chs 4 and 5; A. Callen, 'Renoir: The Matter of Gender', in J. House (ed.), *Renoir, Master Impressionist* (Brisbane, Queensland Art Gallery 1994), pp. 41–51.

19 Blanc, *Grammaire des arts du dessin*, pp. 22–3.

20 See Y. Knibeihler quoting Virey (1812–22) and Reveille-Parise (1837), in *Les Médecins et L'Amour conjugale au X1Xe siècle, Aimer en France 1760–1860* (Faculté des Lettres de l'Université de Clermont-Ferrand-II, 1982), pp. 357–66, discussed in Callen, *The Spectacular Body: Science, Method and Meaning in the Work of Degas*, pp. 112–16.

21 On genius, see C. Battersby, *Gender and Genius: Towards a Feminist Aesthetics* (London, The Women's Press, 1989), chs 11 and 12; on male creativity see Ellman, *Thinking About Women*, pp. 15–18.

22 I am grateful to Paul Tucker for this verbal communication. On Bracquemond and the Impressionists, see C. S. Moffett (ed.), *The New Painting: Impressionism 1874–1886* (Oxford, Phaidon Press, 1986), and J. Isaacson, *The Crisis of Impressionism: 1878–1882* (Ann Arbor, University of Michigan Museum of Art, 1980).

23 Bracquemond, *Du dessin et de la couleur*, pp. 37 and 47 – my italics.

24 *Ibid.*, p. 75.

25 *Ibid.*, pp. 64; 45–6.

26 *Ibid.*, p. 46, italics in original. For more detailed discussion of these issues, see Callen, *The Spectacular Body: Science, Method and Meaning in the Work of Degas*, pp. 114, 116, 122–3.

27 For an important historical study of this theme, see J. Lichtenstein, *The Eloquence of Colour: Rhetoric and Painting in the French Classical Age* (Berkeley and Los Angeles, University of California Press, 1993).

28 On the history of palette layout, see J. Gage, *Colour and Culture* (London, Thames and Hudson, 1993), ch. 10; on Impressionist palette and pigments, see D. Bomford, J. Kirby, J. Leighton and A. Roy, *Art in the Making: Impressionism* (London, National Gallery and Yale University Press, 1990), pp. 51–71, and Callen, *The Art of Impressionism: Painting Technique and the Making of Modernity*, chs 9–11.

29 W. G. C. Byvanck, *Un Hollandais à Paris en 1891: Sensations de littérature et d'art* (Paris, 1892), p. 177, quoted in Tucker, pp. 102–4, my italics.

30 See Anne Higonnet, 'Writing the Gender of the Image: Art Criticism in Late Nineteenth-Century France', *Genders*, no. 6, Autumn 1989, pp. 60–73; Tamar Garb, '"L'Art féminin": The Formation of a Critical Category in Late Nineteenth-Century France', *Art History*, vol. 12, no. 1, March 1989, 39–65; A. Callen, 'Immaterial Views? The Female Spectator of Modern Art in France, *c.* 1879', in B. Rigby (ed.), *French Literature, Thought and Culture in the Nineteenth Century: A Material World* (London, Macmillan, 1993), pp. 184–97.

31 C. Mauclair, 'Exposition Claude Monet: Durand-Ruel', *La Revue indépendante de Littérature et d'Art*, NS 19, May 1891, 267–9; Roger Marx, 'Les Meules de M Claude Monet', *Le Voltaire*, 7 May 1891, both quoted in Tucker, p. 108.

32 Bracquemond, *Du dessin et de la couleur*, p. 101.

33 See Michel Foucault on Bentham's Panoptican in *Discipline and Punish* (Harmondsworth, Penguin, 1979). For feminist film theories see for example Laura Mulvey, 'Visual Pleasure and Narrative Cinema' (1975) in *Visual and Other Pleasures* (London, Macmillan, 1989); Mary Ann Doane, *The Desire to Desire: The Woman's Film of the1940s* (London, Macmillan, 1987); Kaja Silverman, *The Acoustic Mirror: The Female Voice in Psychoanalysis and Cinema* (Bloomington and Indianapolis, Indiana University Press, 1988); Jacqueline Rose, *Sexuality in the Field of Vision* (London, Verso, 1986). For art history, see footnotes 10, 13, 30 and T. Garb, 'The Forbidden Gaze', in K. Adler and M. Pointon (eds), *The Body Imaged: The Human Form and Visual Culture since the Renaissance* (Cambridge, Cambridge University Press, 1993), pp. 33–42; D. Bershad, 'Looking, Power and Sexuality' and G. Pollock, 'The Gaze and The Look', both in R. Kendall and G. Pollock (eds), *Dealing with Degas: Representations of Women and the Politics of Vision* (London, Pandora, 1992), pp. 95–105, 106–30. See also Hal Foster (ed.), *Vision and Visuality* (Seattle, Bay Press, 1988).

34 Bershad, 'Looking, Power and Sexuality', pp. 99, 102.

35 See M. Douglas, *Purity and Danger: An Analysis of Concepts of Pollution and Taboo* (London, Routledge Kegan Paul, 1966), p. 2, and A. Corbin, 'Commercial Sexuality in Nineteenth-Century France: A System of Images and Regulations', in Gallagher and Laqueur, *The Making of the Modern Body*; and Callen, *The Spectacular Body: Science, Method and Meaning in the Work of Degas*, ch. 2; see also Bernheimer, *Figures of Ill-Repute: Representing Prostitution in Nineteenth-Century Paris*.

36 On the physiology of optics in the 1820s and 1830s, and its implications for theories of vision, see J. Crary, 'Modernizing Vision', in Foster (ed.), *Vision and Visuality*, pp. 29–44, and J. Crary, *Techniques of the Observer: On Vision and Modernity in the Nineteenth Century* (Cambridge, Mass. and London, MIT Press, 1990).

37 H. von Helmholtz, *Handbuch des physiolgischen Optik* (Leipzig, 1867); Ogden N. Rood, *Modern Chromatics* (New York, 1879), French translation, *Théorie scientifique des couleurs* (Paris, 1881).

38 F. Fénéon, 'Oeuvres récentes de Claude Monet', *Le Chat Noir*, 16 May 1891, quoted in Tucker, p. 108.

39 On the nineteenth-century demise of 'Cartesian perspectivalism' see M. Jay, *Downcast Eyes: The Denigration of Vision in Twentieth-Century French Thought* (Los Angeles, UCLA Press, 1994), chs 2 and 3.

40 D. Wildenstein, *Monet: Catalogue raisonné* (Taschen/Wildenstein Institute, Cologne, 1996), vol. III, nos 1280–4 (all Monet works cited referred to as 'W'). The three exhibited at the Durand-Ruel Gallery in Paris in May 1891 were W.1280–W.1282 (nos 8–10 respectively, out of a total of fifteen *Grainstack* canvases shown); each shows a distinctive light effect: direct southerly/early afternoon sunlight with cast shadows (W.1280); *gris-clair* light (W.1281); sunset (W.1282).

41 In landscape painting/theory, the horizon was taken to be sea-level, or its equivalent, and hence below the level of the represented 'skyline' – where sky and land meet. See, for example, the illustrations of this phenomenon in Pierre Henri de Valenciennes's *Traité de perspective* (Paris, Desenne, 1800).

42 See outline of debates in A. C. Hanson, *Manet and the Modern Tradition* (New Haven and London, Yale University Press, 1997), pp. 178–80; see also Callen, *The Art of Impressionism: Painting Technique and the Making of Modernity*, chs 10–11.

43 On *plein air* and ambient light effects, see M. Minneart, *The Nature of Light and Colour in the Open Air* (New York, Dover, 1954) and J. J. Gibson, *The Senses Considered as Perceptual Systems* (London, Allen and Unwin, 1968), ch. 1; on their effects in painting, see Callen, *The Art of Impressionism: Painting Technique and the Making of Modernity*, ch. 8.

44 On the genesis and methods of Monet's Series paintings, see J. House, *Monet: Nature into Art* (New Haven and London, Yale University Press, 1986), ch. 12, and also Tucker, chs 4 and 5.

45 The sense of temporality in Monet's Series (and a heightened awareness of the act of looking *per se*) may well have links with the new physiology of vision in the period, which identified both a measurable 'persistence of vision' in the duration of an after-image, and a measurable time-lag due to the speed of nerve transmission; see Crary, *Techniques of the Observer: On Vision and Modernity in the Nineteenth Century*, p. 37.

46 See R. Golan on the Orangerie setting of the *Nymphéas* cycle, in 'Oceanic Sensations', in P. Tucker (ed.), *Monet and the Twentieth Century* (New Haven and London, Royal

Academy of Arts in association with Yale University Press), 1998, pp. 86–9. I shall not develop here links to stereoscopic photography or early film.

47 I am grateful to Paul Hills for this observation.

48 Crary, 'Modernizing Vision', pp. 32–3.

49 On the *léché* or 'licked' surface common in academic painting, see C. Rosen and H. Zerner, *Romanticism and Realism: The Mythology of Nineteenth-Century Art* (London, Faber, 1984), ch. 8.

50 See A. Callen, 'Renoir: The Matter of Gender', in House, *Renoir, Master Impressionist*, pp. 40–51, and T. Garb, 'Berthe Morisot and the Feminising of Impressionism', in T. J. Edelstein (ed.), *Perspectives on Morisot* (New York, Hudson Hills Press, 1990), pp. 57–66.

51 L'Angèle (Raymond Bouyer), 'Lettre d'Angèle', p. 399, quoted in Tucker, p. 151.

52 Tucker, p. 121.

53 Taschen/Wildenstein nos 1292–8, 1300, 1303–8 and 1309–13, respectively. Universal stretchers came into use in the 1880s; examination of the stretchers for these canvases would need to be undertaken to verify whether Universal stretcher bars were indeed used by Monet here. Some canvases do not conform to these groupings: W.1291 (92 x 73 cm); W.1299 (91.5 x 81.5 cm); W.1301 (116 x 73 cm, vertical marine 50); and W.1302, discussed here.

54 This is not the only *Poplars* in which a tree was overpainted; W.1308, for example, has a similar compositional change, but here a different *mise-en-page*, which includes the river in the foreground, makes this work less challenging. House (*Monet: Nature into Art*, pp. 186–7) notes changes to the two views of the poplars from the marshes (W.1310 and W.1311), works I discuss below.

55 Tucker's chapter 5 on the *Poplars*, entitled 'Rooted in "La France"', makes and elaborates this point, see especially pp. 147–51. Ironically, of course, the trees were felled soon after Monet finished painting them; to complete his work on the Series he paid for a stay of execution (see Tucker, p. 115; House, *Monet: Nature into Art*, p. 201, and W.1291, p. 518, vol. III).

56 According to Wildenstein, W.1302 was probably shown at Monet's 1892 Durand-Ruel Gallery exhibition of this Series as no. 6; W.1312 appeared as no. 2. Five other three-poplar compositions were exhibited (W.1303, W.1304, W.1305, W.1307, W.1308), and seven or eight of the seven-poplar compositions (W.1291, W.1292, W.1294, W.1296, W.1297, W.1298(?), W.1299, W.1300); *Four Poplars* (W.1309) was also shown. On Monet and French rococo, see Tucker, ch. 5.

57 On the gendered spectator at this time, see A. Callen, 'Immaterial Views? Science, Intransigence and the Female Spectator of Modern French Art in 1879', in Rigby (ed.), *French Literature, Thought and Culture in the Nineteenth Century: A Material World*, pp. 184–97.

58 In his catalogue introduction; see Gustave Geffroy, 'Les Meules de Claude Monet' (1891), quoted in Tucker, p. 108 (and see his n. 19, p. 290).

59 Camille Pissarro, letter of 5 May 1891 to his son Lucien, quoted in Tucker, p. 109.

60 Octave Mirbeau, 'Claude Monet', *L'Art dans les deux Mondes*, 7 March 1891, quoted in Tucker, p. 106.

61 Zola's important critique in 1880 was symptomatic, seeing Monet's work as too hurriedly painted and hence insufficiently resolved ('Le Naturalisme au Salon, I, II, III', *Le Voltaire*, 18, 19, 20 June 1880). On Impressionism as effeminate, see n. 30 and 50 above.

62 Monet, to Thiébault-Sisson, critic of *Le Temps*, cited in Tucker, p. 84.

63 Octave Maus, 'Claude Monet-Auguste Rodin', *L'Art moderne*, vol. 9, 7 July 1889, quoted in Tucker, p. 59, my italics. See Battersby, *Gender and Genius: Towards a Feminist Aesthetics*, ch. 11.

64 Mirbeau, 'Claude Monet', pp. 183–5; Octave Mirbeau, 'Claude Monet', *Le Figaro*, 10 March 1889 – the front page review which formed the basis of Mirbeau's essay on Monet for the catalogue of the important Monet-Rodin exhibition at the Galeries Georges Petit where Monet showed at least 145 works in June 1889: according to Théo van Gogh (1889), Mirbeau's review was critical to the success of the show; see Tucker pp. 57–8 and p. 288, notes 26 and 27.

65 Mirbeau, 'Claude Monet' (1889), quoted and paraphrased by Tucker, pp. 57–8. On nineteenth-century concerns over healthy masculinity, see Abigail Solomon-Godeau, *Male Trouble: A Crisis in Representation* (London, Thames and Hudson, 1997) and in late nineteenth-century France, A. Callen, 'Masculinity, Normality and the Homosocial', in M. Kemp and M. Wallace (eds), *The Art and Science of the Human Body* (Autumn 2000); and see n. 67, below.

66 Guy de Maupassant, *A Woman's Life* (Harmondsworth, Penguin Books, 1965), pp. 7–8.

67 J. Smith, 'Abulia: Sexuality and Diseases of the Will in the Late Nineteenth Century', *Genders*, no. 6, Autumn 1989, p. 103; cf. Foucault on the 'invention' of perverse sexualities in the late nineteenth century, *The History of Sexuality*, vol. 1 (Harmondsworth, Penguin Books, 1981), pp. 36–49.

68 Mirbeau, 'Claude Monet' (1889), quoted in Tucker, p. 58.

69 R. Bowlby, *Just Looking: Consumer Culture in Dreiser, Gissing and Zola* (Cambridge, Cambridge University Press, 1985), p. 149.

70 See Tucker, pp. 56–9, 106–7 and *passim*. The idea of serialised novels, first consumed in periodical form, or 'pulp' fiction for the traveller, makes interesting parallels with Monet's Series enterprise.

71 Pissarro letter of 3 April 1891, quoted in Tucker, p. 106.

72 Pissarro letter of 9 April 1891, quoted in Tucker, p. 106.

73 Pissarro letter of 5 May 1891, quoted in Tucker, p. 109.

74 Mirbeau, 'Claude Monet' (1889), quoted in Tucker, p. 58; Zola, quoted in Bowlby, *Just Looking: Consumer Culture in Dreiser, Gissing and Zola*, pp. 149–50.

75 See E. Showalter, *The Female Malady: Women, Madness and English Culture l830–1980* (London, Virago, 1987); and J. Goldstein, *Console and Classify: The French Psychiatric Profession in the Nineteenth-Century* (Cambridge, Cambridge University Press, 1987).

76 Bowlby, *Just Looking: Consumer Culture in Dreiser, Gissing and Zola*, p. 150.

Notes to Chapter 4

1 The initial research and analysis for this chapter were conducted for my Ph.D. dissertation. Further research was made possible through a fellowship in November 1995 at the Yale Center for British Art, New Haven, Connecticut. I would also like to thank the participants of the Women's Study Group and the British Studies Group at Texas Christian University for their comments and suggestions in response to informal presentations of this research.

2 See Ina Taylor, *Helen Allingham's England: An Idyllic View of Rural Life* (Exeter, Webb and Bower, 1990).

3 H. Allingham and E. Baumer Williams (eds), *Letters to William Allingham* (London, Longmans, Green and Co., 1911), pp. 73–4.

4 M. Huish, *Happy England* (London, Adams and Charles Black, 1903), p. 20.

5 A. Wilton and A. Lyles, *The Great Age of British Watercolours 1750–1880* (London, Royal Academy of Art and Washington D.C., National Gallery of Art, 1993).

6 D. Cherry, *Painting Women, Victorian Women Artists* (London and New York, Routledge, 1993), p. 65.

7 S. Wilcox and C. Newall, *Victorian Landscape Watercolours* (New York, Hudson Hills Press in association with the Yale Center for British Art, 1992), p. 50.

8 Like many other young artists, Allingham relied heavily on a mentor to attain membership in the Old Water-colour Society, and this may have been even more important as a woman artist. The landscape watercolorist Alfred Hunt (a friend of William Allingham) reportedly 'went through her portfolio and selected the pictures he thought best displayed her talent, then personally undertook to propose her election'. See Taylor, *Helen Allingham's England: An Idyllic View of Rural Life*, p. 37.

9 *The Times* (London, 26 December 1876), p. 10.

10 Cherry, *Painting Women, Victorian Women Artists*, p. 66.

11 *Ibid.*, p. 67.

12 J. Marsh, *Back to the Land, the Pastoral Impulse in England from 1880–1914* (New York, Quartet Books, 1982), pp. 3–6.

13 J. Ruskin, *The Art of England: Lectures given in Oxford by John Ruskin during his tenure of the Slade Professorship* (Kent, George Allen, 1884), p. 140.

14 *Ibid.*, p. 142.

15 J. Ruskin, 'Lecture II Lilies: Of Queens' Gardens', *The Works of John Ruskin*, eds E. T. Cook and A. Wedderburn (London, George Allen, 1864).

16 Ruskin, *The Art of England: Lectures given in Oxford by John Ruskin during his tenure of the Slade Professorship*, p. 117.

17 H. Faberman, '"The Best Shop in London": The Fine Art Society and the Victorian Art Scene', in S. P. Casteras and C. Denney (eds), *The Grosvenor Gallery, A Palace of Art in Victorian England* (New Haven and London, Yale Center for British Art and Yale University Press, 1996), p. 149.

18 *Magazine of Art*, July 1889, vol. 12, pp. 296–300.

19 'Fine Art Society, Exhibition No 82', 'Catalogue of a collection of water-colour drawings, illustration a summer among the flowers by George S. Elgood, R.I.' (London, Fine Art Society, 1891), p. 5.

20 W. Allingham, *Catalogue of a collection by Mrs. Allingham, R.W.S. Illustrating Surrey Cottages* (London, Fine Art Society, 1886), p. 6.

21 *The Academy*, 3 April 1886, p. 245.

22 J. D. Hunt, 'The Cult of the Cottage', in *The Lake District, A Sort of National Property* (Manchester, Countryside Commission and London, Victoria and Albert Museum, 1986), p. 78.

23 G. H. Ford, 'Felicitous Space: The Cottage Controversy', in V. C. Knoepflmacher and G. B. Tennyson (eds), *Nature and the Victorian Imagination* (Berkeley, University of California Press, 1977), pp. 34 and 48.

24 Taylor, *Helen Allingham's England: An Idyllic View of Rural Life*, p. 77.

25 M. Jackson, *Exhibition no. 86 Catalogue of a Collection of Drawings by Mrs. Allingham, R.W.S.* (London, The Fine Art Society, 1891), p. 6.

26 W. Vaughan, 'The Englishness of British Art', *Oxford Art Journal*, 13 (1990), p. 17.

27 W. W. Fenn, 'The Love of Landscape', *The Art Journal*, 44 (July 1882), p. 197.

28 S. Dick, *The Cottage Homes of England* (London, Edward Arnold, 1909), pp. 267, 270 and 273.

29 *The Times* (London), 6 December 1878, p. 3.

30 Dick, *The Cottage Homes of England*, p. 276.

31 This claim for the English nature of watercolour was repeated by a wide variety of critics: see J. Wainwright, 'Some Observations of the Present State of the English School of Water-Colour Painting', in *Transactions of the National Association for the Advancement of Art and its Application to Industry, 1888–1891*, vol. II (London, 1888; New York, Garland Press, 1979), p. 131; J. L. Roget, *A History of the Old Water-Colour Society* (London, Longmans, Green, and Co., 1891), p. 111; R. Jope-Slade, 'Current Art', *Magazine of Art*, 15 (February 1892), p. 117; M. Huish, *British Watercolour Art* (London, The Fine Art Society & Adam and Charles Black, 1904), p.v.; and 'Art Exhibitions', *The Times* (London), 13 March 1905, p. 3.

32 A. L. Baldry, *The Practice of Water-Colour Painting* (London, Macmillan and Co., 1911), pp. 3–4.

33 C. Phillips, *Frederick Walker and his Works* (London, Seeley and Co., 1897), pp. 5–6.

34 Wilcox and Newall, *Victorian Landscape Watercolours*, p. 55.

35 *The Standard*, 2 May 1887, p. 3.

36 *The Times*, 3 May 1878, p. 4; 'Exhibition of the Society of Painters in Water Colours', *Art Journal*, vol. 19, Jan. 1880, p. 74; 'Art: Royal Society of Painters in Water Colours', *Spectator*, vol. 62, 4 May 1889, p. 609; Baldry, *Correspondence* (London, National Art Library, Victoria and Albert Museum, 1911), p. 40. See also Wilcox and Newall, *Victorian Landscape Watercolours*, p. 57.

37 A. L. Baldry, 'Mrs Allingham', *The Magazine of Art*, 22 (1899), p. 355.

38 Wilcox and Newall, *Victorian Landscape Watercolours*, pp. 50–1.

39 P. L. Reilly, 'The Taming of the Blue, Writing Out Color in Italian Renaissance Theory', in N. Broude and M. D. Garrard (eds), *The Expanding Discourse: Feminism and Art History* (London, Harper Collins, 1992), p. 87.

40 Cherry, *Painting Women, Victorian Women Artists*, pp. 65–73.

41 A. Helmreich, 'Contested Grounds: Garden Painting and the Invention of a National Identity in England, 1880–1914', Ph.D., Northwestern University, pp. 228–9.

42 *Ibid.*, pp. 237–9.

43 *The Times* (London), 6 April 1894, p. 4.

44 Cherry, *Painting Women, Victorian Women Artists*, p. 127.

45 *The Atheneum*, 28 November 1903, p. 725.

46 Baldry, 'Mrs Allingham', *Magazine of Art*, p. 361.

47 J. Marsh and P. Nunn, *Pre-Raphaelite Women Artists* (Manchester, Manchester City Art Galleries, 1997), p. 20.

48 M. Huish, *Happy England* (London, Adam and Charles Black, 1903), pp. 98–9.

49 Huish, *British Watercolour Art*, p. 78.

50 Baldry, *Correspondence*.

51 Jackson, *Exhibition no. 86 Catalogue of a Collection of Drawings by Mrs. Allingham*, p. 7.

52 N. Green, *The Spectacle of Nature, Landscape and Bourgeois Culture in Nineteenth-Century France* (Manchester and New York, Manchester University Press, 1990), p. 94.

53 *The Atheneum*, 3970, 28 November 1903, p. 725.

54 M. Wiener, *English Culture and the Decline of the Industrial Spirit, 1850–1980* (New York, Cambridge University Press, 1981).

55 A. Howkins, 'The Discovery of Rural England', in R. Colls and P. Dodd (eds), *Englishness, Politics and Culture, 1880–1920* (Dover, Croom Helm, 1986), p. 69.

56 Allingham, *Catalogue of a Collection by Mrs. Allingham, R.W.S. Illustrating Surrey Cottages*, p. 3.

57 *Illustrated London News*, 10 April 1886, p. 369.

58 Dick, *The Cottage Homes of England*, p. 8.

59 E. K. Helsinger, *The Rural Scene and National Representation, 1815–1850* (Princeton, N.J., Princeton University Press, 1999), p. 7.

60 L. Davidoff and B. Westover, *Our Work, Our Lives, Our Words: Women's History and Women's Work* (Basingstoke, Macmillan Education, 1996), p. 140.

61 T. Cusack, 'The Irish Cottage and "Banal Nationalism"', paper delivered at the annual Association of Art Historians Conference, Exeter, England, 1998.

62 R. H. MacDonald, *The Language of Empire: Myths and Metaphors of Popular Imperialism 1880–1918* (Manchester and New York, Manchester University Press, 1994), p. 6.

63 J. Ruskin, 'Inaugural Lecture on Art', *Works of John Ruskin*, p. 43.

64 'The Business Side of Art', *Art Journal*, August 1888, p. 251.

65 Cherry, *Painting Women: Victorian Women Artists*, pp. 184–5.

66 See Anna Gruetzner Robins, 'The London Impressionists at the Goupil Gallery. Modernist Strategies and Modern Life', in Kenneth McConkey, with a chapter by Anna Gruetzner Robins, *Impressionism in Britain* (New Haven and London, Yale University Press, 1995).

67 McConkey, *Impressionism in Britain*, p. 36.

68 Anna Gruetzner Robins, 'Sickert "Painter-in-Ordinary" to the Music-Hall', in Wendy Baron and Richard Shone (eds), *Sickert Paintings* (New Haven and London, Yale University Press in association with the Royal Academy of Arts, 1992), p. 35.

69 *The Builder*, 7 May 1887, pp. 665–7.

70 *Ibid*.

Notes to Chapter 5

1 J. van Santen Kolff, 'Een blik in de Hollandsche schilderschool onze dagen', 4 parts: *De Banier, tijdschrijft van 'Het Jonge Holland'* (The Hague, 1875), no. 2, pp. 258–71 and 306–37; no. 3, pp. 43–73 and 157–203.

2 G. H. Marius, *De Hollandsche schilderkunst in de negentiende eeuw* (The Hague, Nieuwenhuis, 1903); *Max Havelaar*, an account of the growth, economic conditions of production and distribution of coffee in Dutch trading companies in Java, caused a furore on publication, and continued to have political and symbolic effect well into the twentieth century. Multatuli was the pseudonym of E. D. Dekker.

3 That this reassessment began in 1945 is of course significant to post-war cultural politics; *Den Haag eert de Nederlandsche schilders van de 19de eeuw* (The Hague honours the Dutch painters of the nineteenth century) (The Hague, Pulchri Studios, 1945), initiated the process. R. de Leeuw, J. Sillevis and C. Dumas (eds), *The Hague School: Dutch Masters of the 19th Century* (Grand Palais, Paris and Royal Academy London, 1983)

contains a detailed bibliography. There was also a reappraisal of Dutch seventeenth-century landscape painting. See W. Stechkow, *Dutch Landscape Painting of the Seventeenth Century* (London, Phaidon, 1966); A. Jensen Adams, 'Competing Communities in the "Great Bog of Europe", Identity and Seventeenth Century Dutch Painting', in W. J. T. Mitchell (ed.), *Landscape and Power* (Chicago and London, University of Chicago Press, 1994); R. Falkenberg, *et al.* (eds), *Natuur en Landschap in de Nederlandse Kunst, 1500–1850* (Zwolle, Uitgiverij Waanders, 1998).

4 D. Matless, *Landscape and Englishness* (London, Reaktion, 1998).

5 Mitchell (ed.), *Landscape and Power*, p. 13.

6 J. Butler, *Gender Trouble* (London and New York, Routledge, 1990).

7 For a discussion that explored notions of realism see C. Ford, 'Where Meaning Lies', *Art History*, vol. 22, no. 1 (March 1999), pp. 124–30. R. Bergsma, 'Mens en Natuur–De Natuur van de Man', in R. Bionda and C. Blotkamp (eds), *De Schilders van Tachtig, Nederlandse Schilderkunst 1880–1895*, translated as 'Man and nature–the nature of Man', *Dutch Painting in the Age of Van Gogh 1880–1895*, both (Zwolle, Waanders, 1990), pp. 36–58. See also J. Sillevis, 'Romanticism and Realism', in R. de Leeuw J. Sillevis and C. Dumas (eds), *The Hague School*, pp. 37–50.

8 Van Santen Kolff, 'Een blik in de Hollandsche schilderschool onze dagen', in *De Banier, tijdschrift van 'Het Jonge Holland'*, pp. 158 and 161.

9 A. Jensen Adams, in Mitchell (ed.), *Landscape and Power*, p. 44.

10 A. Lambert, *The Making of the Dutch Landscape* (London, Seminar Press, 1971), p. 113.

11 The history of land reclamation in The Netherlands is a continuous cycle of reclamation, inundation, reclamation; see J. van Veen, *Dredge, Drain, Reclaim* (The Hague, T. Nijhoff, 1948) and P. Wagret, *Polderlands* (Paris, Dunod, 1959) and (London, Methuen, 1968).

12 See, for example, Pieter van Santvoort, *Landscape with a Farmhouse and Country Road*, 1625 (Staatliche Museen zu Berlin Preussischer Kulturbesitz, Gemäldegalerie) or Jacob van Ruisdael, *Ferryboat with Cattle*, 1649 (The Hague, Instituut Collectie Nederland).

13 C. Blotkamp, 'Art Criticism in *De Nieuwe Gids 'Simolius'*, V, nos 1/2 (1971), pp. 116–36, and his 'Artists as Critics: Art Criticism in The Netherlands 1880–1895', in R. Bionda and C. Blotkamp (eds), *De Schilders van Tachtig*, pp. 82–94; J. Beckett, 'Discoursing on Dutch Modernism', *Oxford Art Journal*, vol. 6, no. 2 (1983), pp. 67–79.

14 N. Green, *The Spectacle of Nature: Landscape and Bourgeois Culture in Nineteenth-Century France* (Manchester, Manchester University Press, 1990).

15 From the 1890s a range of new reviews was introduced representing different aspects of nature in leisure magazines. They include *De Levende Natuur* (from 1896), the weekly paper *Buiten* (from 1907), and a whole series of popular Verkade albums devoted to the seasons and different aspects of the countryside. See M. de la Prise, *Holland, Official Tourist Guide*, n.d., 5th edn; Baedeker, *Belgium and Holland* (Leipzig, editions from 1880) and C. B. Black, *Holland and its Picture Galleries* (London, Keisling & Co., 1904).

16 P. Halkes, 'The Mesdag Panorama: Sheltering the All-Embracing View', *Art History*, vol. 22, no. 1 (March 1999), pp. 83–98.

17 Letter quoted in de Leeuw, Sillevis and Dumas (eds), *The Hague School*, p. 183.

18 M. Foucault, *Power/Knowledge*, interviews and other writings 1972/1977; C. Gordon ed. (Brighton, Harvester Press, 1980).

19 The butter industry, for example, developed from the 1860s by Antoon Jurgens and Simon van den Bergh became a major Dutch export to the Ruhr, the East Indies and to Britain, and from 1871 was augmented by the production of margarine.

20 The economic and colonial dimensions of this formation were discussed in H. Roland Holst-van Schalk, *Kapitaal en Arbeid in Nederland*, 2 vols (Amsterdam, Socialistiche Uitgeverij, 1902, reprinted 1932, Nijmegen, 1973).

21 David Low, 'The Potato', 1843, *Elements of Practical Agriculture* (London, Longmans, Brown, and Longmans), pp. 412–16. In the north and south of The Netherlands, the acreage devoted to potato production more than doubled between 1860 and 1910, the acreage was exceeded only by winter rye, and closely followed by oats. See table in J. W. Robertson Scott, *A Free Farmer in a Free State* (London, Heineman, 1912), p. 159.

22 Low, *Elements of Practical Agriculture*, p. 412.

23 F. Orton and G. Pollock, *Avant Gardes and Partisans Reviewed* (Manchester, Manchester University Press, 1996), p. 22.

24 *Vincent van Gogh, Brieven aan zijn broeder* (Amsterdam, Mij. Voor Goede en Goedkoope Lectuur, 1914), trans. as *The Complete Letters of Vincent van Gogh* (London, Thames and Hudson) in both vol. 2, Letter 404.

25 Sadée's painting also drew on a pictorial model initiated by Jozef Israëls and Alexander Mollinger in the 1860s in which the figure moved from a support role to centre stage in the landscape, e.g: Israëls's *The Shepherd's Prayer*, 1864, Toledo Museum of Art, Toledo; *Children of the Sea*, 1863, Stedelijk Museum, Amsterdam.

26 Inquiry Report discussed *De Nieuwe Tijd*, 1910.

27 D. Cherry, *Painting Women: Victorian Women Artists* (London and New York, Routledge, 1993), p. 169.

28 J. Beckett and D. Cherry, 'Working Women', in Beckett and Cherry (eds), *The Edwardian Era* (Oxford, Phaidon, 1987); G. Pollock, 'With my Own Eyes: Fetishism and the Labouring Body and the Colour of its Sex', *Art History*, 17:3 (1994), pp. 342–82.

29 The main Dutch dealers E. J. van Wisselingh, C. M. van Gogh and Goupil and Co. in Amsterdam and The Hague were by 1917 perceived by some critics as 'of great importance in the history of The Hague School', C. Dumas in de Leeuw, Sillevis and Dumas (eds), *The Hague School*, pp. 125–36.

30 Unattributed entry in *Ibid.*, p. 191.

31 M. Douglas, *Purity and Danger* (London and New York, Routledge, 1966 (1994)), p. 3.

32 *Ibid.*, p. 4.

33 Some critics complained about the number of images of potatoes, see F. J. Verheijst, 'Kunst-ten-toon-stelling, Utrecht, Amsterdam, s'Gravenhage III', *De Amsterdammer* (11 June 1884); W. J. v. W, 'Een kunstcriticus', *De Nieuwe Gids*, 2 (1887), p. 49.

34 On artists in Zeeland see I. Spaande and P. van der Velde (eds), *Reünie op 't Duin: Mondriaan en tijdgenoten in Domburg* (Zwolle, Uitgeverij Waanders, 1998).

35 K. Baedecker, *Belgium and Holland, Handbook for Travellers* (Leipzig, Baedecker 1910), p. 298.

36 Mauve's charcoal drawings of agricultural workers may well have influenced van Gogh and Witsen at this date, see for example *Figure Studies*, charcoal drawing, Toledo

Museum of Art, Toledo. Van Gogh's work exhibited in Amsterdam: Panorama, 1895 and Stedelijk Museum, Amsterdam, 1905 and 1914–15.

37 Douglas, *Purity and Danger*, p. 4.

38 Fear of flooding to these cities instigated the draining programme in the 1830s; by 1852, 18,000 hectares of new land had been created, followed by land speculation and poor farming practices.

39 State health supervision, medical training and practice were established in the four health bills of 1 June 1865.

40 J. Bradley, 'P. Mondrian', *The Knickerbocker Weekly,* 14.2, 1944, n.p.

41 G. G. van der Hoeven, in *Politik och Kultur,* Helsingfors, 1907, quoted in Robertson Scott, *A Free Farmer in a Free State*, p. 320.

42 For example: Gabriël's *In the Month of July* (Amsterdam, Rijksmuseum), J. Maris's *View of Montigny-sur-Loing* (Rotterdam, Boymans van-Beunigen Museum), 1870 or his *Truncated Windmill* (Amsterdam, Rijksmuseum), 1872; or Willem Maris's *Cow Drinking* (private collection).

43 R. Welsh, *Piet Mondrian and the Dutch Landscape*, exhibition catalogue (The Hague, Van Voorst van Beest Gallery, 1989), p. 2.

44 Douglas, *Purity and Danger*, p. 36.

45 Bleaching fields were central to seventeenth-century Dutch landscape iconography, notably in the works of Jan van Ruisdael.

46 D. Silverman, 'Weaving Paintings: Religious and Social Origins of Vincent van Gogh's Pictorial Labour', in M. S. Roth (ed.), *Rediscovering History: Culture, Politics and the Psyche* (Stanford, Stanford University Press, 1994), pp. 137–68; see also Hubert Henkels, 'Mondrian in his Studio', *Mondriaan, Zeichnungen, Acquarelle, New York Bilder* (Stuttgart, Staatsgalerie, The Hague and Baltimore, 1981).

47 The analysis of the role played by Theosophy has long been a cornerstone of art history's engagement with the formation of Dutch abstract painting. See R. Welsh, *Piet Mondrian* (New York, Solomon Guggenheim Museum, 1971), pp. 36–51.

48 R. P. Welsh and J. M. Joosten, *Two Mondrian Sketchbooks* (Amsterdam, Meulenhoff International, 1969), pp. 16, 18, 21 and 22.

49 Welsh and Joosten, *Piet Mondrian, Catalogue Raisonée* (1996), nos. B.10–11B; B.12, B.30–4, B.371.

50 B. Canter, *Holland Express*, no. 35 (29 August 1917), pp. 411; L. van Kuik, 'Schilderkunst', *Holland Express*, no. 40 (6 October 1915), p. 478.

51 T. van Doesburg, 'Grondbegrippen der nieuwe beeldende kunst', *Tijdschrift voor Wijsbegeerte*, Haarlem, XIII, no. 1 (1919), pp. 30–49; XIII, no. 2, April (1919), pp. 169–88. Quotation, p. 44; published, with alterations, as *Grundbegriffe der neuen gestaltende Kunst*, VI, Bauhausbuch (1925); translated as *Principles of Neo-Plastic Art* (London, Lund Humphries, 1966).

52 Windows for the Villa Karperton, designed by Jan Wils, were described by van Doesburg as a 'Small Pastoral …: Motifs: animals, namely "bull and horse"'; those for the Landsbouwwinterschool, Drachten, 1921, are called '*Grote*' *pastorale.*

53 Animals became key motifs in this reconfiguration, referencing seventeenth- and nineteenth-century paintings such as Maris's *Cow Drinking* (1880, private collection). Mondrian's small oils of 1904–6 such as *Vaars in de weide* (1904) and *Stier* (1904), both Gemeente Museum, The Hague, and van Doesburg's *Composition VIII: The Cow*, Museum of Modern Art, New York, are part of this formation.

Notes to Chapter 6

1 For further discussion on this topic see C. Nash, 'Re-mapping and renaming: new cartographies of identity, gender and landscape in Ireland', *Feminist Review*, no. 44 (1993), pp. 39–57.

2 B. Loftus, *Mirrors William 111 and Mother Ireland* (Dublin, Picture Press, 1990).

3 See D. Kiberd, *Inventing Ireland: The Literature of the Modern Nation* (London, Jonathan Cape, 1995), pp. 29–31.

4 Where his peasants assume more simian features, the inference is paradoxically of a people who are beyond redemption, who deserve in some way the disasters fallen upon them. For more detailed discussion on this topic see S. Bhreathnach-Lynch, 'Framing the Irish Victorian paintings of the Irish peasant', *Journal of Victorian Culture*, 2:2 (1997), pp. 245–63.

5 See T. Brown, *Ireland, A Social and Cultural History 1922–1985* (London, Fontana Press, 1985), pp. 79–101.

6 There were other pockets of rural Ireland where Irish was spoken and a distinctive life-style maintained. However it was to be the west of the country which became synonymous with a Gaelic national identity.

7 Quoted in K. McConkey, *A Free Spirit Irish Art 1860–1960* (London, Antique Collectors Club, 1990), p. 63.

8 For a more detailed account of the history of this design see S. McCoole, *Hazel, A Life of Lady Lavery 1880–1935* (Dublin, The Lilliput Press, 1996), pp. 139–42, 147.

9 J. Baudrillard, *Simulations* (New York, Semiotext(e), 1983).

10 Prior to independence nationalist feminist women had believed that their role would not be solely confined to the home. For an account of the opposition by feminists to the legislation which controlled every area of women's lives, see M. G. Valiulis, 'Power, gender, and identity in the Irish Free State', *Journal of Women's History*, 6:4/7:1 (1994/1995), pp. 117–36.

11 Interestingly, this painting dates from 1916, before the founding of the Free State. Its vision of the Irish family anticipates the ideal of post-independent Ireland.

12 *The Standard Irish Readers Intermediate Book* (Dublin, The Educational Company of Ireland Limited, n.d.).

13 Nash, 'Re-mapping and renaming', p. 47.

14 Brown, *Ireland, A Social and Cultural History*, p. 98.

15 M. Collins, *The Path to Freedom* (Dublin, Talbot Press, 1922), p. 119.

16 For a history of the development of the thatched cottage and its ideological significance see B. P. Kennedy, 'The Traditional Irish Thatched House: Image and Reality 1793–1993', in A. M. Dalsimer (ed.), *Visualizing Ireland: National Identity and the Pictorial Tradition* (Winchester, MA, Faber and Faber Inc. Publishers, 1993), pp. 165–79.

17 Keating's connection with the scheme is detailed in A. Bielenberg, 'Keating, Siemens and the Shannon Scheme', *History Ireland*, 5:3 (1997), pp. 43–7.

18 This point is stressed by Elizabeth Butler Cullingford in 'Thinking of her … as … Ireland: Yeats, Pearse and Heaney', *Textual Practice*, 4:1 (1990), pp. 1–21.

19 A full report of the speech is in *All Hallows Annual* (1922), p. 16.

Notes to Chapter 7

1 'Velikaia tema iskusstva', *Literatura i iskusstvo*, 8 (19 February, 1944), p. 1.
2 V. Sysoev, *Aleksandr Deineka* (Moscow, Izobrazitel'noe iskusstvo, 1972), p. 13.
3 V Gaposhkin, 'Zhivopistsy moskva i leningrad', *Sovetskoe iskusstvo*, 4 (25 January, 1946), p. 2.
4 T. Clark, 'The "New Man's" body: a motif in early Soviet culture', in M. Cullerne Bown and B. Taylor (eds), *Art of the Soviets. Painting, Sculpture and Architecture in a One-Party State, 1917–1992* (Manchester, Manchester University Press, 1993), p. 34.
5 C. Lodder, *Russian Constructivism* (New Haven and London, Yale University Press, 1983), p. 149.
6 M. Cullerne Bown, *Socialist Realist Painting* (New Haven and London, Yale University Press, 1998), pp. 100–1, 127.
7 R. A. Bauer, *The New Man in Soviet Psychology* (Cambridge, Mass., Harvard University Press, 1952), p. 100.
8 'Iskusstvo plakata', *Sovetskoe iskusstvo*, 23 (8 June, 1941), p. 1.
9 Clark, 'The "New Man's" body', pp. 40–3.
10 K. Nepomnyashchy, *Soviet War News*, 912 (18 July, 1944), p. 4.
11 'Za dal'neishee razvitie massovoi fizkul'tury', *Pravda* (16 July, 1944), p. 1.
12 *Krasnyi sport*, 28 (11 July, 1944), p. 1; 'Shire razmakh massovoi fizkul'tur', *Ibid.*, 32 (8 August, 1944), p. 1; 'Vtoroi v sovetskom soiuze', *Ibid.*, 26 (27 June, 1944), p. 1; 'V chet' osvobozhdeniia Sovetskoi Ukrainy. Fizkul'turnye prazdniki v gorodakh USSR', *Ibid.*, 42 (17 October, 1944), p. 1.
13 A. Zhdanov, 'Speech at the First All-Union Congress of Soviet Writers 1934', *On Literature Music & Philosophy*, E. Fox, S. Jackson and H. C. Feldt (trans.) (London, Lawrence and Wishart, 1950), p. 15.
14 Cullerne Bown, *Socialist Realist Painting*, p. 116.
15 'Narodnye khudozhniki', *Literatura i iskusstvo*, 3 (31 July, 1943), p. 1.
16 M. Gorky, 'Soviet Literature', *Soviet Writers' Congress 1934* (London, Lawrence and Wishart (1935) 1977), pp. 58–9.
17 *Krasnyi sport*, 29 (18 July, 1944), p. 1.
18 L. Attwood, *The New Soviet Man and Woman* (Basingstoke, Macmillan in association with the Centre for Russian and East European Studies, University of Birmingham, 1990), pp. 1, 8, 20, 47, 63–6, 120, 133, 151–3.
19 E. Naiman, 'Historectomies. On the Metaphysics of Reproduction in an Utopian Age', in J. T. Costlow, S. Sandler and J. Vowles (eds), *Sexuality and the Body in Russian Culture* (Stanford, Stanford University Press, 1993), p. 262.
20 Cullerne Bown, *Socialist Realist Painting*, p. 170.
21 G. Revzin, 'Devushka moei mechti', *Iskusstvo*, 3 (1990), pp. 39–43.
22 'Svetoch sotsialisticheskoi kultury', *Sovetskoe iskusstvo*, 25 (22 June, 1941), p. 1; A. Bassekhes, 'Mysli o zhivopisi', *Ibid.*, p. 3; *Ibid.*, 25 (14 June, 1944), pp. 1–3.
23 F. Nietzsche, *The Will to Power*, W. Kauffmann and R. J. Hollingdale (trans.) (Ann Arbor, University of Michigan Press, 1968), pp. 260, 282, 395, 399, 463–4, 480, 529, 668, 693, 715, 753, 755, 960–4.
24 Bauer, *The New Man*, pp. 100, 132–40, 168.
25 B. Groys, *The Total Art of Stalinism*, C. Rougle (trans.) (New Jersey and Oxford, Princeton University Press (1988) 1992), p. 36.

26 H. Goscilo, 'Monsters Monomaniacal, Marital and Medical: Tatiana Tolstoya's Regenerative Use of Gender Stereotypes', in Costlow, *et al.*, *Sexuality*, pp. 219, 282; T. Mamonova, *Russian Women's Studies: Essays on Sexism in Soviet Culture* (Oxford, Pergamon, 1989), p. 112.

27 N. Bukharin, 'Poetry Poetics and the Problems of Poetry in the USSR', in *Soviet Writers' Congress*, p. 255.

28 M. Cullerne Bown, *Art Under Stalin* (London, Phaidon, 1991), p. 113.

29 Cullerne Bown, *Socialist Realist Painting*, p. 170.

30 M. Tarasov, 'A Woman Director General of Railway Traction', *Soviet War News*, 789 (8 March, 1944), p. 3.

31 V. Varikov, 'Zadacha khudozhnika', *Literatura i iskusstvo* (14 March, 1942), p. 3; B. Ioganson, 'Bor'ba za kartinu', *Literatura i iskusstvo*, 8 (19 February, 1944), p. 2.

32 V. Mukhina, 'Tema i obraz v monumental'noi skulpture', *Sovetskoe iskusstvo*, 2 (14 November, 1944), p. 2.

33 Sysoev, *Deineka*, p. 13.

34 Costlow *et al.*, 'Introduction', *Sexuality*, p. 18; J. Hubbs, *Mother Russia: The Feminine Myth in Russian Culture* (Bloomington, University of Indiana Press, 1988), pp. 234–5.

35 A. Tikhomirov, 'Master peizazha vystavka kartin G Shegelia', *Literatura i iskusstvo*, 18 (1 May, 1943), p. 4.

36 'Pobeda sotsialisticheskogo realizma', *Sovetskoe iskusstvo*, 1 (5 January, 1941, p. 1.

37 A. Gerasimov, 'O sovremennoi russkoi khudozhestvennoi kulture', *Literatura i iskusstvo*, 27 (3 July, 1943), p. 3.

38 'K zhenshchinam vsego mira', *Sovetskoe iskusstvo*, 36 (11 September, 1941), p. 2; *Ibid.*, 33 (18 August, 1942), p. 1; Postanovlenie TsK VKP (b) 'O mezhdunarodnom zhenskii den' – 8 Marta', *Pravda* (8 March, 1943), p. 1.

39 Postanovlenie TsK VKP (b) 'O mezhdunarodnom zhenskii den' – 8 Marta', *Sovetskoe iskusstvo*, 10 (9 March, 1941), p. 1.

40 *Pravda* (8 March, 1943), 1; Postanovlenie TsK VKP (b) 'O mezhdunarodnom zhenskii den' – 8 Marta', *Pravda* (5 March, 1944), p. 1; K. Nikolaeva, 'Sovetskaia zhenshchina v Otechestvennoi voine', *Ibid.*, p. 3.

41 M. Orlova, 'Vystavka "Geroicheskii front i tyl"', *Literatura i iskusstvo*, 52 (25 December, 1943), p. 3; Ioganson, 'Bor'ba ... '.; F. Roginskaia, 'O vyrazitel'nosti obraza v kartine', *Sovetskoe iskusstvo*, 17 (19 April, 1946), p. 2.

42 July, *Soviet Calendar 1917–1947. Thirty Years of the Soviet State* (Moscow, 1947).

43 'A State Act of Outstanding Political Significance. New Soviet Maternity and Child Welfare Charter', *Soviet War News*, 905 (11 July, 1944), p. 8.

44 Postanovlenie TsK VKP (b) 'O mezhdunarodnom zhenskii den' – 8 Marta, *Sovetskoe iskusstvo*, 10 (8 March, 1945), p. 1; *Ibid.*, p. 11 (8 March, 1946), p. 1.

45 *Soviet Youth News*, 5 (29 October, 1943), p. 2.

Notes to Chapter 8

 1 Thistern refers to the English experience as culturally distinct from, and not encompassing, a wider British experience of modernity. Scottish, Northern Irish and to some extent Welsh experiences of modernity are all distinguishable from that of the English and the English response has few claims to speak on behalf of these other British constituencies.

2 W. Lewis, *The Childermass* (London, Chatto & Windus, 1928), p. 1. Compare lines 257–65 of T. S. Eliot's *Waste Land* (London, Faber and Faber, 1922).

3 Rosemary Jackson, *Fantasy: The Literature of Subversion* (London, Routledge, 1981), pp. 52, 43. Further references are given after quotations in the text. For a reading which proposes Science Fiction as the illuminating comparison with Lewis's post-war fiction, see Fredric Jameson, *Fables of Aggression: Wyndham Lewis, the Modernist as Fascist* (Berkeley, Los Angeles, London, University of California Press, 1979).

4 Jackson, *Fantasy: The Literature of Subversion*, p. 42.

5 *Ibid.*, p. 46.

6 *Ibid.*

7 Lewis's 1918 novel *Tarr*, which was largely written before the war, is in a realist mode in this socially mimetic sense. See also Jackson, *Fantasy: The Literature of Subversion*, pp. 46–7.

8 See Peter Bürger, *Theory of the Avant-Garde* (trans. Michael Shaw) (Manchester and Minneapolis, Manchester University Press, 1984), and Thomas Crow, 'Modernism and Mass Culture in the Visual Arts', in *Modern Art in the Common Culture* (New Haven and London, Yale University Press, 1996).

9 For a meditation on the social dynamics of modernism see T. J. Clark, *Farewell to an Idea: Episodes from the History of Modernism* (New Haven and London, Yale University Press, 1999).

10 This tension reflects the views of modernism laid down by Clement Greenberg on the one hand and the editorial contributors to the volume of the Vancouver conference on 'Modernism and Modernity' – in which Crow's essay on 'Modernism and Mass Culture in the Visual Arts' first appears – on the other. See Benjamin H. D. Buchloh, Serge Guilbaut and David Solkin (eds), *Modernism and Modernity: The Vancouver Conference Papers* (Halifax, Nova Scotia, 1983), which includes Greenberg.

11 Wyndham Lewis, *Blasting and Bombardiering* (London, Eyre and Spottiswoode, 1937), p. 35.

12 I am indebted in my thinking about this point throughout this chapter to Lisa Tickner's essay, 'Men's Work? Masculinity and Modernism', in Norman Bryson, Michael Ann Holly and Keith Moxey (eds), *Visual Culture: Images and Interpretations* (Hanover and London, Wesleyan University Press, 1994).

13 *Blast*, 1 (1914), p. 33.

14 See Tickner, 'Men's Work?', pp. 63–4 .

15 David Peters Corbett, *The Modernity of English Art, 1914–1930* (Manchester, Manchester University Press, 1997).

16 See Alison Light, *Forever England: Femininity, Literature and Conservatism between the Wars* (London and New York, Routledge, 1991).

17 Tickner, 'Men's Work?', p. 55.

18 D. Goldring, *South Lodge: Reminiscences of Violet Hunt, Ford Madox Ford and the 'English Review' Circle* (London, Constable and Co., 1943), pp. 39–40.

19 Ford Madox Ford, *No Enemy*, cited in W. C. Wees, *Vorticism and the English Avant-Garde* (Manchester, Manchester University Press, 1972), p. 38.

20 Pound's reported ambition to be 'literary dictator of London' (while Lewis ruled the art-world) was a step on the way to achieving a public position from which the analysis and understanding of the world the new art offered could be regularly and effectively disseminated. See Richard Aldington, *Life for Life's Sake: A Book of Reminiscences* (New York, Viking Press, 1941), p. 101.

21 *Blast,* 1 (London, 1914), p. 30.

22 *Ibid.*

23 See Richard Cork, 'Landscape and Pastoral', *Twentieth Century English Art*, exhib. cat. (London, Royal Academy, 1987).

24 *Blast*, 1 (London, 1914), p. 34.

25 *Ibid.*, p. 36.

26 *Ibid.*, p. 39.

27 *Ibid.*, p. 36.

28 *Ibid.*, pp. 39–40.

29 See Wyndham Lewis, 'Edward Wadsworth', *Listener*, 30 June 1949, reprinted in Walter Michel and C. J. Fox (eds), *Wyndham Lewis on Art: Collected Writings, 1913–1956* (London, Thames & Hudson, 1969), p. 422.

30 *Blast,* 1 (London, 1914), pp. 23–4.

31 For a highly stimulating and original discussion of some of these issues see Jane Beckett and Deborah Cherry, 'Modern Women, Modern Spaces: Women, Metropolitan Culture and Vorticism', in Katy Deepwell (ed.), *Women Artists and Modernism* (Manchester, Manchester University Press, 1998), pp. 36–54.

32 Lisa Tickner argues that the overt, asserted masculinity of the pre-war English modernists is a symptom of 'crisis' 'in the years after 1900', 'Men's Work?', p. 34.

33 John Cournos, 'The Death of Futurism,' *The Egoist*, 4 (London, 1917), p. 6.

34 Phillip Gibbs, *Realities of War* (London, William Heinemann, 1920), p. 107.

35 Lewis, *The Childermass*, p. 3.

36 *Ibid.*, p. 8.

37 *Ibid.*, p. 2.

38 *Ibid.*, p. 5.

39 *Ibid.*, p. 74.

40 Wyndham Lewis, *The Art of Being Ruled* (London, Chatto and Windus, 1926), p. 112.

41 Lewis, *The Childermass*, p. 76.

42 See the discussion of post-war masculinity in Martin Green, *Children of the Sun: A Narrative of 'Decadence' in England after 1918* (London, Pimlico, 1977). Green speaks of the 'readiness to adopt effete or dandy gestures – and a distrust of the major masculine roles' as part of a complicated post-war reaction, p. 87. See also on general alterations in social organisation and representation following on the war, Samuel Hynes, *A War Imagined: The First World War and English Culture* (London, Pimlico, 1990), pp. 361–82 deal directly with relevant matters; Malcolm Smith, 'The War and British Culture', in Stephen Constantine, Maurice W. Kirby and Mary B. Rose (eds), *The First World War in British History*; Paul Fussell, *The Great War and Modern Memory* (London, Oxford University Press, 1970).

43 Aldington was very likely an unwilling signatory to the Manifesto.

44 Richard Aldington, *Death of a Hero* (London, William Heinemann, 1932), first published 1929, p. 18.

45 Aldington, *Death of a Hero*, p. 429.

46 Christopher Isherwood, *Lions and Shadows: An Education in the Twenties*, first edition 1938 (London, New English Library, 1974), pp. 46–7.

47 Isherwood, *Lions and Shadows*, p. 52.

48 See John Taylor, *A Dream of England: Landscape, Photography and the Tourist's Imagination* (Manchester, Manchester University Press, 1994) and David Peters

Corbett, Ysanne Holt and Fiona Russell (eds), *Geographies of Englishness: Landscape and English Art 1880–1940* (New Haven and London, Yale University Press, forthcoming).

49 Light, *Forever England*, p. 10.

50 See David Matless, *Landscape and Englishness* (London, Reaktion, 1998).

51 Charles Harrison, *English Art and Modernism, 1900–1939* (London and Bloomington, Indiana, Indiana University Press, 1981), pp. 165–6.

52 For alternative readings, see essays by Chris Stephens and Alan Powers in *The Geographies of Englishness*.

53 See *Ben Nicholson*, exhib. cat. (London, Tate Gallery, 1993) for a recent and very full account of Nicholson's career.

54 See Corbett, *The Modernity of English Art*, ch. 4.

55 *Ben Nicholson*, p. 30.

56 See *A Painter's Place: Banks Head Cumberland 1924–31*, exhib. cat. (Abbot Hall Art Gallery, Bristol, 1991).

57 *Ben Nicholson*, p. 28.

58 Many women artists made good use of this, see Corbett, *The Modernity of English Art*, ch. 6.

Notes to Chapter 9

I am most grateful to the Humanities Research Board of the British Academy and to Bristol University for generous grants towards the research out of which this chapter grew.

1 'Correspondance? … C'est pschutt; ce n'est pas pschutt.' Mauvieuse is a character in F. Champsaur, *Miss America* (Paris, Ollendorff, 1885); this quotation, p. 28.

2 Cézanne spoke of 'ce vieux sol natal … la terre où j'ai tant ressenti, même à mon insu.' Regarding Provence, Cézanne also told Philippe Solari in a letter of 23 July 1896: 'quand on est né là-bas … rien ne vous dit plus' (when one was born down there … nothing else means a thing). For Cézanne's letters, see J. Rewald, *Paul Cézanne: correspondance* (Paris, Grasset, 1978).

3 On Cézanne's attachment to his 'native' landscape, see A. Boime, 'Cézanne's Real and Imaginary Estate', *Zeitschrift für Kunstgeschichte*, LXI/4 (1998), pp. 552–67.

4 F. Henriet, *Coup d'oeil sur le Salon de 1853* (Paris, Nouveau Journal des Théâtres, 1853), pp. 1–21.

5 See P. Smith, 'Joachim Gasquet, Virgil and Cézanne's Landscape: "My Beloved Golden Age"', *Apollo*, CXLVIII/439 (1998), especially pp. 17–19.

6 E. Zola, *L'Oeuvre, Les Rougon-Maquart*, IV (Paris, Fasquelle et Gallimard, 1966), p. 38. See also J. Newton, 'French Literary Landscapes', in R. Thomson (ed.), *Framing France: The Representation of Landscape in France, 1870–1914* (Manchester and New York, Manchester University Press, 1998), pp. 53–4 on Zola's view of nature as feminine.

7 On the idea that the interest of a work of art is intentional, see R. Wollheim, *Painting as an Art* (Princeton, Princeton University Press; London, Thames and Hudson, 1987), pp. 17–19, 37–9 and 361, n. 23.

8 This argument derives from *ibid.*, pp. 80–5; see also R. Wollheim, 'Correspondence, Projective Properties, and Expression in the Arts', in S. Kemal and I. Gaskell (eds), *The Language of Art History* (Cambridge, Cambridge University Press, 1991), pp. 53–4.

9 See Wollheim, *Painting as an Art*, pp. 46–7 and 72–5.

10 See Y.-A. Bois, 'L'écart: théorie et pratique cézanniennes' in *Cézanne aujourd'hui: actes du colloque organisé par le musée d'Orsay 29 et 30 novembre 1995* (Paris, Réunion des Musées Nationaux, 1998), pp. 87–94 (translated as 'Cézanne: Words and Deeds' in *October*, 84 (Spring 1998), p. 37), which endorses Brice Marden's opinion that the Mont Sainte-Victoire is a 'giant tit'. See P. Smith, *Interpreting Cézanne* (London, Tate Publishing, New York, Stewart, Tabori & Chang, 1996), p. 67 for the way that the apples and pears in Cézanne's still lives take on properties of (whole) bodies and T. Garb, *Bodies of Modernity: Figure and Flesh in Fin-de-Siècle France* (London, Thames and Hudson, 1998), p. 229, n. 12 for a contemporary view of the way that apples and pears metaphorise breasts.

11 On this kind of ('central') imagining, see Wollheim, *Painting as an Art*, pp. 103–4 and 129, and Wollheim, *On Art and the Mind* (London, Allen Lane, 1973), pp. 58–9 and 72–4.

12 On the 'metaphorical object', see Wollheim, *Painting as an Art*, pp. 305–47.

13 The epithet is Bernard's; see E. Bernard, *Souvenirs sur Paul Cézanne et lettres* (Paris, Rénovation Esthétique, 1921), pp. 60–1. On Cézanne's admiration for Baudelaire, see the artist's letters of 13 and 28 September 1906 to his son, L. Larguier, *Dimanche avec Paul Cézanne* (Paris, L'Édition, 1925), pp. 146–7, J. Gasquet, *Cézanne* (Paris, Bernheim-Jeune, 1926 (1921)), pp. 20, 101, 133 and 183, A. Vollard, *En écoutant Cézanne, Degas, Renoir* (Paris, Grasset, 1938), p. 49 and P. Smith, *Interpreting Cézanne*, p. 30.

14 C. Baudelaire, *Oeuvres complètes*, I (Paris, Gallimard, 1975), pp. 22–3; cf. *ibid.*, pp. 49–50, 56, 65–6, 156–7 and 158–9, 337–8, 301–3.

15 See J. S. Boggs, *et al.*, *Degas* (Paris, Ottawa and New York, 1988), p. 57.

16 See P. Brame and T. Reff, *Degas et son oeuvre: A Supplement* (New York, Garland, 1984), no. 134.

17 See Wollheim, *Painting as an Art*, p. 85. On the relation of corporeal metaphor to phantasy, see *ibid.*, pp. 84 and 344–8.

18 J. Gasquet, *Cézanne* (Paris, Bernheim-Jeune, 1926), p. 18. Cézanne perhaps echoed this thought in the letter of 23 July 1896 to Solari (see note 2) which followed its remarks about the landscape with the injunction: 'Il faudrait … se ficher une bonne biture' (One should … get roaring drunk).

19 Baudelaire, *Oeuvres complètes*, I, p. 11; see also *ibid.*, pp. 839–47.

20 See Baudelaire, *Oeuvres complètes*, II (Paris, Gallimard, 1976), pp. 132–3, 328–9, 433, 623–8, 660–8, 693–4, 784 and 1394.

21 Alphonse de Lamartine, *Harmonies poétiques et religieuses* (1830) in *Oeuvres complètes* (Brussels, Wahlen, 1846), p. 422 .

22 F. Desnoyers, *Fontainebleau. Paysages. Legendes. Souvenirs. Fantaisies* (Paris, Hachette, 1855), pp. 9-10.

23 Baudelaire, *Oeuvres complètes*, II, p. 663; cf. *ibid.*, pp. 666–7 and p. 741 (on Meryon).

24 See Wollheim, *Painting as an Art*, pp. 82–4.

25 Baudelaire, *Oeuvres complètes*, I, pp. 32–3.

26 Wollheim, *Painting as an Art*, p. 82.

27 Van Gogh, *Brieven aan zijn Broeder* (edited by J. van Gogh-Bonger) III (Amsterdam, Mij. voor Goede en Goedkoope Lectuur, 1914), p. 458 and Van Gogh, *The Complete Letters of Vincent Van Gogh*, III (Boston, New York Graphic Society, 1958), p. 295

(letter no. 649). The painting is no. 2097 in J. Hulsker, *The Complete Van Gogh: Paintings, Drawings, Sketches* (New York, Abrams, 1980).

28 Wollheim, *Painting as an Art*, pp. 82–6 and Wollheim, 'Correspondence, Projective Properties, and Expression in the Arts', pp. 59–64.

29 On the criterion, see M. McGinn, *Wittgenstein and the Philosophical Investigations* (London and New York, Routledge, 1997), pp. 29–31 and D. Bloor, *Wittgenstein: A Social Theory of Knowledge* (London, Macmillan, 1983), pp. 41–6.

30 Desnoyers, *Fontainebleau. Paysages. Legendes. Souvenirs. Fantaisies*, pp. 25–34 (these excerpts 27–8).

31 Cf. Théodore de Banville's poem, 'A la forêt de Fontainebleau', in *ibid.*, pp. 34–6.

32 See Wollheim, *Painting as an Art*, pp. 318–26 and 332–3.

33 See Wollheim, *On Art and the Mind*, pp. 5–6, 10–11, 12–13 and 16–20 on the painting as the 'criterion' of the artist's visual experience. According to E. Bernard, 'Paul Cézanne', *L'Occident* (July, 1904), p. 36, Cézanne held the 'opinion': 'Lire la nature, c'est la voir sous le voile de son interprétation par taches colorés se succédant selon une loi d'harmonie' (To read nature is to see it under the veil of its interpretation as coloured patches following one another according to a law of harmony). See also Larguier, *Dimanche avec Paul Cézanne*, pp. 137–8 and Cézanne's letter to Gasquet of 26 September 1897.

34 Baudelaire, *Oeuvres complètes*, II, p. 423.

35 See Wollheim, *On Art and the Mind*, pp. 42, 50–1 and 76–9, S. Freud, *The Standard Edition of the Complete Psychological Works of Sigmund Freud* (London, Hogarth Press, 1953–74), XIV, pp. 237–59, XVIII, pp. 105–8, XXII, p. 63 and XVIII, pp. 230–1, and M. Klein, *Our Adult World and Other Essays* (London, William Heinemann, 1963), pp. 5–8, 55–9 and 282–7.

36 See Klein, *Our Adult World and Other Essays*, pp. 5 and 56, and P. Heimann, 'Certain Functions of Introjection and Projection in Early Infancy', in M. Klein *et al.*, *Developments in Psycho-Analysis* (London, Hogarth Press, 1952), pp. 125 and 161.

37 On reintrojection, see M. Klein, *Contributions to Psychoanalysis* (London, Hogarth Press, 1948), p. 330, Klein, 'Notes on Some Schizoid Mechanisms' in Klein *et al.*, *Developments in Psycho-Analysis*, pp. 292–3 and 303–4, Klein, *Our Adult World and Other Essays*, pp. 59 and 93–5, and Heimann, 'Certain Functions of Introjection and Projection in Early Infancy', p. 126.

38 See Klein, *Contributions to Psychoanalysis*, pp. 282–5 and 292–4, and Klein, *Our Adult World and Other Essays*, p. 59.

39 See Wollheim, *On Art and the Mind*, pp. 49–51 and 76 and Wollheim, *Painting as an Art*, pp. 266–8 (on projective identification in Ingres's art).

40 See Klein, *Our Adult World and Other Essays*, pp. 61–99.

41 Baudelaire, *Oeuvres complètes*, I, pp. 307–10 and 291–2.

42 See *ibid.*, pp. 650 and 676 for Baudelaire's understanding of how gender is at issue in acts of identification.

43 Many of Cézanne's later landscapes involved his returning to sites that he had frequented, but not painted, in his youth. See J. Rewald, 'The Last Motifs at Aix' in W. Rubin *et al.*, *Cézanne: the Late Work* (Boston, New York Graphic Society, 1977), pp. 83–106.

44 See Klein, *Contributions to Psychoanalysis*, p. 282, Klein, 'Notes on Some Schizoid Mechanisms', p. 300 and Klein, *Our Adult World and Other Essays*, pp. 10 and 56.

45 See Klein, *Contributions to Psychoanalysis*, p. 282, Klein, *Our Adult World and Other Essays*, pp. 56 and 59–60 and Heimann, 'Certain Functions of Introjection and Projection in Early Infancy', pp. 146–9.

46 See Klein, *Contributions to Psychoanalysis*, p. 290, Klein, 'Notes on Some Schizoid Mechanisms', pp. 296–9, Klein, *Our Adult World and Other Essays*, pp. 3, 5 and 59–60, and Heimann, 'Certain Functions of Introjection and Projection in Early Infancy', p. 153.

47 See Klein, 'Notes on Some Schizoid Mechanisms', pp. 297–8 and 304, Klein, *Our Adult World and Other Essays*, p. 60 and Heimann, 'Certain Functions of Introjection and Projection in Early Infancy', p. 205.

48 See Klein, *Contributions to Psychoanalysis*, pp. 284–7, 305–9 and 317, Klein, 'Notes on Some Schizoid Mechanisms', pp. 294–5 and Heimann, 'Certain Functions of Introjection and Projection in Early Infancy', pp. 135–6 and 160–1.

49 See Klein, *Contributions to Psychoanalysis*, pp. 285, 290–2, 318 and 321 and Klein, *Our Adult World and Other Essays*, pp. 11 and 58.

50 See Klein, *Contributions to Psychoanalysis*, pp. 291, 294 and 315, Klein, 'Notes on Some Schizoid Mechanisms', p. 296, Klein, *Our Adult World and Other Essays*, p. 97 and H. Segal, 'A Psychoanalytic Approach to Aesthetics', [1947], in J. Phillips and L. Stonebridge (eds), *Reading Melanie Klein* (London and New York, Routledge, 1998), p. 206.

51 See Bernard, *Souvenirs sur Paul Cézanne et lettres*, p. 19, Larguier, *Dimanche avec Paul Cézanne*, p. 26 and Vollard, *En écoutant Cézanne, Degas, Renoir*, p. 66.

52 See Bernard, *Souvenirs sur Paul Cézanne et lettres*, pp. 57–8. See also Gasquet, *Cézanne*, p. 21.

53 Gasquet, *Cézanne*, pp. 99–100. See also Vollard, *En écoutant Cézanne, Degas, Renoir*, pp. 23, 46–7, 57, 63, 65 and 78.

54 See Klein, *Contributions to Psychoanalysis*, pp. 291–2.

55 *Ibid.*, p. 210.

56 This idea helps Cézanne's attempt to develop a 'logique de sensations organisées' (logic of organised sensations) that might help ensure in advance the outcome of the painting; see Bernard, 'Paul Cézanne', p. 36. Cézanne described 'l'idéal du bonheur terreste' (the ideal of earthly happiness) as 'Avoir une belle formule' (to have a good formula); see M. Doran, *Conversations avec Cézanne* (Paris, Macula, 1978), p. 102 and cf. Larguier, *Dimanche avec Paul Cézanne*, p. 134.

57 Vollard, *En écoutant Cézanne, Degas, Renoir*, p. 59.

58 See Segal, 'A Psychoanalytic Approach to Aesthetics', p. 214 on the ability of the artist to tolerate and overcome anxieties.

59 See Smith , *Interpreting Cézanne*, p. 30.

60 In this respect the painting resembles the 'transitional object' described in D. Winnicott, *Playing and Reality* (London and New York, Routledge, 1991); see especially pp. 1–26, 38–64 and 104–10.

61 On the relation of reparative, artistic feelings to mourning, see Klein, *Contributions to Psychoanalysis*, pp. 311–38 and Segal 'A Psychoanalytic Approach to Aesthetics'.

62 Gasquet, *Cézanne*, p. 130.

63 See for example F. Henriet, *Le Paysagiste aux champs: croquis d'après nature* (Paris, Faure, 1866), p. 14; cf. R. P. Rivière and J. F. Schnerb, 'L'Atelier de Cézanne' (*La Grande Revue*, 25 December, 1905) on Cézanne's view that 'le motif' was 'une portion

de nature embarrassée par le regard et s'isolant par cela même, faisant un tout de ce qui est un fragment' (the motif [was] a portion of nature circumscribed by the field of vision, and isolated by it, which makes a whole out of what is a fragment). This extract reprinted in Doran, *Conversations avec Cézanne*, p. 90 and cited in T. Reff, 'Painting and Theory in the Final Decade', in Rubin *et al.*, *Cézanne: the Late Work*, p. 45.

64 On the space of the painting in the Metropolitan Museum, New York (J. Rewald, *et al.*, *The Paintings of Paul Cézanne* (New York, Abrams, London, Thames and Hudson, 1996), no. 511), see R. Shiff, 'Cézanne's Physicality', in Kemal and Gaskell, *The Language of Art History*, p. 160.

65 Cf. Rewald *et al.*, *The Paintings of Paul Cézanne*, nos. 910–11, 913–15, 931–2.

66 The effect of Cézanne's paintings is familiar in photographs taken with a telephoto lens; cf. Reff, 'Painting and Theory in the Final Decade', p. 27, P. Machotka, *Cézanne: Landscape into Art* (New Haven and London, Yale University Press, 1996), p. 25 and E. Loran, *Cézanne's Composition* (Berkeley and Los Angeles, University of California Press, 1970), pp. 60, 98, 101–5 and 124–5.

67 See J.-D. Regnier, *De la lumière et de la couleur chez les grands maîtres anciens* (Paris, Renouard, 1865), pp. 52–3. On Cézanne's familiarity with Régnier's text, see R. Ratcliffe, *Cézanne's Working Methods and their Theoretical Background* (unpublished Ph.D. thesis, University of London, 1960), p. 166 and J. de Beucken, *Un Portrait de Cézanne* (Paris, Gallimard, 1955), p. 304.

68 Cézanne was also given to 'elongating forms upwards'; see Machotka, *Cézanne: Landscape into Art*, p. 27.

69 J. Rewald, *Paul Cézanne: the Watercolours* (New York, Abrams, London, Thames and Hudson, 1983), no. 433. See Machotka, *Cézanne: Landscape into Art*, p. 89 for a telling comparison between the painting and the motif.

70 See A. Stokes, *Inside Out: An Essay in the Psychology and Aesthetic Appeal of Space* (London, Faber and Faber), pp. 51–68, Wolheim, *On Art and the Mind*, pp. 315–35 and Shiff, 'Cézanne's Physicality', p. 173, n. 24.

71 Gasquet, *Cézanne*, p. 131.

72 On the 'undecidable' and 'undecidability', see J. Derrida, 'The Double Session', in P. Kamuf, *A Derrida Reader* (New York, Columbia University Press, 1987), pp. 185–95.

73 Bernard, *Souvenirs sur Paul Cézanne, une conversation avec Cézanne* (Paris, Michel, 1926), p. 80.

74 See S. Gardner, 'The Nature and Source of Emotion', in J. Hopkins and A. Saville (eds), *Psychoanalysis, Mind and Art: Perspectives on Richard Wollheim* (Oxford and Cambridge, Mass., Blackwell, 1992), p. 49.

75 Baudelaire, *Oeuvres complètes*, I, p. 42.

76 Rewald *et al.*, *The Paintings of Paul Cézanne*, no. 837.

77 Segal, 'A Psychoanalytic Approach to Aesthetics', pp. 208–9.

78 The point is that painting is not a form of private therapy, since the spectator can identify with the artist's way of seeing the picture; see Wollheim, *Painting as an Art*, pp. 43–5 and 95–6, and F. Schier, 'Painting after Art? Comments on Wollheim', in N. Bryson *et al.*, *Visual Theory* (Cambridge, Polity, 1991), pp. 61–73. Cf. Segal, 'A Psychoanalytic Approach to Aesthetics', p. 216: 'the reader identifies with the author through the medium of the work of art' and 're-experiences own early depressive anxieties' and so 're-experiences a successful mourning, re-establishes his own internal objects and ... world'.

Notes to Chapter 10

1 James E. Lovelock, *The Ages of Gaia: A Biography of Our Living Earth* (New York, Norton, 1988). For a critique of the Gaia hypothesis, see W. F. Doolittle, 'Is Nature Really Motherly?', *CoEvolution Quarterly*, 29 (1981), pp. 58–65. For an argument that the new evolutionary biology is *not* sexed along traditional, narcissistic, human lines, but in relation to a radical, post-zoocentric model based on unicellular sexuality, see D. Sagan, 'Metametazoa: Biology and Multiplicity', in Jonathan Crary and Sanford Kwinter, eds, *Incorporations* (New York, Zone Books, 1992), pp. 362–85. I take the Gaia hypothesis at its root to be a critique of the passive earth with its patriarchal God, for which is substituted the vision of a goddess within whose watery body we dwell. Despite Sagan's fascinating argument, we have yet to see the demise of the female earth – but Smithson, Sagan and others do suggest a productive drift in that direction.

2 Londa Schiebinger, in *Nature's Body* (Boston, Beacon Press, 1993), demonstrates the peculiar need to taxonomise plants in terms of human sexual reproduction, when the two biological systems are in fact highly divergent.

3 Carolyn Merchant, 'Mining the Earth's Womb', in Joan Rothschild, ed., *Machina Ex Dea: Feminist Perspectives on Technology* (New York, Pergamon, 1983), pp. 99–117. See also Merchant, *The Death of Nature: Women, Ecology, and the Scientific Revolution* (New York, Harper and Row, 1983).

4 The word 'earthworks' appears ironically in Smithson's essay 'A Tour of the Monuments of Passaic, New Jersey', originally published as 'The Monuments of Passaic', reprinted in Jack Flam, ed., *Robert Smithson: The Collected Writings* (Berkeley, University of California Press, 1996), pp. 68–74 (henceforth Smithson, *Collected Writings*). On his mordantly clever 'tour' of this dilapidated industrial town with its monuments of rusty pipes and railroad bridges (discussed further below), Smithson brings with him a science fiction novel by Brian Aldiss titled *Earthworks* in which mankind is forced to manufacture artificial soil. The name recurs with greater frequency following the 1969 'Earth Art' exhibition at Cornell University. Smithson himself adopts the term that same year as a name for what he and his colleagues are doing. See his 'Aerial Art', *Studio International* (February–April 1969), reprinted in Smithson *Collected Writings*, pp. 116–18. Discussing works of art which would be situated in off-ramp portions of an airport, visible primarily from the air, Smithson writes: 'On the boundaries … we might construct *earthworks* or grid-type frameworks close to the ground level'. 'Earthworks' came to be the name for the entire movement of large-scale, land-based art, as recent monographs attest.

5 I am grateful to my colleague Farouk El-Baz, director of the Boston University Center for Remote Sensing, for emphasising the impact of this single photograph, whose cultural underpinnings and impact we have often discussed. See also F. White, *The Overview Effect: Space Exploration and Human Evolution* (Boston, Houghton Mifflin, 1987).

6 A public-service announcement from the time was dubbed 'The Crying Indian'. An actor dressed in traditional Native American buckskins was shown standing next to a river in which bits of trash drifted by. His face turned slowly towards the camera (and viewer), and a single tear slowly coursed down his cheek.

7 In Smithson's own words of praise, 'Heizer calls his earth projects "The alternative to the absolute city system".' In Robert Smithson, 'A Sedimentation of the Mind: Earth

Projects', *Artforum* (September, 1968), and Smithson, *Collected Writings*, pp. 100–13. The Heizer quote is on p. 102.

8 Robert Smithson, 'Frederick Law Olmsted and the Dialectical Landscape', *Artforum* (February, 1973), in Smithson, *Collected Writings*, pp. 163–4. (Emphasis added.)

9 Smithson, *Collected Writings*, p. 164. (Emphasis added.)

10 Echoing Barnett Newman's references to the Indian mounds, Smithson wrote: 'When one looks at the Indian cliff dwelling[s] …, one cannot separate art from nature. And one can't forget the Indian mounds in Ohio.' *Ibid.*, p. 164. For analysis of Newman's and Pollock's position in regard to nature and the Sublime, see ch. 1 of Caroline Jones, *Machine in the Studio: Constructing the Postwar American Artist* (Chicago, University of Chicago Press, 1996).

11 See ch. 5 of Jones, *Machine in the Studio*.

12 Robert Smithson, letter to Nancy Holt, *c.* 1960, Archives of American Art (AAA), reel 3832 frame 742. The works described romantic places: *Equator, The Ruins, Walls of Dis, Coronado's Journey*; natural scientific marvels: *Living Extinction, Flesh Eater, Spider Lady, Shark Man, White Dinosaur, Blue Dinosaur*; and liminal states: *Portrait of a Lunatic, Portrait of a Transvestite, The Victim, The Absence, The Assassin*. All titles are as recorded on the Artists Gallery list, *Artists Gallery Papers*, AAA, Reel D313, frame 1182.

13 Robert Smithson, 'From the Walls of Dis' (*c.* 1959), in Smithson, *Collected Writings*, p. 316.

14 See, for example, the 1959 *Walls of Dis*, a painting illustrated in Jones, *Machine in the Studio*, p. 287 that goes with the poem of the same name excerpted above. Vertical bands trap a dinosaur-like creature whose open mouth seems to roar with frustration. Despite the shift from vertical to horizontal, the metaphor of cross-bedding is eerily intact in the sophisticated layout of Smithson's 1970 essay 'Strata: A Geophotographic Fiction' within Smithson, *Collected Writings*, p. 77, and hints of that 1959 'Hell' can still be heard in 'Strata's geological narrative: 'MEMORY AT THE CHTHONIC LEVEL … NEAR THE BLIND RIVER … BURROWS IN A MOUNTAIN OF CORRUPTION … STALE TIME. ONE-CELLED NOTHINGS. ABSENCE OF OXYGEN.'

15 Art historian Eugenie Tsai writes: 'A collector named John Streep purchased a number of suites from this period. He encountered Smithson by chance in 1973 and made a deal with the artist to exchange the early suites for examples of Smithson's more recent work. According to Nancy Holt, Smithson was relieved the trade was to occur, as he did not want the early drawings "out in the world." Before the trade could take place, Smithson died; Streep passed away shortly thereafter.' Tsai gives no indication of what happened to the works in Streep's estate. Eugenie Tsai, *Robert Smithson Unearthed: Drawings, Collages, Writings* (New York, Columbia University Press, 1991), n. 59, p. 43.

16 For illustrations from *Hitler's Opera*, see Jones, *Machine in the Studio*, p. 289.

17 As Klaus Theweleit argues, the crucified/hardened fascist is not exotic; he is all too well known; he is not Other, but Any. See K. Theweleit's 'Male Fantasies', vol. 1, *Women, Floods, Bodies, History* (1977), trans. by Stephen Conway (Minneapolis, University of Minnesota Press, 1987); vol. 2, *Male Bodies: Psychoanalyzing the White Terror* (1978), trans. by Erica Carter and Chris Turner (Minneapolis, University of Minnesota Press, 1989).

18 A brief excursus on what is taken to be the psychosexual dynamic of the technological sublime (that is, the narrative construct 'sublime' as read in psychoanalytic terms): like all experiences of the sublime, the technological sublime recapitulates experiences of early childhood, but does so within a matrix that is culturally specific to a highly industrialised environment. The individual experiences an enormous, potentially threatening, devouring or absorptive Other in specifically mechanised form. (The Other here is, psychologically speaking, both the bad mother of Kleinian object-relations theory and the Patriarchal Law of Lacanian theorists – both oceanic origin and punishing, civilised terminus of existence.) Because of the Freudian death instinct, the ensuing loss of ego boundaries and shattering of self can be experienced with intoxicating pleasure; as the self fragments, a heady liberation ensues, and the splintered fragments of the self are projected on to the mechanised Other as the oceanic experience develops. Creativity then retrospectively orders this experience through narrative, dream, imagery, music, etc.; if the artwork is successful, the shattered and projected fragments of the self are then taken back into the viewer or creator and re-introjected. In the technological sublime, some portion of the hardened mechanical Other is adopted in the process. The hardened self is then experienced, at least initially, as enriched – more complete and more powerful than before, yet eerily dependent on the rhythm and dynamic of sublimity for regeneration. Ultimately, the hardened self is a figure for that privileged Lacanian signifier, the Phallus, yet, as Lacanians know, the experience of claiming it always reinforces its exteriority and unavailability. Hence the desire for the sublime endures. As is hoped is obvious from the text, the enormity necessitated for the sublime to occur is an enormity of scale (relation between parts), not size (literal dimensions). It can be found in a grain of sand, a steel filing or a collage drawing as easily as a screaming steam engine or streaming cataract. The domain of the sublime is not literal, for its field lies with the Imaginary in its encounter with the Symbolic.

19 Smithson, 'A Tour of the Monuments of Passaic, New Jersey', *Robert Smithson: Collected Writings*, p. 71.

20 Guy Hocquenhem, *Homosexual Desire* (1972), translated by Daniella Dangoor (Durham, Duke University Press, 1993), p. 149.

21 Sigmund Freud, 'Three Essays on the Theory of Sexuality' (1905) in James Strachey, ed., *The Standard Edition of the Complete Psychological Works of Sigmund Freud*, vol. VII (London, Hogarth Press, 1953), p. 151, n. 1.

22 For an illustration of *Blind in the Valley of the Suicides*, see Jones, *Machine in the Studio*, p. 291.

23 Castration and blindness are often paired in narratives of sexual and other crimes against 'natural' law. Orestes, who killed his mother, is said in some accounts to have expiated his crime by cutting off a finger; Borges, in enumerating all the literary greats who wrote from or out of blindness, includes this intriguing sentence: 'Democritus of Abdera tore his eyes out in a garden so that the spectacle of reality would not distract him; Origen castrated himself.' Jorges Luis Borges, 'Blindness', in *Seven Nights*, trans. by Eliot Weinberger (New York, New Directions, 1984), p. 119, cited by Jacques Derrida, *Mémoires d'aveugle: L'autoportrait et autres ruines* (Paris, Éditions de la Réunion des musées nationaux, 1990); translated as *Memoirs of the Blind: The Self-Portrait and Other Ruins* (Chicago, University of Chicago Press, 1993), pp. 34–5. As Derrida has discussed, these ancient mythologies of blindness are well worn in our

psyches, but they pale before the complexities introduced by Biblical narratives of the kind that motivated Smithson at the time of the Hitler suite. Derrida writes: 'Is blindness going to be translated by castration? Is anyone still interested in this? To illustrate the overwhelming "truth" of this Freudian axiom (though it is the question of truth that we are here placing under observation – or into memory, and into the memory of the blind), one has all the material for a simple and striking demonstration in the story of Samson. Samson loses every phallic attribute or substitute, his hair and then his eyes, after Delilah's ruse had deceived his vigilance, thereby giving him over to a sort of sacrifice, a physical sacrifice. He is not only a figure of castration, a castration-figure, but, a bit like all the blind, like all one-eyed men or cyclops, a sort of phalloid image, an unveiled sex from head to toe. ...' *Ibid.*, pp. 104 and 106. See also a book that highly influenced Smithson, Anton Ehrenzweig's *The Hidden Order of Art* (Berkeley, University of California Press, 1967), which has much on the themes of blindness, castration and the 'scattered and buried god'.

24 See Jones, *Machine in the Studio*, pp. 294–300.

25 Smithson interviewed by Cummings, in *Collected Writings*, p. 151.

26 See, for example, *Untitled [or Second-Stage Injector]* (illustrated in Jones, *Machine in the Studio*, p. 293), where an industrial mold injection device is surrounded by lounging hermaphrodites and a drawing of Minos, king of Hell, from Michelangelo's *Last Judgment*, a figure whose penis is being mouthed by a snake (doubly phallic metaphor of male–male oral sex). There is, of course, an entire history to the 'gendering' of fellatio. See T. van der Meer, 'Sodomy and the Pursuit of a Third Sex in the Early Modern Period', in Gilbert Herdt, ed., *Third Sex, Third Gender: Beyond Sexual Dimorphism in Culture and History* (New York, Zone Books, 1994), pp. 137–212 and especially p. 162. This figure of Minos is especially significant, as Smithson writes about him in the context of an essay from the mid-1960s titled 'What Really Spoils Michelangelo's Sculpture', *The Collected Writings*, pp. 346–8. On the essay's dating see Tsai, *Smithson Unearthed*, n. 11, p. 53. Here is Smithson: 'The infirmity of [Michelangelo's] melancholia seems infinite and unending. ... Out of this comes the dismal comedy of enervation, a devastated sense of humor, a ruined joke, mock sacrifice, an obliteration of doom. *Only nature is left with its maggots and filth – a snake chewing a penis.* But this is not sad, it is hilarious', p. 348. And elsewhere in the essay: 'Could it be that great art has a *knowledge* of corruption, while *natural* art is innocent of its own corruption because it is mindless and idealess?', p. 346 (emphasis added). Once again, 'nature' is seen to display (male) 'homosexual tendencies', and the scare quotes Smithson placed around the word 'knowledge' may suggest the kind of 'knowing' alluded to in the Bible. The Bible, of course, was a primary source for the moral judgment against sodomy, and for Smithson, brought up as a Catholic, it also provided the discourse in which knowledge is most intimately linked to the body's capacity for pleasure, and the mind's for shame.

27 Smithson, interviewed by Cummings, *Collected Writings*, p. 151.

28 See Jones, *Machine in the Studio*, pp. 294 and 309–10, and Jones, 'Robert Smithson's Suppressed "Preconscious Works": Intentionality and Art Historical [Re]construction', in *Memory and Oblivion: Proceedings of the XXIXth International Congress of the History of Art* held in Amsterdam, 1–7 September 1996, Wessel Reinink and Jeroen Stumpel, eds (Dordrecht, The Netherlands, Kluwer Academic Publishers, 1999) pp. 937–48.

29 Smithson, *Collected Writings,* p. 136. Smithson wrote this brief statement in 1970.

30 As well as their spatial function, these triangulated spirals also served as temporal boundaries between phases in Smithson's 'consciousness' – the time of the dis-equilibrated erotic cartouche, on the one hand, and the polysemous jetty, on the other.

31 See note 26, above.

32 See, for example, Sigmund Freud, 'Leonardo Da Vinci and a Memory of his Childhood' (1910), *The Standard Edition, Vol. XI,* pp. 98–101.

Notes to Chapter 11

For their helpful comments on earlier versions of this chapter I thank Erin Campbell, Anne Dunlop, Robyn Laba, Maureen Ryan, Bronwen Wilson and William Wood.

1 'Diary of the Master of the Horse', The Royal Archives, Windsor Castle, Windsor.

2 That is, in the 'town' of London; i.e., in the West End, Westminster, not the City. See *The Morning Chronicle* and *The Times,* 25 May, 1793, p. 1.

3 This assembly deemed the Russian Armament was part of an attempt to convince Catherine the Great to come to peace with the Ottoman Empire. For a discussion of the political situation, see F. London and C. Rivington, *The Annual Register, or a view of the History, Politics, and Literature, for the Year 1792,* 33 (London, St. Paul's Church-Yard, 1795), p. 99.

4 Stephan Oettermann, *The Panorama: History of a Mass Medium,* trans. Deborah Lucas Schneider (New York, Zone Books, 1997), p. 105.

5 Diary entry cited in George Richard Corner, 'The Panorama: with Memoirs of its Inventor, Robert Barker, and His Son, the late Henry Aston Barker', *Art Journal,* N.S. 3 (1857), p. 47.

6 *Ibid.*

7 See for examples: Richard D. Altick, *The Shows of London* (Cambridge, Mass., and London, Harvard University Press, 1978), p. 134; Silvia Bordini, *Storia del Panorama: La visione totale nella pittura del XIX secolo* (Rome, Officina Edizioni, 1984), p. 15; and Oettermann, *The Panorama: History of a Mass Medium,* p. 105.

8 Peter de Bolla, 'The Visibility of Visuality: Vauxhall Gardens and the Siting of the Viewer', in Stephen Melville and Bill Reading, eds, *Vision and Textuality* (London, Macmillan, 1995), p. 284.

9 *Ibid.*

10 Altick, *The Shows of London,* p. 189; from Pliny's *Natural History,* XXXV, p. 65, cited in Norman Bryson, *Looking at the Overlooked: Four Essays on Still Life Painting* (Cambridge, Mass., Harvard University Press, 1990), p. 30.

11 Lorraine Daston, 'The Naturalized Female Intellect', *Science in Context,* 5:2 (1992), p. 220.

12 *Ibid.*

13 *Ibid.,* p. 216.

14 In spite of their views on the value of the female intellect, people on both sides of the debate during the eighteenth century were in agreement that there was such a thing. *Ibid.,* p. 217.

15 Bryson, *Looking at the Overlooked,* p. 31.

16 *Ibid.*

17 Daston, 'The Naturalized Female Intellect', p. 212.

18 *Ibid.*, p. 219; and Anon., 'Fashionable Malady at Paris', *Lady's Monthly Museum*, 6 (London, April 1801), pp. 294–5.

19 Ludmilla Jordanova, 'Naturalizing the Family: Literature and the Bio-Medical Sciences in the Late Eighteenth Century', in Jordanova, ed., *Languages of Nature: Critical Essays on Science and Literature* (London, Free Association Books, 1986), p. 98; Fanny Burney, *Evelina, or, The History of a Young Lady's Entrance into the World* (New York and London, W. W. Norton and Company, 1965), p. 66.

20 Michael Roper and John Tosh, 'Historians and the Politics of Masculinity', in Roper and Tosh, eds, *Manful Assertions: Masculinities in Britain since 1800* (London, Routledge, 1991), p. 18.

21 G. J. Barker-Benfield, *The Culture of Sensibility: Sex and Society in Eighteenth-Century Britain* (Chicago and London, University of Chicago Press, 1992), p. 376.

22 For example, the physician George Cheyne and the philosopher David Hume confessed to having the weak constitutions that were associated with delicate nerves. See Barker-Benfield, *The Culture of Sensibility: Sex and Society in Eighteenth-Century Britain*, p. 7; the following references each state that male scholars, like women, were of weak disposition, Le Moyne (1660), pp. 286–7, Roussel (1775) 1809, pp. 60–1, cited in Daston, 'The Naturalized Female Intellect', p. 219.

23 Anna Seward, *Letters of Anna Seward written between the years 1784 and 1807*, ed., A. Constable, vol. 2 (Edinburgh, 1811), p. 381.

24 Oettermann, *The Panorama: History of a Mass Medium*, pp. 13, 105, 186, and in the German version of his book, p. 82.

25 *Ibid.*, p. 12.

26 *Ibid.*

27 *Ibid.*

28 de Bolla, 'The Visibility of Visuality: Vauxhall Gardens and the Siting of the Viewer', p. 283.

29 E. B. Kubek, 'Women's Participation in the Urban Culture of Early Modern London. Images from Fiction', in Ann Bermingham and John Brewer, eds, *The Consumption of Culture 1600–1800: Image, Object, Text* (London and New York, Routledge, 1995), p. 450.

30 Joshua Collins (pseud.), *A Practical Guide to Parents and Guardians, in the right choice and use of books in every branch of education*, 2nd edn (London, Thomas Reynolds, 1802), p. 29, cited in Peter de Bolla, *The Discourse of the Sublime: Readings in History, Aesthetics and the Subject* (Oxford, Basil Blackwell, 1989), p. 274.

31 Kubek, 'Women's Participation in the Urban Culture of Early Modern London', p. 452.

32 Hannah More, *Strictures on the Modern System of Female Education, With a View of the Principles and Conduct Prevalent Among Women of Rank and Fortune*, vol. I, 6th edn (London, T. Cadell Jr. and W. Davies, 1799), p. 143.

33 Hannah More, *Essays on Various Subjects, Principally Designed for Young Ladies* (London, T. Cadell, 1785), p. 5.

34 Jean-Christophe Agnew, *Worlds Apart: The Market and the Theatre in Anglo-American Thought, 1550–1750* (Cambridge, Cambridge University Press, 1986), pp. 97–8.

35 Daston, 'The Naturalized Female Intellect', p. 219.

36 Antoine Léonard Thomas, *Essai sur le caractère, les moeurs et l'esprit des femmes dans les différens siècles* (Paris, Moutard, 1772), pp. 112–13, cited in Daston, 'The Naturalized Female Intellect', p. 219.

37 Michel Foucault, 'Of Other Spaces', trans. Jay Miskowiec in *Diacritics*, 16:1 (Spring, 1986), 24.

38 *Ibid.*, p. 27.

39 The text on Figure 35 reads that the king was expected to review the fleet on 25 July, 1791, but there is no record that he did so.

40 Adi Ophir and Steven Shapin, 'The Place of Knowledge: A Methodological Survey', *Science in Context*, 4:1 (1991), p. 14.

41 Martin Kemp, *The Science of Art: Optical Themes in Western Art From Brunelleschi to Seurat* (New Haven and London, Yale University Press, 1990), p. 214.

42 de Bolla, 'The Visibility of Visuality: Vauxhall Gardens and the Siting of the Viewer', p. 194.

43 *Ibid.*

44 Because at this time there was not a light source powerful enough to project the image on to the canvas, the artist moved back and forth from the platform to the canvas to paint the panorama. See Oettermann, *The Panorama: History of a Mass Medium*, p. 54; Roger Chartier, *On the Edge of the Cliff* (London, Johns Hopkins University Press, 1997), p. 91.

45 John Joshua Kirby, *Dr. Brook Taylor's Method of Perspective Made Easy Both in Theory and Practice* (Ipswich, Printed by W. Craighton for the author, 1754), p. 62, cited in de Bolla, 'The Visibility of Visuality: Vauxhall Gardens and the Siting of the Viewer', pp. 196–7.

46 *Ibid.*, p. 196.

47 J. Steven Watson, *The Reign of George III, 1760–1815* (Oxford, Clarendon Press, 1960), p. 314.

48 Kirby, *Dr. Brook Taylor's Method of Perspective Made Easy both in Theory and in Practice*, p. 62, cited in de Bolla, 'The Visibility of Visuality: Vauxhall Gardens and the Siting of the Viewer', p. 197.

49 de Bolla, 'The Visibility of Visuality: Vauxhall Gardens and the Siting of the Viewer', p. 209.

50 *Ibid.*, p. 198; See also N. Bryson, *Vision and Painting: The Logic of the Gaze* (New Haven and London, Yale University Press, 1989), p. 121.

51 *Ibid.*

52 This debate is best exemplified in the writings of David Hume and Immanuel Kant.

53 Jonathan Crary, *Techniques of the Observer: On Vision and Modernity in the Nineteenth Century* (Cambridge, Mass., and London, MIT Press, 1990), p. 72.

54 de Bolla, 'The Visibility of Visuality: Vauxhall Gardens and the Siting of the Viewer', p. 285.

55 Pierre Maine de Biran, *Considerations sur les principes d'une division des faits psychologiques et physiologiques*, in *Oeuvres des Maine de Biran*, vol. 13, ed. P. Tisserand (Paris, 1949), p. 180, cited by Régis Michel in an unpublished paper delivered at the Théodore Généault conference held at the University of British Columbia on 11 October, 1997.

56 Oettermann writes that he experienced this feeling himself when he visited the 1814 Panorama in Thun, Switzerland, *The Panorama: History of a Mass Medium*, p. 59.

57 *The Globe and Mail*, Toronto, 15 February, 1999.
58 M. Foucault, 'Of Other Spaces.' *Diacritics*, 16 (1986) p. 27
59 J. S. Watson, *The Reign of George II 1760–1815*, The Oxford History of England, ed. Sir G. Clark (Oxford, Clarendon Press, 1960), p. 304.

Notes to Chapter 12

The final draft of this chapter was written while I was in receipt of the AHRB Research Leave Scheme. I am grateful to the Board for its support.

1 The exhibition *Richard Long* took place at the Lisson Gallery, London, 23 January– 24 February.
2 Fuchs states the 'word works' were first made in 1969 and taken up again by Long in 1977. R. H. Fuchs, *Richard Long* (London, Thames and Hudson; New York, Solomon H. Guggenheim Foundation, 1986). The work takes the form of drawings, sculptures, editioned prints, photographic multiples and books and text works. For a list which gives the variety of Long's enterprise see J. Haldane, *A Road from the Past to the Future – Work by Richard Long from the Haldane Collection* (Crawford, Crawford Arts Centre, 1997).
3 This aspect of Long's art takes its most striking form in Richard Long's travel book illustrated with 130 illustrations in colour, *A Walk Across England. A Walk of 382 Miles in 11 Days from the West Coast to the East Coast of England* (London, Thames and Hudson, 1997). The book was commissioned by the Children's Library Press, Venice, California.
4 Interestingly, Brettell expressed a similar reaction to Long. See Houston, Contemporary Arts Museum, *Circles, Cycles, Mud, Stones* (catalogue with an essay by Richard Brettell) 1996. He suggests that walking has assumed a mythological importance in the English imagination and that Long has an important place within this tradition.
5 A. Sleeman, *More or Less. The Early Work of Richard Long* (Leeds, The Centre for the Study of Sculpture, Henry Moore Institute, 1997), p. 6.
6 See M. Compton, *Some Notes on the Work of Richard Long by Michael Compton* (London, British Council, 1976), published for the Venice Biennale.
7 H. Fulton, *Richard Long: Walking in Circles* (London, South Bank Centre, 1991), pp. 241–6.
8 See Richard Long, *Five, six, pick up sticks, Seven, eight, lay them straight* (London, The Curwen Press for Anthony d'Offay, 1980), n.p.
9 L. Mulvey, 'Topographies of the Mask and Curiosity', in Beatriz Colomina, ed., *Sexuality and Space* (New York, Princeton Architectural Press, 1992), pp. 67–8.
10 The work is reproduced in *Richard Long No Where* (Orkney, Piers Arts Centre, 1994), with photographs and statement by the artist published on the occasion of an exhibition), p. 45.
11 See the film *Stones and Flies: Richard Long in the Sahara*, directed by Richard Haas, Arts Council of Great Britain in Association with Channel 4 television, HPS Films Berlin and Centre Pompidou, La Sept, CNAP and WDR, 1988.
12 Mulvey, 'Topographies of the Mask and Curiosity', pp. 67–8.
13 Compton, *Some Notes on the Work of Richard Long by Michael Compton*.

14 For example, in 1989, the curator, Hugh M. Davies described Long's preparations for an exhibition in California: 'We corresponded about this exhibition for almost two years and met last summer in Bristol, England, to review plans and photographs of the gallery, the artist and family arrived only a scant nine days prior to the opening. Fortunately Long is remarkably well-organised and works quickly and efficiently.' See H. M. Davies (La Jolla, California, La Jolla Museum of Contemporary Art, 1989), n.p.

15 See Robin Hanbury-Tenison, ed., *The Oxford Book of Exploration* (Oxford and New York, Oxford University Press, 1993).

16 By the early 1980s several of Long's critics had drawn attention to this aspect of Long. For example, Lynne Cook, in 'Richard Long' *Art Monthly*, May 1983, no. 66, p. 9, called him 'a pioneering explorer'. Brettel also compared Long to 'nineteenth century colonial administrators in India, Africa, Australia and Canada who root themselves in the familiar experience of the English landscape', Brettell, *Circles, Cycles, Mud, Stones*, p. 51.

17 Seymour, *Richard Long: Walking in Circles*, p. 7.

18 A. C. Kirkpatrick, 'Richard Long No Where', *transcript*, vol. 2 (1996), p. 49.

19 Sleeman, *More or Less. The Early Work of Richard Long*, p. 2.

20 M. Giezen, *Richard Long in Conversation, Bristol 19.11.1985* (Holland, MW Press, 1985, 1986) (in two parts), p. 12; quoted in Sleeman, *More or Less*, p. 2.

21 R. Cork in *Richard Long: Walking in Circles*, p. 249.

22 For a discussion of the middle-class settlement of the Home Counties, see A. Howkins, 'The Discovery of Rural England', in R. Colls and P. Dodd, eds, *Englishness: Politics and Culture 1880–1920* (London, New York and Sydney, Croom Helm, 1986), pp. 62–88.

23 See M. L. Pratt, *Imperial Eyes. Travel Writing and Transculturation* (London and New York, Routledge, 1992).

24 Kirkpatrick, 'Richard Long No Where', p. 49.

25 Seymour in *Richard Long: Walking in Circles*, p. 39.

26 Fuchs, *Richard Long*, p. 75. Elsewhere Fuchs points out that 'modern life, modern equipment, modern means of transport – and modern ideas – have given him these landscapes', p. 43.

27 See Cork, *Richard Long: Walking in Circles*, p. 250.

28 Pratt, *Imperial Eyes. Travel Writing and Transculturation*, p. 201.

29 *Ibid.*, p. 202.

30 Long, *Five, six, pick up sticks*, n.p. Alison Sleeman pointed out to me that a large number of people figure in the recent Long publication *Mirage*, Italy, 1997 and that Long mentions a Venezuelan Indian guide in *Being in the Moment*, Parc, 1999. However, as the publication dates show, the decision to include these references is a recent departure, in spite of the fact that they refer to earlier projects. I am grateful to Alison Sleeman for her comments about this essay and the useful references she provided.

31 M. Codognato, *Richard Long* (Rome, Palazzo delle Esposizione, 1994), pp. 17–18.

32 These two installations were exhibited at the Showroom gallery in London in 1988. See H. Vowles and G. Banks, 'The Art of Difference', *Marxism Today*, January 1989, pp. 58–9. In 1983 Rasheed Araeen voiced his criticism of Long in 'Long walks around the world' (a letter to *Art Monthly*, September, 1983, no. 69, p. 25), 'the nostalgia of the Empire now combines insidiously with the grand vision of international monopoly capital, whose tentacles have now reached, literally and symbolically, even the remote areas of the Kilimanjaro, the Himalayas, Alaska, the Andes ... While high technology makes people leave the land and move to the shanties of the city in search of food and

shelter, the romantics of the affluent metropolis wearing the cloaks of humanism move out with their cameras into the wilderness to claim the earth again ...' In 1991 Areen exhibited a related work *A Long Walk in the Widerness*, an installation consisting of two parallel lines made up of cast-off shoes at the Vancouver Art Gallery in Canada. See P. Overy, 'The New Works of Rasheed Araeen', in *Rasheed Araeen* (exhib. cat. (London, South London Art Gallery, 1994), pp.15, 19.

33 Dylan, 'You ain't goin' nowhere', *The Historic Basement Tapes*. Long included these lines in *Nowhere*, a book of thirty colour photographs of a walk of 131 miles within an imaginary circle in the Monadhliath Mountains, Scotland in 1993. The book was published on the occasion of the Richard Long exhibition at the Piers Arts Centre, Orkney, 1994. Kirkpatrick 'Richard Long No Where', p. 38 quoted the Dylan lyrics.

34 *Stones and Flies: Richard Long in the Sahara* (see note 11).

35 I am indebted to Brandon Taylor for his observations about this work made in the 'Art of the Walk: Parody, Ontology and Photography in the Early Work of Richard Long', his paper at the Art Historians' Association Conference, London 1997, which he kindly allowed me to read.

36 Compton, *Some Notes on the Work of Richard Long by Michael Compton*, compares Long to Constable.

37 These works are reproduced in Brettel, *Richard Long Walking in Circles*.

38 *Stones and Flies: Richard Long in the Sahara*.

39 M. Lobacheff in *Richard Long* (catalogue for Sao Paulo Biennale, 1994) (London, British Council, 1994), p. 7.

40 Sylvester uses this phrase in the introduction 'Doing Almost Nothing' he wrote for *Richard Long* (Sao Paulo, Sao Paulo Biennale, 1994). It was commissioned by the British Council with the agreement of the artist, who subsequently asked that it be left out of the catalogue. It was published in the *London Review of Books* (20 October 1994), and republished in D. Sylvester, 'Richard Long', *About Modern Art* (London, Pimlico, 1997), pp. 307–11.

41 *Stones and Flies: Richard Long Walking in the Sahara*.

42 Compton, *Some Notes on the Work of Richard Long by Michael Compton*, n.p.

43 *Ibid.*

44 'Words after the Fact Richard Long 1982', *Touchstones Richard Long* (Bristol, Arnolfini Gallery, 1983), n.p.

45 'Ten Mile Places' is published in *Richard Long Walking in Circles* (1991), p. 48.

46 Long, *Five, six, pick up sticks*, n.p.

47 G. Rose, *Feminism and Geography* (London, Routledge, 1993) and C. Nash, 'Reclaiming Vision: Looking at Landscape and the Body', *Gender, Place and Culture*, vol. 3, no. 2, pp. 149–69, 1996.

48 Fuchs, *Richard Long*, p. 44.

49 Nash, 'Reclaiming Vision: Looking at Landscape and the Body', p. 154.

50 This was part of the Land Art film, 1968–9, made by Gerry Schum for T.V. Gallery. Long's walk took place on 20 January, 1969.

51 Long, *Five, six, pick up sticks*, n.p.

52 J. Seager, 'The Earth is not Your Mother', *Earth Follies* (London, Routledge, 1994), in Linda McDowell and Joanne P. Sharp, *Space, Gender Knowledge* (London, Routledge, 1997), p. 171.

53 Bob Dylan, 'Tangled up in Blue', *Blood on the Tracks* (1974).

Notes to Chapter 13

1 S. Freud, 'The Sexual Life of Human Beings', in *The Complete Introductory Lectures on Psychoanalysis* (London, Hogarth Press, 1966), p. 315.

2 J. Kristeva, *Powers of Horror: An Essay on Abjection*, trans. Leon Roudiez (New York, Columbia University Press, 1982), p. 2.

3 M. Douglas, *Purity and Danger: An Analysis of Concepts of Pollution and Taboo* (New York and London, Praeger Publishers, 1966), p. 35.

4 *Ibid.*, p. 37.

5 *Ibid.*, p.165.

6 A. Huyssen, 'Mass Culture as Woman: Modernism's Other', in *After the Great Divide: Modernism, Mass Culture, Postmodernism* (Bloomington, Indiana University Press, 1986), p. 52 .

7 M. Thompson, *Rubbish Theory: The Creation and Destruction of Value* (Oxford, Oxford University Press, 1979).

8 *Ibid.*, p. 65.

9 *Ibid.*, p. 33.

10 B. C. Matilsky, *Fragile Ecologies: Contemporary Artists' Interpretations and Solutions* (New York, Rizzoli, 1992), p. 101.

11 *Studio International* (London, December 1988), p. 4.

12 B. Oakes, *Sculpting with the Environment – A Natural Dialogue* (New York and London, International Thomson Publishing, 1995), p. 61.

13 *Ibid.*, p. 63.

14 D. DeLillo, *Underworld* (New York, Scribner, 1997), p. 286.

15 Matilsky, *Fragile Ecologies*, p. 68.

16 Oakes, *Sculpting with Environment*, p. 193.

Index

Note: Page numbers given in *italic* refer to illustrations.